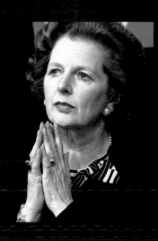

MARGARET
THATCHER

A Life in Pictures

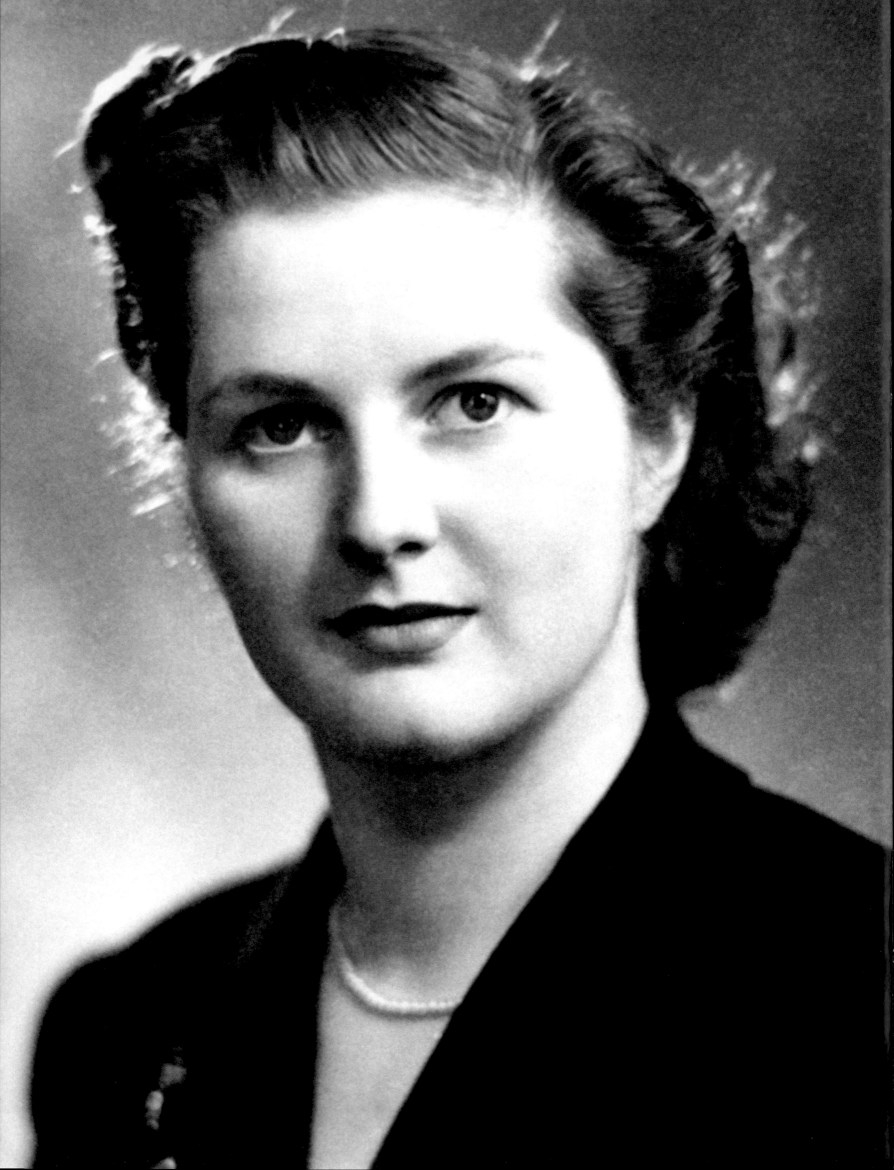

MARGARET
THATCHER

A Life in Pictures

Edited by Elizabeth Roberts

Interviews with Ann Widdecombe and Lord Healey

AMMONITE

PRESS
ASSOCIATION
Images

First Published 2009 by
Ammonite Press
an imprint of AE Publications Ltd,
166 High Street, Lewes, East Sussex BN7 1XU

Text copyright Ammonite Press
Images copyright Press Association Images
Copyright in the work Ammonite Press

ISBN 978-1-906672-27-0

Editor: Elizabeth Roberts
Picture research: Press Association Images
Design: Gravemaker + Scott

Colour reproduction by GMC Reprographics
Printed and bound by Kyodo Nation Printing, Thailand

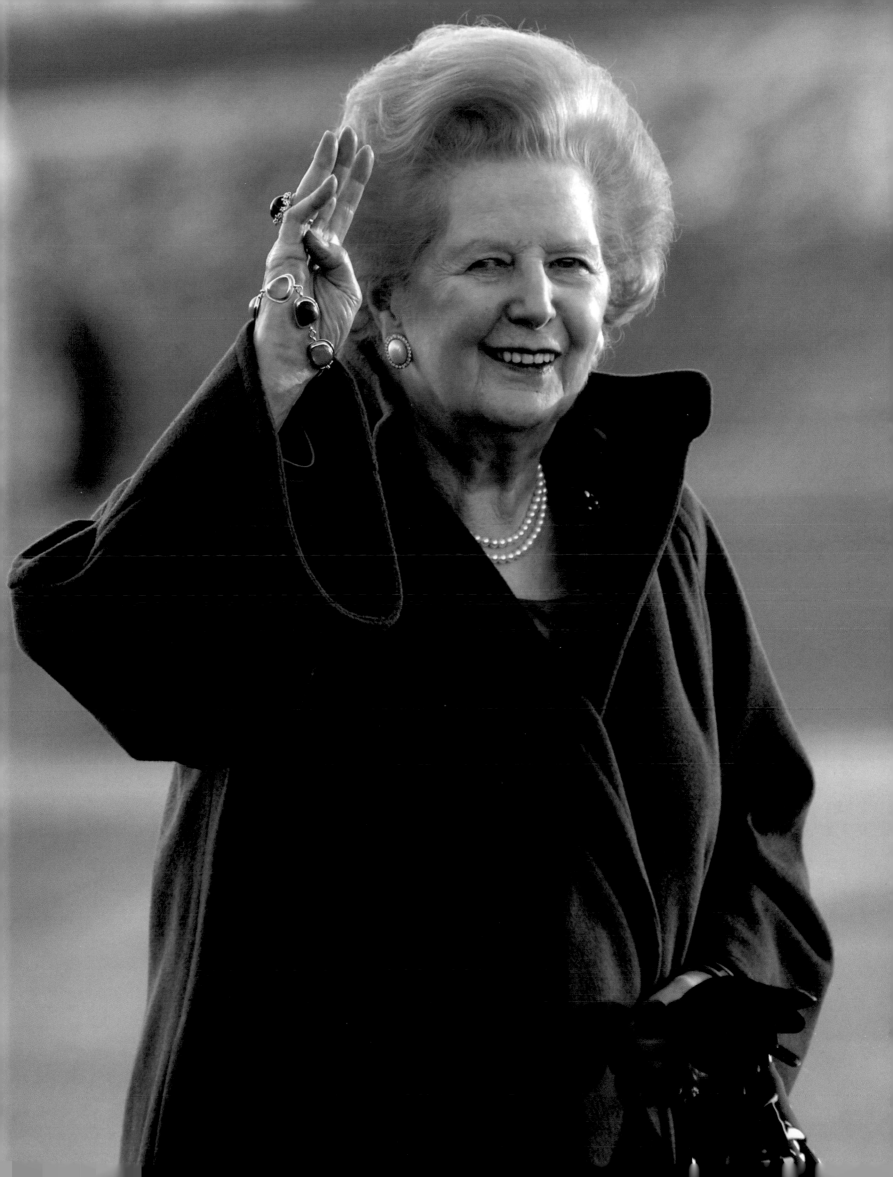

1925 Margaret Hilda Roberts, born 13 October to Beatrice Stephenson Roberts and Alfred Roberts in Grantham, Lincolnshire.

1936 Wins a scholarship to Kesteven and Grantham Girls School.

1943 Goes to Oxford University to study Natural Sciences, specialising in chemistry.

1946 Becomes President of the Oxford University Conservative Association, the third woman to hold the post.

1947 Graduates from Oxford with a second-class degree in Natural Sciences.

1949 Selected as the Conservative candidate for Dartford.

1951 13 December, marries Denis Thatcher.

1953 Qualifies as a barrister, specialising in taxation. Gives birth to twins, Mark and Carol.

1958 Selected as Conservative candidate for Finchley.

1959 Wins the Finchley seat and becomes a Member of Parliament.

1961 Becomes Parliamentary Undersecretary at the Ministry of Pensions and National Insurance.

1965 Promoted to Conservative spokesman on Housing and Land.

1966 Moved to the Shadow Treasury team.

1967 Again moved to the Shadow Cabinet as Shadow Fuel spokesman.

1970 Becomes Secretary of State for Education and Science under the leadership of Edward Heath.

1974 Becomes Shadow Environment Secretary after the Conservatives are defeated in the February general election.

1975 11 February, becomes Conservative Party Leader after her challenge to Edward Heath.

1976 Makes a speech attacking the Soviet Union and is dubbed 'The Iron Lady' by the Soviet press.

1979 4 May, becomes Britain's first female Prime Minister.

1982 The British retake the Falklands Islands from Argentina under Thatcher's leadership.

1983 The Conservatives win a landslide victory in the general election and she begins her second term in office.

1984 Narrowly escapes assassination by the IRA in Brighton.

1984/1985 The Miners' Strike. The end of the strike is seen as a major victory by Thatcher in curbing the power of the unions.

1985 Signs the Hillsborough Anglo-Irish Agreement with Irish Taoiseach, Garret FitzGerald.

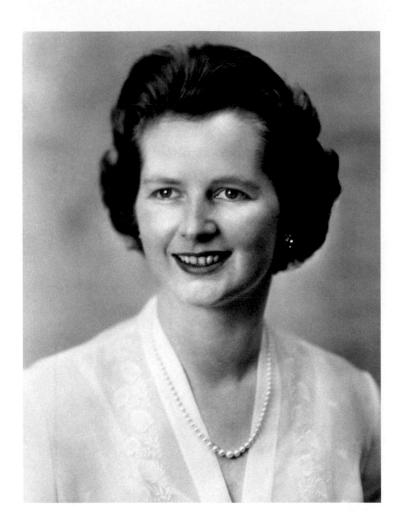

1987 The Conservatives win a third term and she becomes the longest continuously serving Prime Minister in the UK since Lord Liverpool (1812-1827).

1989 Challenged for the leadership of the Conservative Party by Sir Anthony Meyer, without success.

1989 End of the Cold War.

1990 1 November, Sir Geoffrey Howe resigns from his post as Deputy Prime Minister in protest at Thatcher's European policy. Later Michael Heseltine challenges her for the leadership of the party.

22 November, she withdraws from the second ballot for the leadership.

27 November, John Major wins the leadership.

28 November, she resigns as Prime Minister.

1992 Retires from the House of Commons and conferred with a life peerage as Baroness Thatcher of Kesteven in the County of Lincolnshire.

1995 Appointed a Lady of the Order of the Garter, the UK's highest order of Chivalry.

2003 26 June, Denis Thatcher dies.

2005 13 October, celebrates her 80th birthday.

2008 24th August, it is announced that she is suffering from dementia.

Contents

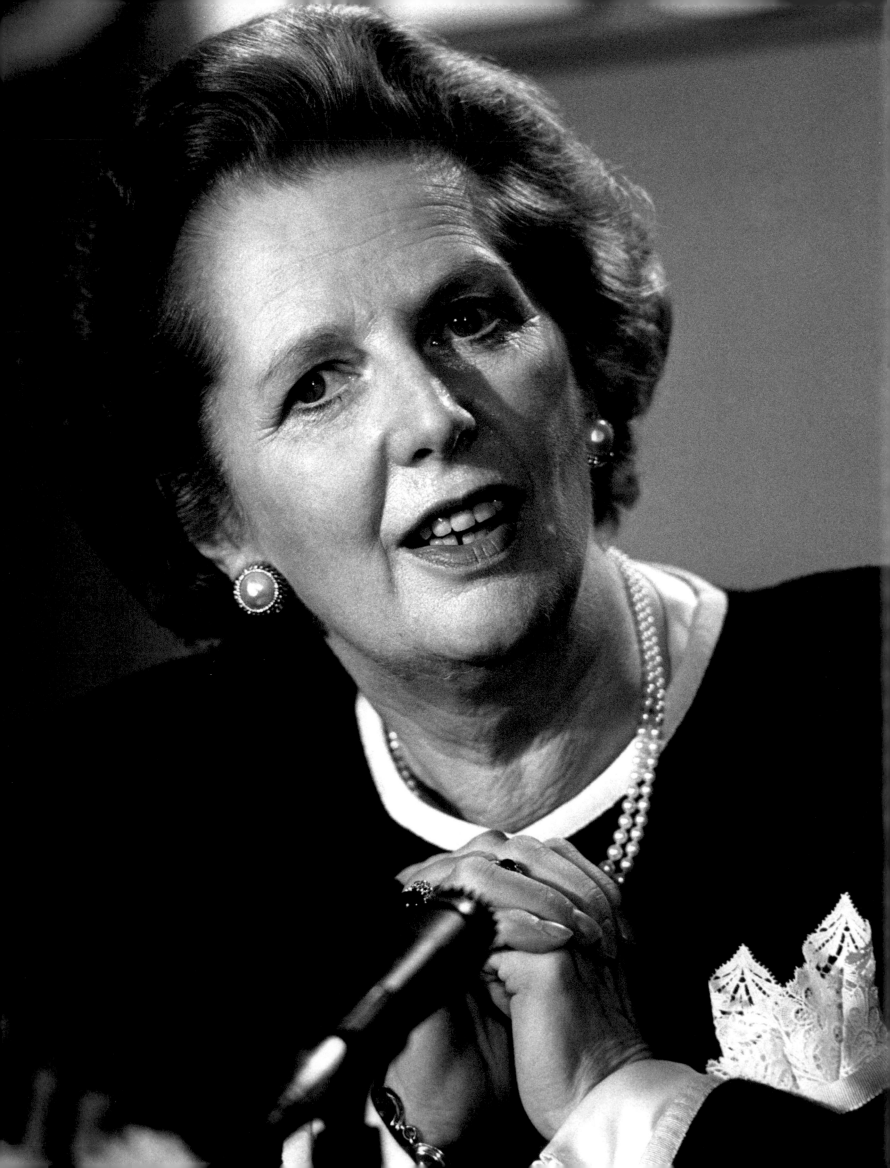

Introduction

History is a strange thing, it unravels itself in little bits, seemingly unrelated, day by day. But, in retrospect, it's a continuous coherent story. Once we've put all the pieces together, we have the big picture – the history. When the Press Association's photographers, back in 1949, started taking pictures of Margaret Roberts it was only because she was the youngest ever female Conservative candidate. No-one dreamt that she was going to be the first female Prime Minister in the UK. If they had, they might have taken even more pictures.

Since the late 1800s, photographers from the Press Association have been taking photographs of what or who they thought were relevant or important to the day. Once reproduced in a newspaper those images were then archived and many of them have lain on shelves, either in glass plate, negative or print form, for many years, perhaps never seeing the light of day again. With the advent of digital cameras, modern day images are stored digitally, but the procedure is much the same. Only when we start to realise their relevance do we begin to track back through time and put them all together.

Even if we didn't live through Margaret Thatcher's premiership, or if we were too young to give it credence at the time, we still know the story – the Iron Lady, the first woman Prime Minister in Britain who held office for a record-breaking third term. If our political curiosity is whetted and we delve into the facts further, and then add images to it, we can claim a third dimension.

An archive of photography is a wonderful place in which to recreate history – to bring it to life – we can put together the everyday, the ordinary and the extraordinary, knowing its relevance to what was then, the future. If we look at a shot of the young Margaret Thatcher enthusiastically campaigning in the Finchley by-election of 1959 we can feel a thrill of anticipation, for it is the real beginning of the story of an unprecedented road to power.

Whether we admire her politics or hate them – and many people are polarised to those extremes – we cannot deny that her story is a fascinating one. She changed the face of Britain at the time, and forever, in a way no other Prime Minister has, either before or since. In hindsight, it's one of the most intriguing stories of the twentieth century.

In the following pages her life is traced through pictures chosen from the Press Association archive. These images trace her story from youth, through middle age, and growing old. We see her family and her career, her admirers and her enemies; her rise to power and her downfall. And through it all, the making of history.

She was one of the most photographed women in the UK, along with the Queen and the Princess of Wales, but there will be few images taken from where this book leaves off. As her life begins to fade, in dementia, we can look back over her time in office and place it within the context of not only Britain but the world, for her influence was that widespread. She was, undoubtedly, one of the most powerful women in recent history.

Elizabeth Roberts

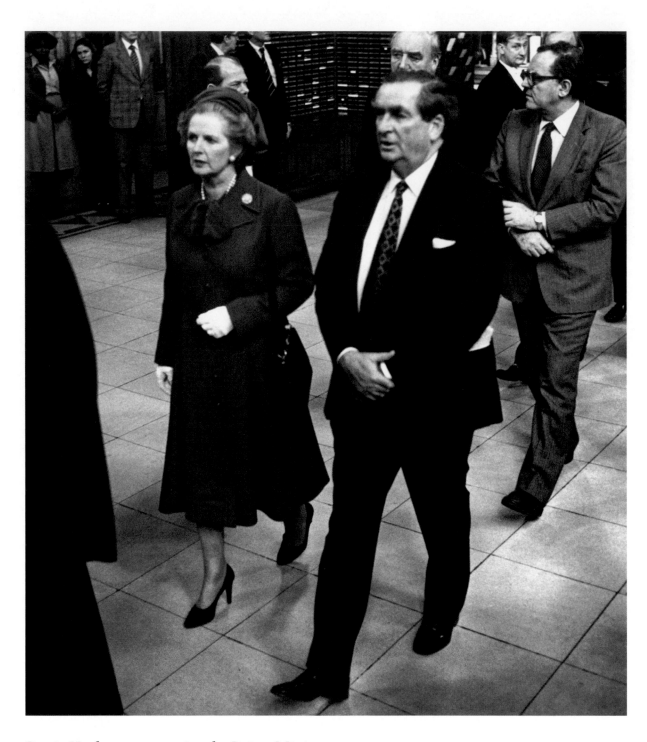

*Denis Healey accompanies the Prime Minister
in his role as Deputy Leader of the Labour Party.*

20 November 1980

Interview with Lord Healey

Elizabeth Roberts: You served as deputy leader of the Labour Party during Margaret Thatcher's time in office – how do you think she will be remembered as a political leader?

Lord Healey: I feel the country will still be divided on her. She was the one who really recognised that there had been a change in public opinion, and that the country was turning against the nanny-state, and although the public didn't know or care anything about monetarism, her adoption of it was the sort of thing that they thought would be very helpful. But she overdid it – she overdid everything in the end. She went through an extraordinary change because she was very much a Heathite at the beginning, but I think that by the time she became Prime Minister she really had become very right wing indeed. She had extraordinary views – she said, 'there's no such thing as society' – which is why she was able to stop free school milk and became known as 'Margaret Thatcher milk snatcher'. I think that she damaged the country very much and, of course, by the end her own party turned against her and got rid of her, and she wept as she left Downing Street. The television caught it and it was an historic moment really.

ER You obviously don't share her political viewpoint, but what do you see as her strengths as a political leader?

LH Well I think, frankly, that she would only work with people who would follow her lead and that's why more moderate Tories like Geoffrey Howe or Christopher Soames turned very much against her. And in the end of course, under Heseltine's lead, they got rid of her.

ER And what about her weaknesses?

LH Her big weakness was being too self-confident. She also had very little understanding of people who didn't share her views, which is always a weakness. And it became very damaging to her.

ER What good do you think she did for Britain?

LH Well, she supported something which was immensely helpful in the end to the Labour Party, and that's to say she destroyed the power of the union barons by supporting John Smith's introduction of one-man, one-vote in the unions – although I was very much against her reasons for doing it.

ER And what do you regret about her time in office?

LH I think most of the domestic policies after her Heathite years were very damaging to the country – but the most damaging thing of all was getting us into the Falklands war because we had no interest whatever in the Falkland Islands, it was totally unimportant to Britain. If we'd reacted early enough and put just 100 soldiers there we could have prevented the Argentineans taking it over. But we didn't do that. The fact that she defeated them made her a national heroine. And I think she is remembered still for her role in the Falklands war. Although our interests in winning that war turned out to be absolutely negligible.

ER Why do you think her downfall came when it did?

LH It was partly because of her resistance to Europe, but I think it was basically that opposition to her, inside her own party, had been steadily building up but none of them were prepared to oppose her directly except Heath, who lost out completely

early on. I think if Carrington hadn't resigned they might have persuaded her to go earlier, but in the end of course it was Heseltine who headed the group, which really forced her to leave. She's a very sad figure – she had no interests whatever except in the power of politics, and her husband's death really broke her last human link. As you know, she has become slightly mentally frail as well as physically frail. One of the most extraordinary things is that I met her at Wakefield Place in Sussex, which is near where we live, and she was terribly affectionate because she felt that our generation was enormously superior to the current one. I gave her a great hug, which my daughter captured on camera – but we didn't unfortunately sell it to the *News of the World*!

ER Do you think the Conservatives could have continued in office without her leadership?

LH I think her time was coming to an end, and the Tory time was coming to an end. And an extremely narrow-minded belief in monetarism, which Keith Joseph sold her, damaged her a great deal with the country as a whole.

ER She was enormously powerful. What do you think the key to that was?

LH Basically, she insisted on having total control over her party, and over the country, but of course, in the end, both the country and her party turned against that, and not unnaturally.

ER Do you think if she was a young politician now that she would have reached anything like that extent of power?

LH I don't think so, no. I think the extraordinary thing about politics now is that the class war is dead. In fact, Attlee really killed it, but it didn't die finally until after she went, and now almost the whole country is middle of the road – and that was the one thing that Maggie never was.

ER Is there any other political leader that you would compare her with?

LH I think there may have been one or two in the nineteenth century but she was unique really in the history of the country and the history of the Conservative Party.

Lord Healey is a British life peer and Labour politician. He was Secretary of State for Defence from 1964 to 1970 and Chancellor of the Exchequer from 1974 to 1979.

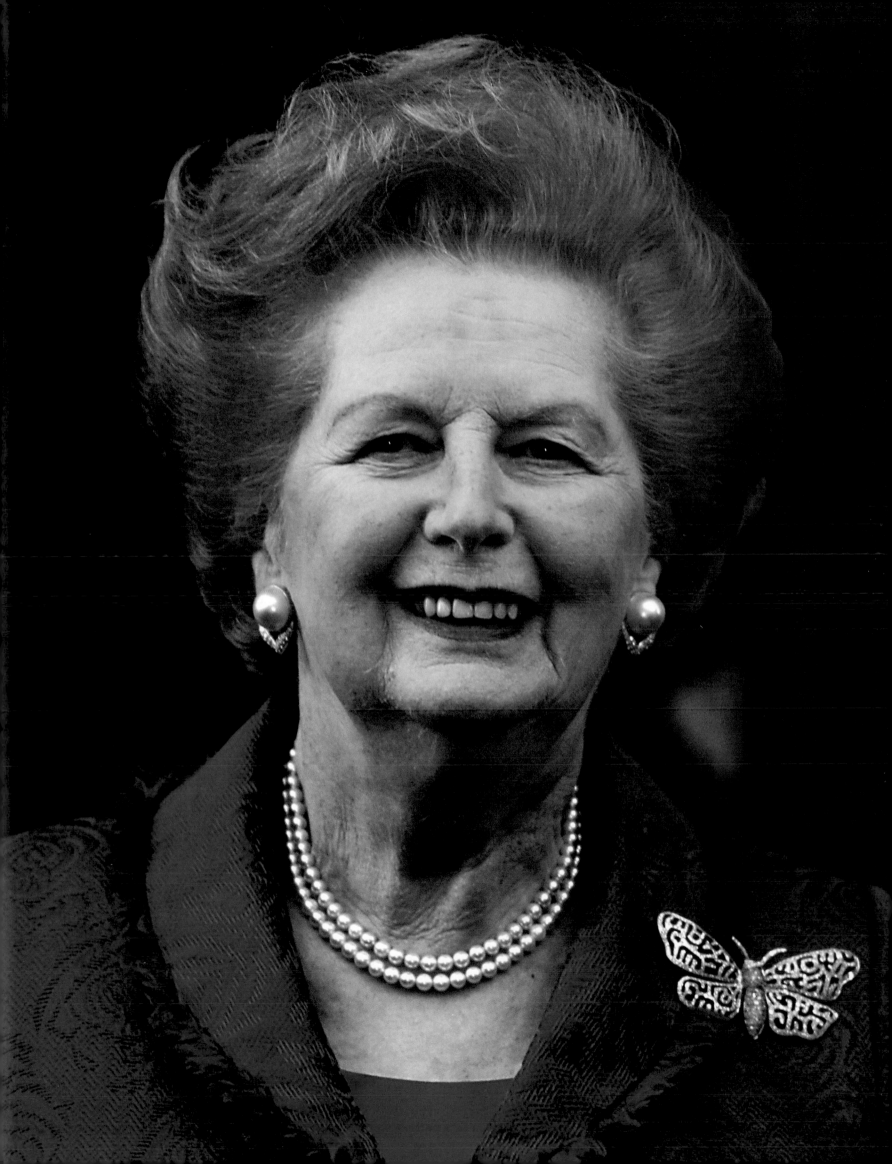

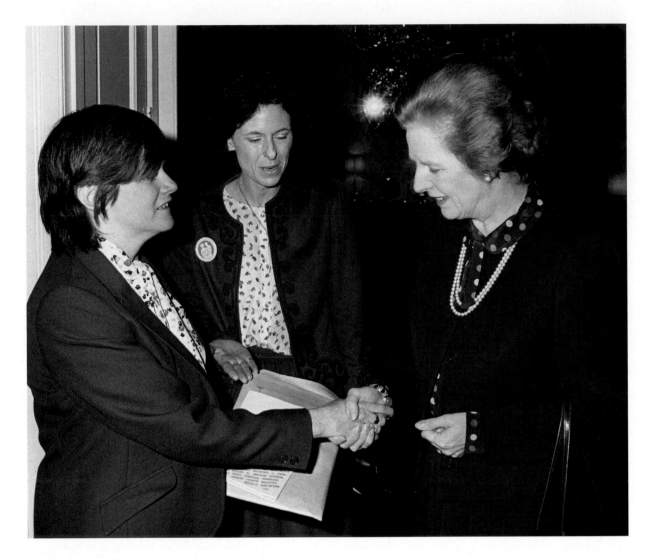

*Margaret Thatcher greets Ann Widdecombe at a reception at
No 10 for members of the Women and Families for Defence.
"The only time she could fit us in was very early in the morning,
before breakfast, and we expected just to be photographed
and come out. Instead she spent half an hour sitting on the sofa
talking to me... I remember her with considerable affection."*

22 May 1984

Interview with Ann Widdecombe

Elizabeth Roberts: You have known Margaret Thatcher for a long time – how do you think she will be remembered as a political leader?

Ann Widdecombe: I think she will be remembered as an extremely significant Prime Minister if you consider how she completely turned the country round. Those of us who can remember 1979 – the massive power of the unions, the state owning so many assets, the real socialism that there was – and if one thinks how, in 11 years, that it was all gone, the trade union power was severely reduced, the big state monopolies had been sold off (and in a boardroom the waitress was just as likely to own shares as the directors). People who thought they were condemned to a lifetime of renting could buy their council houses. The country was a seriously different place and very few Prime Ministers can say that. Some have kept the country the same – people like Winston Churchill, who fought for our freedom, who fought for us to stay as we were – but very few have, without any outside interference, actually changed the country. And of course, she had a considerable input into the fall of communism. There was a time in the mid to late '80s when there were only three serious players on the world stage, and they were Thatcher, Reagan and Gorbachev.

ER What would you say was her finest moment?

AW I think it is difficult to point to any one moment because I think it was her whole premiership that was great. But I think probably her greatest moments were the ones that we'll never know anything about. They were those when she had to convince people that we really could win – we could win if we took on the miners, we could win if we do this, if we do that. I suspect that those hidden moments were probably her finest.

ER And what about her lowest moment?

AW I think that came with her downfall, because I think she was not expecting it, that she had been so successful, that she had done so much, and the party was in its third term. She had taken her finger off the pulse, and assumed that people would stay loyal because of what she'd done. Whereas the party was intent only on survival.

ER How do you think her years in power changed the course of history?

AW I think they changed the course of this nation's history first of all, very substantially, in the ways that I've already pointed out, and I think that had a ripple impact elsewhere. People saw what she was doing, particularly in Europe, and wanted to copy it. But in world terms her impact was almost certainly the part she played – and it was a part, not a whole – in the fall of communism. Where is communism now? My generation grew up under the shadow of the bomb and the Cold War, and it was taken for granted, we assumed it would go on forever, or at any rate for our lifetime. And it didn't.

ER How important do you think she was as a role model for women?

AW I don't think Mrs Thatcher ever set herself up to be a role model for women. Any more than I ever have. I think she's a role model almost by accident, to this extent – there was a generation, which, from the moment it was old enough to make any sense of the news to the moment it was old enough to vote, knew absolutely nothing except a woman Prime Minister. And that generation now is moving into senior management. And you'll never convince them that there is anything unnatural or

unusual, or even comment-worthy, about a woman being in charge. I think we have yet to see that effect work through, but with that generation now moving to the higher echelons, it will.

ER Which other leaders would you compare her with?

AW I think for sheer tenacity of vision, and for hanging on when people around her were crumbling, there was an element of Churchill in her – just an element, I'm not making a direct comparison. I think in terms of seeing the bigger picture and being able to take people with her, she endured a lot of the frustrations that, say, Wilberforce endured [*William Wilberforce, 1759–1833, a British MP known for his work in the abolition of slavery*].

ER On a personal level, how do you remember her?

AW With considerable affection. Long before I was a Member of Parliament, I was involved in a group called Women and Families for Defence. We'd been set up to counter the Greenham Common people, and one of our publicity stunts was to go to No 14 and hand over a book I'd written on the Soviet threat, and be photographed with Mrs T. The only time she could fit us in was very early in the morning, well before breakfast, and we expected that we would go in, shake hands and be photographed and come out. Instead of which, she spent half an hour sitting on the sofa talking to me. I didn't expect that at all. I do remember her with considerable affection. [*See photo page 14*]

ER What do you think her personal strengths were?

AW I think her biggest strength was determination and vision. She saw what the country should be like and she was determined to get us there. A lot of people know what the country should be like, but you can't do it solo, you've got to get everybody else with you. And she was very good at picking out, and surrounding herself with, the people who shared her vision. At the same time it's worth remembering that her Cabinet consisted of people like Clarke and Heseltine who weren't Thatcherite in that sense but who went along with a lot of the vision.

ER And what about her personal weaknesses?

AW I think she grew out of touch. She wouldn't have fallen in 1990 if she'd stayed much more in touch. I think she grew remote because she was focused on what she was doing, she believed that the vast success she'd had was justification enough and that people would go along with her. I think she lost touch with the insecurities and worries that the party had at the time. And I still say that 1990 was unnecessary if only somebody somewhere had battered down the door and convinced her that there really was revolution stirring outside.

ER If she was young today do you think she would have taken the same path and had as much power as she did then?

AW I think she would have taken the same kind of path. But there has been a lot that has eroded the power of Parliament since then – Europe's won the power of the judiciary – but I think she would still have made a massive impact.

Ann Widdecombe is a Conservative Party politician, television presenter and novelist.

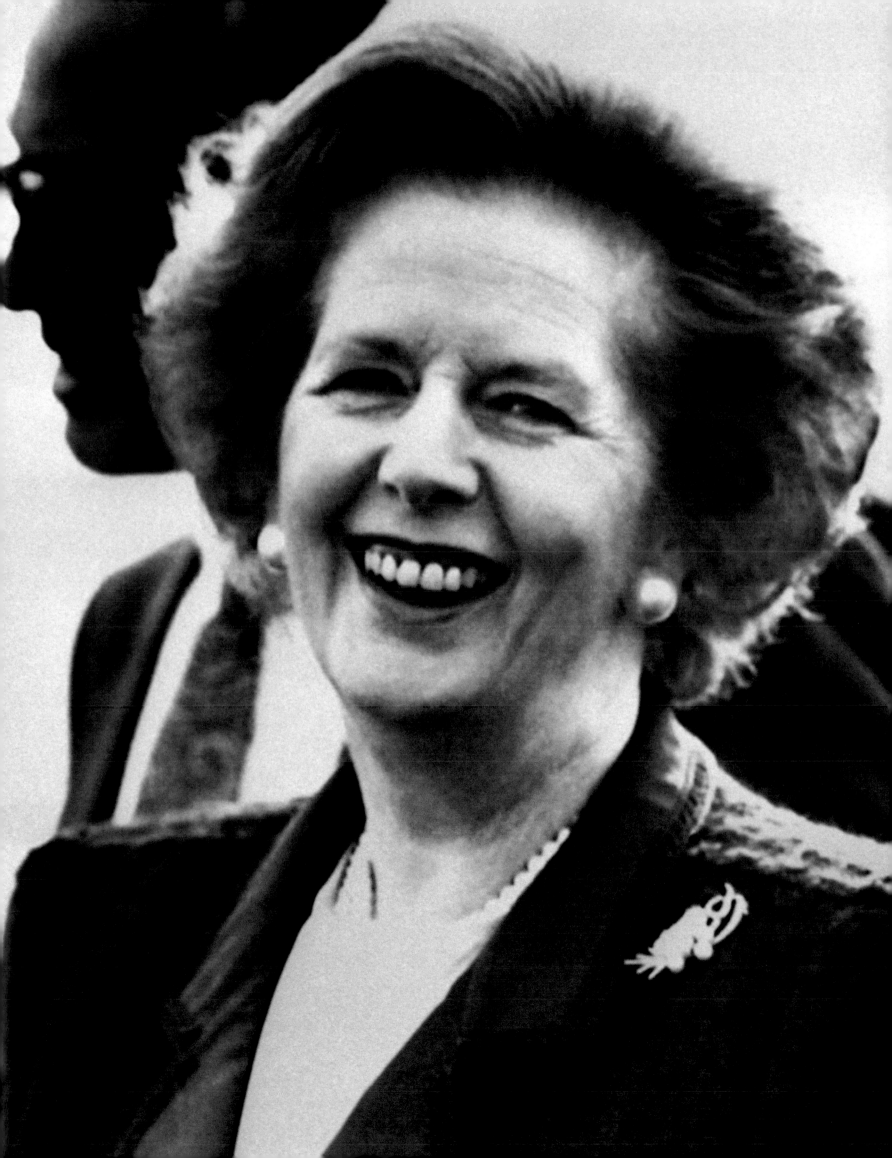

CHAPTER 1

Starting Out

The 25-year-old Margaret Roberts, the Conservative candidate for Dartford, on her way to a garden party at Buckingham Palace. She was born on 13 October 1925 in Grantham in Lincolnshire, the daughter of a grocer. She went to Oxford University and then became a research chemist.

13 July 1950

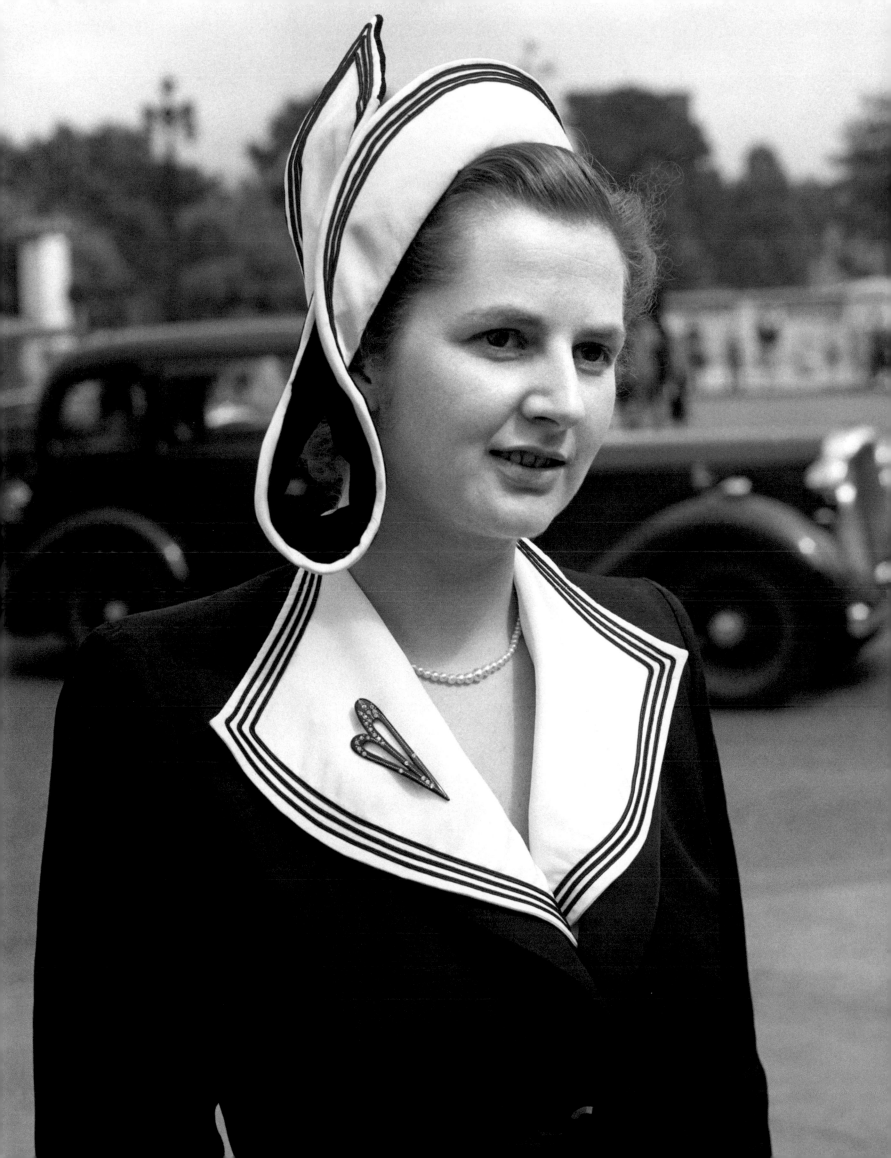

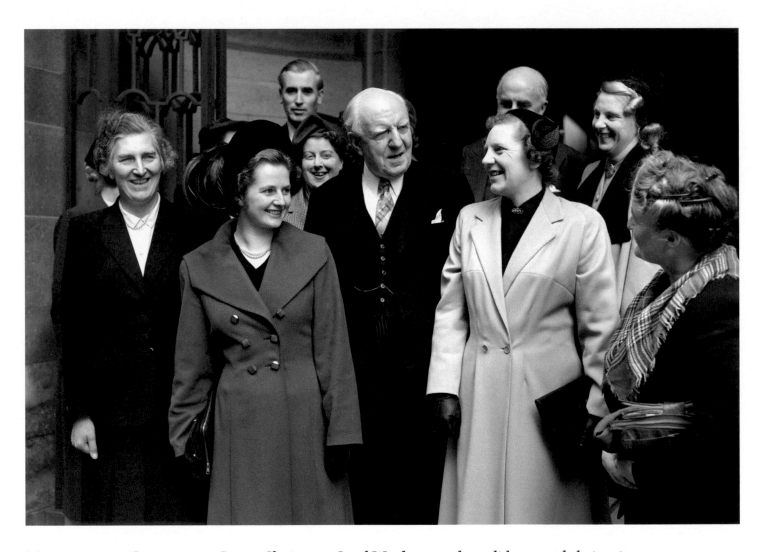

Margaret joins Conservative Party Chairman, Lord Woolton, and candidates and their wives,
at a briefing for the forthcoming general election at Church House in London.

30 September 1951

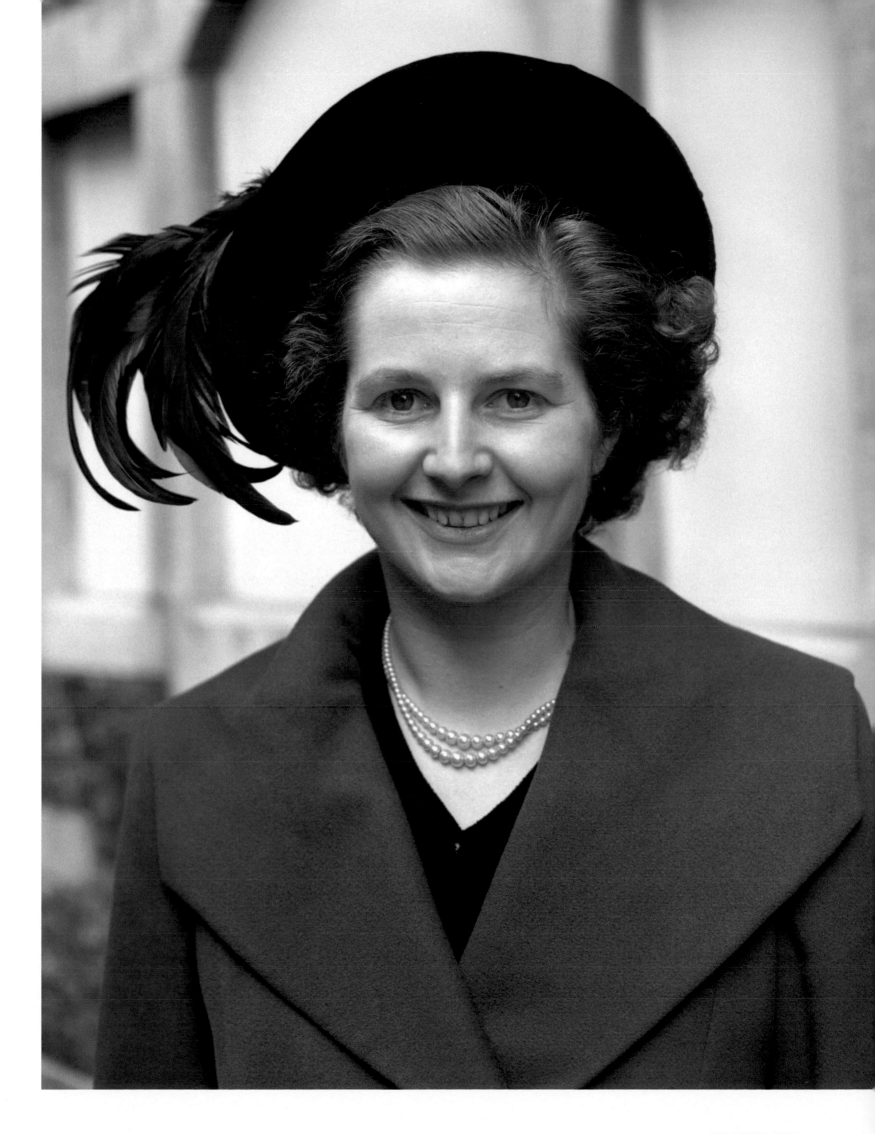

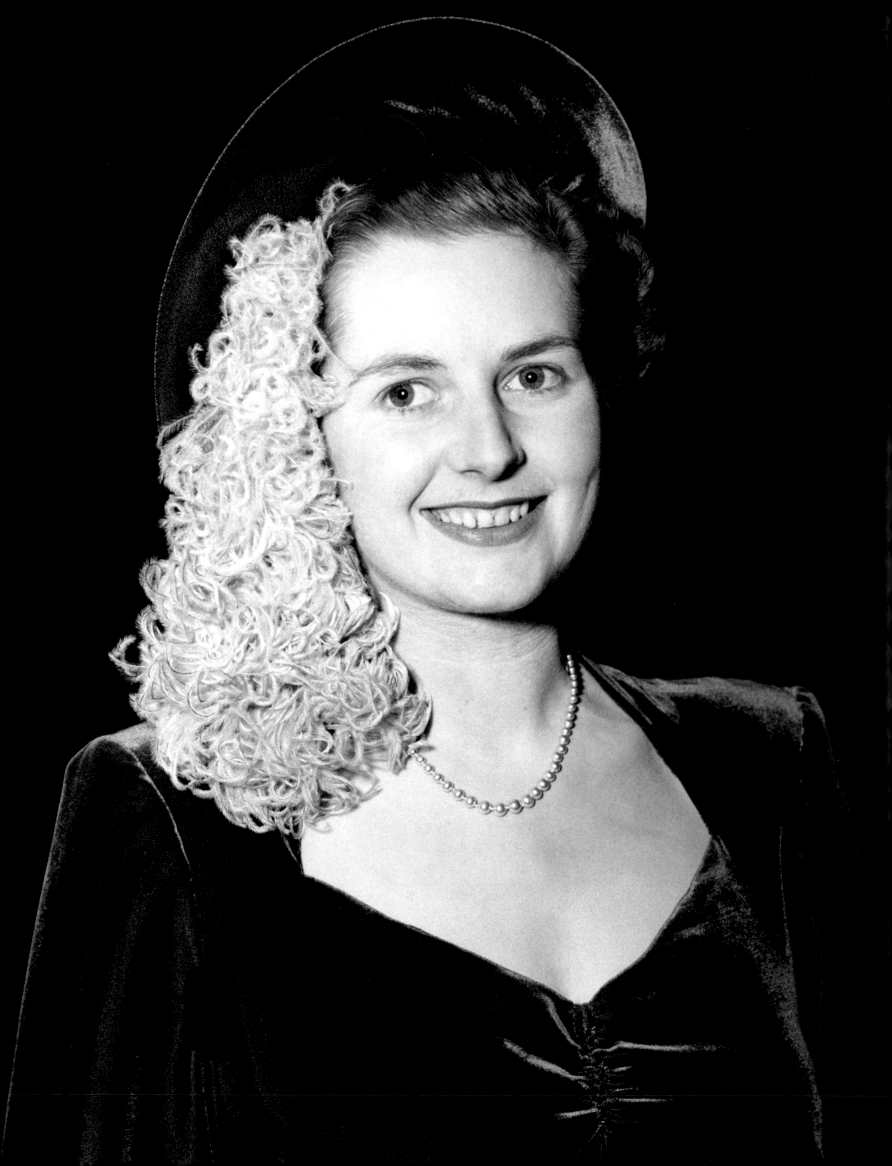

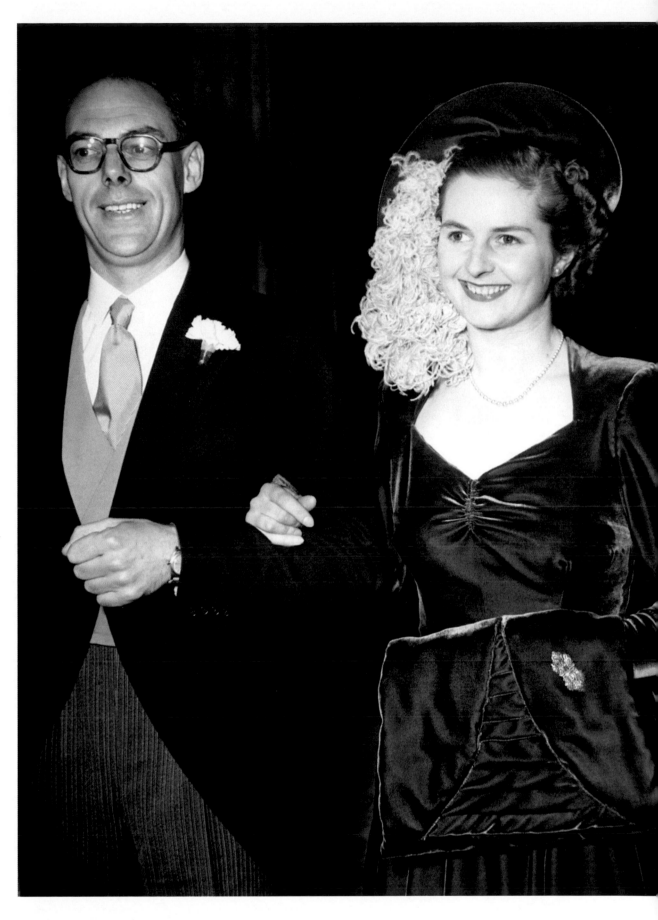

*Margaret Roberts and Denis Thatcher
on their wedding day. The ceremony
took place at Wesley's Chapel in London.*

13 December 1951

By 1959 the Thatchers had a family
– twins Mark and Carol – and Margaret
had become MP for Finchley. She had
also retrained to become a barrister.

10 May 1959

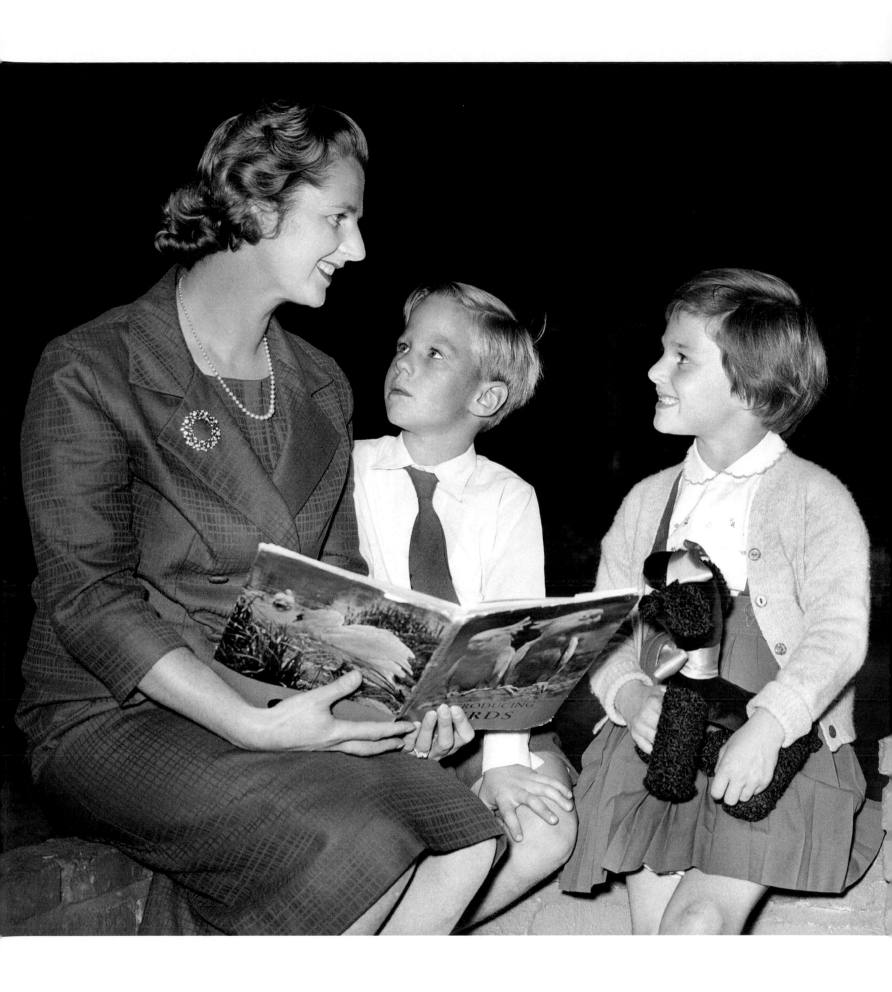

A studio portrait.

24 September 1959

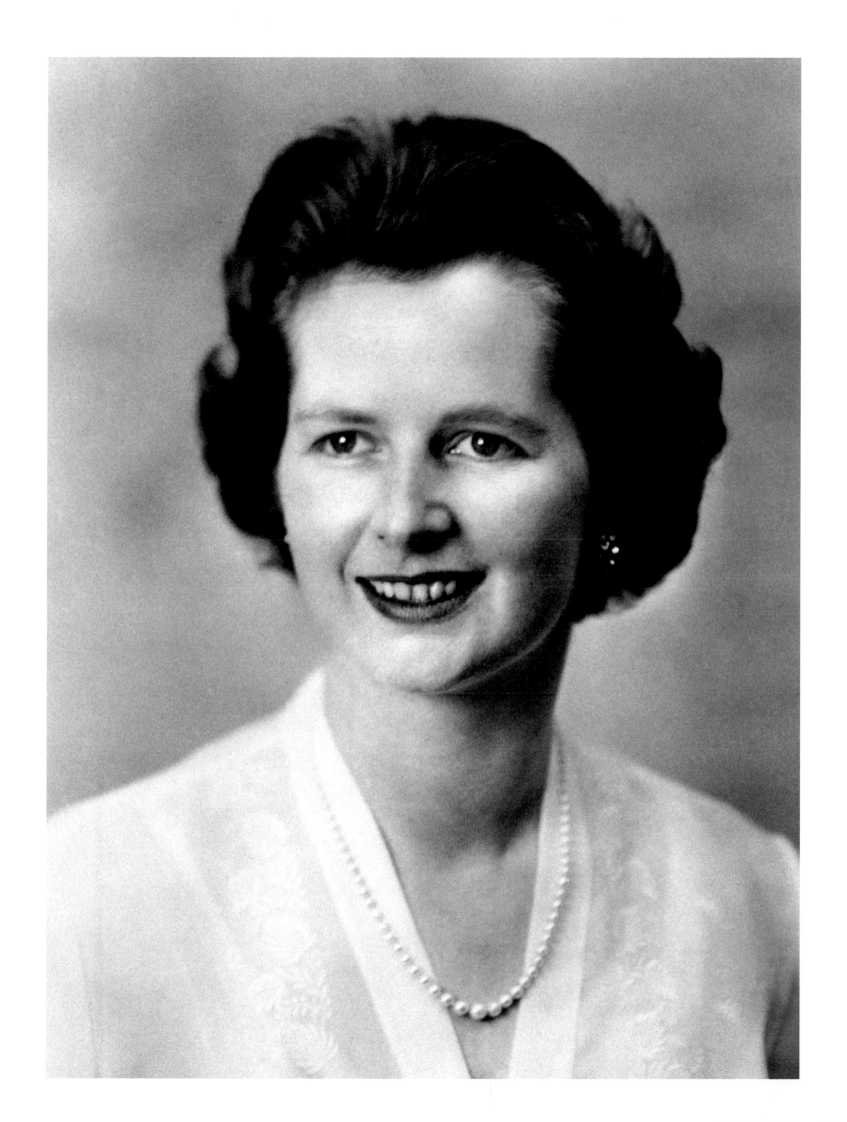

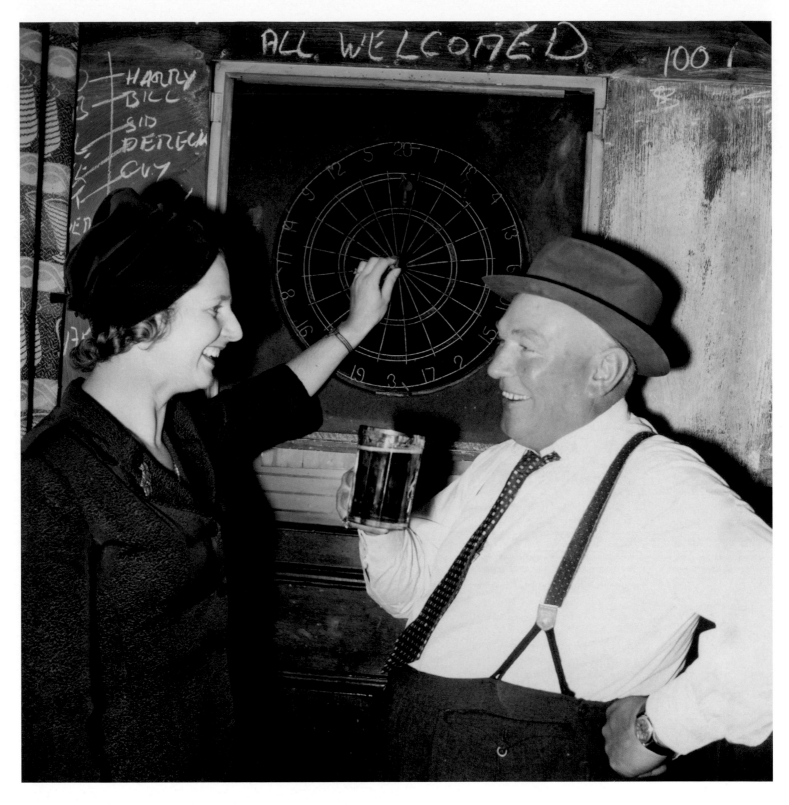

*Always an enthusiastic campaigner, Margaret went
out on the streets and pubs to talk to local people.
Here she jokes with Fred Booth, a Finchley greengrocer.*

25 September 1959

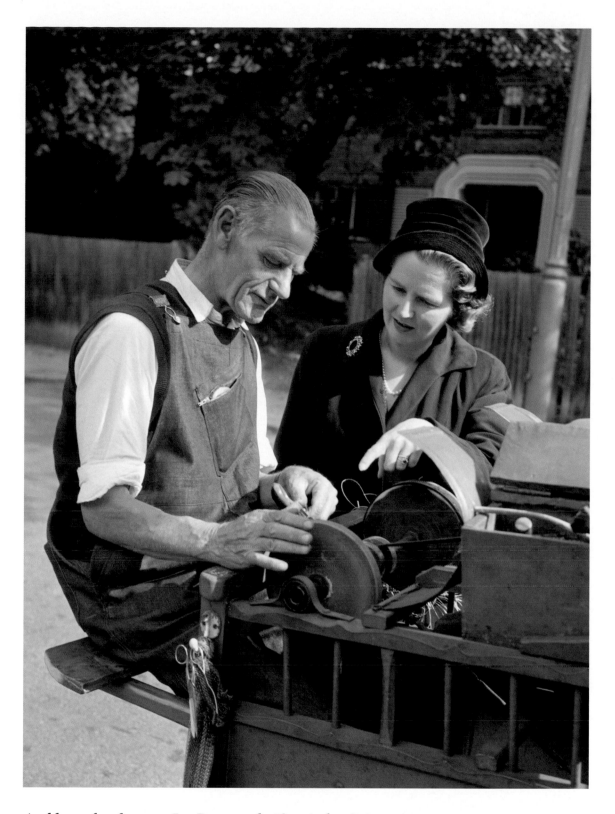

*And here she chats to Joe Payne, a knife grinder. It is an important time
in the campaign, for Harold Macmillan had just called a general election in October.
As it turned out, it was to be a high point in Tory fortunes of the post-war era
with the Conservatives claiming victory. And it was Margaret's big break.*

25 September 1959

Relaxing in the garden at home in Farnborough, Kent, still means showing a public face for the camera.

1 October 1959

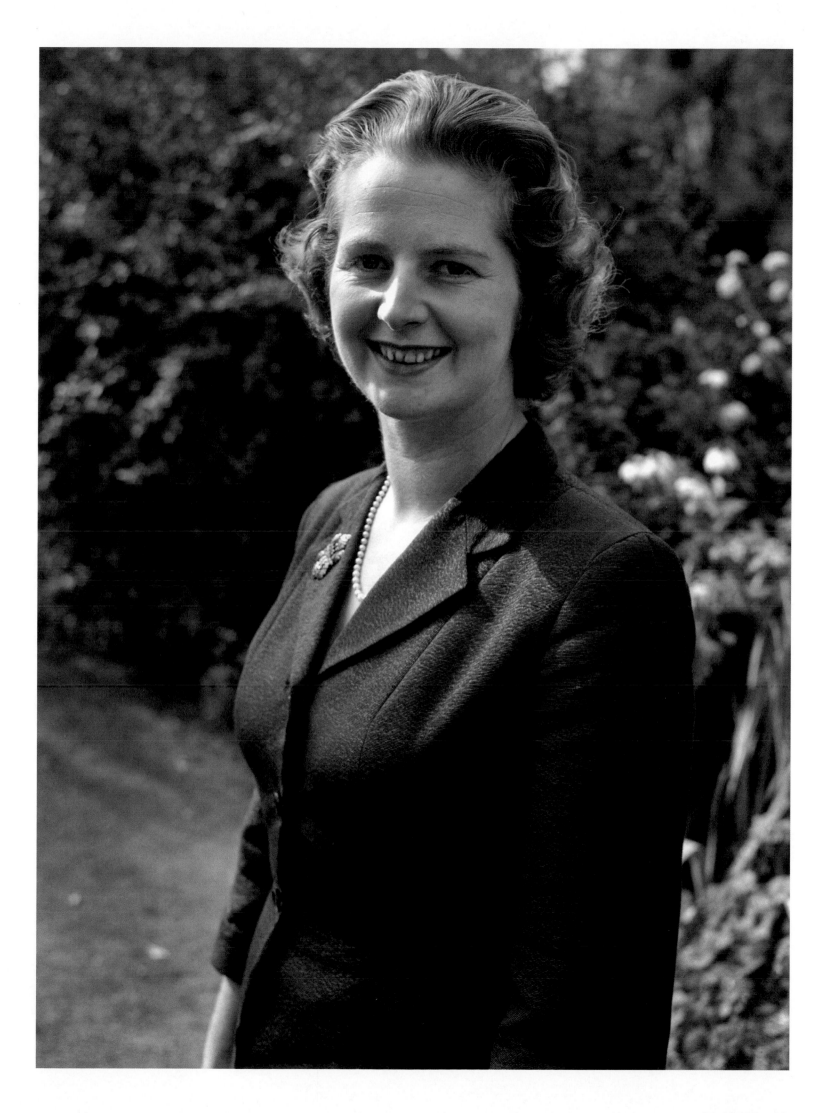

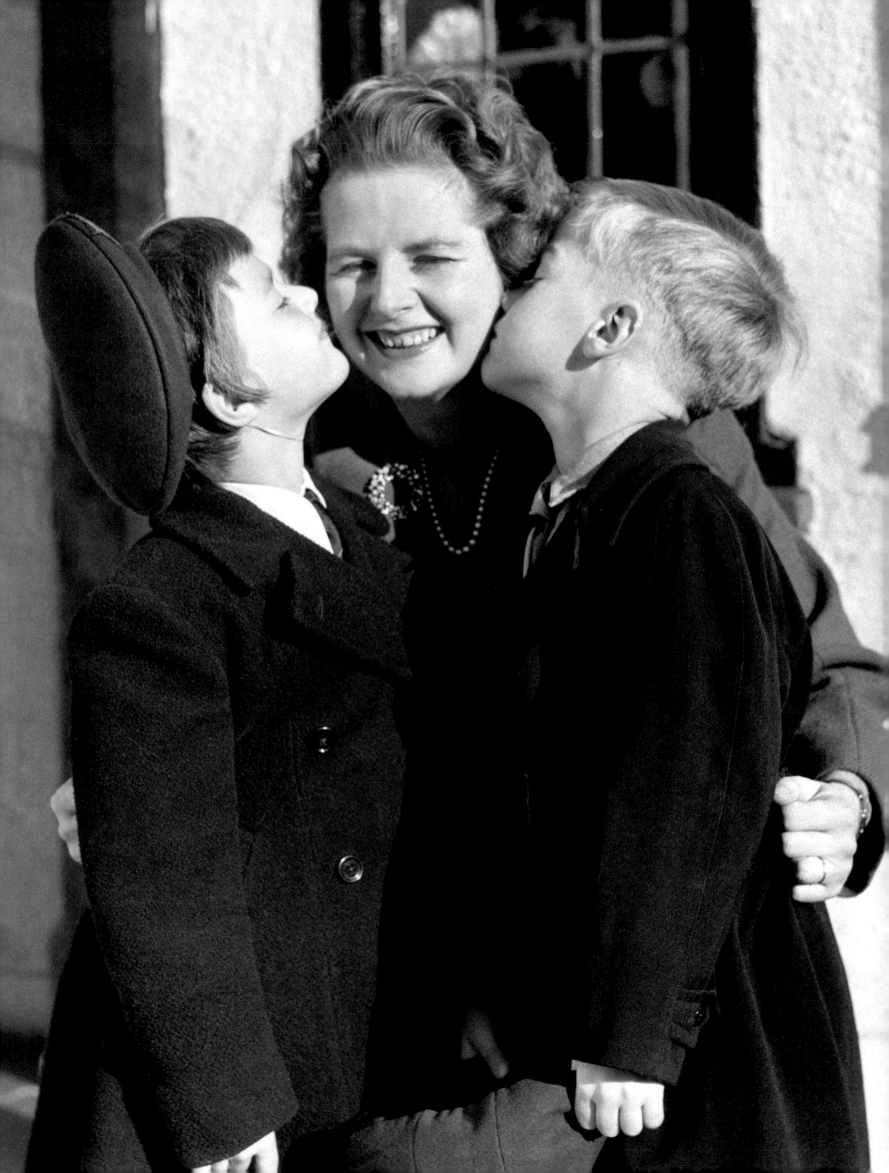

Family life...

20 October 1959

...and public life. Margaret Thatcher arriving at the House of Commons having been elected Conservative MP for Finchley in the general election. She is 33 years old and one of only 12 women members of the Conservative Party.

20 October 1959

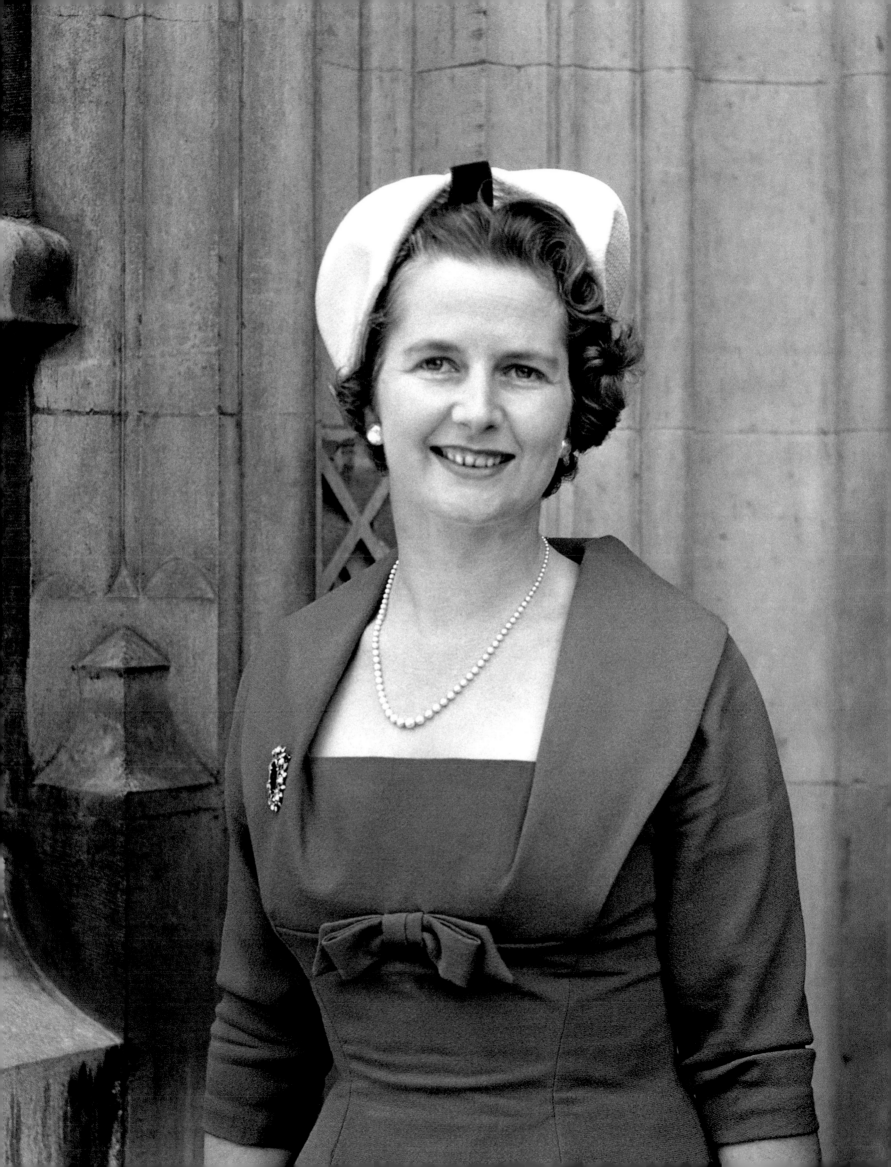

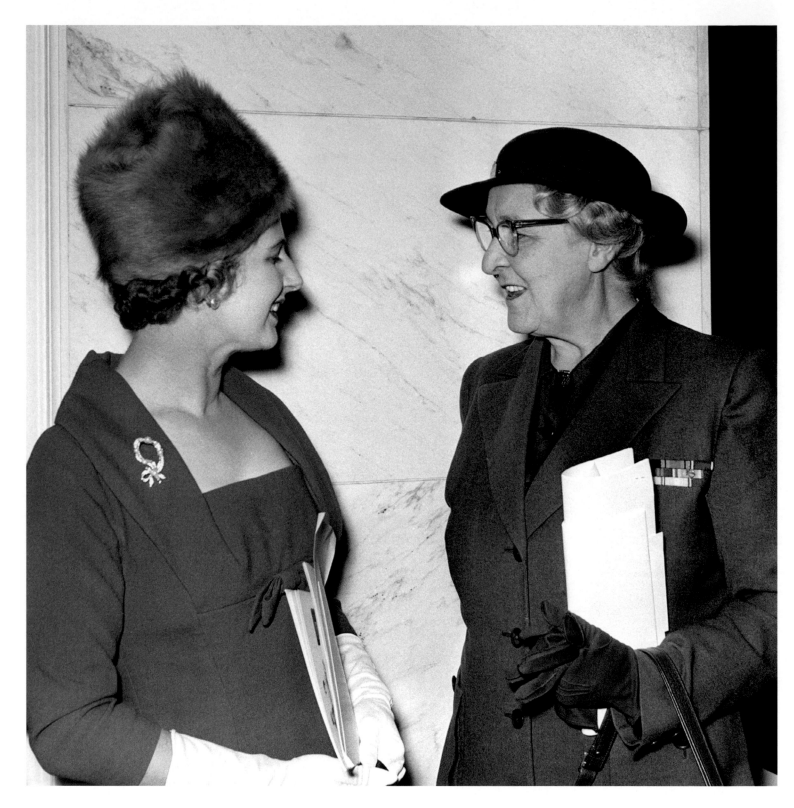

*Margaret chats to the Dowager Marchioness of Reading
at the Women of the Year luncheon.*

6 October 1960

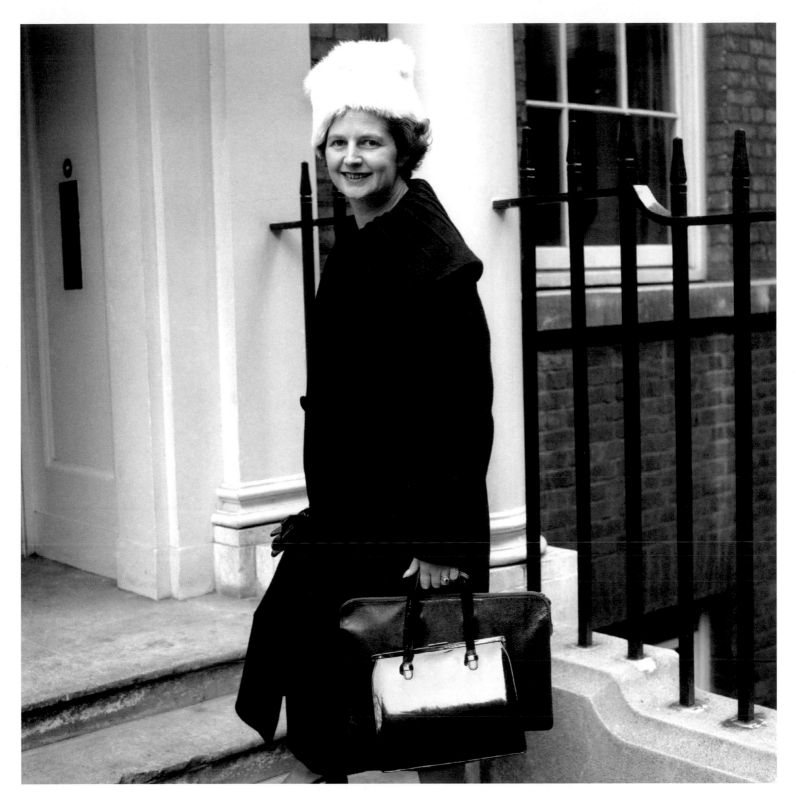

She takes up her new appointment as Joint Parliamentary Secretary at the Ministry of Pensions and National Insurance. Whilst not a highly important post, it was excellent training in the ways of Whitehall.

12 October 1961

She was to hold the ministerial post for the next three years. Here she is seen leaving Euston Station on her way to Llandudno to attend the annual Conservative Party Conference.

9 October 1962

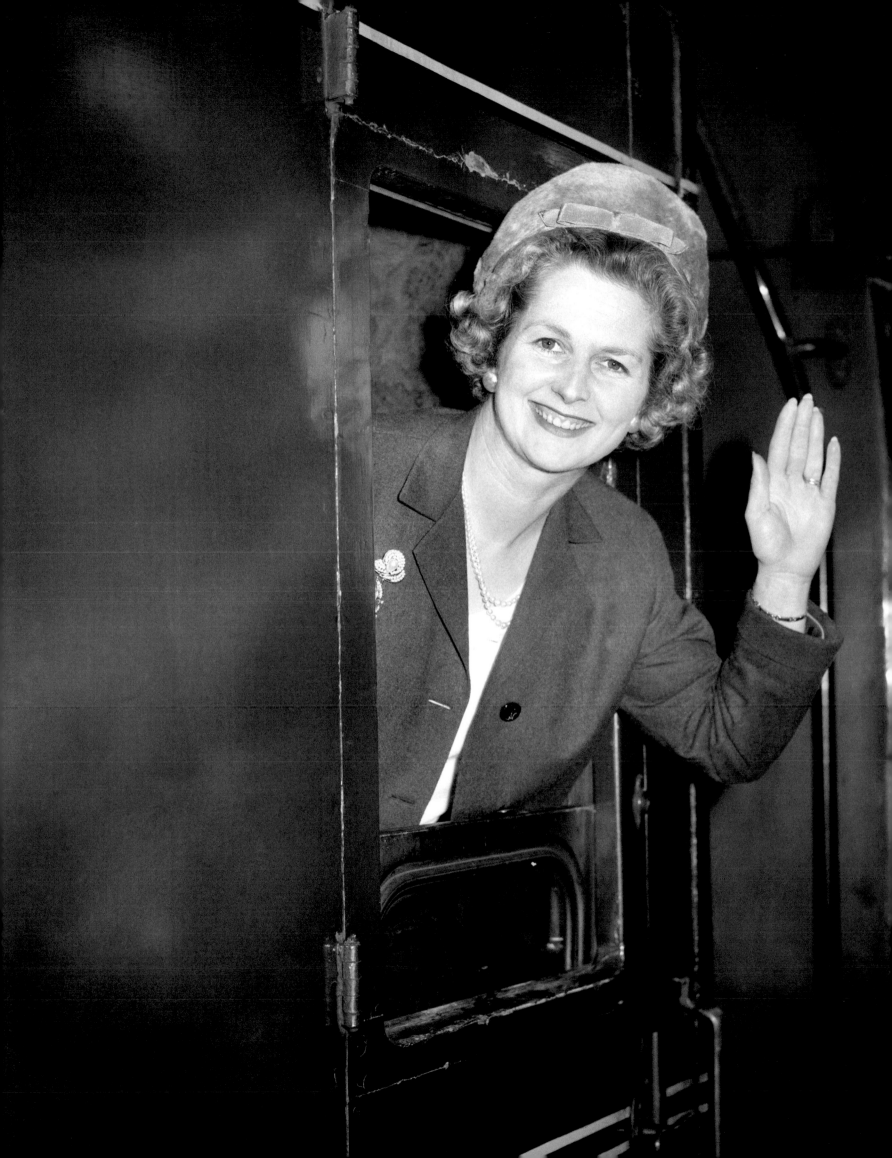

CHAPTER 2

The Rise
to Power

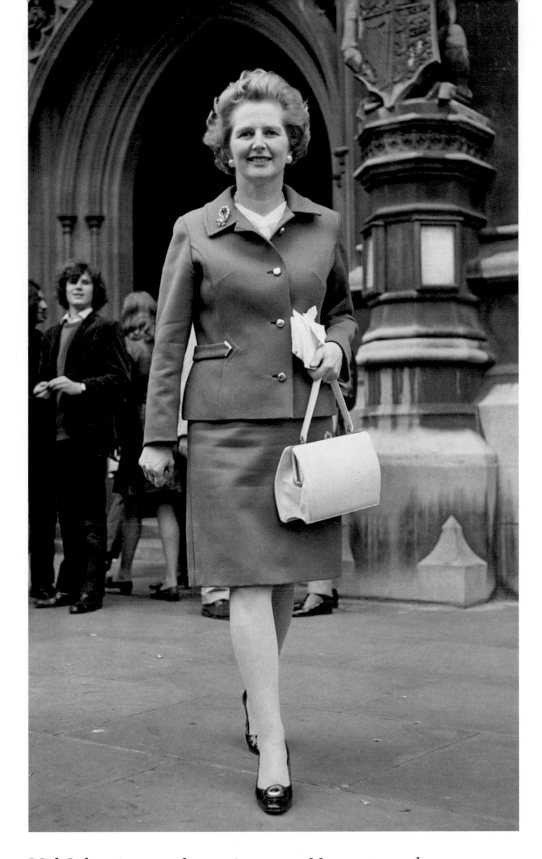

With Labour in power from 1964 to 1970, Margaret served in a number of positions in Edward Heath's Shadow Cabinet. Here she is seen as spokesperson on Education in the Conservative Shadow Cabinet at the Houses of Parliament.

22 October 1969

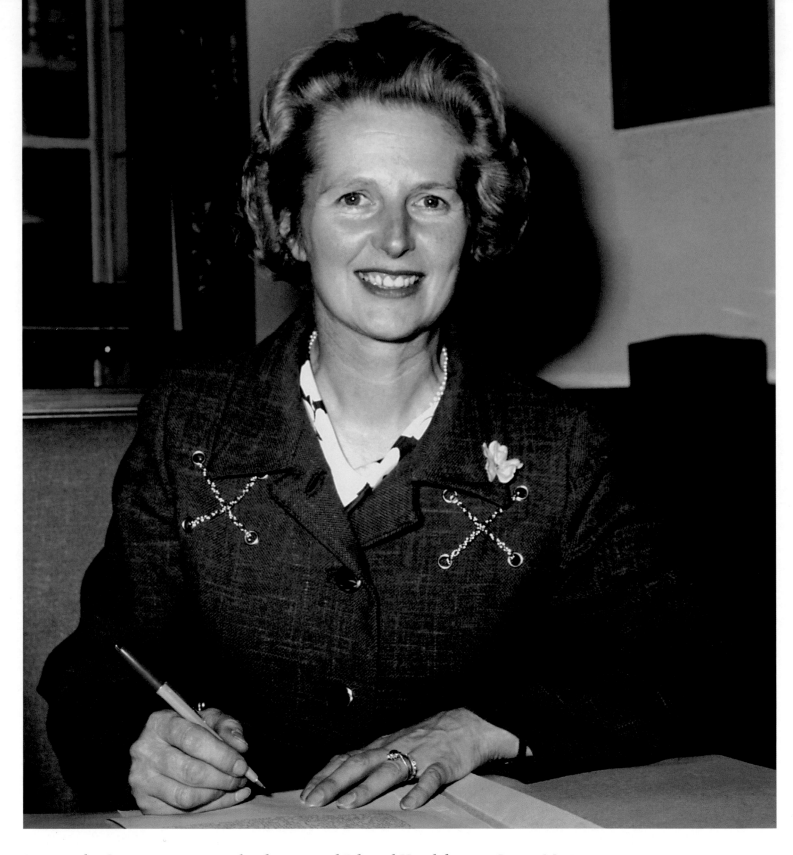

In 1970 the Conservatives won the election and Edward Heath became Prime Minister, making Margaret Secretary of State for Education and Science.

1 June 1970

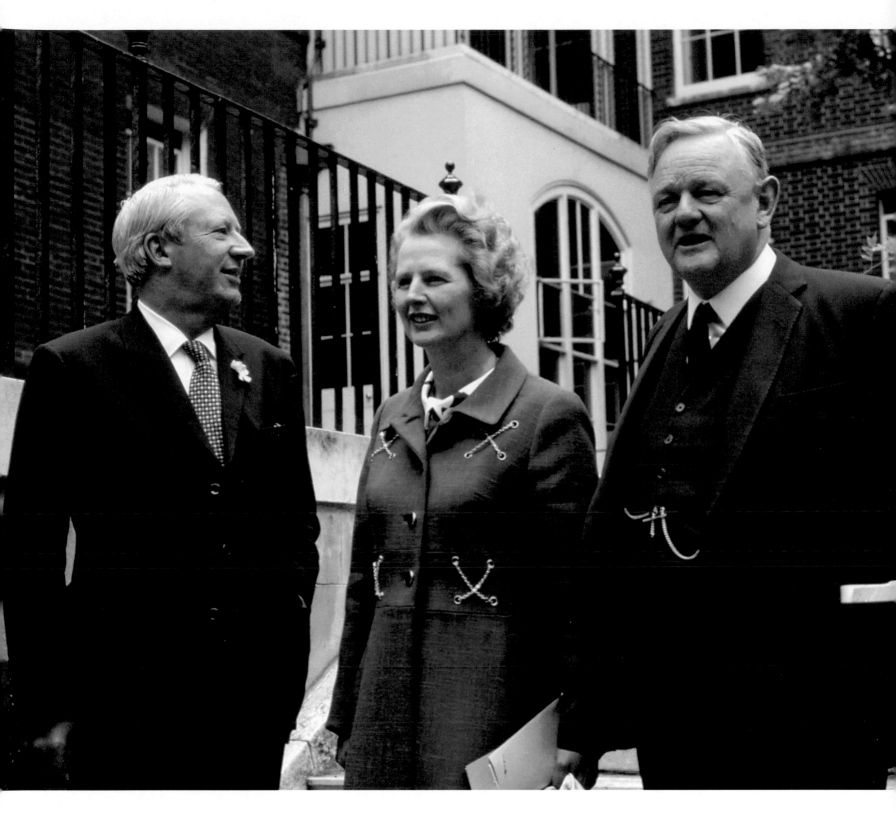

Edward Heath, Margaret and Quentin Hogg, the Lord Chancellor, in the garden of No 10 Downing Street. Margaret at this point had made herself deeply unpopular over her decision to withdraw free milk for the over sevens, inspiring the famous playground taunt, "Margaret Thatcher, milk snatcher". Official papers, now made public under the 30-year rule, reveal that when she wrote to Heath asking for his help in easing her political predicament, he refused.

23 June 1970

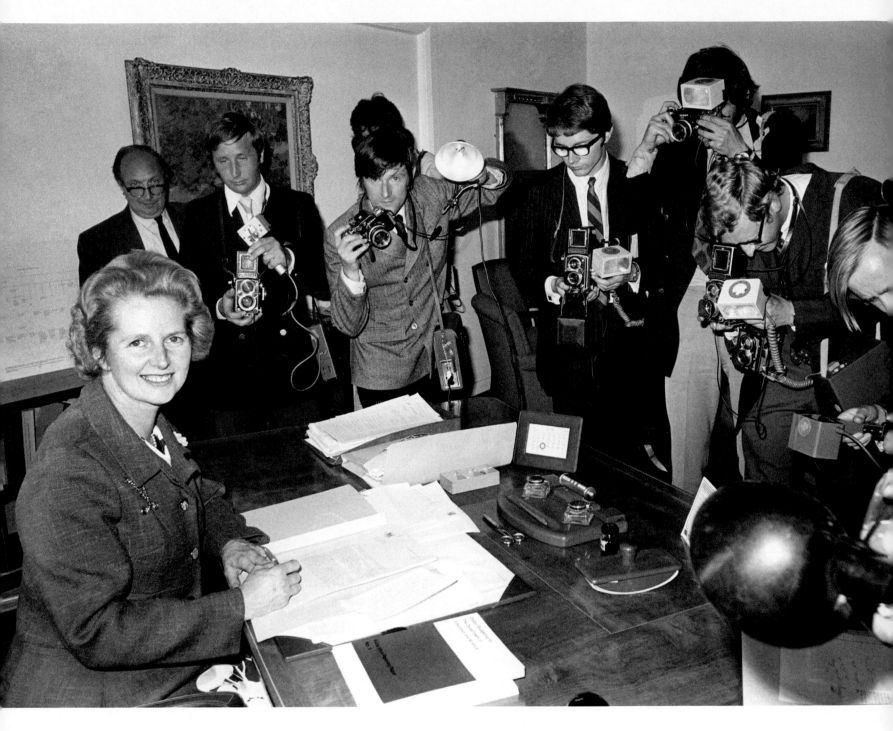

Popular or not, there is strong media interest in the young minister.

23 June 1970

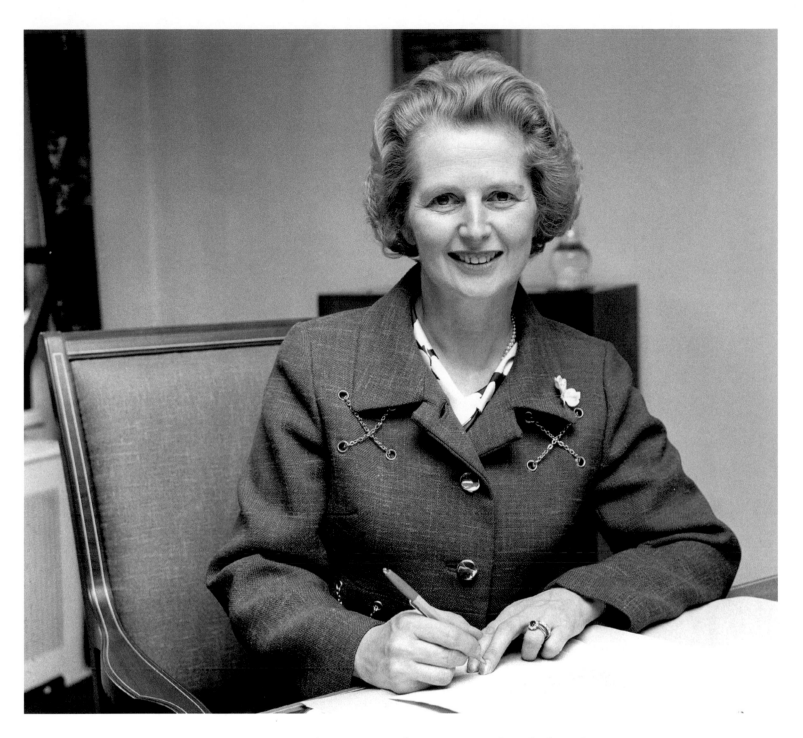

She poses for the cameras at her desk in the Department of Education and Science in Curzon Street, London.

23 June 1970

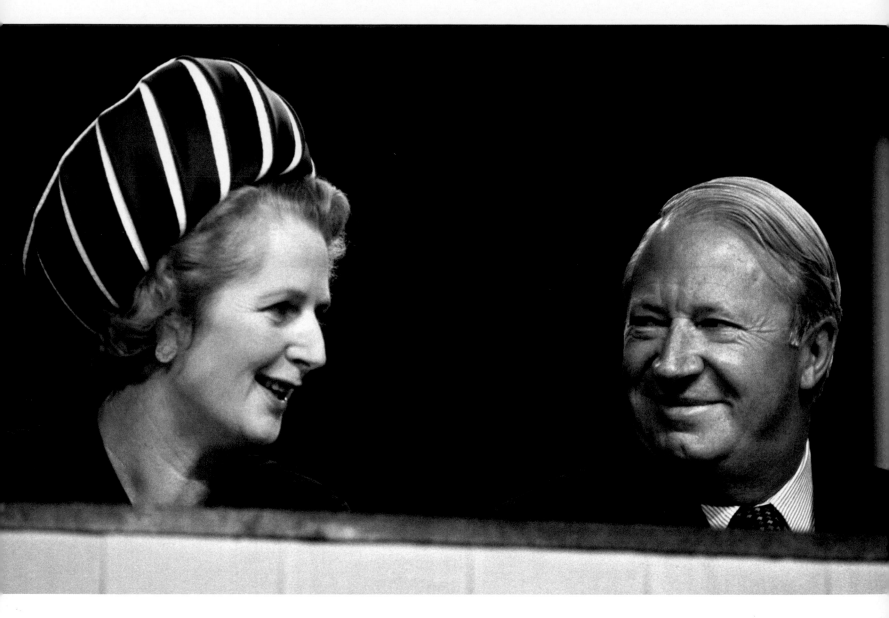

Prime Minister Edward Heath, with Margaret at his side, during a three-minute ovation at the opening of the annual Conservative Party Conference.

7 October 1970

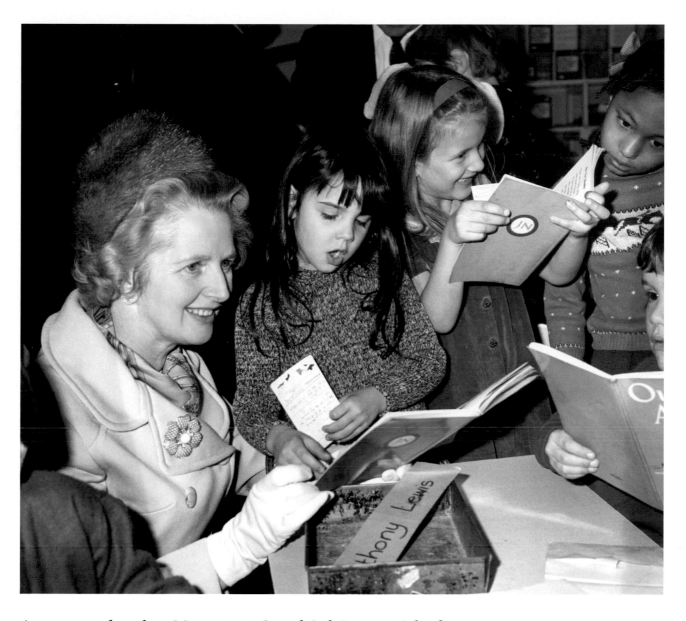

A young pupil reads to Margaret at Gospel Oak Primary School during her tour of London schools.

20 October 1970

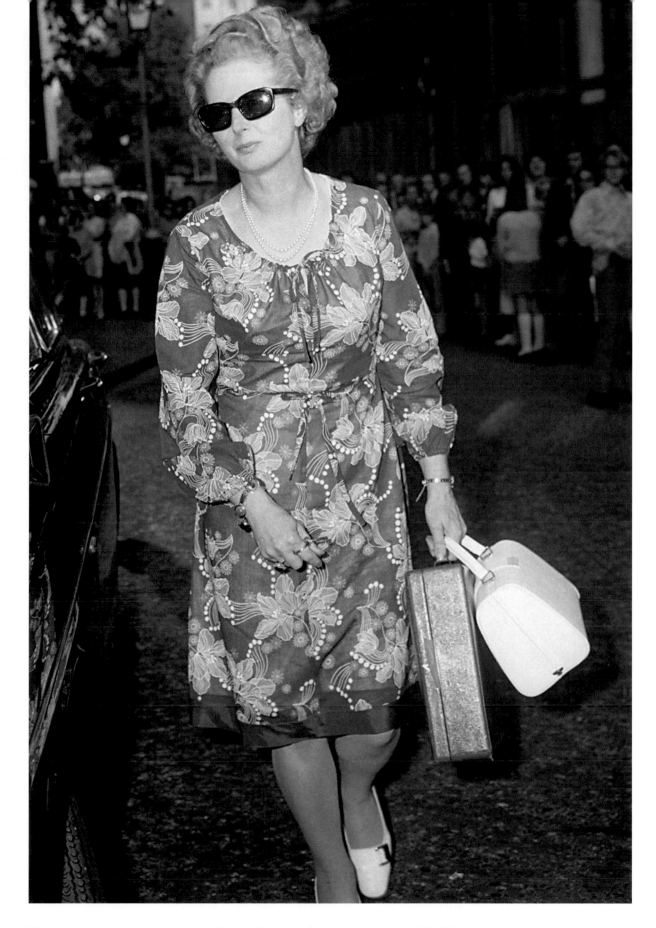

Here she is seen arriving at No 10 for a Cabinet meeting called by the Prime Minister to consider President Nixon's economic package in which he stopped the direct conversion of the US dollar to gold.

16 August 1971

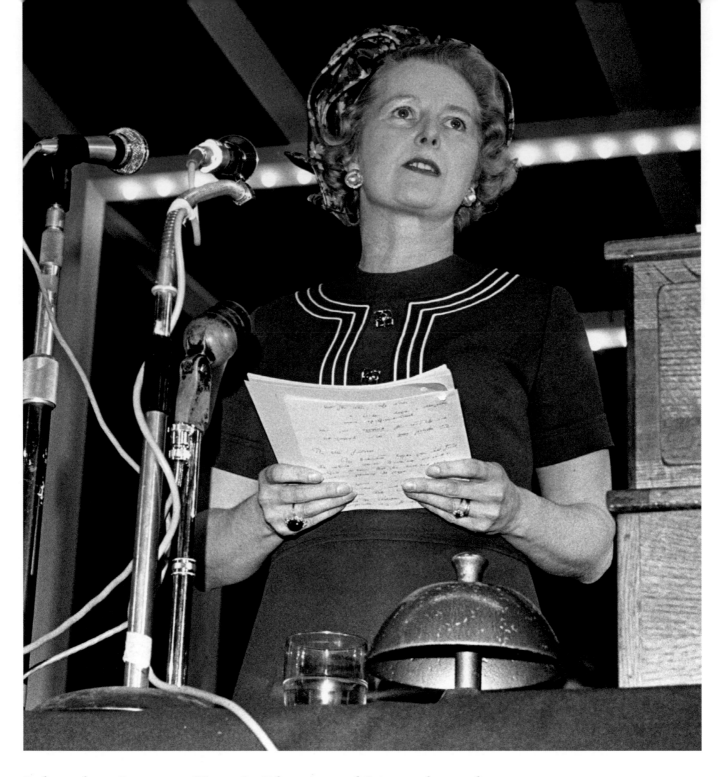

In her role as Secretary of State for Education and Science, she speaks
at the annual conference of the National Union of Teachers in Blackpool.

4 April 1972

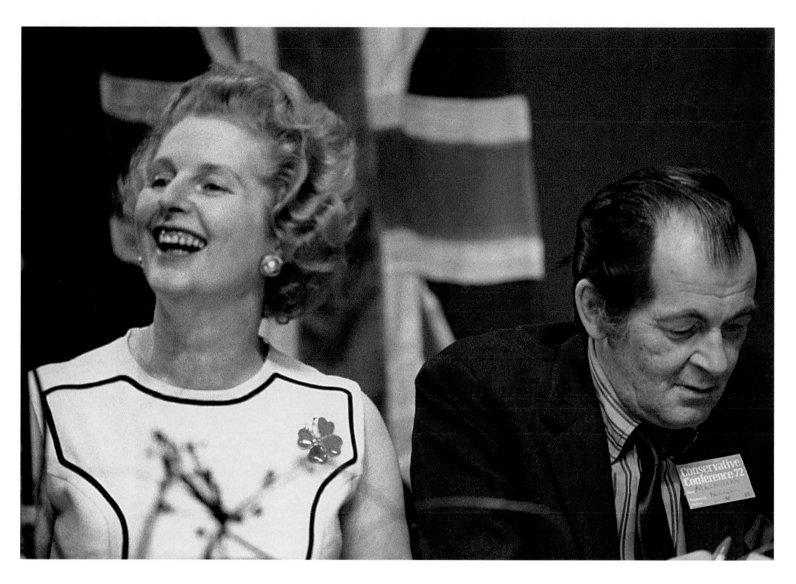

*A moment of laughter at the Conservative Party Conference
as she sits next to Maurice Macmillan, Employment Secretary.*

11 October 1972

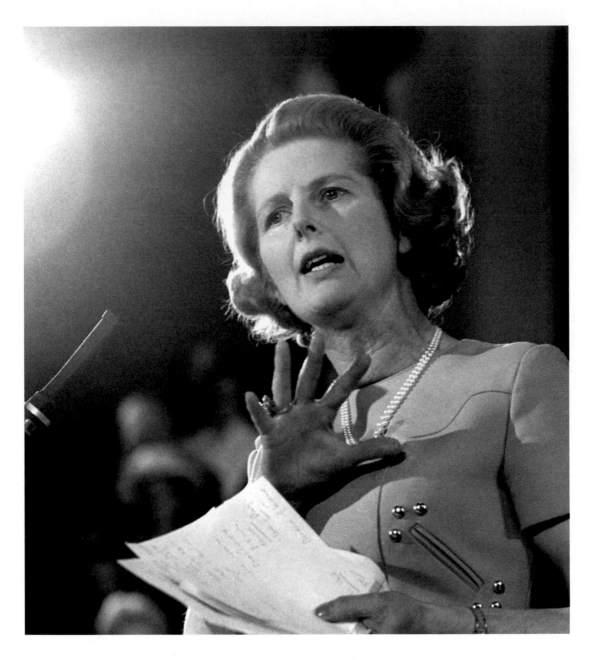

*The face of the future – an adamant speech on education
at the Conservative Women's conference.*

23 May 1973

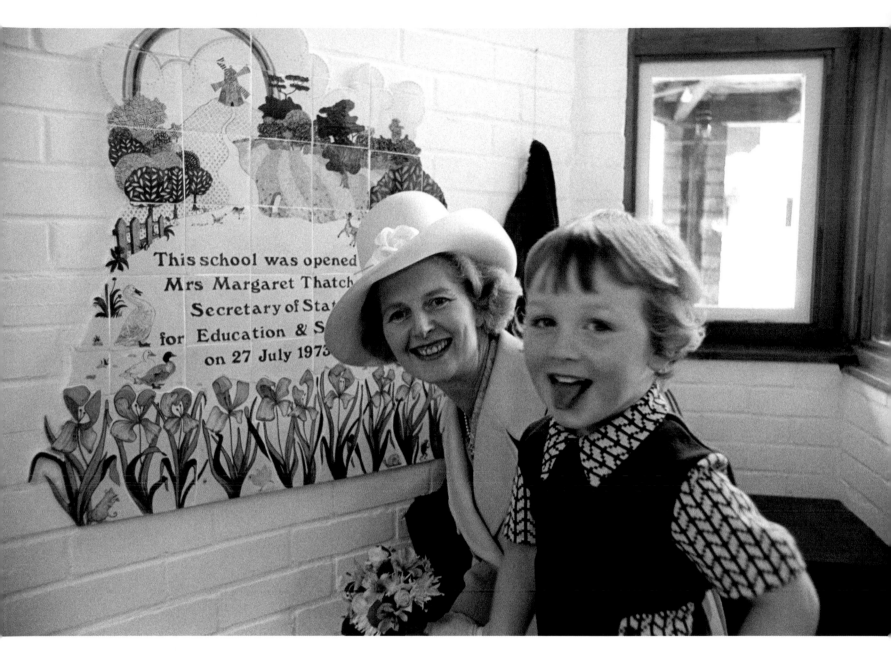

*Posing for the cameras with 3-year-old Gregory Bull at
the opening of the Lordships Nursery School in Letchworth.*

27 July 1973

After the Conservative defeat in the 1974 general election,
Margaret challenges Edward Heath to the leadership of the party.

28 January 1975

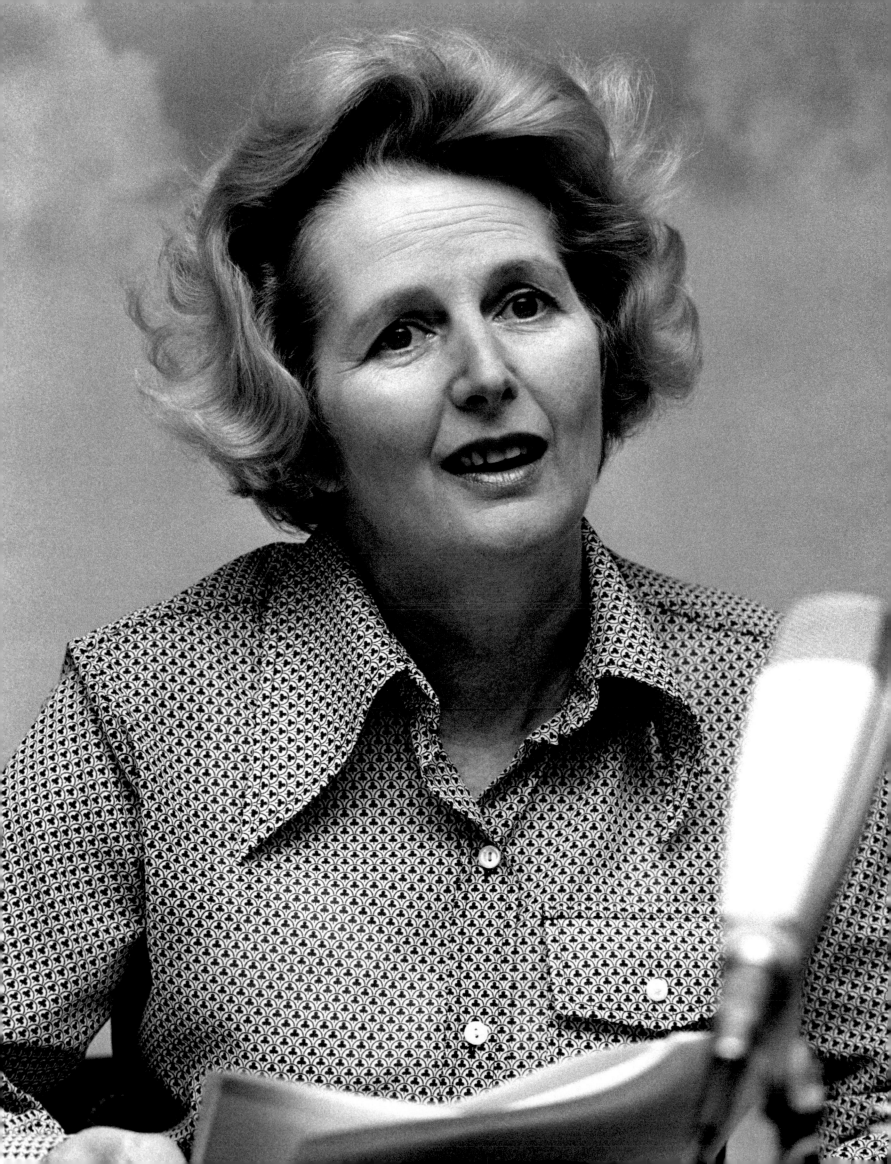

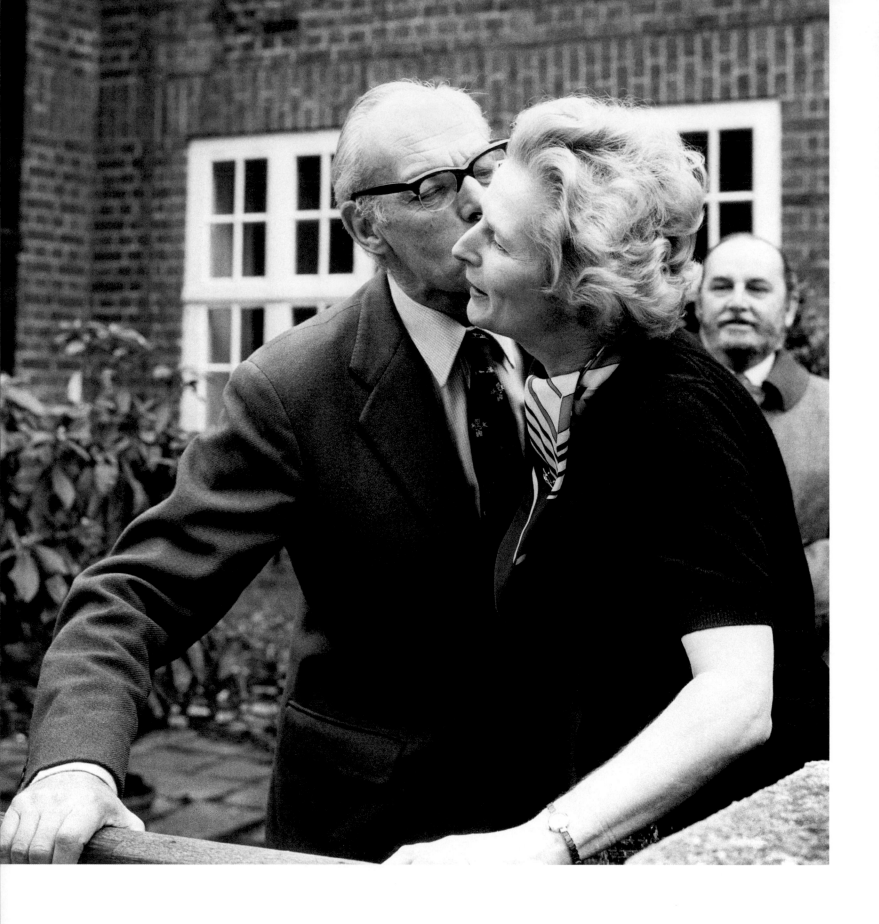

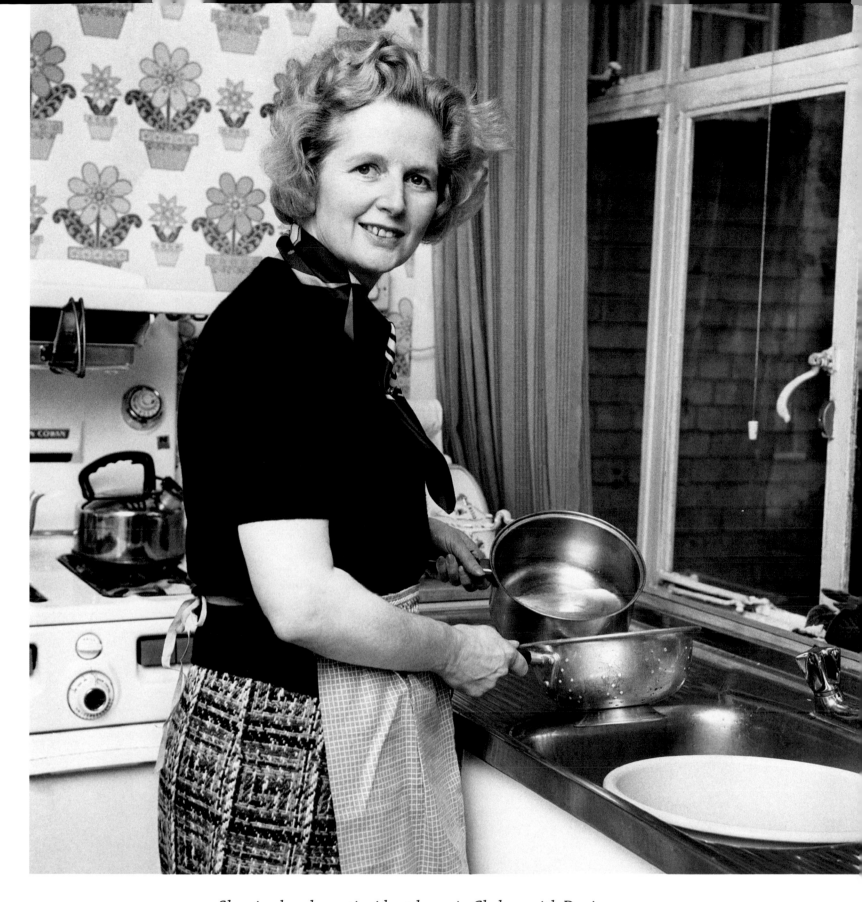

Showing her domestic side at home in Chelsea with Denis.

1 February 1975

*Celebrating at home with Denis and son Mark following her success
in the first round of the election for the Conservative Party leadership,
topping the poll with 130 votes, 11 ahead of Heath.*

4 February 1975

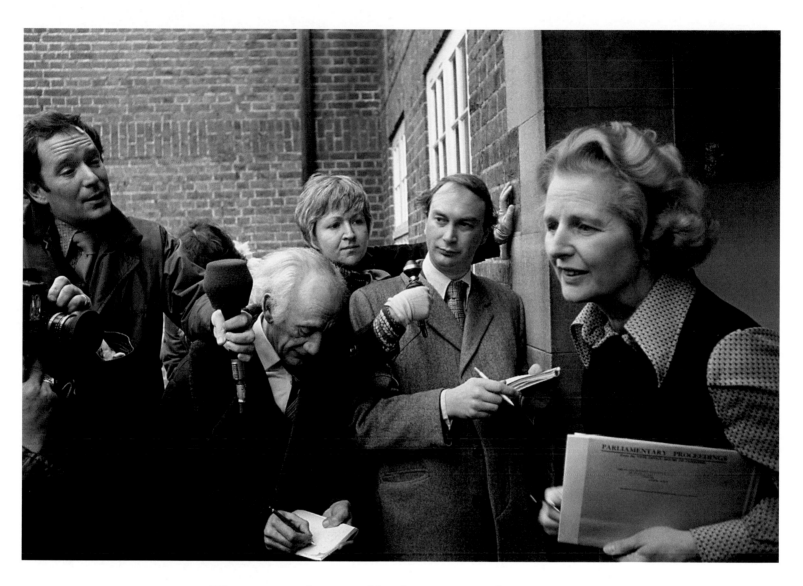

The press are fascinated by this sensational victory
and are waiting on her doorstep the following morning.

5 February 1975

The second round of the ballot for the leadership gives her an outright victory over Heath. She is now leader of the Conservative Party.

11 February 1975

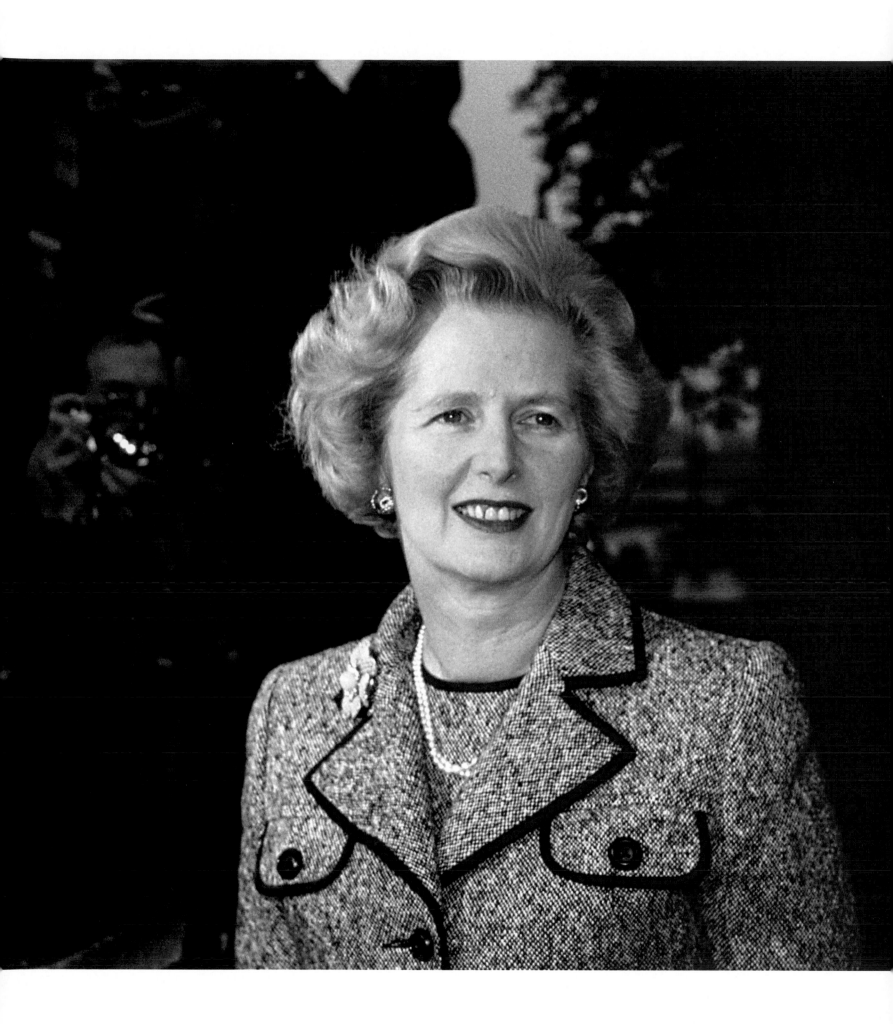

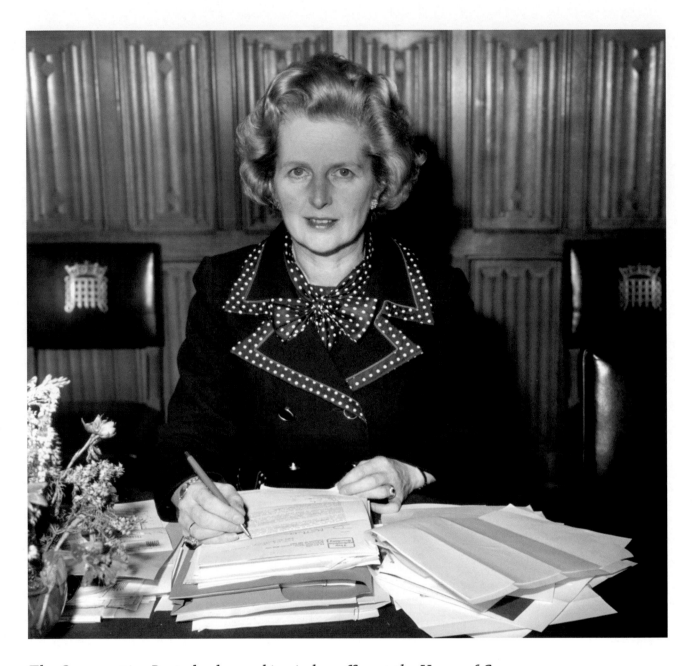

The Conservative Party leader working in her office at the House of Commons.

26 February 1975

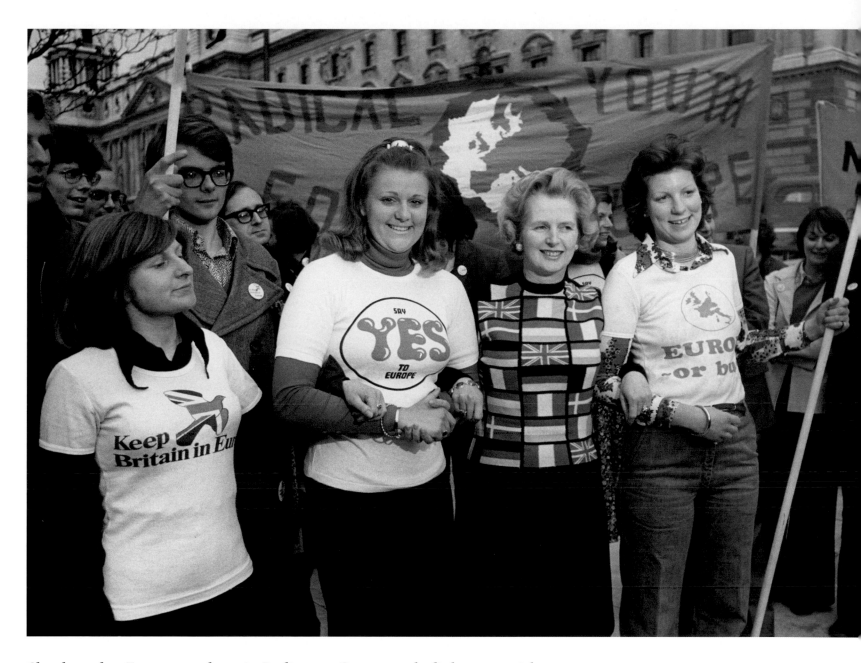

She shows her European colours in Parliament Square as she links arms with
three young pro-Market campaigners starting a vigil beneath the statue of
Sir Winston Churchill on the day before the Common Market referendum.
Her pro-Europe views were to change in the latter part of her reign as Prime Minister.
The jumper she is wearing, with the nine flags, was sent to her by a mill in Peebles.

4 June 1975

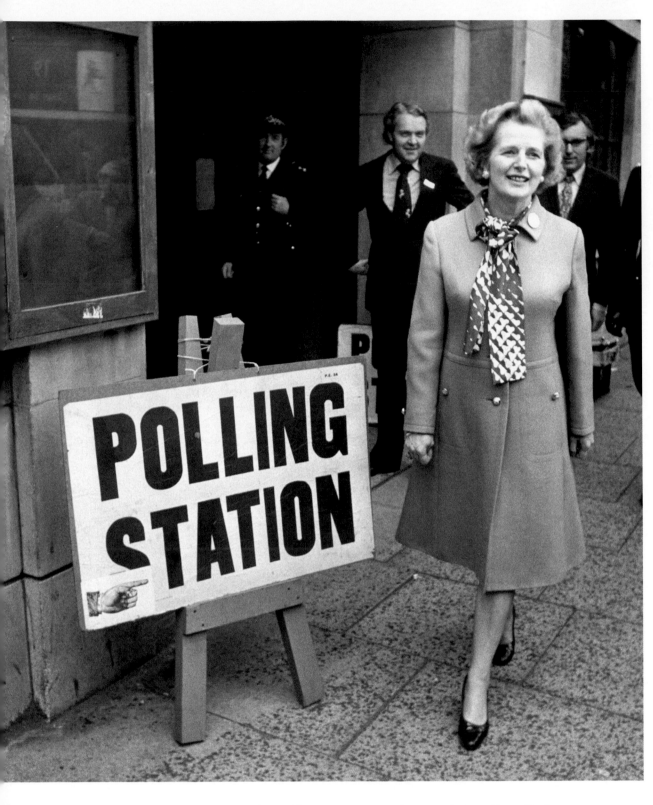

An early morning visit to the polling station in the King's Road in Chelsea to vote in the national referendum on the Common Market.

5 June 1975

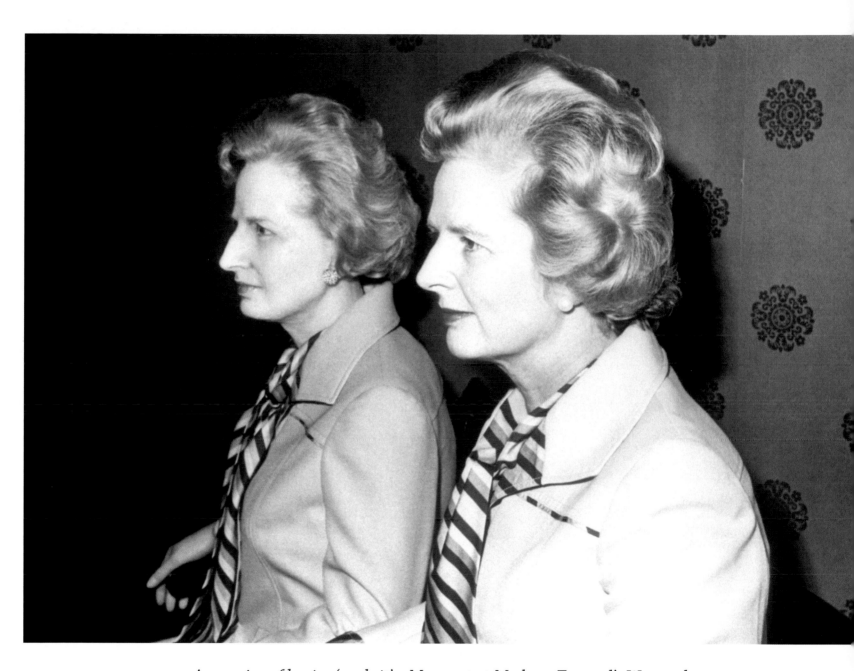

A sure sign of having 'made it' – Margaret at Madame Tussaud's Waxworks seated beside a model of herself by sculptress Jean Fraser.

5 October 1975

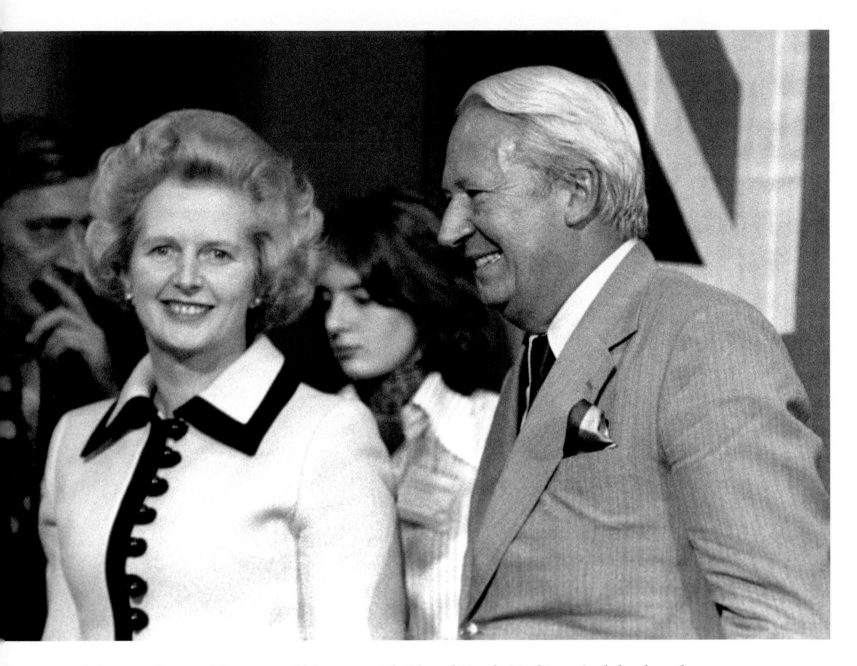

A deceptively amicable picture of Margaret with Edward Heath. The bitter feud that lasted between them may well have begun back in 1970 when he refused to answer her plea for help in the argument that blew up over the withdrawal of free milk from schools.

8 October 1975

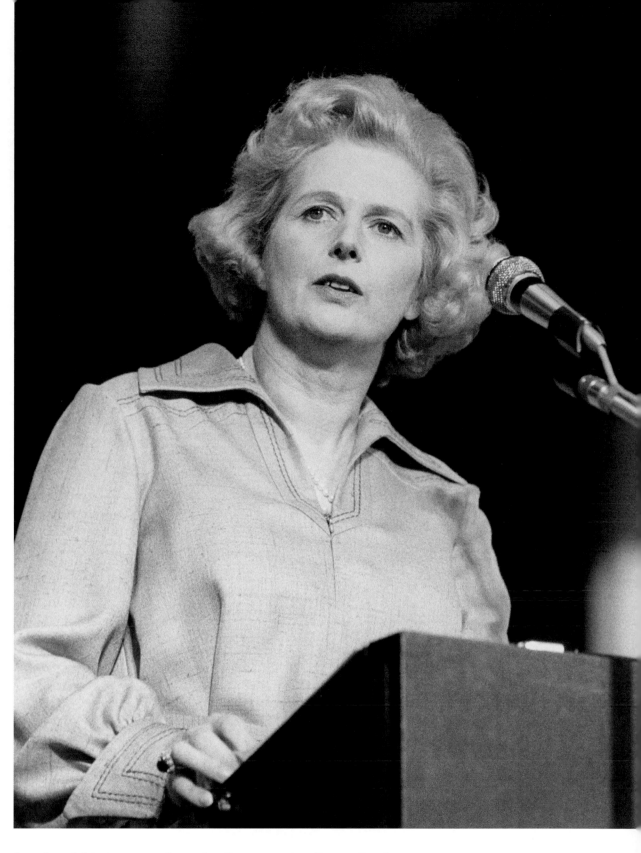

*In a hard-hitting speech at the Conservative Party Conference,
Margaret reveals her vision for the future, which earns her a standing ovation.*

10 October 1975

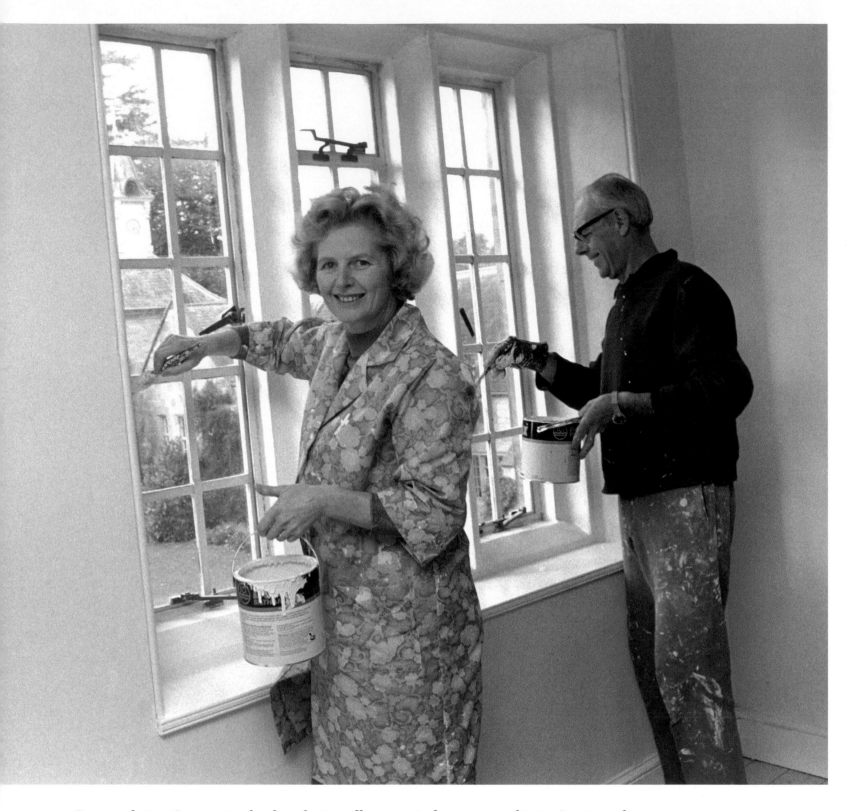

Despite being Opposition leader, she is still a practical woman and joins Denis in decorating their new weekend flat in the grounds of the National Trust's Scotney Castle in Kent.

12 October 1975

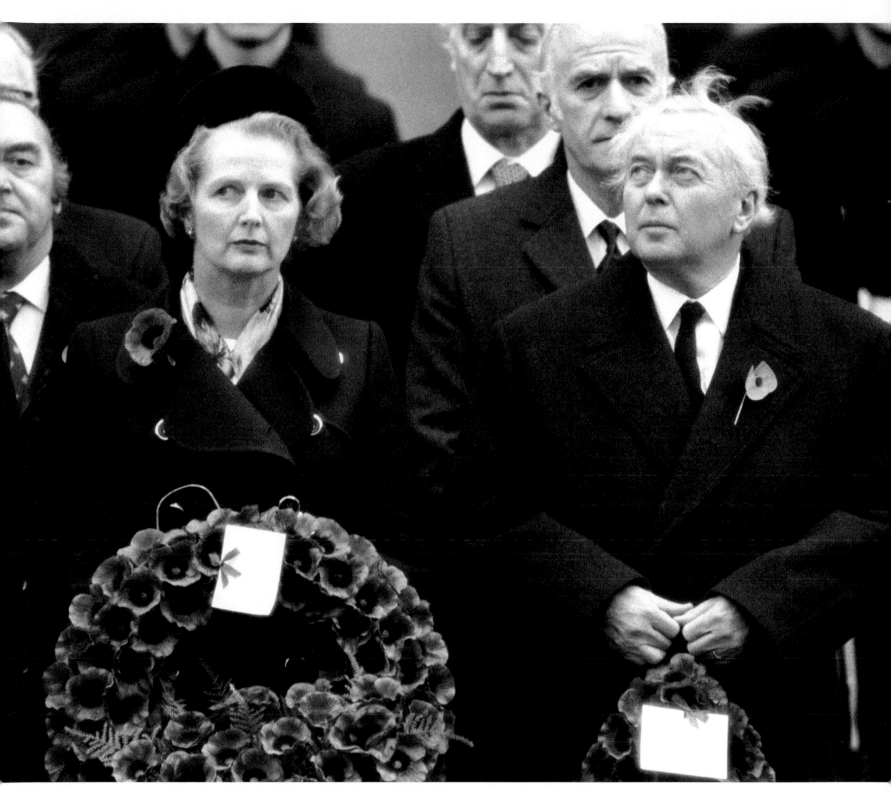

And in more sombre mood with Prime Minister Harold Wilson as they lay wreaths on the cenotaph in memory of the dead of two world wars.

9 November 1975

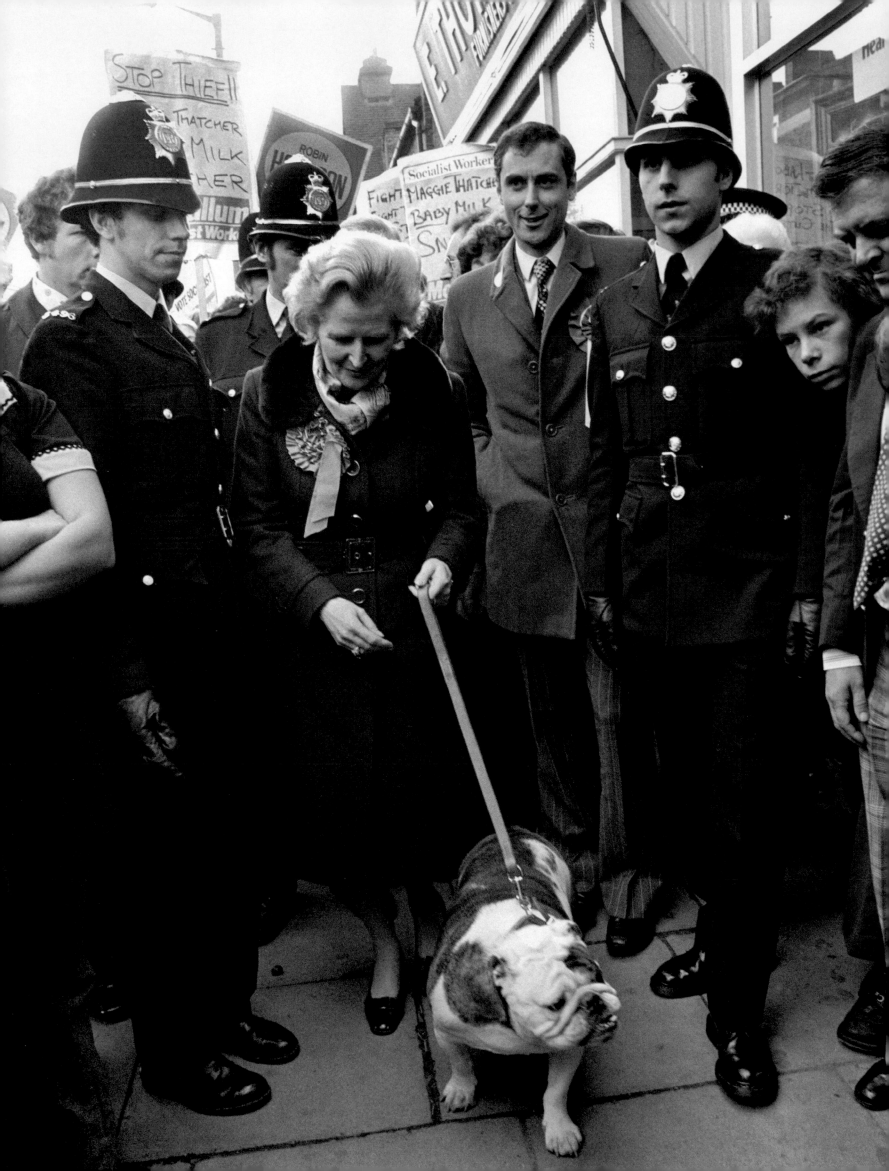

*In jubilant mood after two Tory victories in by-elections
in former Labour strongholds, Workington and Walsall North.*

1 November 1976

FACING PAGE: *During a visit to Walsall North to support the Tory by-election candidate Robin Hodgson
(behind wearing a rosette), she takes the lead of a bulldog – a powerful symbol of Britain's strength and tenacity.*

27 October 1976

On their silver wedding anniversary, Margaret and Denis
celebrate at home in Chelsea with their children, Mark and Carol.

13 December 1976

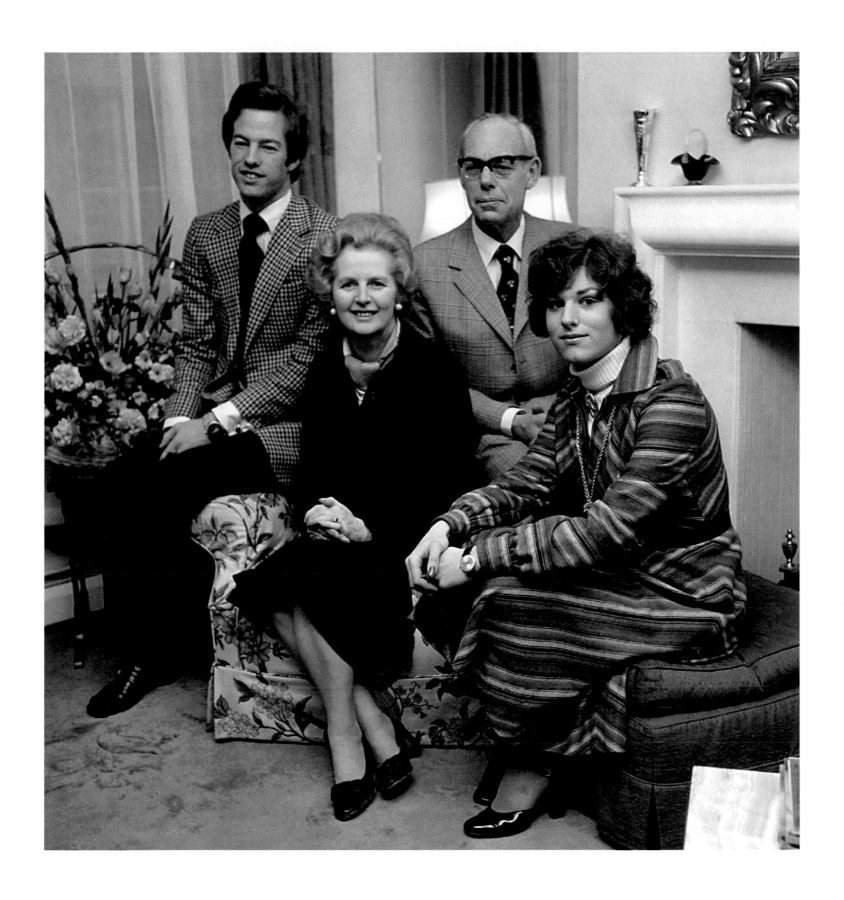

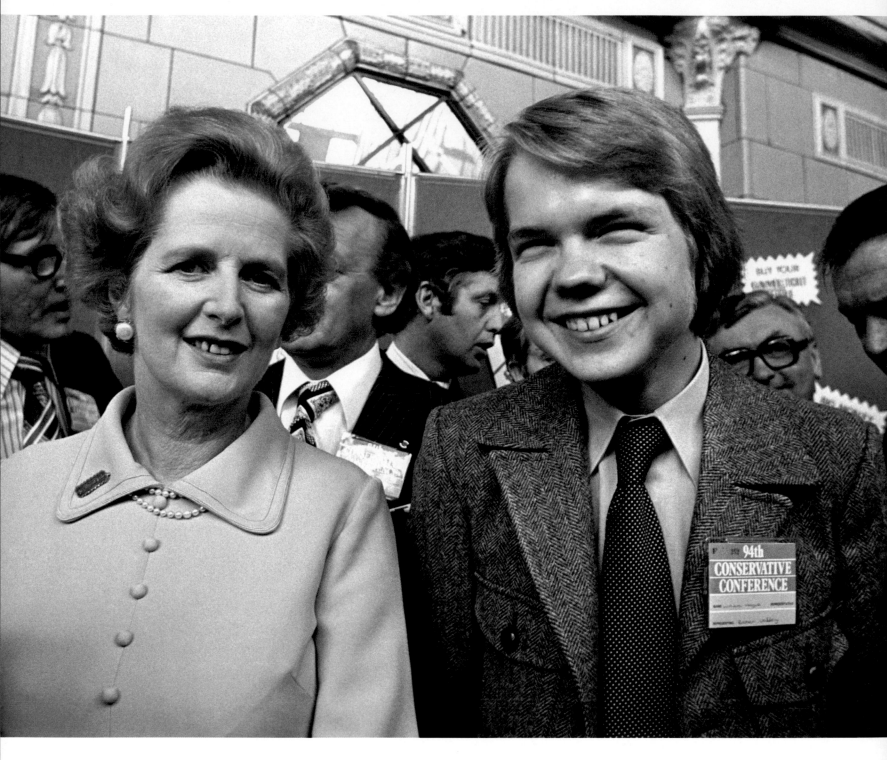

Margaret joins 16-year-old William Hague after he received a standing ovation
from delegates at the Tory Party Conference in Blackpool.

12 October 1977

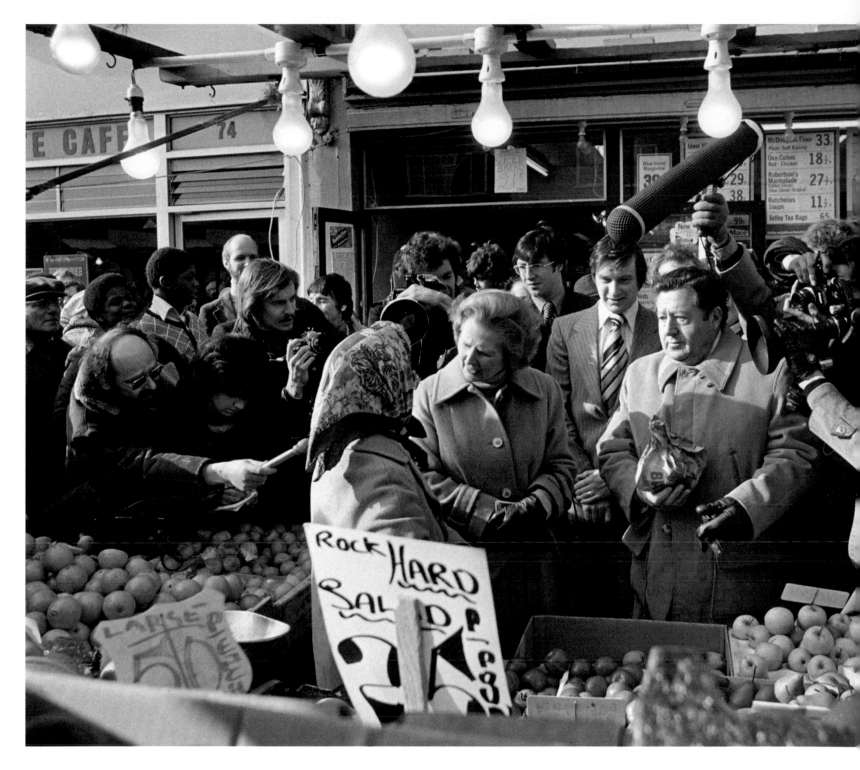

A walkabout in Battersea's Northcote Road Market.

17 February 1978

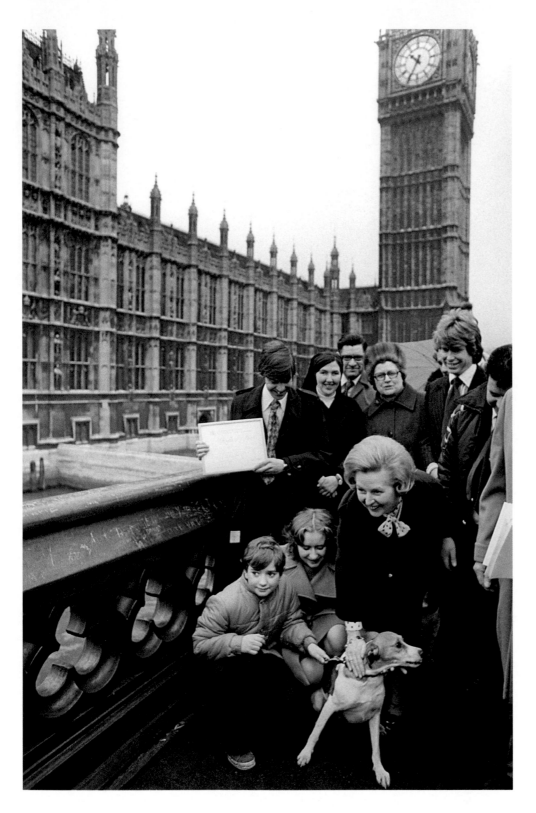

Patrick and Elizabeth Hanlon introduce their dog Jason
to Margaret on Westminster Bridge after she has presented
them with a Certificate of Merit from the RSPCA.

3 April 1978

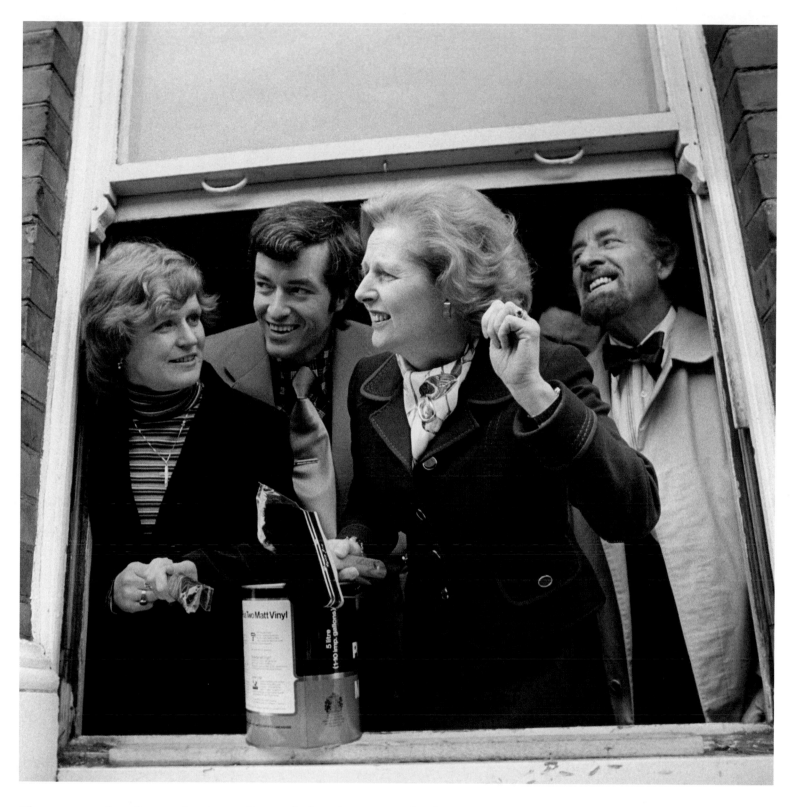

She presents brushes and paint to Britain's first 'Homesteaders'. The Homesteading scheme enabled people to buy a council owned property that was vacant and in need of repair, and in return they would have the interest payments on their mortgage waived for up to three years.

13 April 1978

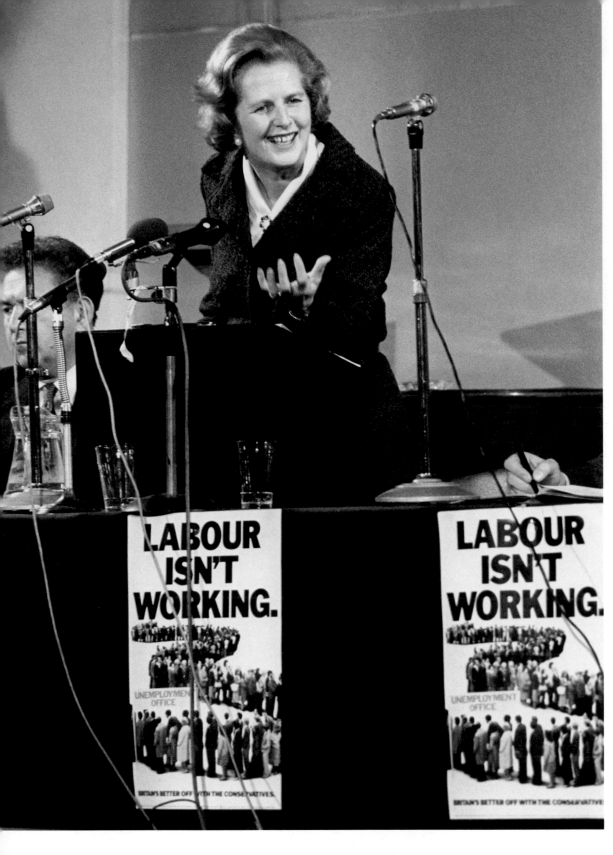

With an impending general election, Margaret gives an impassioned speech at the Conservative Local Government conference at Caxton Hall under the slogan 'Labour isn't Working'. At this time the jobless total had doubled to 1.1 million.

3 March 1979

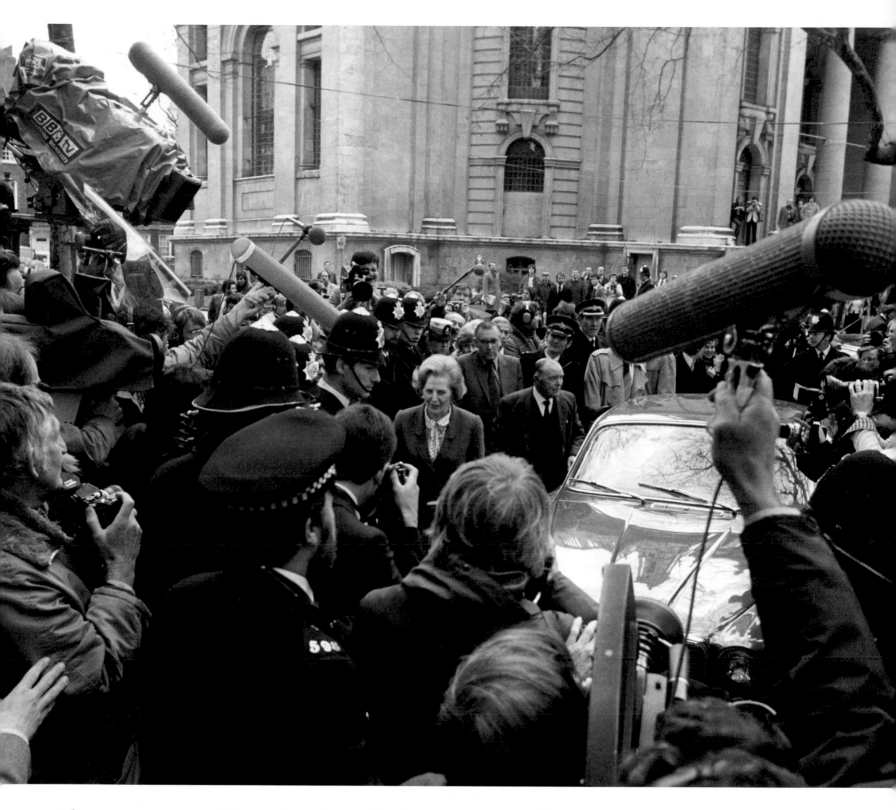

*The press swarm around her as she arrives at Tory headquarters in London
following results of Tory gains in the build-up to the general election in May.*

4 March 1979

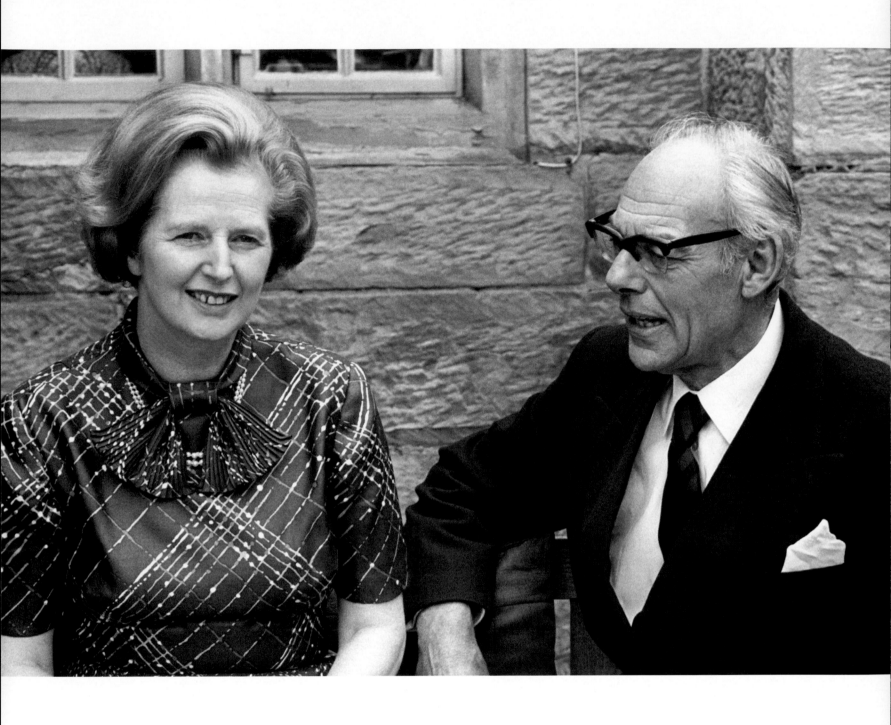

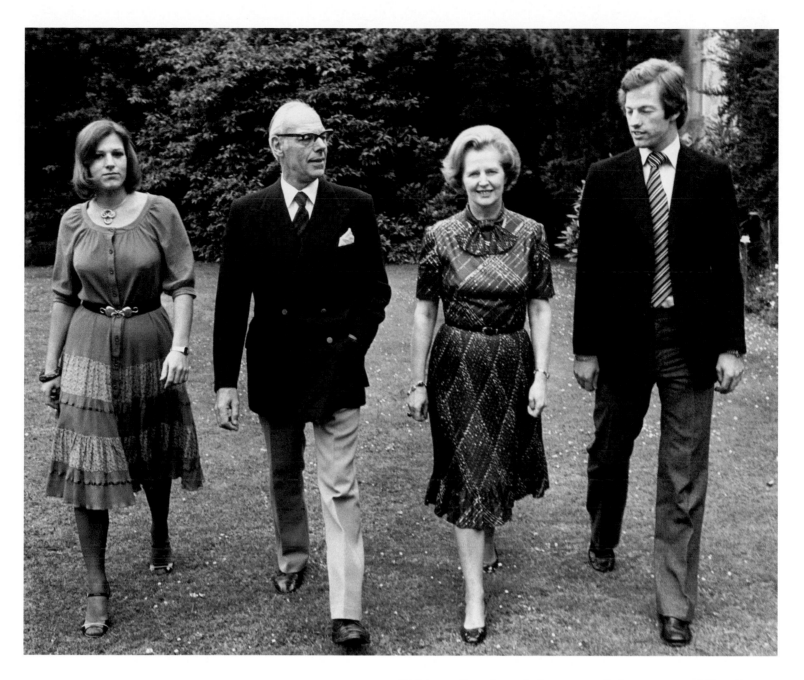

*Taking a break with Denis, and their son and daughter,
at their flat at Scotney Castle before the battle
to become Britain's first woman Prime Minister.*

30 March 1979

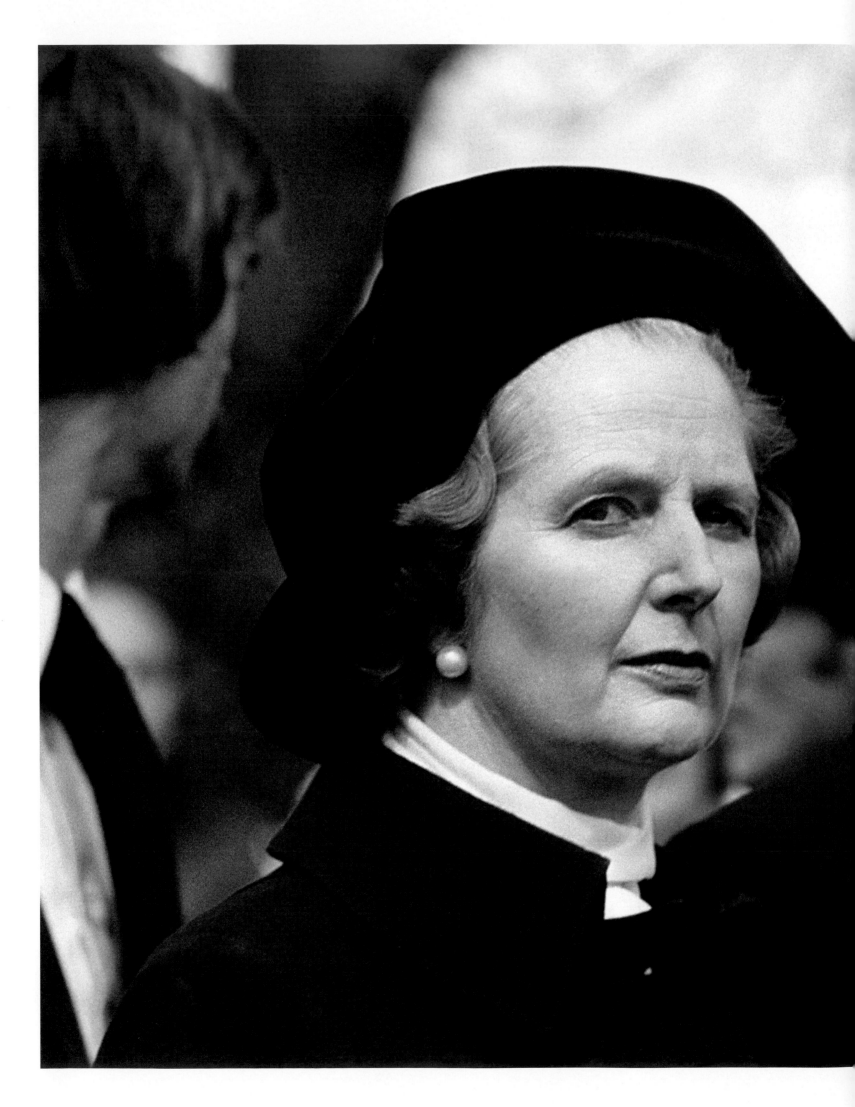

A moment of grief as Margaret and Denis attend the funeral of Airey Neave, Margaret's friend and political advisor. Neave was assassinated in a car bomb attack at the House of Commons, which was attributed to the Irish National Liberation Army.

6 April 1979

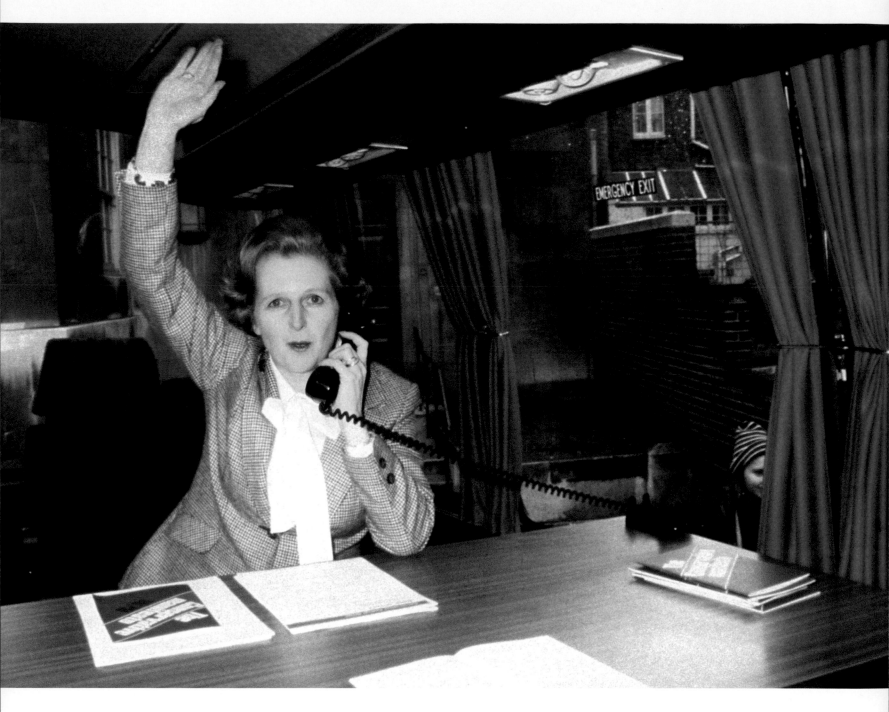

*The election campaign begins in earnest
with a specially equipped coach for the tour.*

12 April 1979

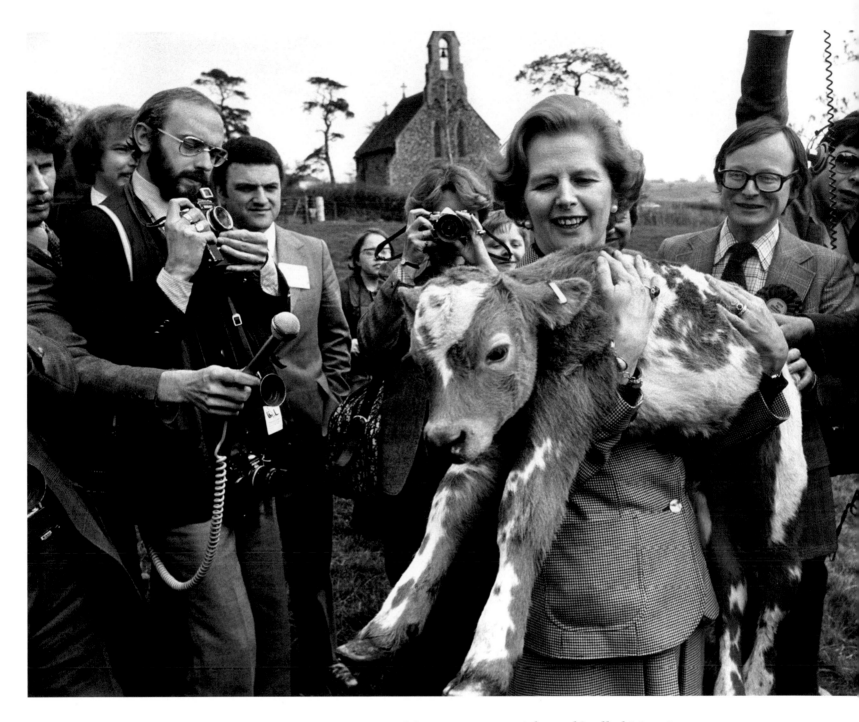

Margaret poses with a calf called Maggie during her electioneering tour of East Anglia.

18 April 1979

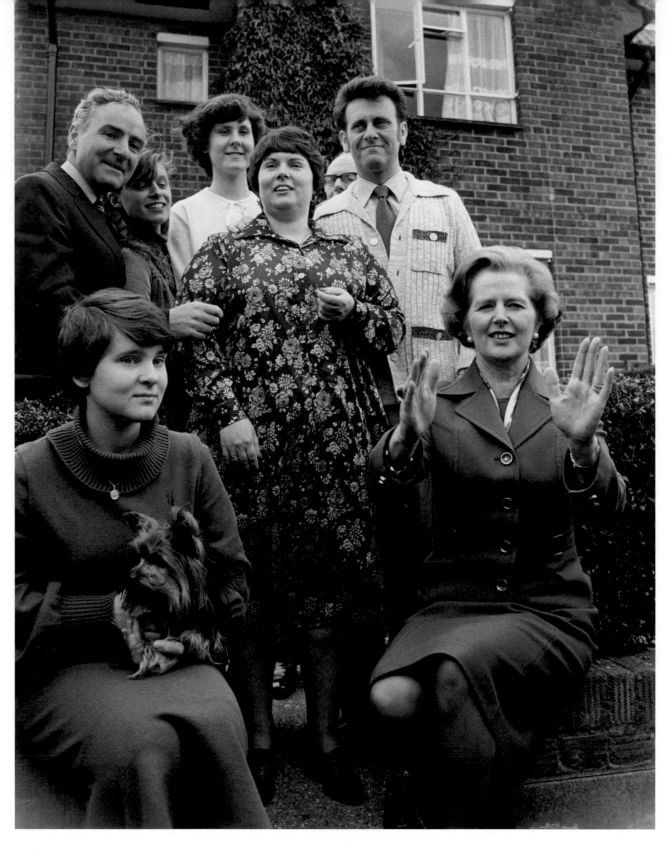

She visits the Parker Family of Ascot Close in Northolt, London, who are among the first to buy their council house home from Ealing Borough Council after the Conservatives took control.

20 April 1979

During a two-day visit to the north,
Margaret meets supporters outside
the Huddersfield Central Committee Rooms.

24 April 1979

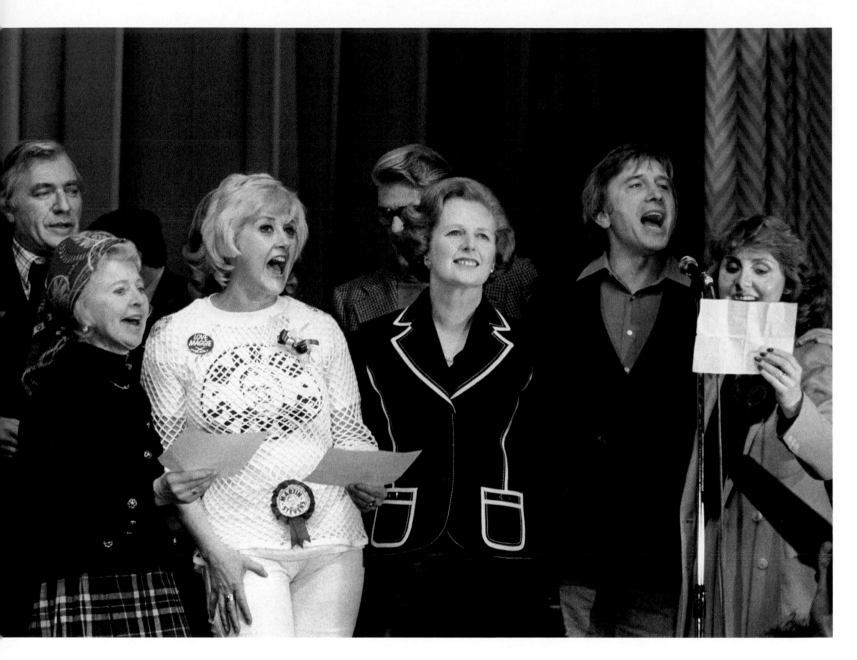

Surrounded by show business stars voicing their support in a song entitled Hello Maggie
on the platform at the Wembley Conference Centre. From left, Nigel Davenport, Molly Weir,
Liz Fraser, Pete Murray, Vince Hill and Lulu.

29 April 1979

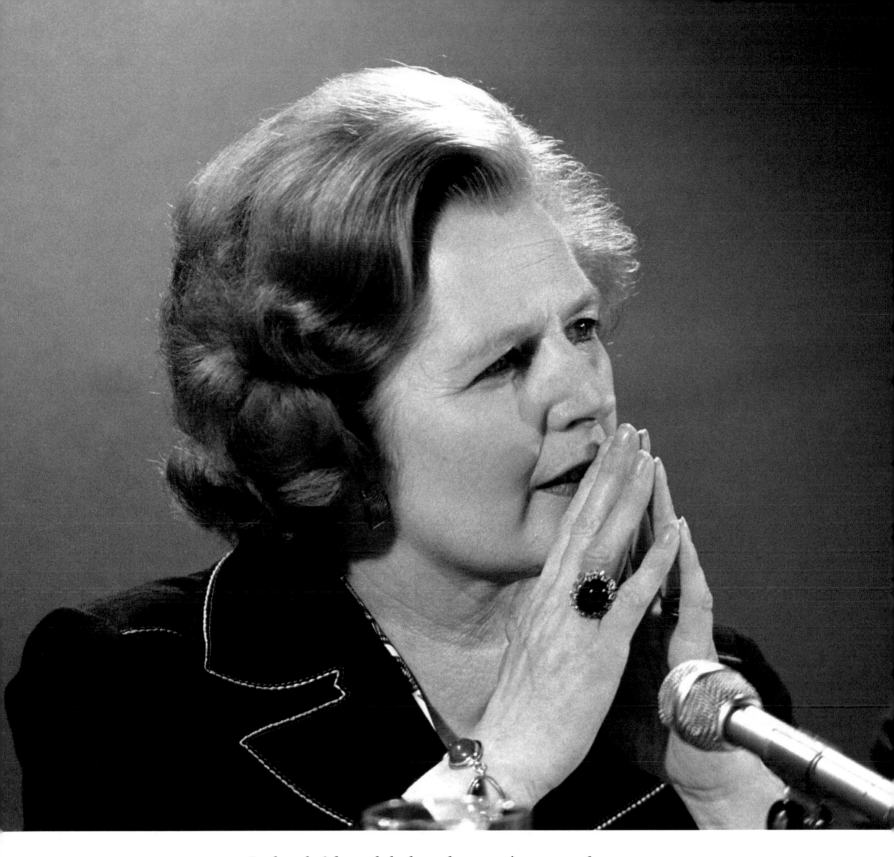

In thoughtful mood she hosts her party's press conference in London as the general election enters its final week.

30 April 1979

History is made. Margaret Thatcher, the first woman Prime Minister in Britain, on the doorstep of No 10 Downing Street after winning the general election.

4 May 1979

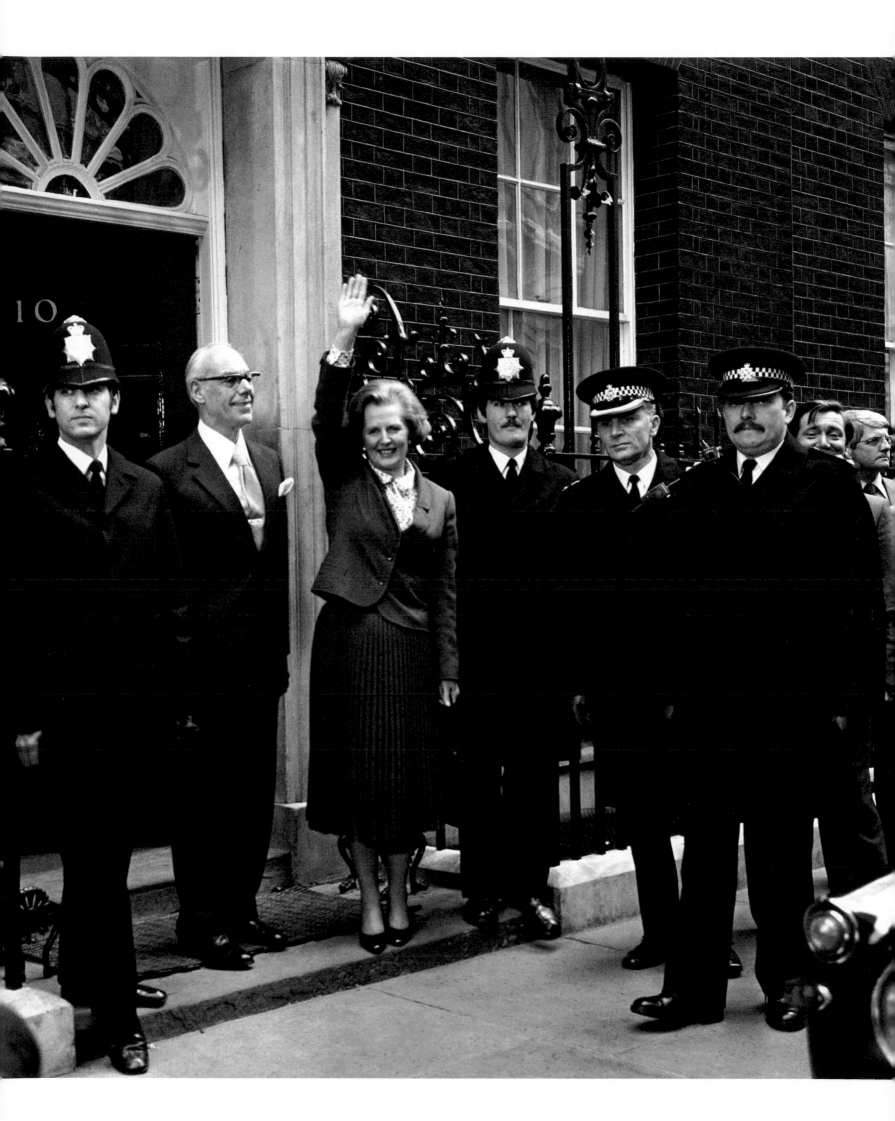

CHAPTER 3

Inside
No 10

*The new Prime Minister
takes up her role outside No 10.*

4 May 1979

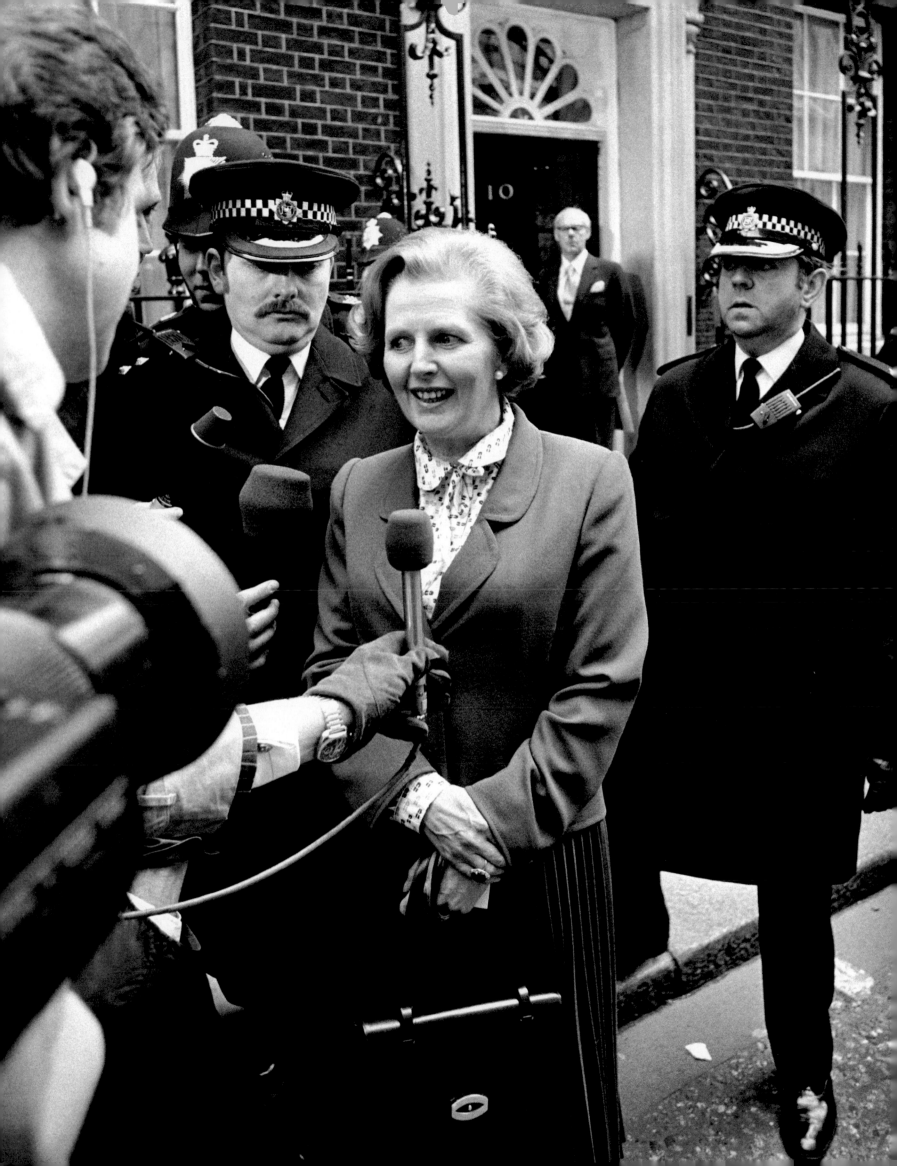

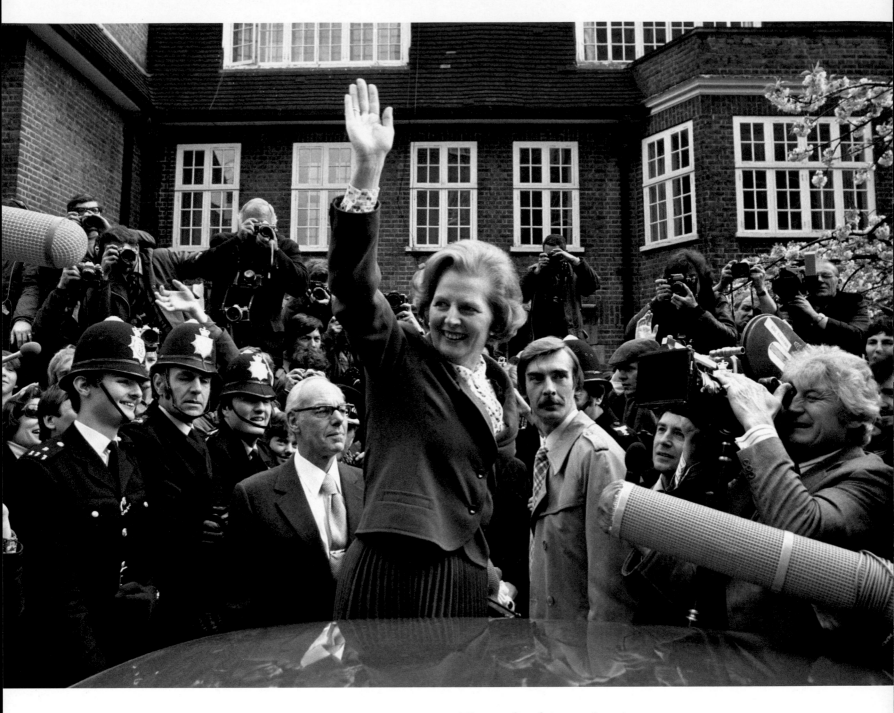

The media clamour for pictures.

4 May 1979

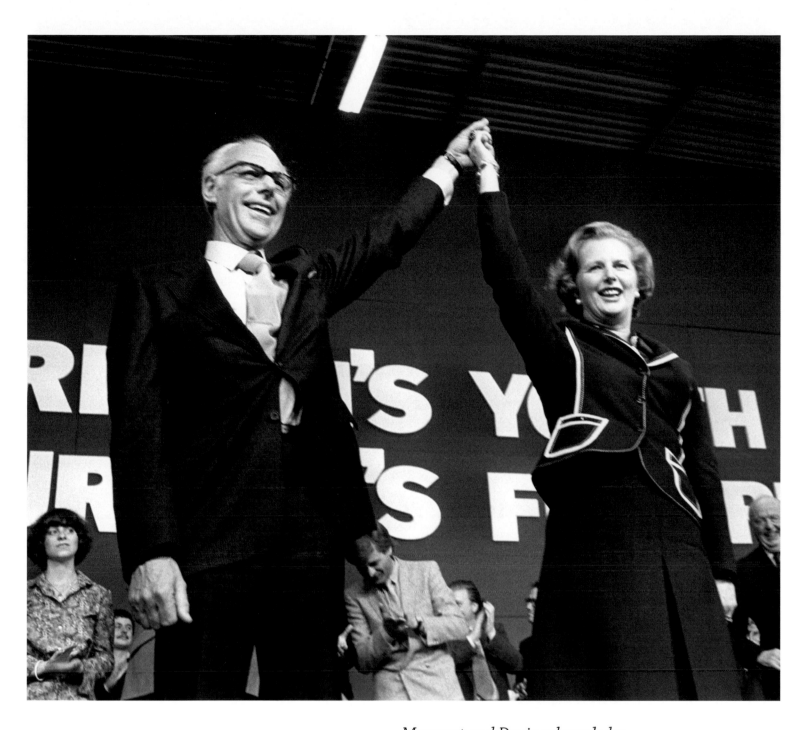

Margaret and Denis acknowledge the applause from a 2,000-strong audience at the National Exhibition Centre in Birmingham where they are attending a Young Conservatives Youth for Europe rally.

3 June 1979

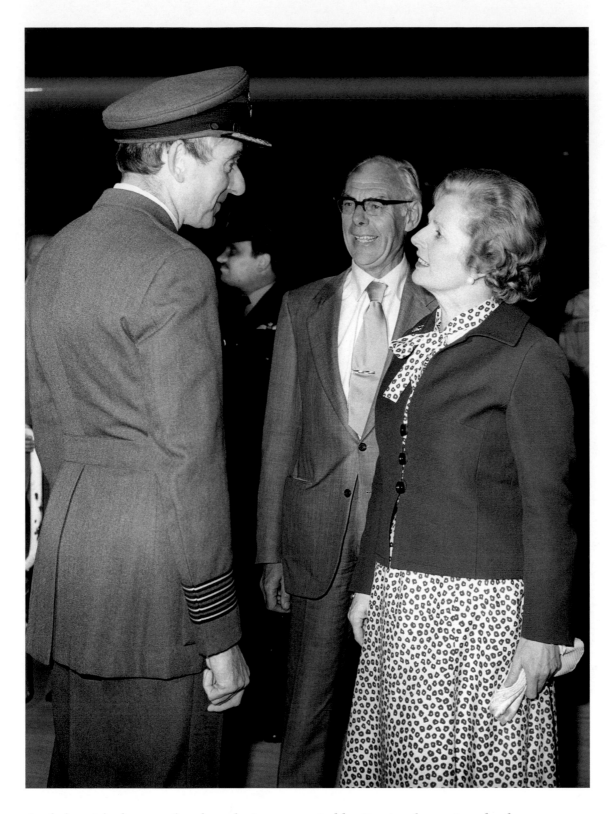

And then it's down to hard work. Accompanied by Denis, she arrives back at London's Heathrow after a week-long Commonwealth conference.

2 August 1979

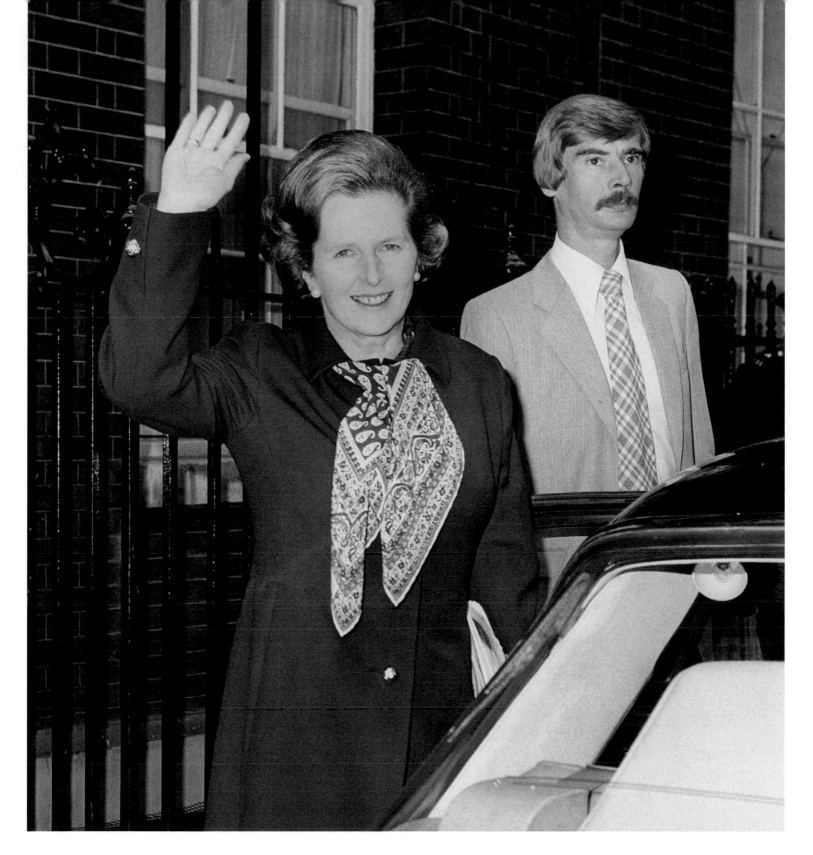

*A wave for the cameras as she leaves Downing Street accompanied
by her Special Branch bodyguard Bob Kinston.*

4 October 1979

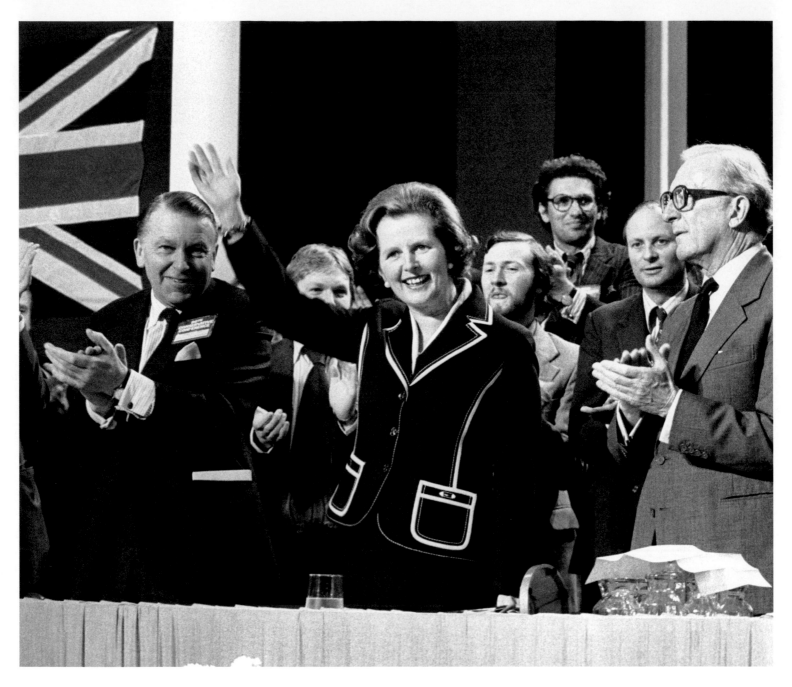

She receives a warm welcome at her first Conservative Party Conference as Prime Minister at the Winter Gardens in Blackpool, flanked by Francis Pym, Secretary of State for Defence (left), and Foreign Secretary, Lord Carrington (right).

10 October 1979

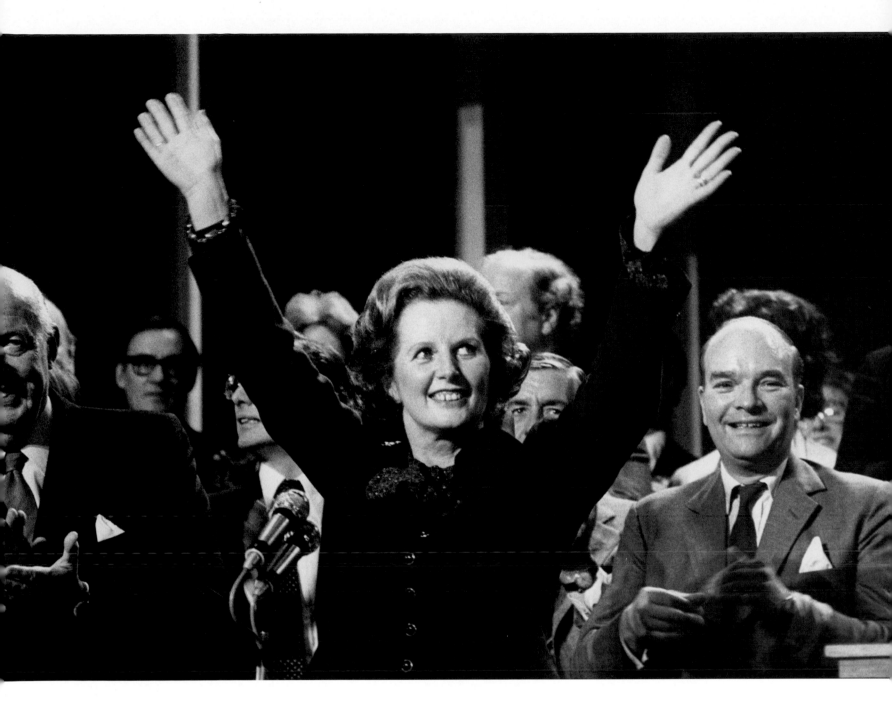

The audience give her a standing ovation after her speech on the final day of the conference in which she tells delegates that millions of British workers are in fear of union power, and pledges government action against militants.

12 October 1979

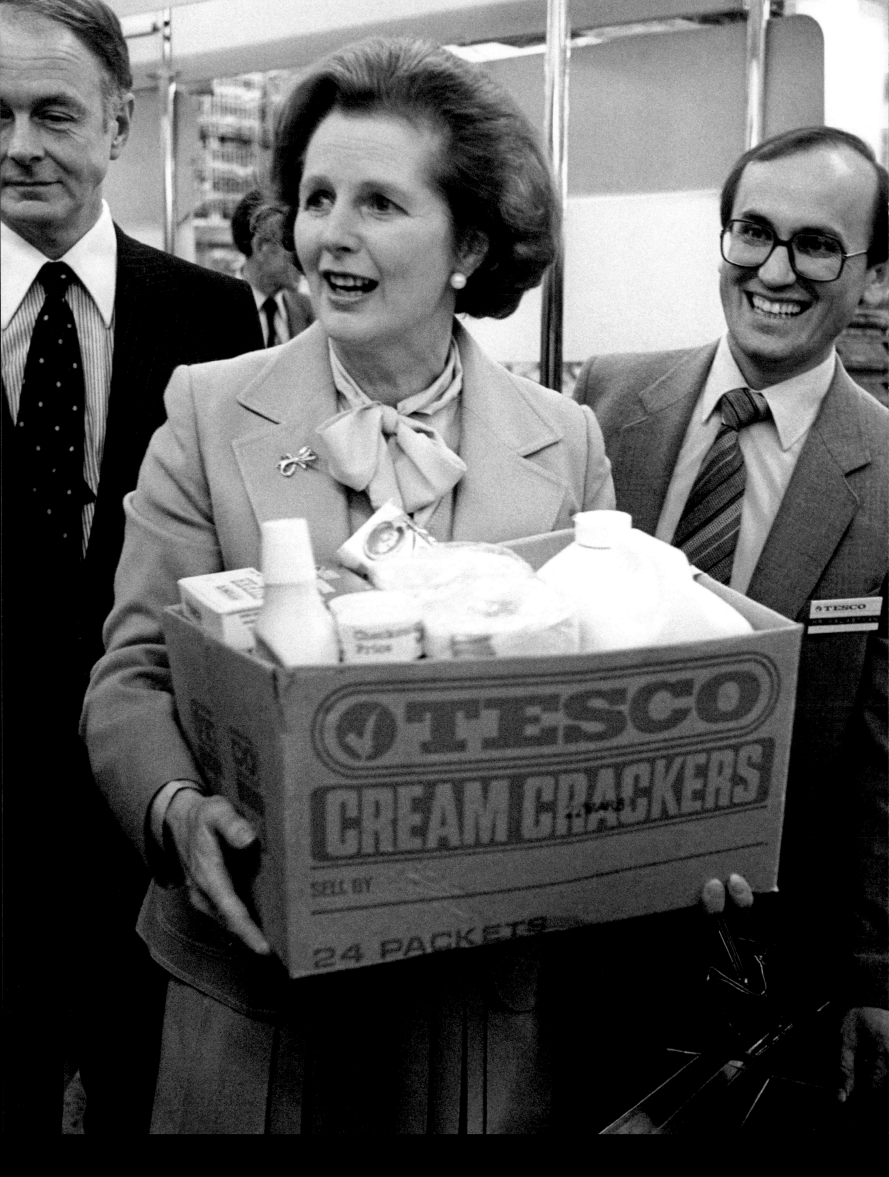

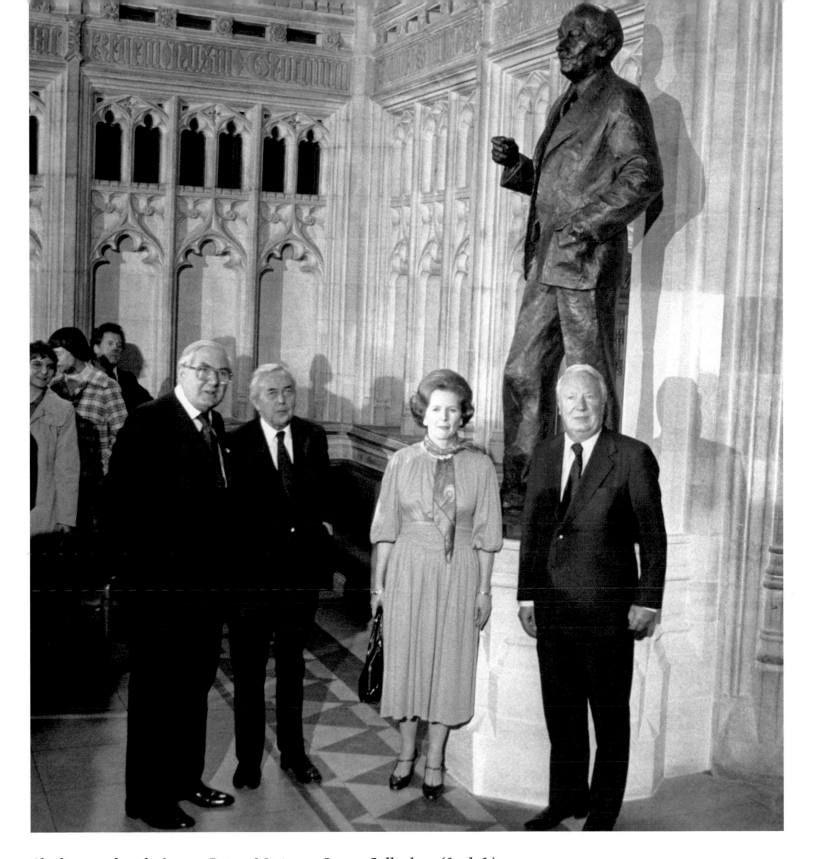

She lines up beside former Prime Ministers James Callaghan (far left),
Harold Wilson (left) and Edward Heath (right).

12 November 1979

FACING PAGE: *Always priding herself on her practical side, she goes shopping in Finchley supermarket.*

26 October 1979

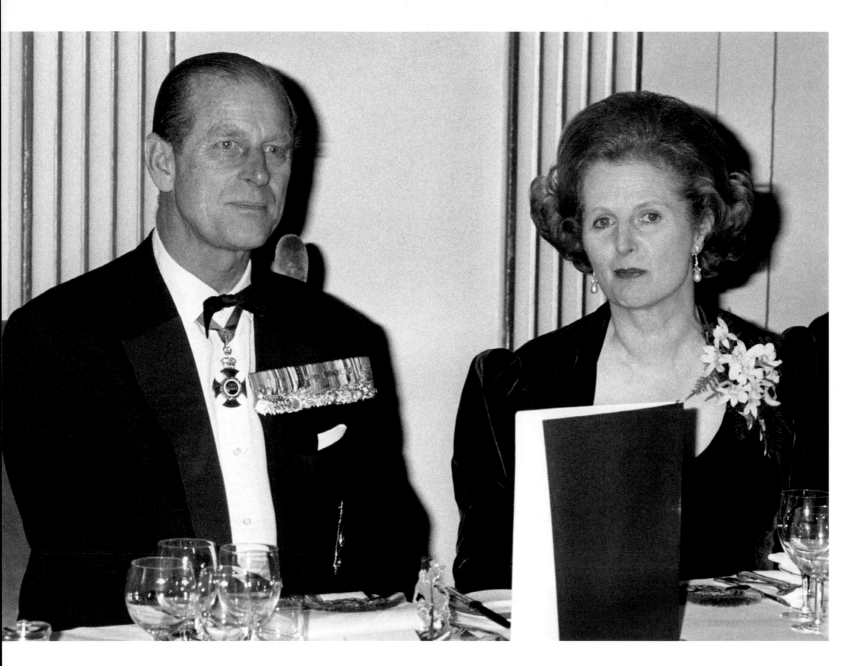

Here she sits alongside the Duke of Edinburgh at an Indonesian banquet at Claridges Hotel in London.

15 November 1979

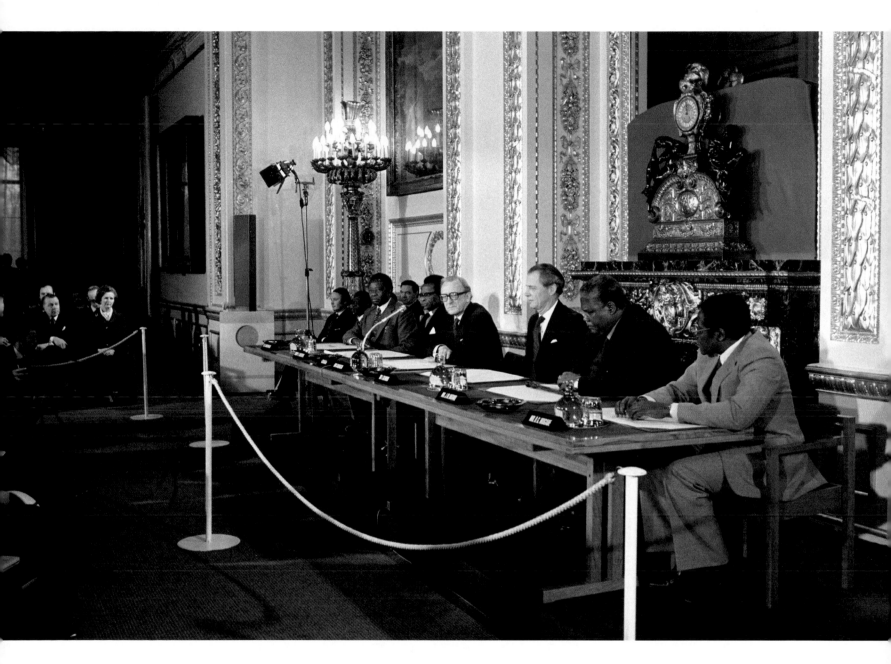

The Rhodesia ceasefire agreement is signed at Lancaster House with guerrilla leaders Robert Mugabe (far right of table), Joshua Nkomo (far left of table) and Lord Carrington (centre, wearing glasses). Margaret watches in the background.

21 December 1979

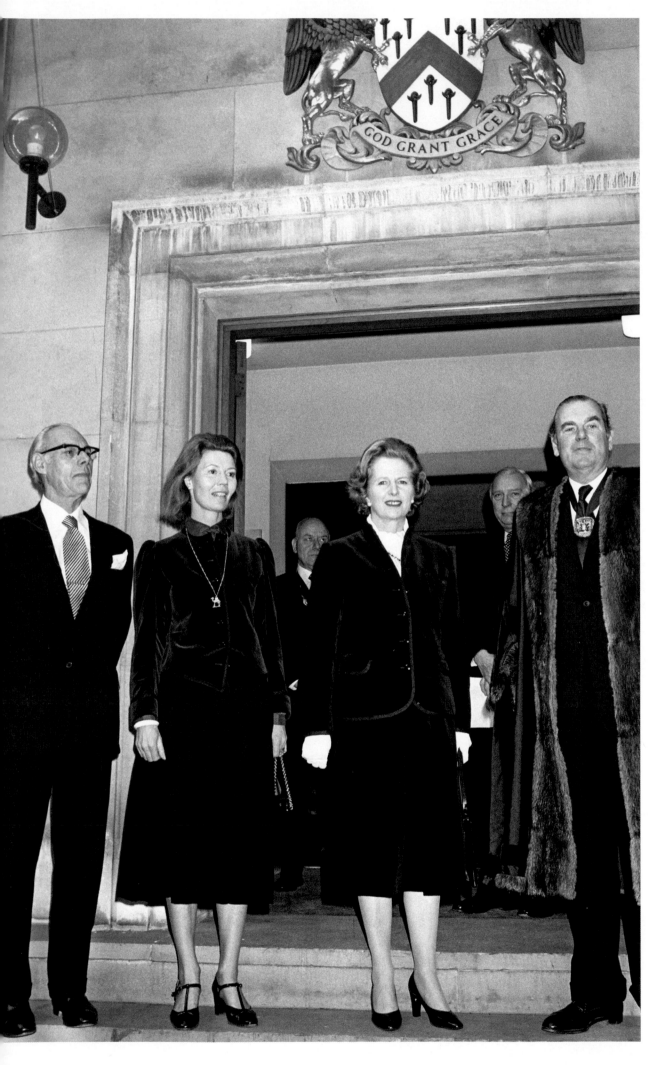

On the steps of
the Grocers' Hall in
the City of London,
she is about to be made
an honorary freeman
of the Worshipful
Company of Grocers
(Margaret was brought
up, the daughter of
a grocer, in Grantham
in Lincolnshire).
Accompanying her are
Denis (far left),
Lady Bossom (left),
the wife of the Master,
and the Master,
Sir Clive Bossom (right).

16 January 1980

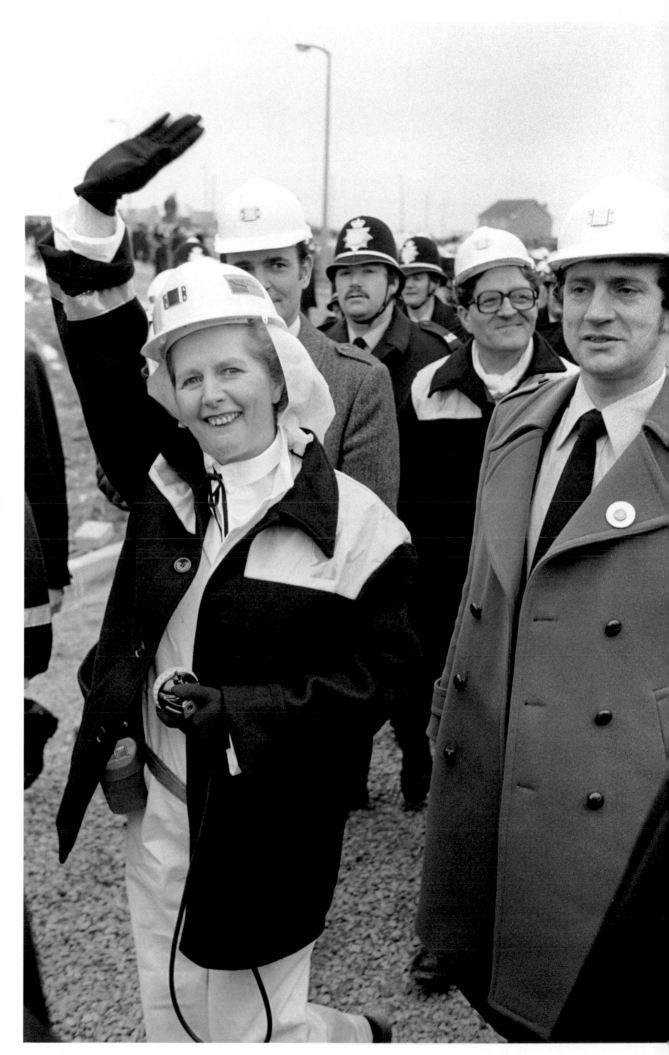

A wave before going down a 1,000ft mine shaft at Wistow Colliery in the Selby coalfield. The mine was finally closed in 2004.

14 March 1980

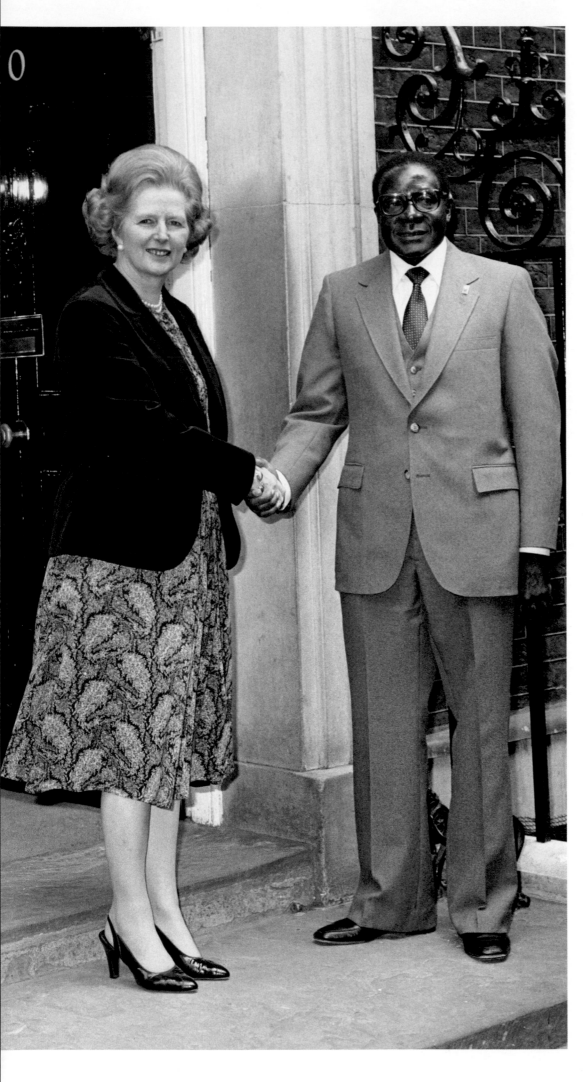

On the steps of No 10 she greets the Prime Minister of the new independent state of Zimbabwe, Robert Mugabe.

9 May 1980

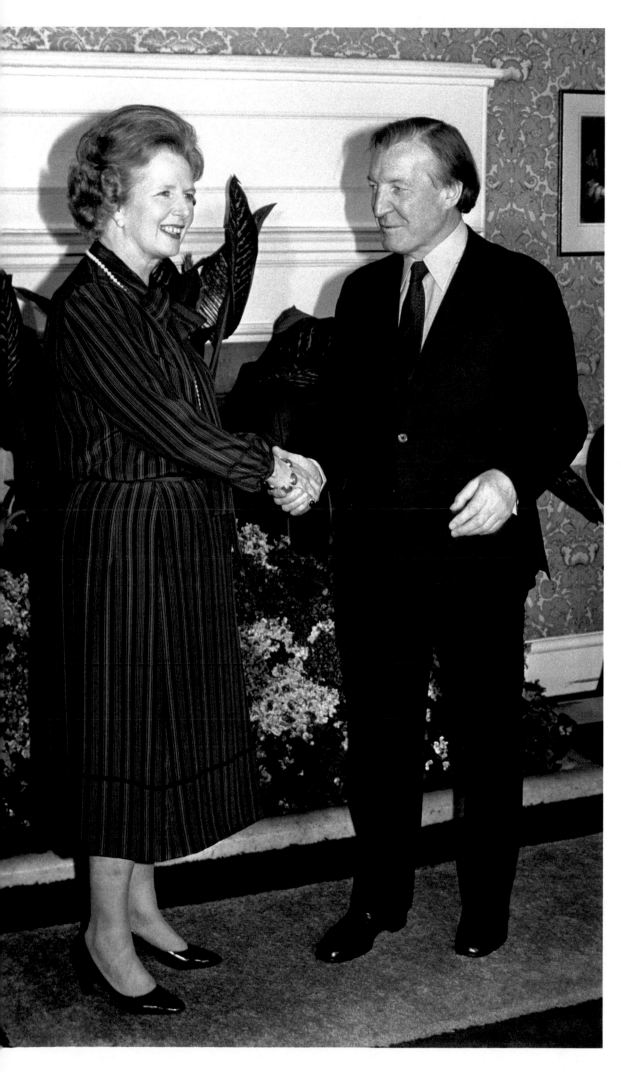

And later in the month she meets with Charles Haughey, Prime Minister of the Irish Republic, for talks on Northern Ireland.

21 May 1980

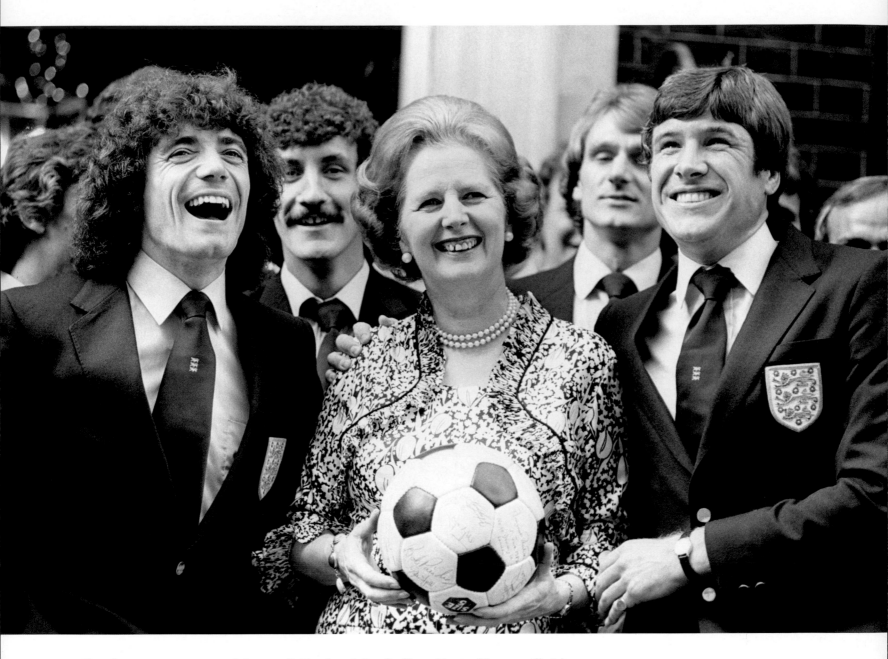

She shares a moment of fun with England footballers Kevin Keegan (left),
Emlyn Hughes and other members of the international squad outside Downing Street
where they have been invited to a reception.

5 June 1980

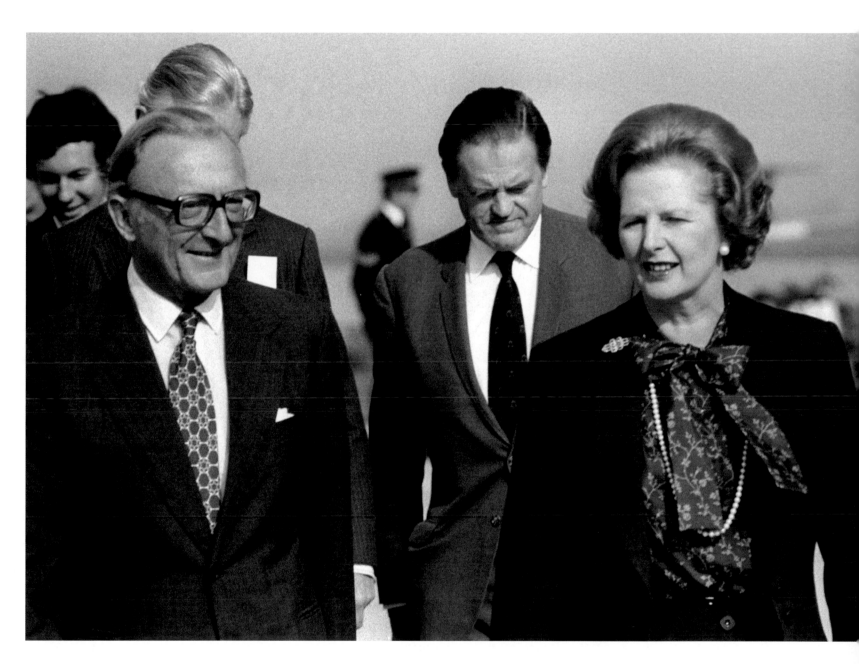

She leaves with Lord Carrington to attend
the Common Market summit in Venice.

12 June 1980

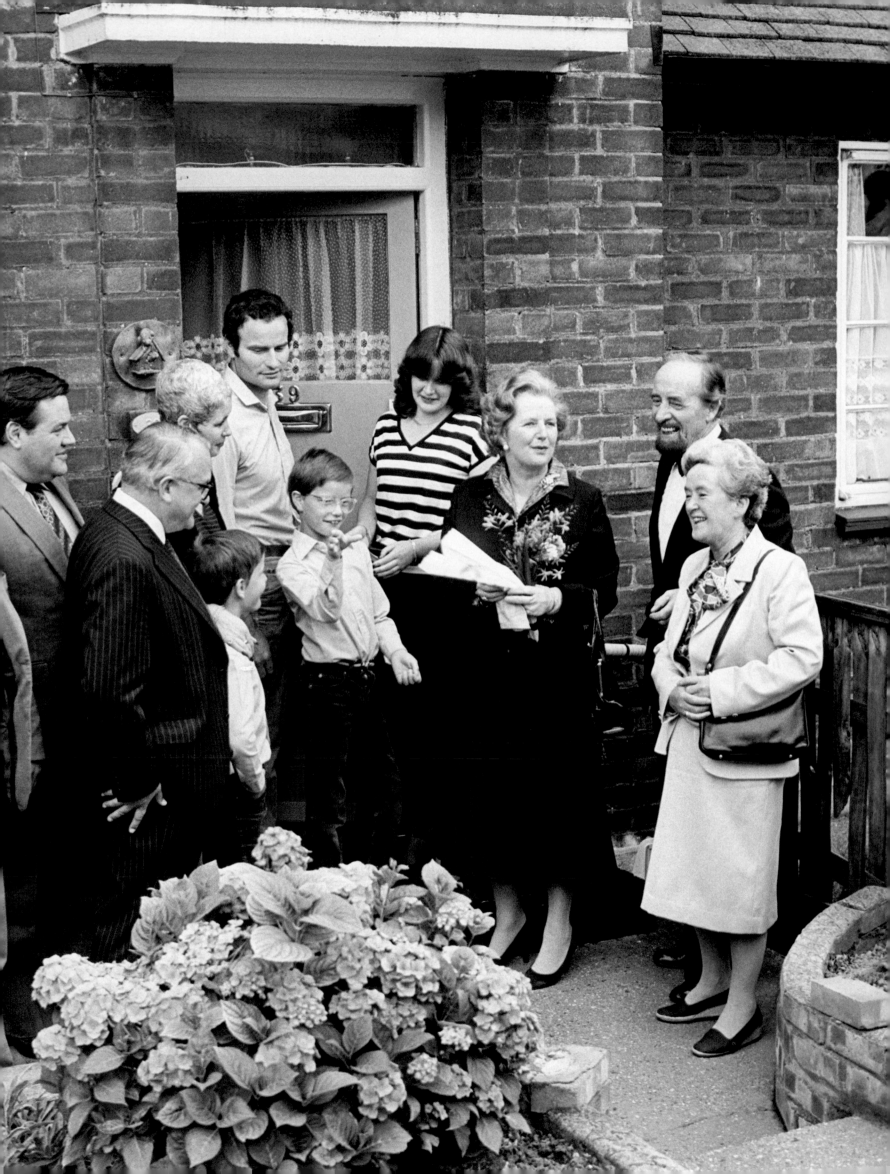

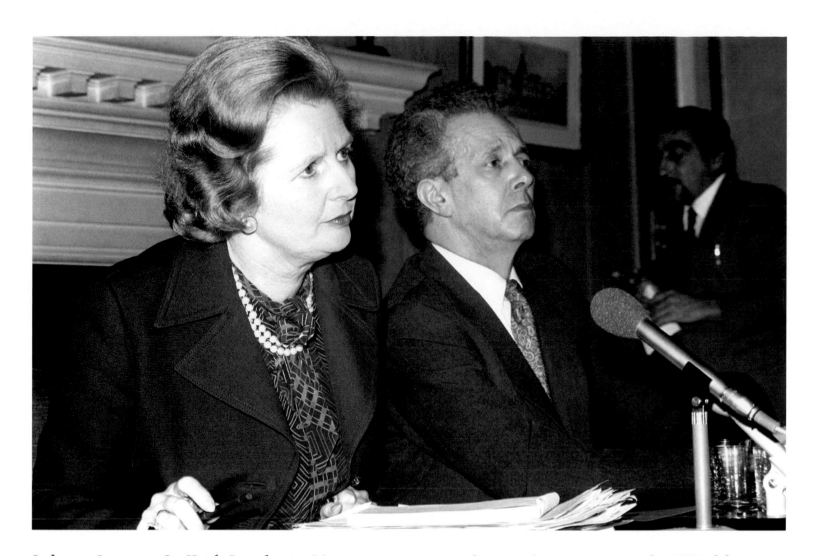

Industry Secretary Sir Keith Joseph joins Margaret at a press conference after a meeting with a TUC delegation at No 10. Sir Keith is a close friend and highly influential in her development of "Thatcherism".

14 October 1980

FACING PAGE: *She hands over a copy of the deeds of 39 Amersham Road, Harold Hill, in Essex, a former council house, to James Patterson and his family. This brings the total of council houses sold by the GLC to 12,000.*

11 August 1980

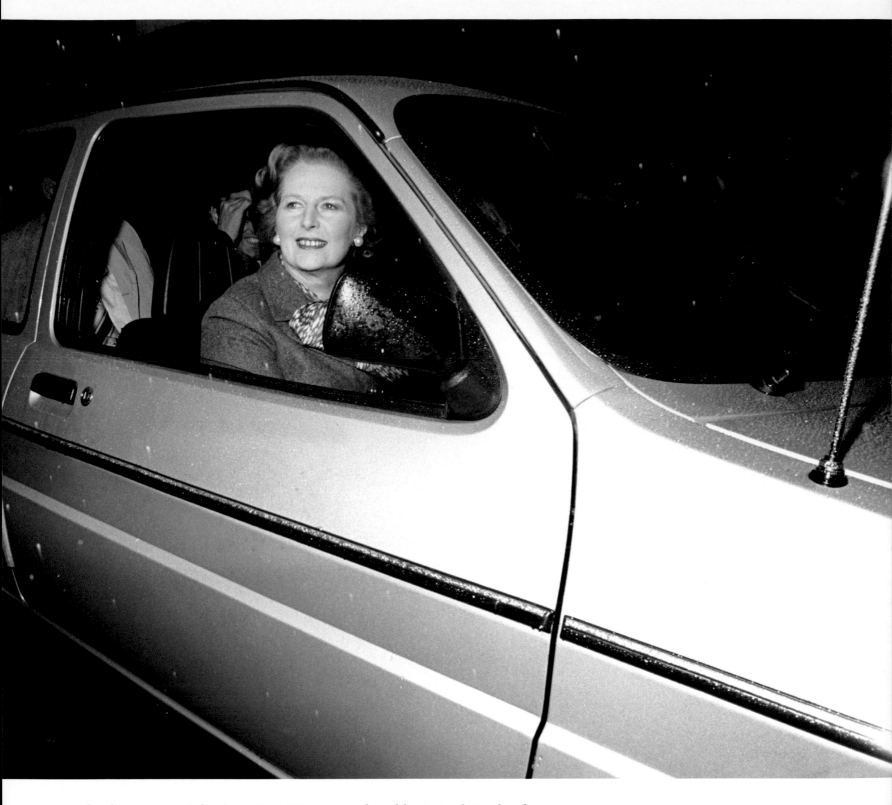

She drives one of the first Mini Metros produced by British Leyland into the National Exhibition Centre in Birmingham to officially open the Motor Show.

17 October 1980

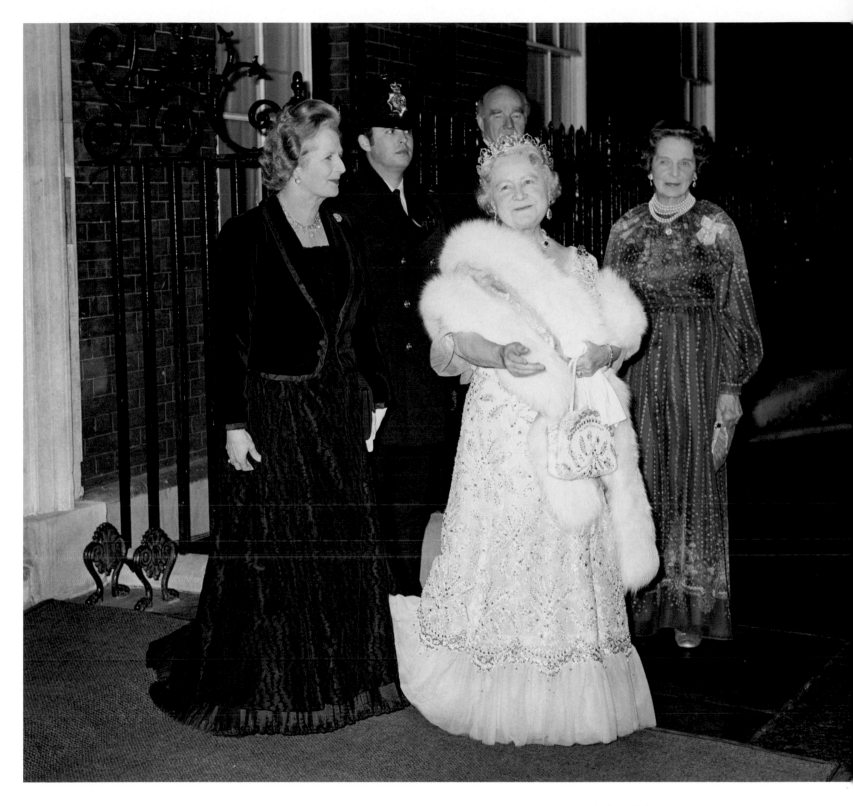

The Queen Mother, on the occasion of her 80th birthday,
visits Downing Street as a guest of Margaret and Denis.

11 November 1980

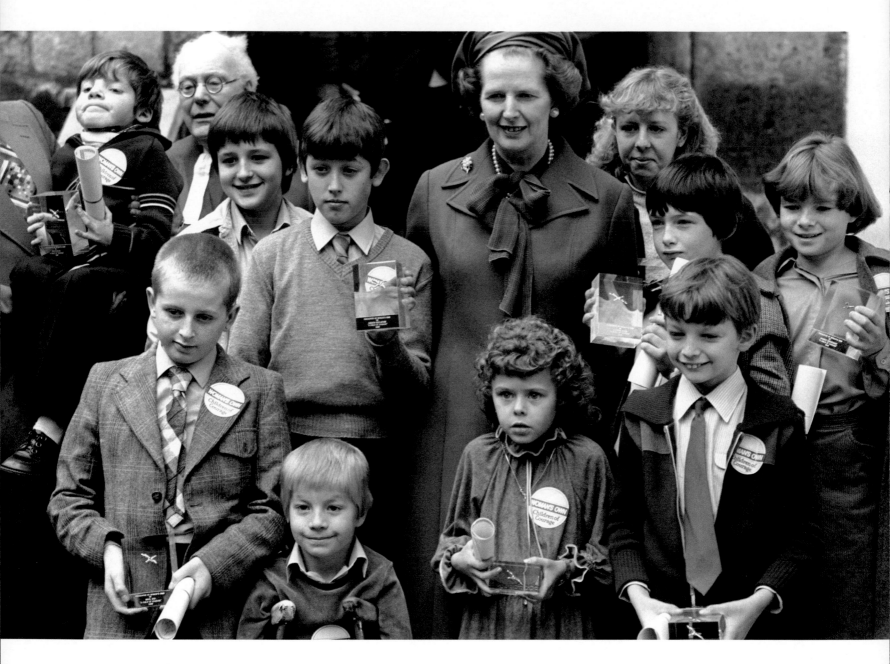

*Margaret with winners of the Woman's Own
Children of Courage Awards at Westminster Abbey.*

17 December 1980

Dressed in protective clothing, she tours the premises of Vacuum Interrupters Ltd.

16 January 1981

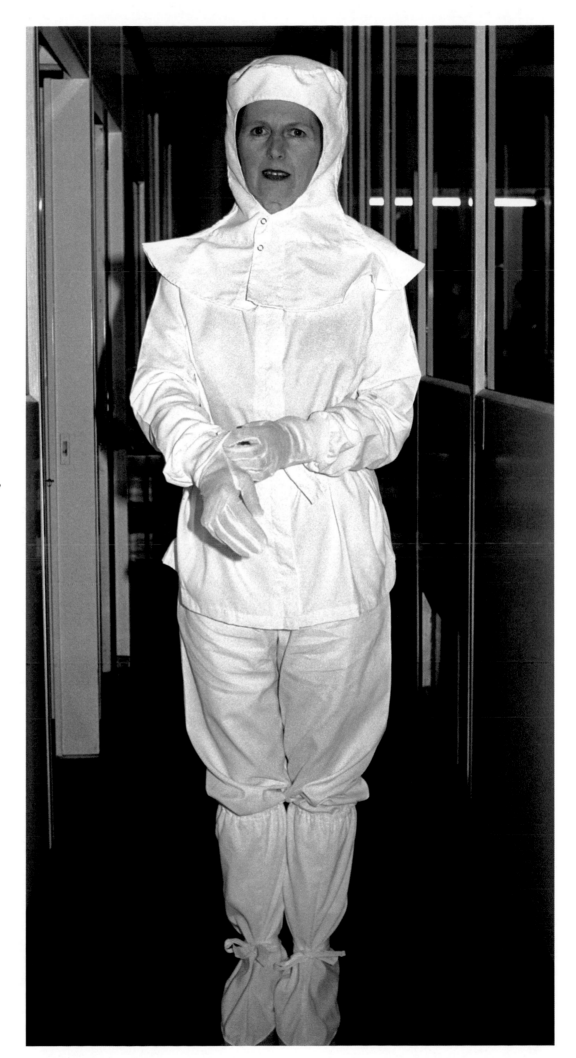

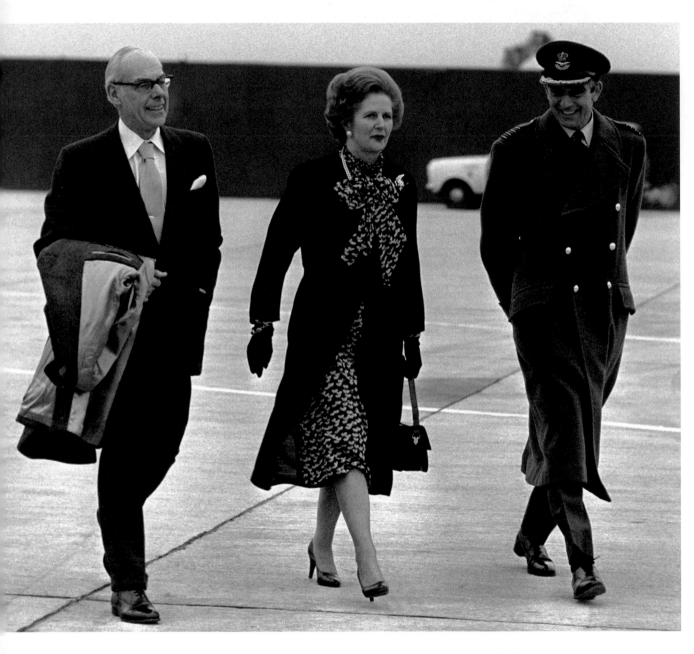

Accompanied by Denis, Margaret arrives at Heathrow Airport on her way to Washington DC to attend the inauguration of President Reagan. It was to be the beginning of a long friendship and political alliance.

25 February 1981

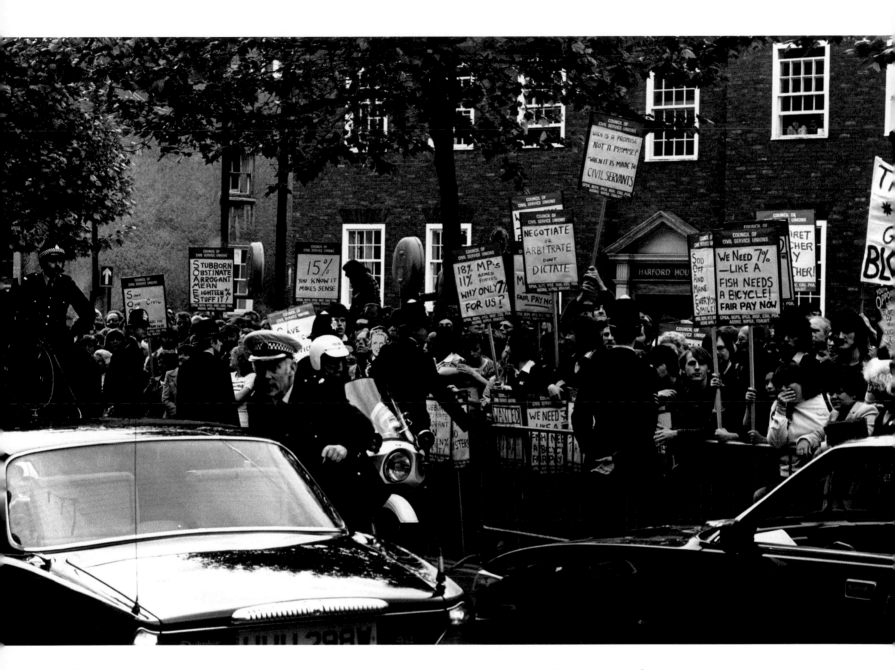

The Prime Minister's car is pelted with eggs as she arrives at a reception for party workers. Although the economic recession is ending, there are tax increases and expenditure cuts, and unemployment has reached 3 million.

5 June 1981

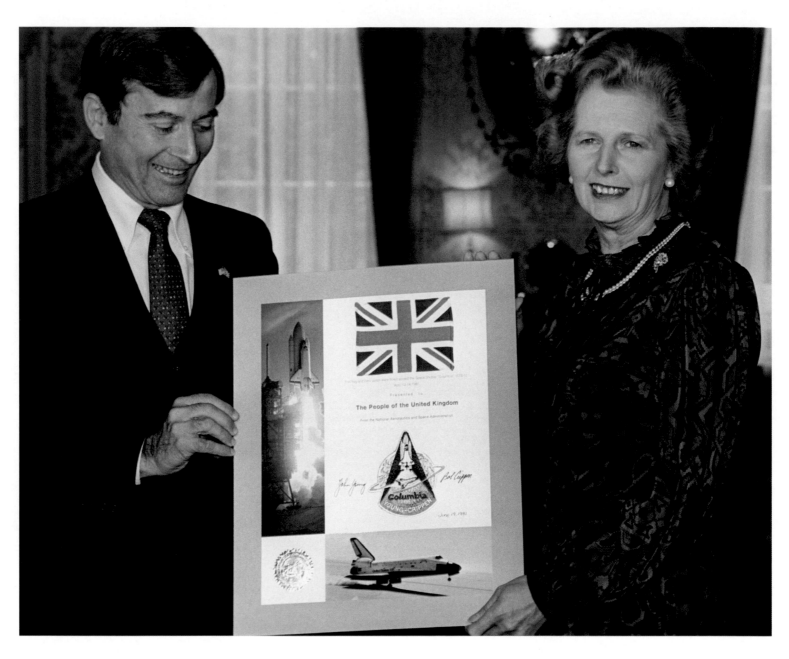

A visit from John Young, Commander of the Colombia Space Shuttle, at No 10 Downing Street.
Young walked on the moon in April 1972 during the Apollo 16 space mission.

19 June 1981

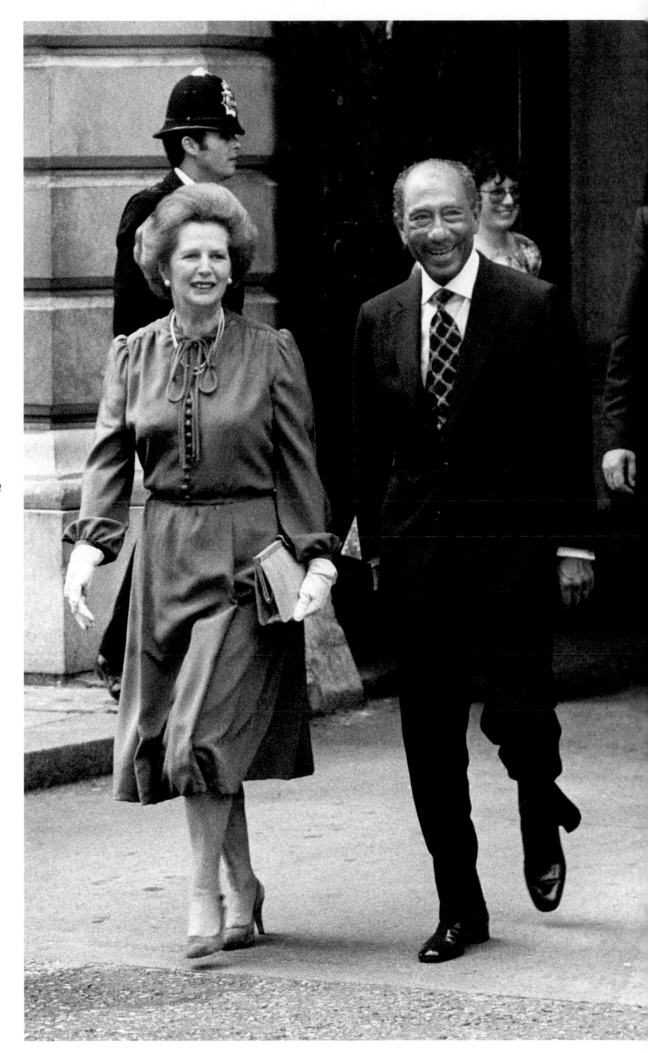

Leaving the Foreign Office with President Anwar Sadat of Egypt for a session of talks at Downing Street with the Foreign Secretary, Lord Carrington.

3 August 1981

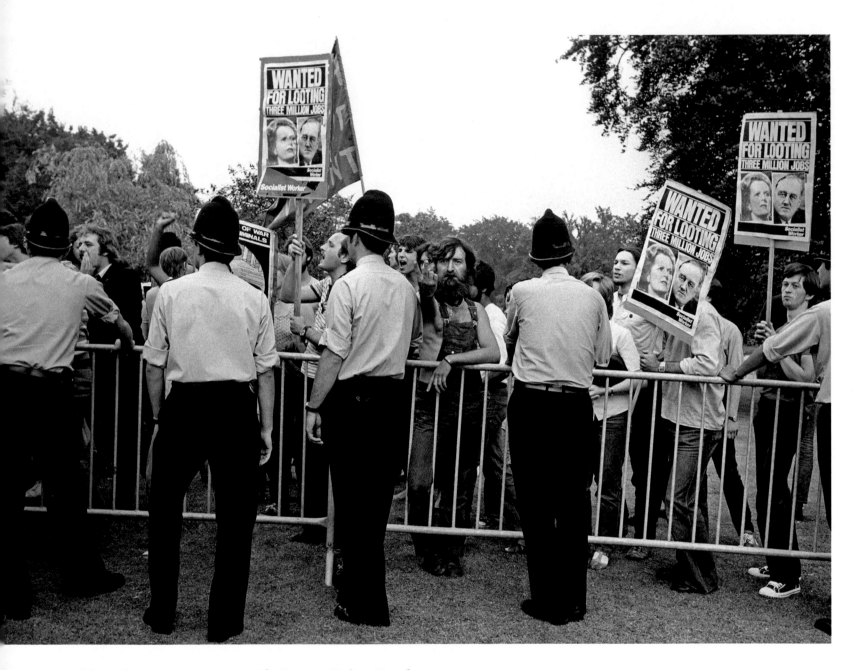

More demonstrations outside County Police Headquarters
in Norfolk where the Prime Minister is on a one-day visit.

5 August 1981

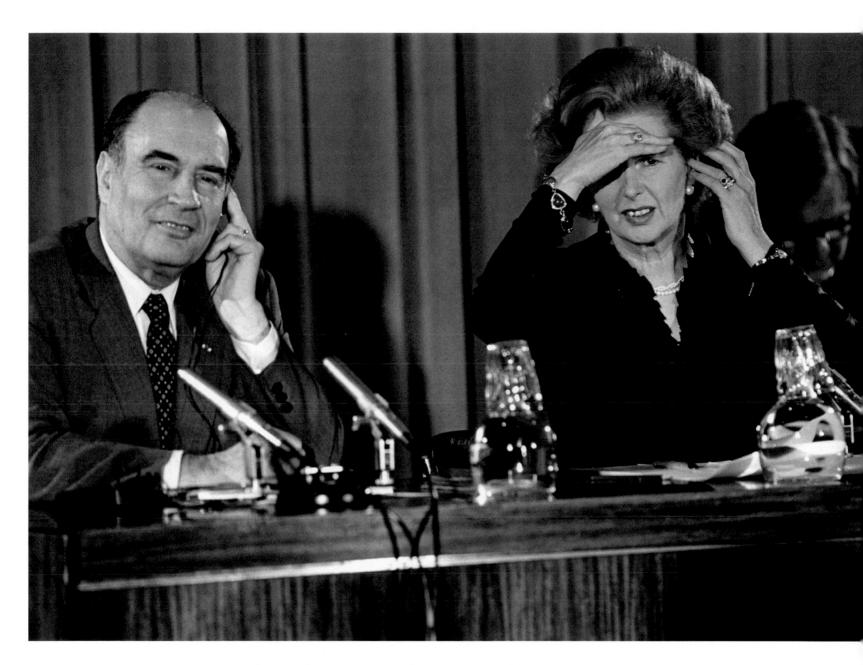

French President François Mitterrand and the Prime Minister receive questions at a joint press conference at Millbank Tower in London where they reached agreement at summit talks to renew the project for a Channel Tunnel.

11 September 1981

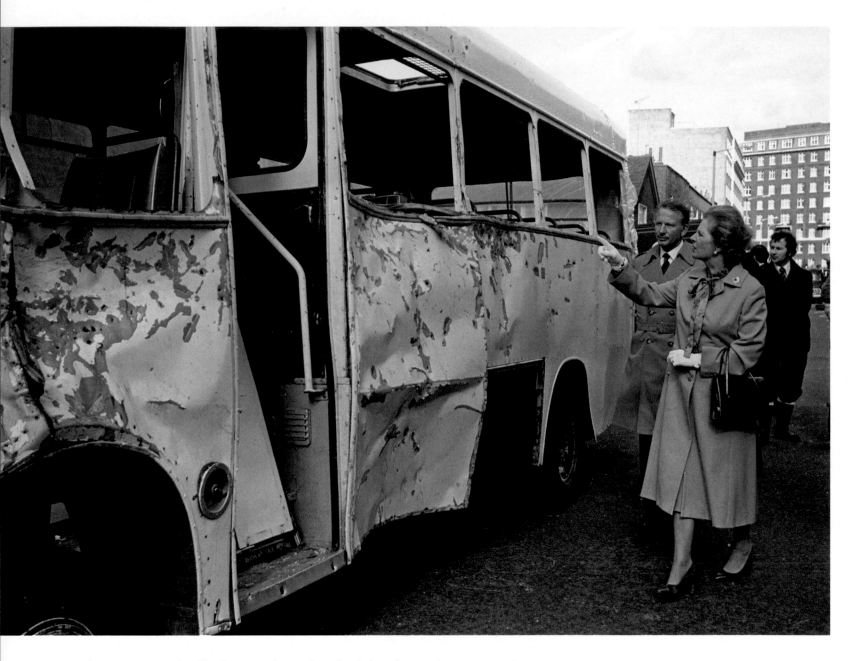

*She inspects a badly damaged coach, which has been the target of
a nail bomb attack, near Chelsea Barracks in London. One woman
died in the explosion and 38 men, many of them soldiers, were injured.*

11 October 1981

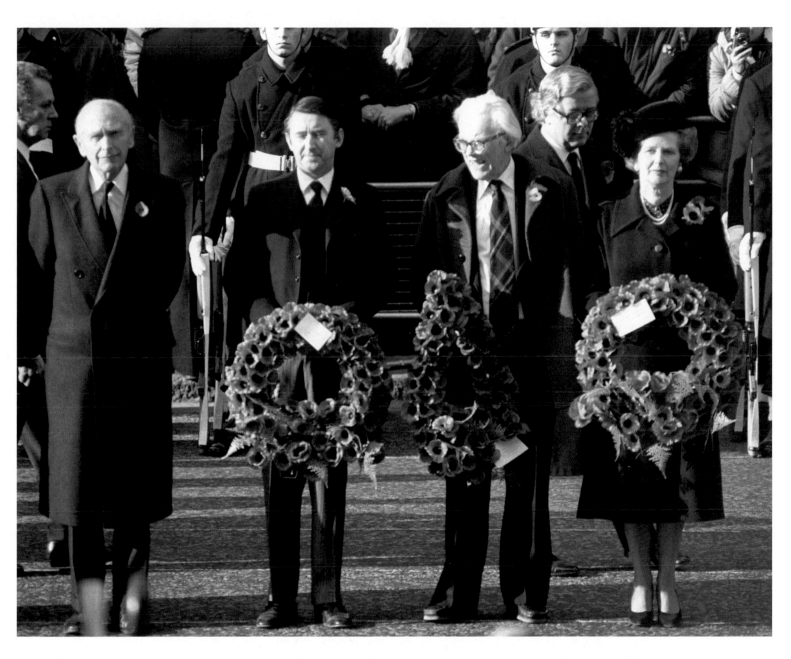

The Prime Minister attends a Remembrance Day service
accompanied by (from left) Lord Home, Liberal leader
David Steel and Opposition leader Michael Foot.

8 November 1981

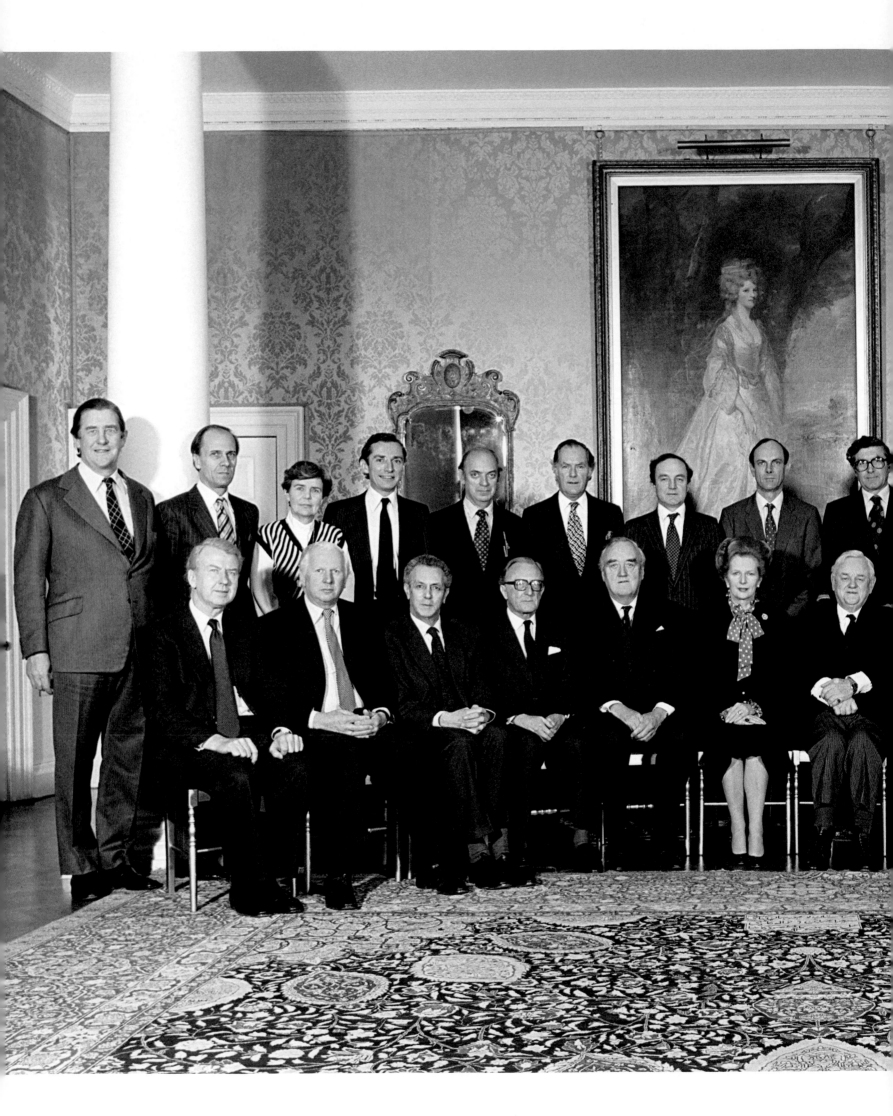

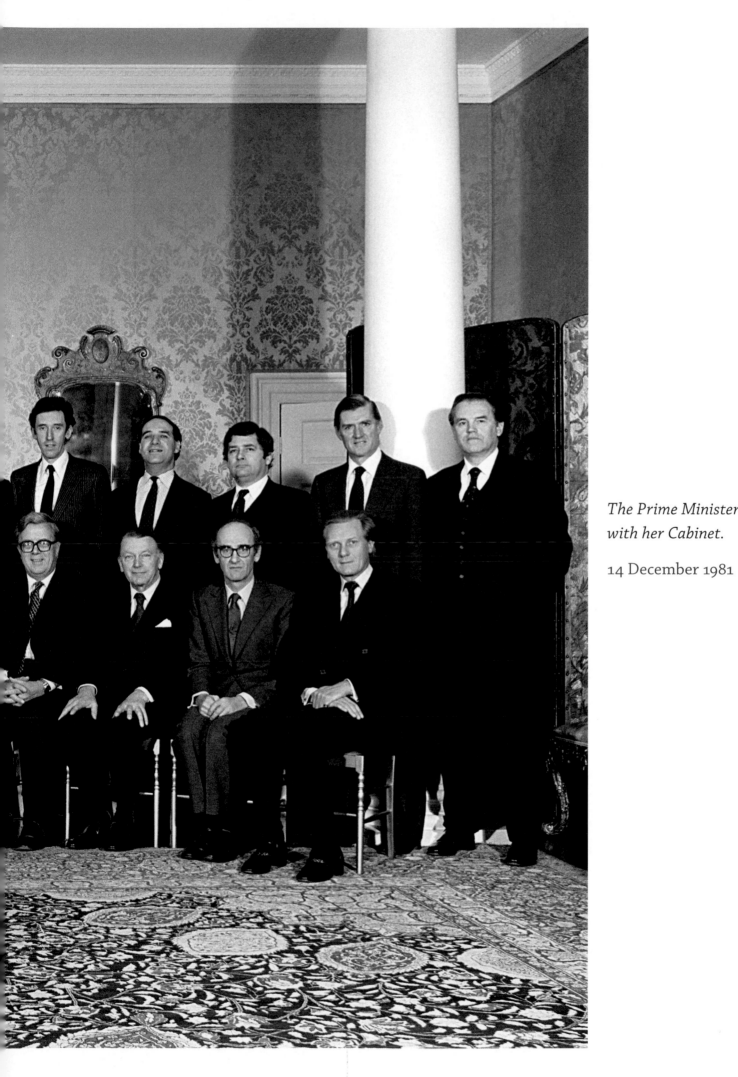

The Prime Minister with her Cabinet.

14 December 1981

A rare moment of public emotion as she leaves the Imperial Hotel in London
after having broken down in tears. Her son Mark, his co-driver Charlotte Verney
and their mechanic, have disappeared in the Sahara Desert during the Paris / Dakar
motor rally. A massive air and ground search is underway.

13 January 1982

Two days later Mark Thatcher arrives back at Heathrow and is greeted by his father.

15 January 1982

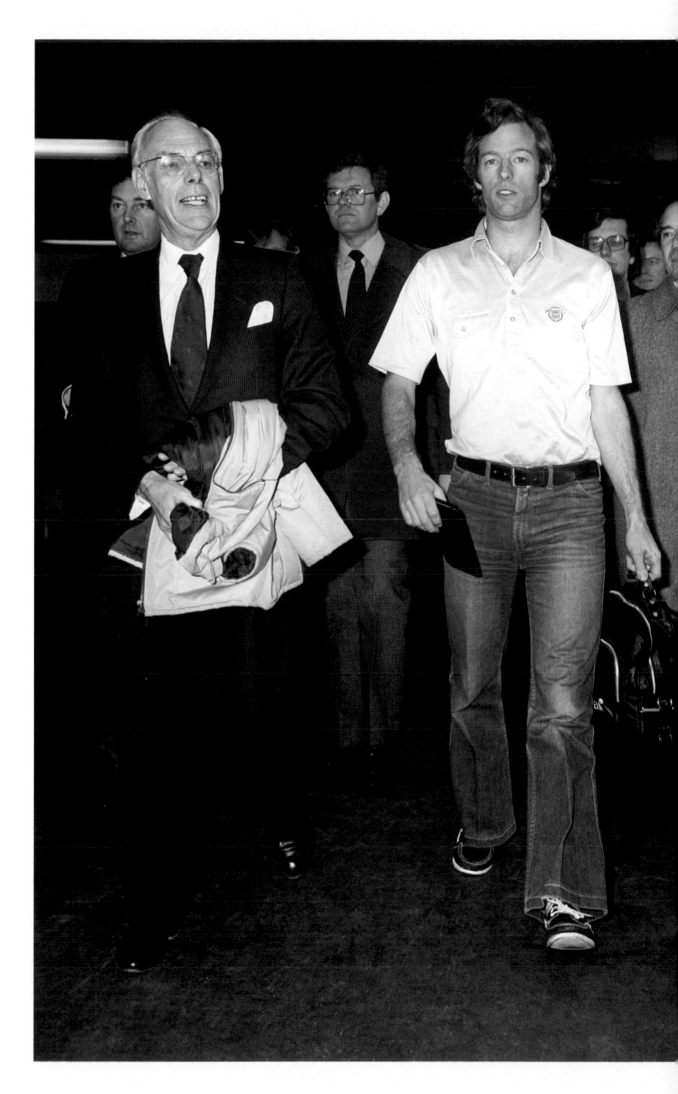

*The Prime Minister
at BBC's Broadcasting
House studios to record
a 15-minute interview
for Pete Murray's Late
Show on Radio 2.*

5 March 1982

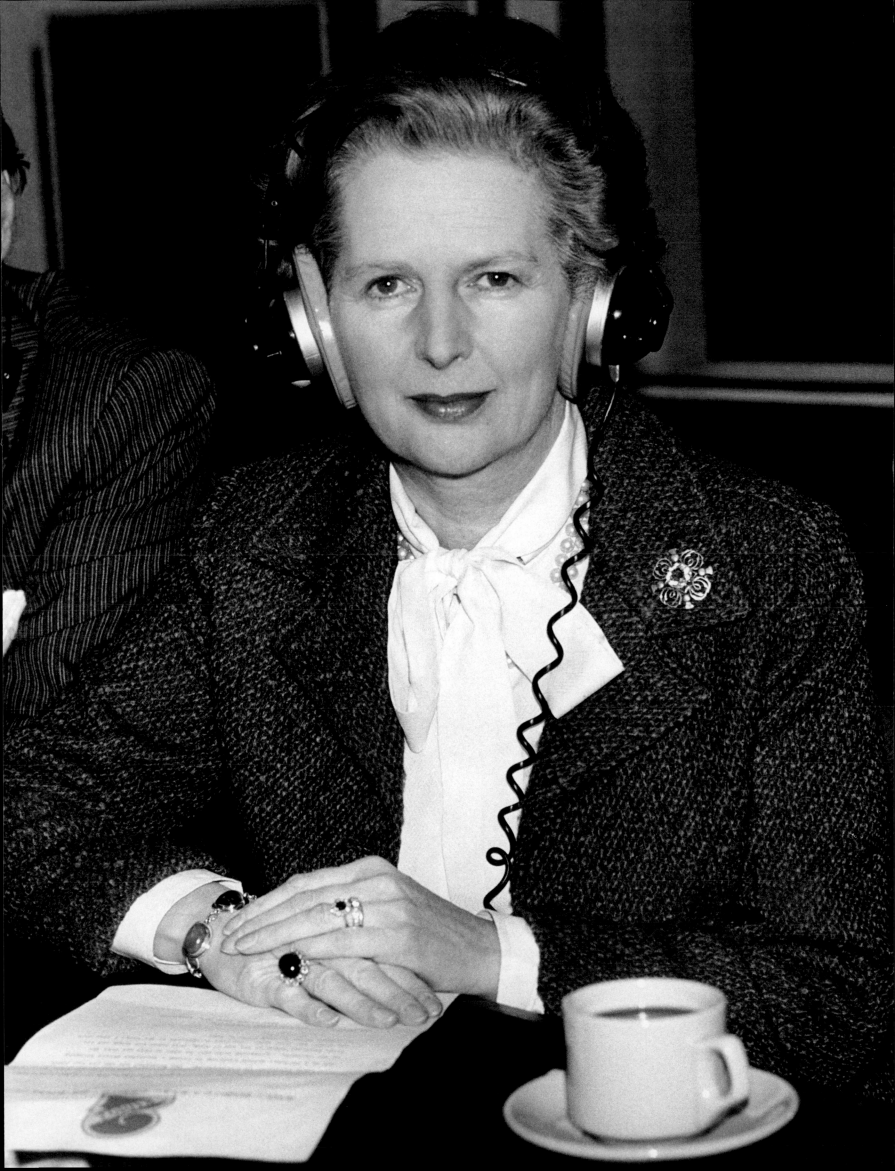

CHAPTER 4

The
Falklands
Crisis

The Prime Minister leaves No 10 after an emergency meeting to discuss the situation in the Falklands Islands. It is the beginning of what is to be her finest hour in the eyes of many of the public – a war fought for the honour of Britain. This chapter in her story is to have a great effect on her popularity in the future.

2 April 1982

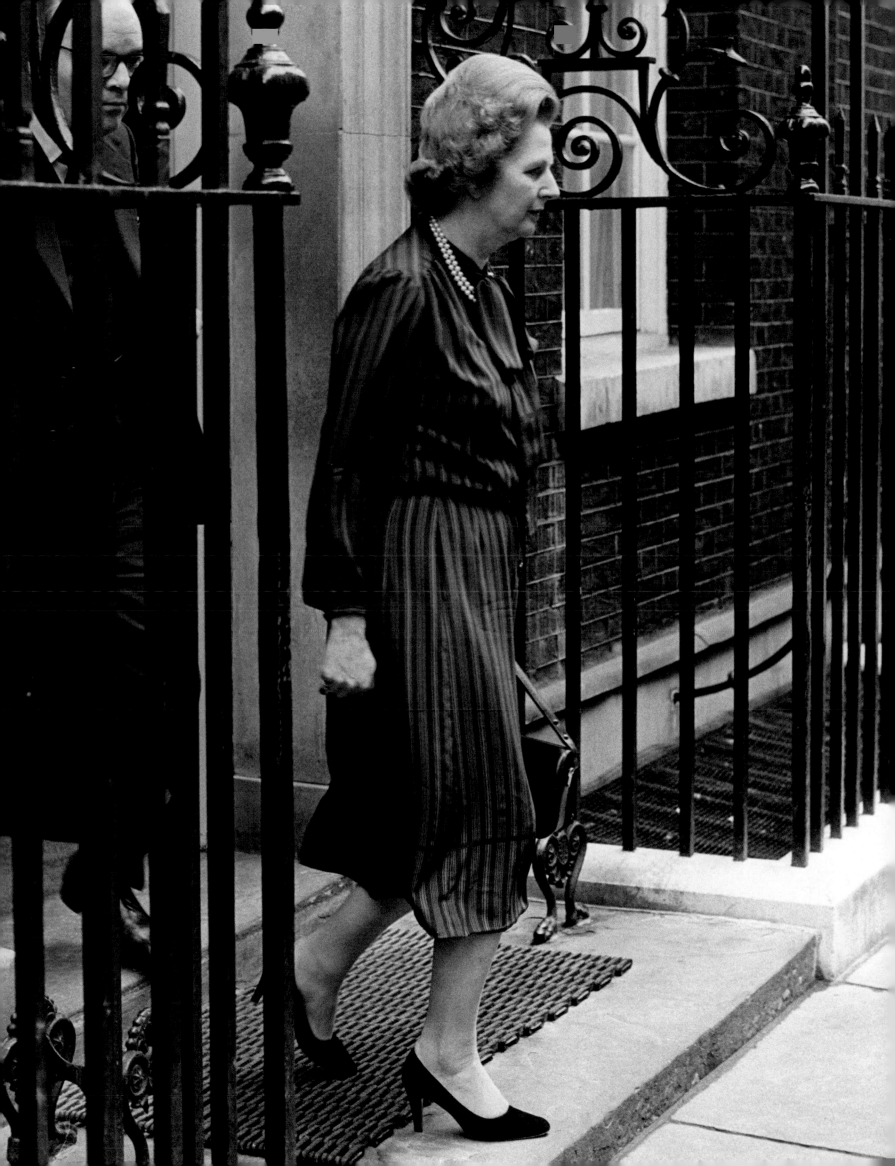

Margaret with the ousted Governor of the Falkland Islands, Rex Hunt (second right), and Royal Marine Majors Gareth Noot (left) and Mike Norman at Downing Street, after their return from the Falklands via Montevideo, Uruguay. They have met to give the Prime Minister first hand accounts of the invasion of the islands.

5 April 1982

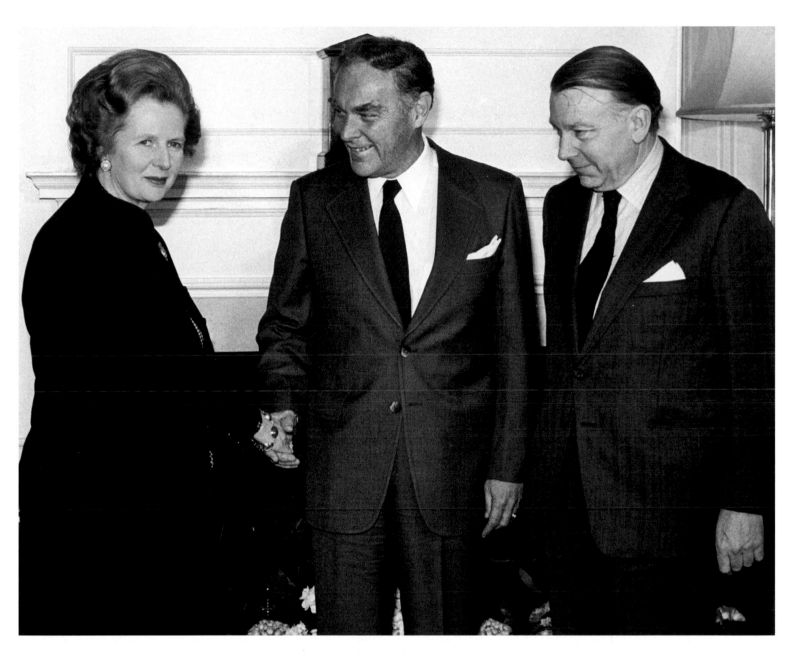

*Alexander Haig (centre), the US Secretary of State,
in No 10 with Foreign Secretary Francis Pym for talks
with the Prime Minister on the Falklands crisis.*

8 April 1982

The Prime Minister leaving No 10 for the House of Commons where there is to be a discussion on the peace offer made by Argentina.

20 April 1982

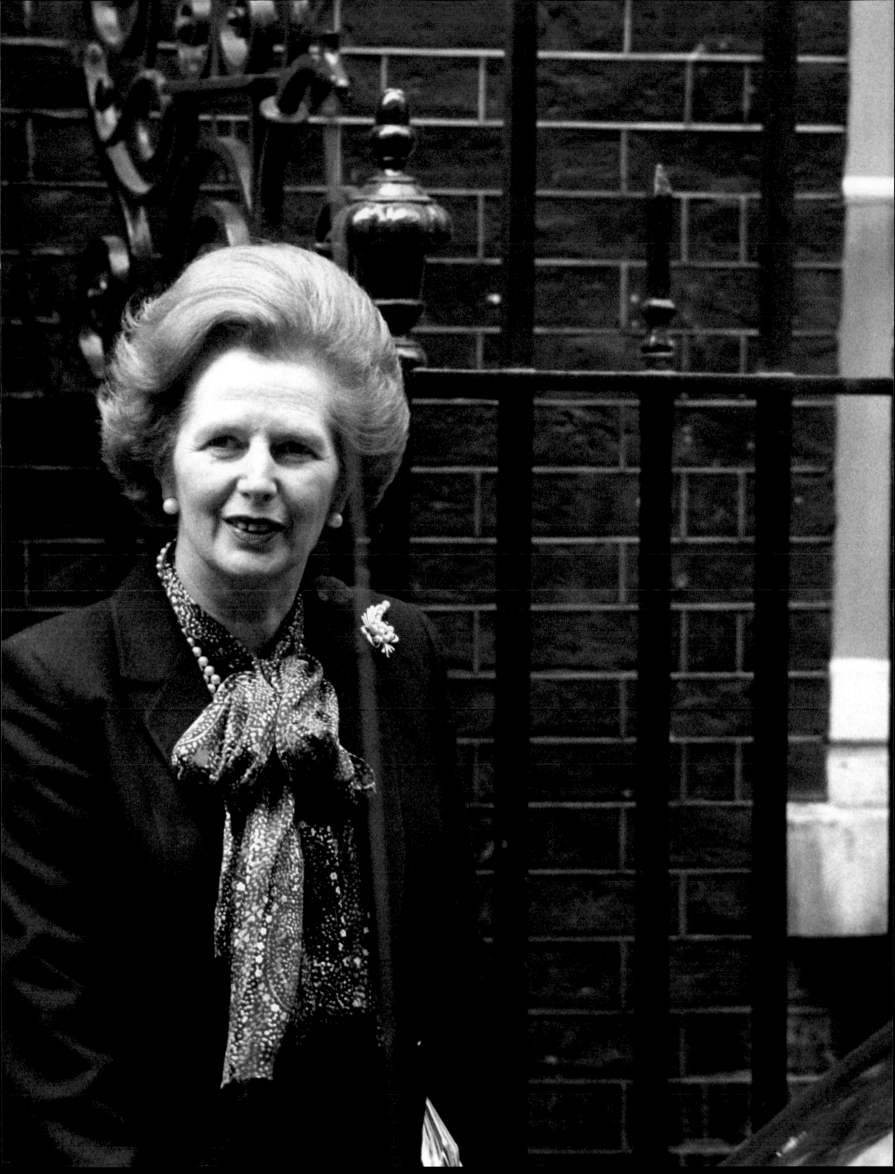

She talks to BBC Panorama interviewers Richard Lindley (right) and Robert Kee about the Falklands in a programme that goes out live from the Whip's Office at Downing Street.

26 April 1982

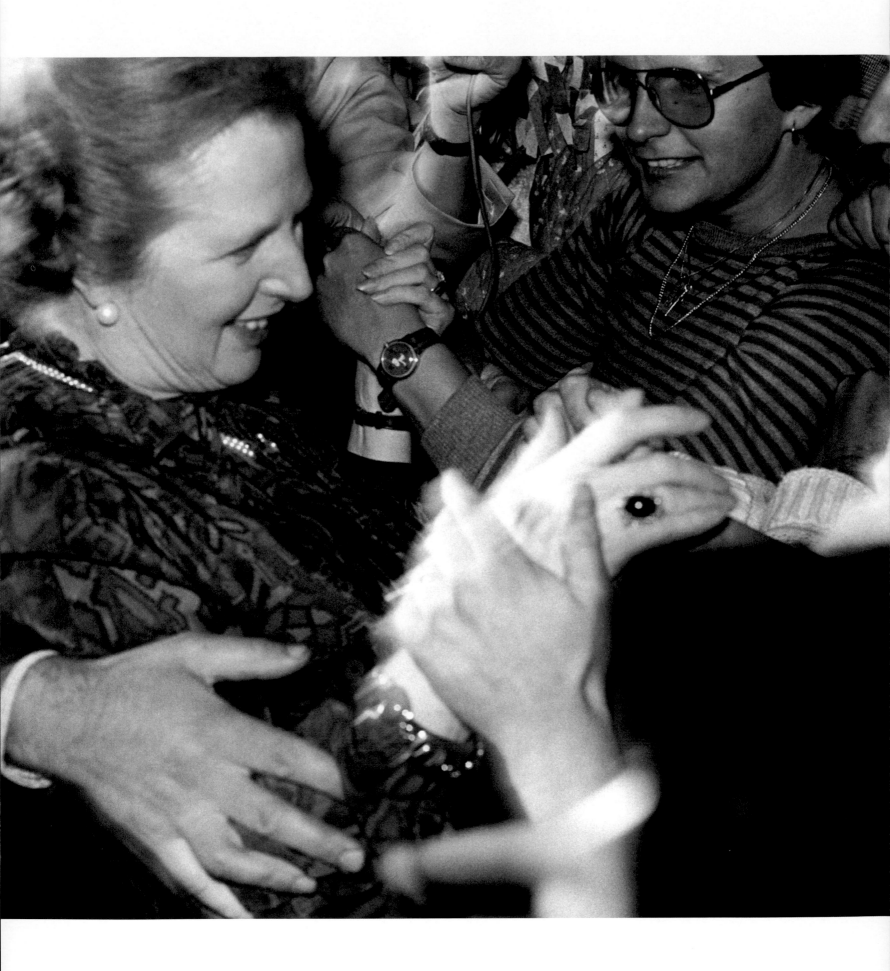

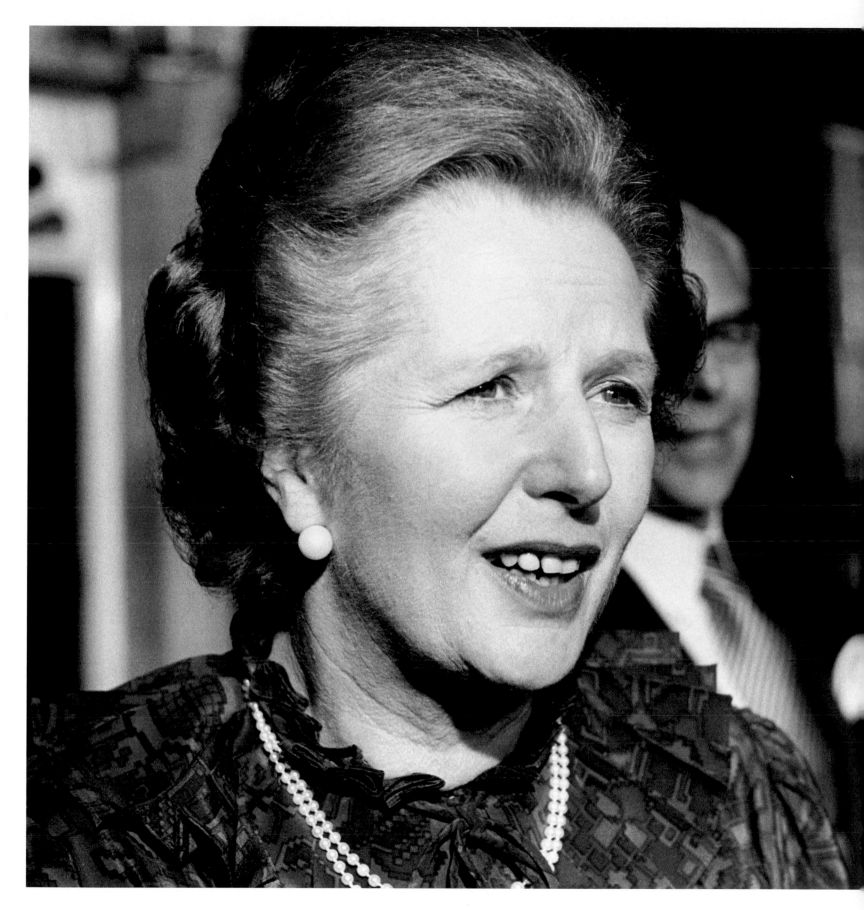

An enthusiastic crowd greet the Prime Minister on her return to No 10 from the House of Commons following her statement regarding the surrender of Argentine armed forces in East and West Falklands at 9 pm local time on 14 June.

15 June 1982

*Civil servants arrive at No 10 for a reception given
by the Prime Minister to say "thank you" to her staff
for their work during the crisis.*

30 June 1982

The United Nations Secretary General, Javier Perez de Cuellar, who figured prominently
during the ill-fated United Nations attempts to defuse the Falklands crisis,
shakes hands with the Prime Minister at No 10 where they have met for talks.

14 July 1982

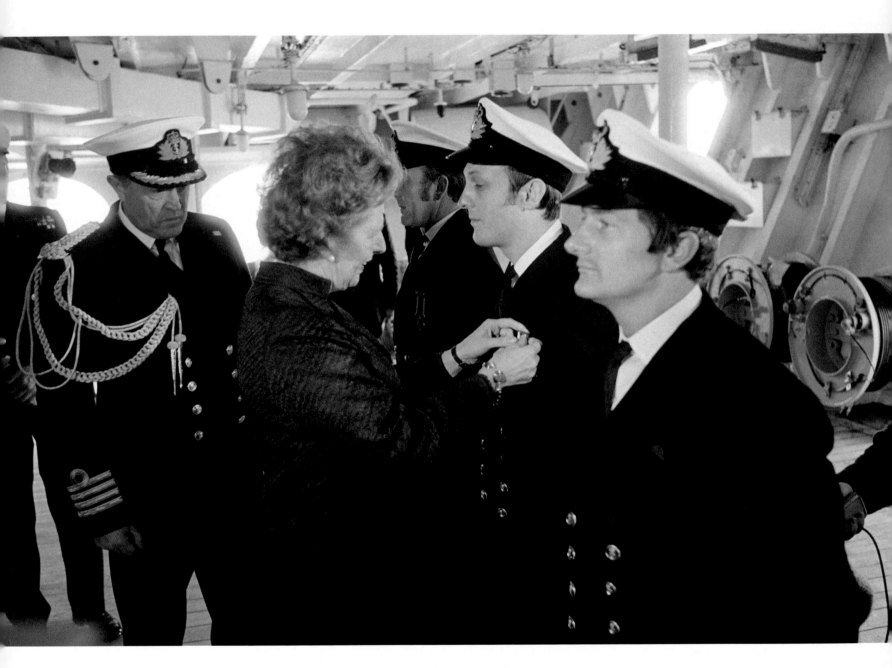

*The Prime Minister decorates an officer with a long service medal on board
the HMS Hermes, which was the flagship of the British forces during the Falklands crisis.
She has gone on board as the ship sails into Portsmouth on its return to England.*

21 July 1982

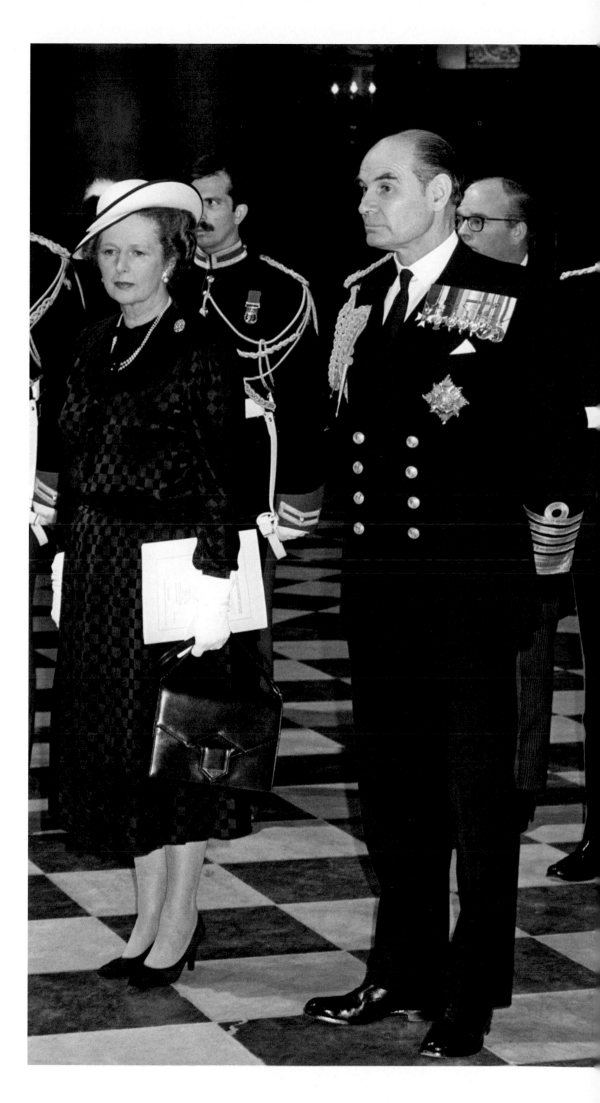

*The Admiral of the Fleet,
Sir Terence Lewin, the Chief
of Defence Staff, with the Prime
Minister at St Paul's Cathedral
for a Falklands Islands Service.*

26 July 1982

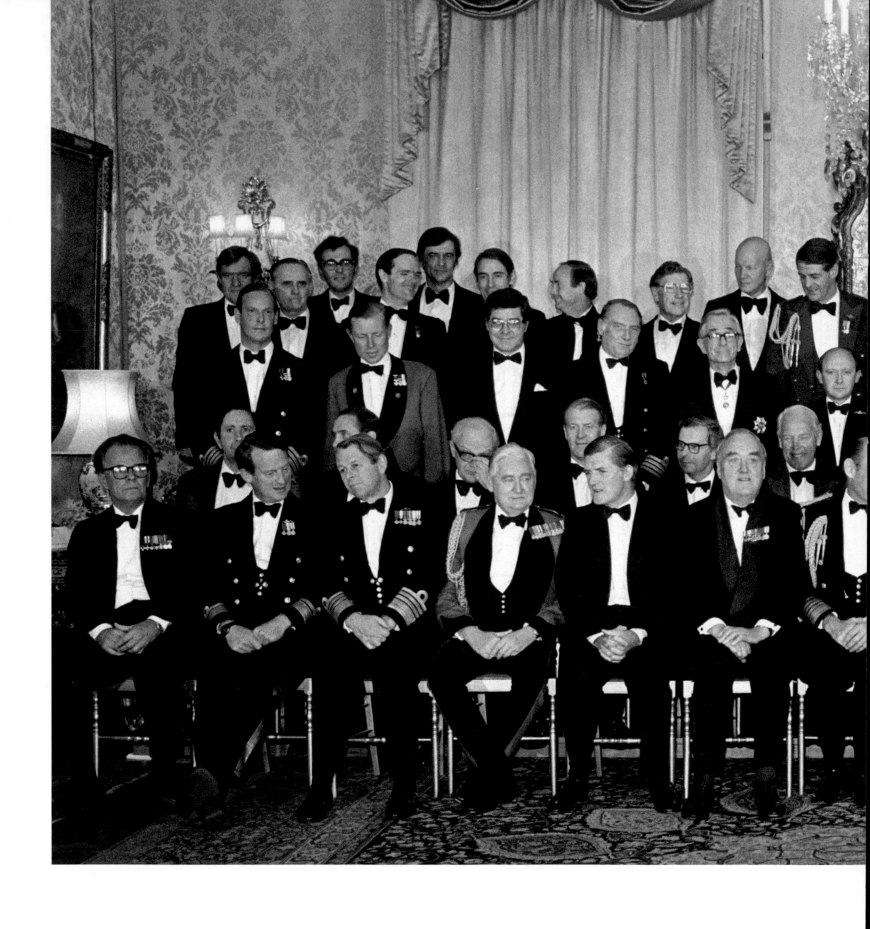

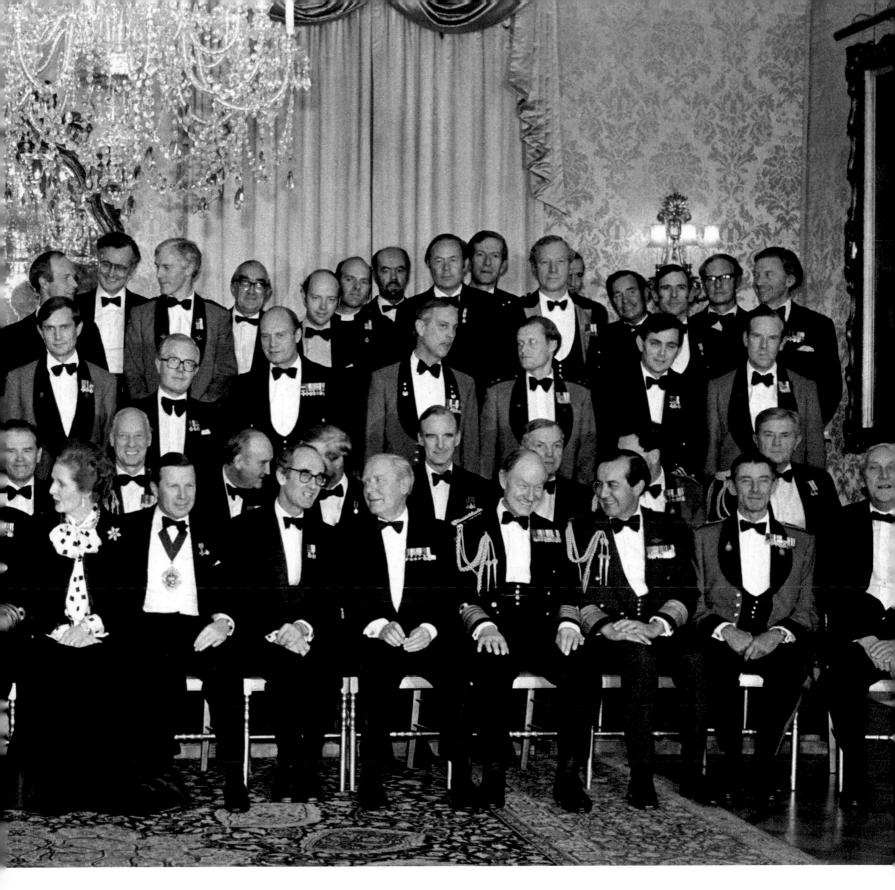

*The Prime Minister with her guests at No 10 at a dinner given
by her for some of those involved in the Falklands campaign.*

11 October 1982

CHAPTER 5

A Second
Term

The Prime Minister in thoughtful mood at a daily Conservative Party press conference, in the run up to the general election in June. It is almost certain, after the successful outcome of the Falklands crisis and the upturn in the economy, that the party will be re-elected.

26 May 1983

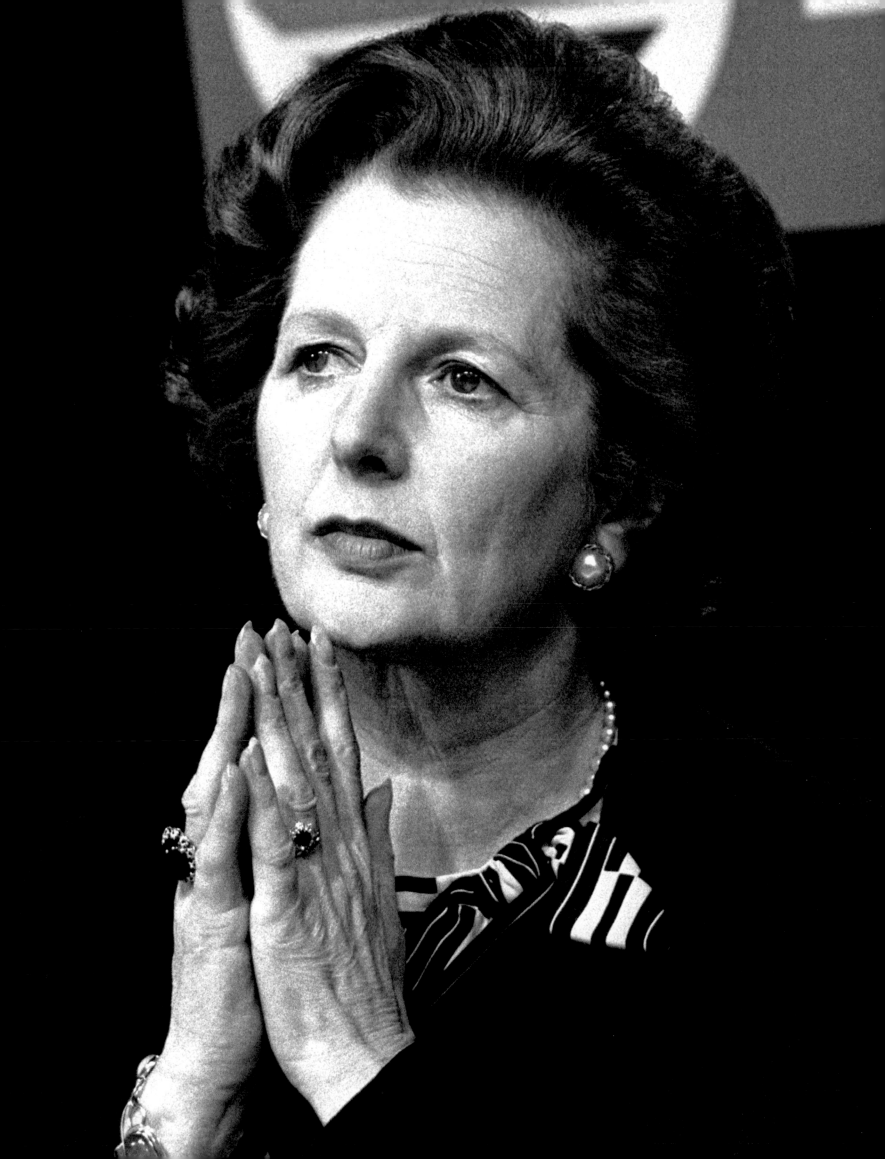

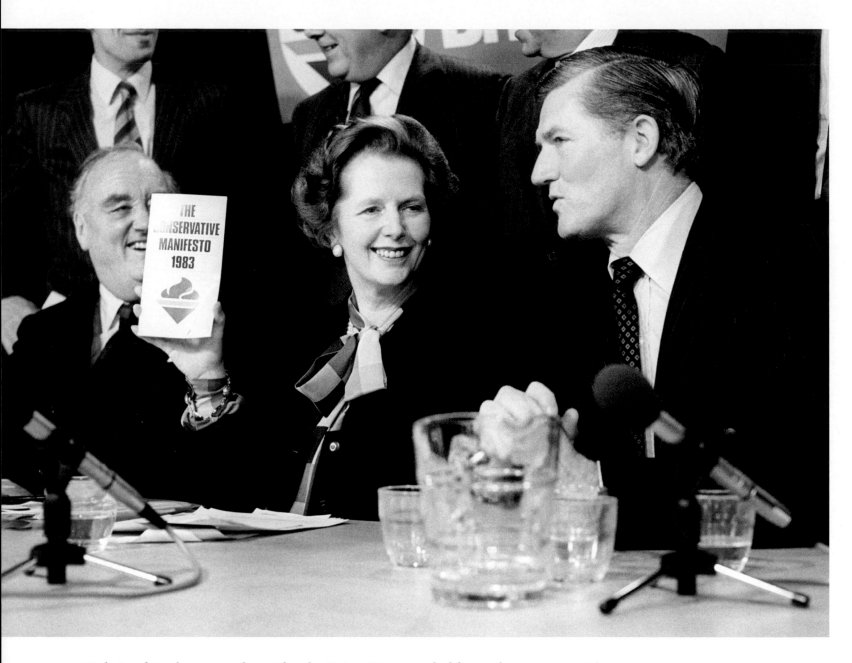

*With Cecil Parkinson at her side, the Prime Minister holds up the party manifesto
in a press conference at Central Office. Privatisation of state-owned industries
and utilities, and reform of the trade unions, plus reduction of taxes and cuts
in social spending have, in her first term, already been implemented.*

1 June 1983

She addresses an audience at Stoneleigh, near Coventry, wearing a garland presented to her by an Asian constituent.

3 June 1983

The campaign continues in Ealing North where she is joined by light-heavyweight boxing champion, John Conteh.

4 June 1983

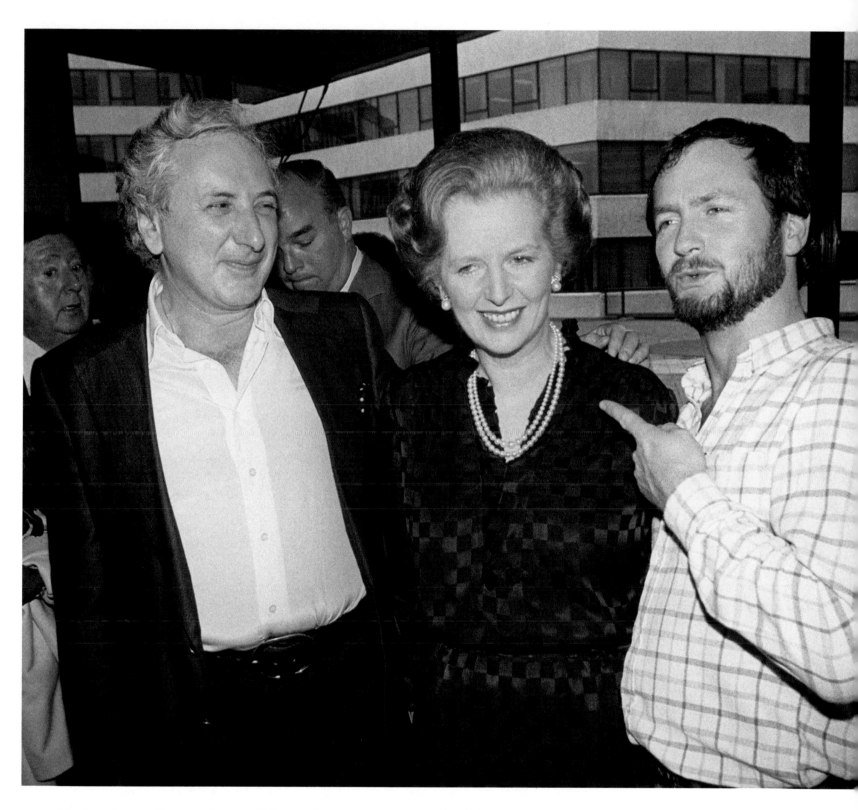

...and in London with comedian and disc jockey Kenny Everett (right) and director Michael Winner.

5 June 1983

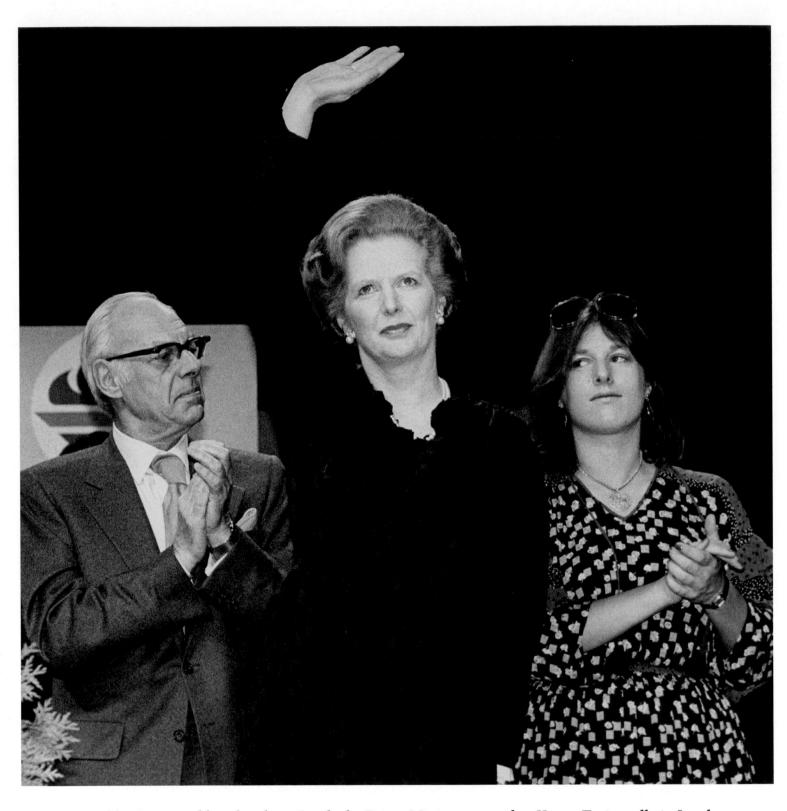

Accompanied by Denis and her daughter Carol, the Prime Minister attends a Young Tories rally in London.

6 June 1983

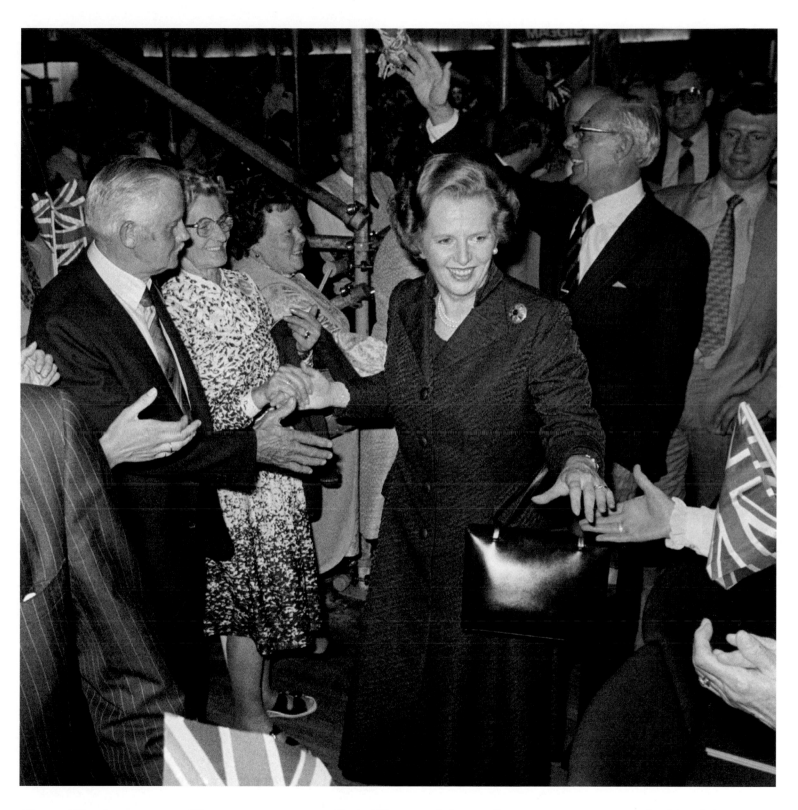

She and Denis are greeted by supporters at a rally in Fleetwood during her campaign visit to the North West.

8 June 1983

A landslide victory and Margaret's
second term in power begins.

10 June 1983

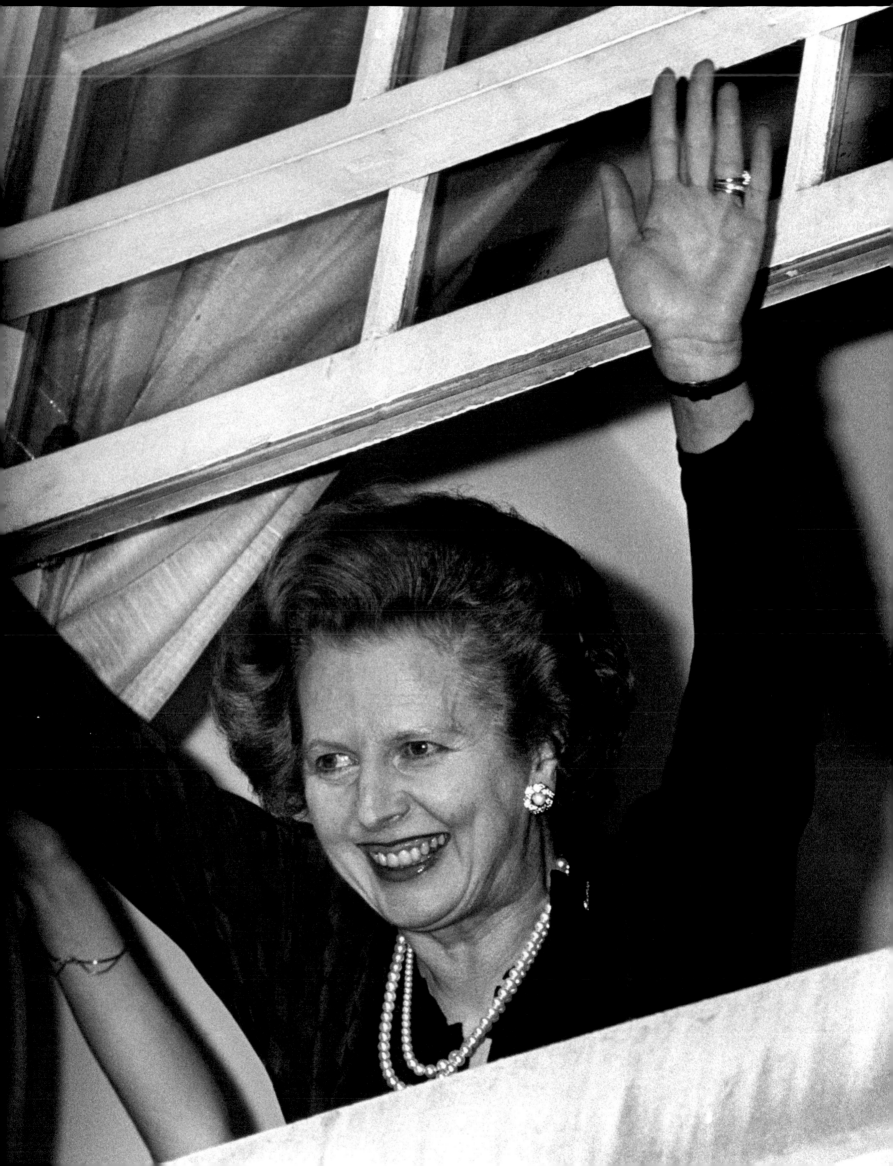

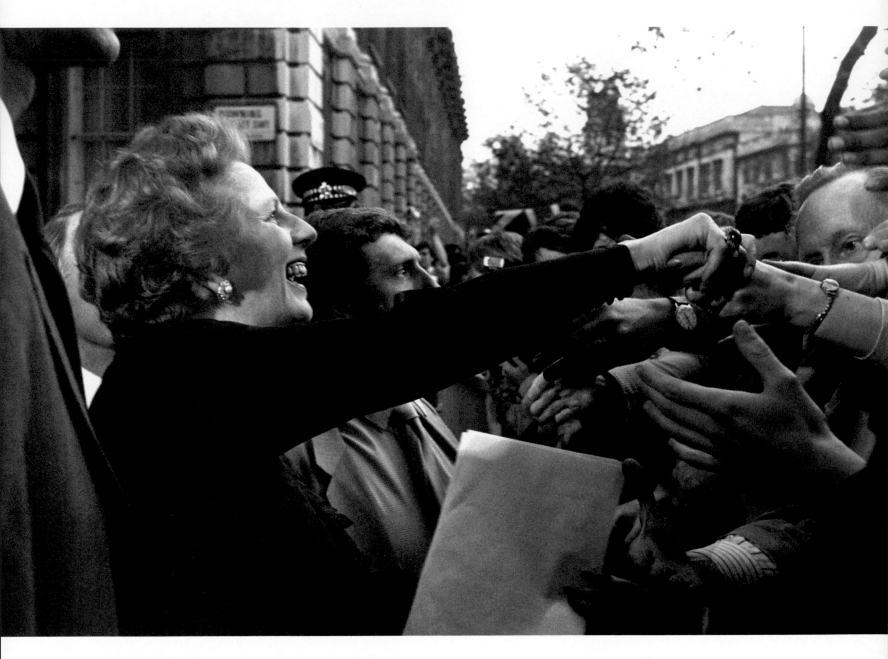

*On her return to Downing Street, she insists on walking
to the corner of Whitehall to shake hands with supporters.*

10 June 1983

*She is applauded by Cecil Parkinson (right) during election
victory celebrations at Tory Party Central Office.*

10 June 1983

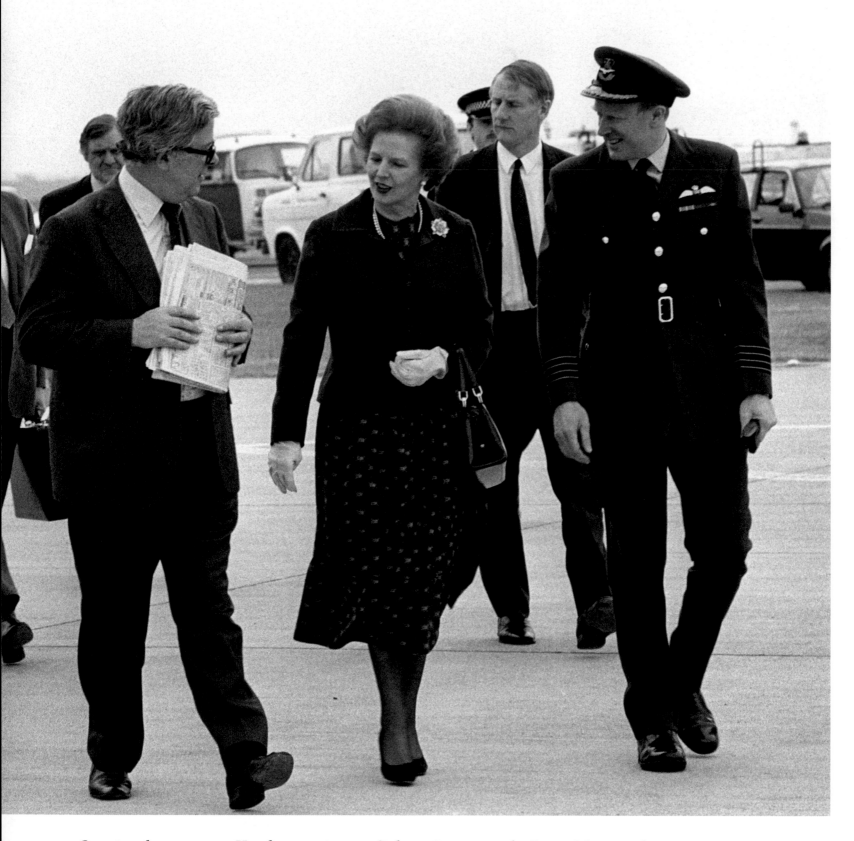

Crossing the tarmac at Heathrow, prior to a flight to Stuttgart, the Prime Minister chats to the new Foreign Secretary, Sir Geoffrey Howe. They are to attend the Stuttgart Summit, where Margaret is to demand tougher controls on agriculture finances, the major cause of Britain's Common Market budget problems.

17 June 1983

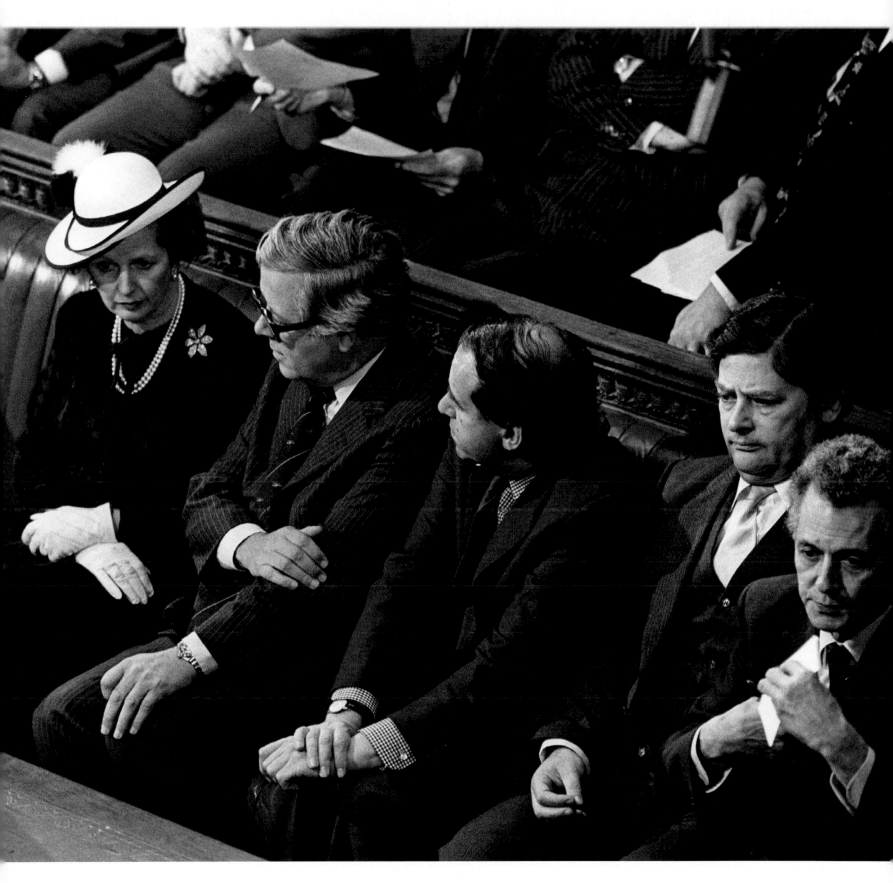

She sits with senior Cabinet colleagues on the front benches at the House of Commons, waiting to be summoned to the House of Lords to hear the Queen's Speech at the State Opening of Parliament. (From left: Margaret Thatcher, Foreign Secretary Sir Geoffrey Howe, Home Secretary Leon Brittan, Chancellor Nigel Lawson and Education Secretary Sir Keith Joseph.)

22 June 1983

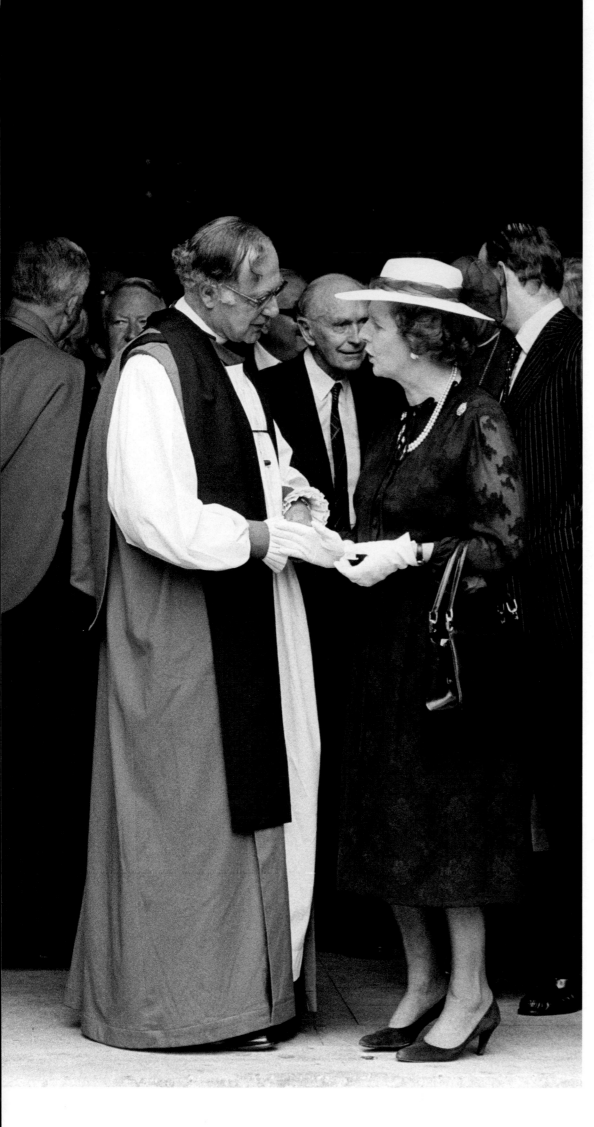

Archbishop of Canterbury Dr. Robert Runcie talks to the Prime Minister after a service at Westminster held to mark the opening of Parliament.

23 June 1983

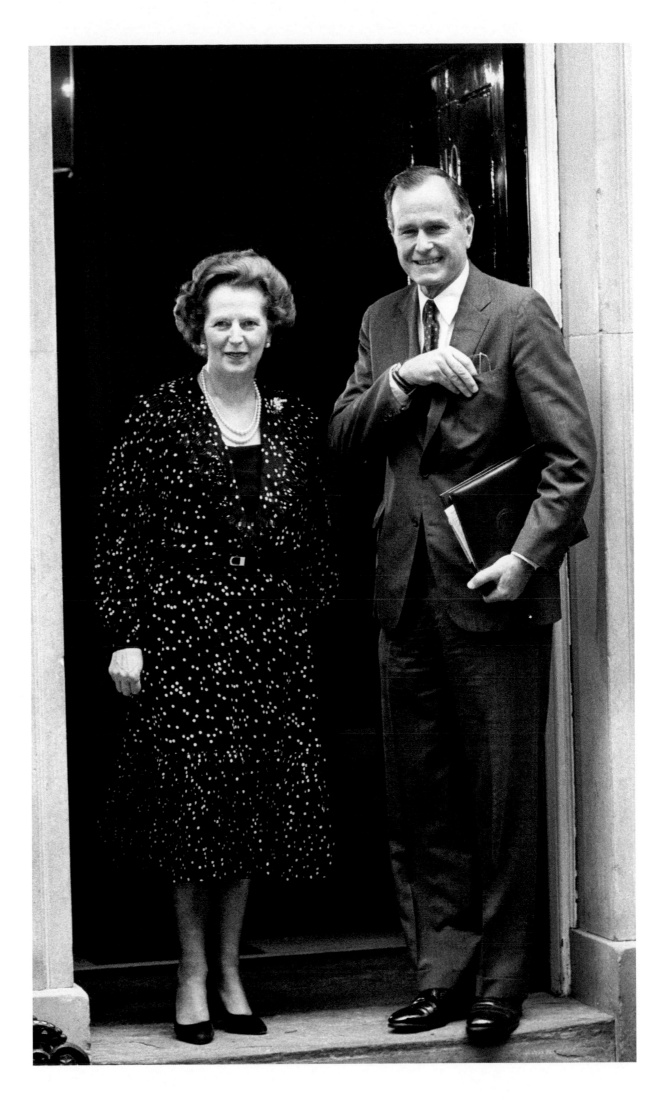

On the steps of No 10, she poses for the cameras with American Vice-President George Bush.

24 June 1983

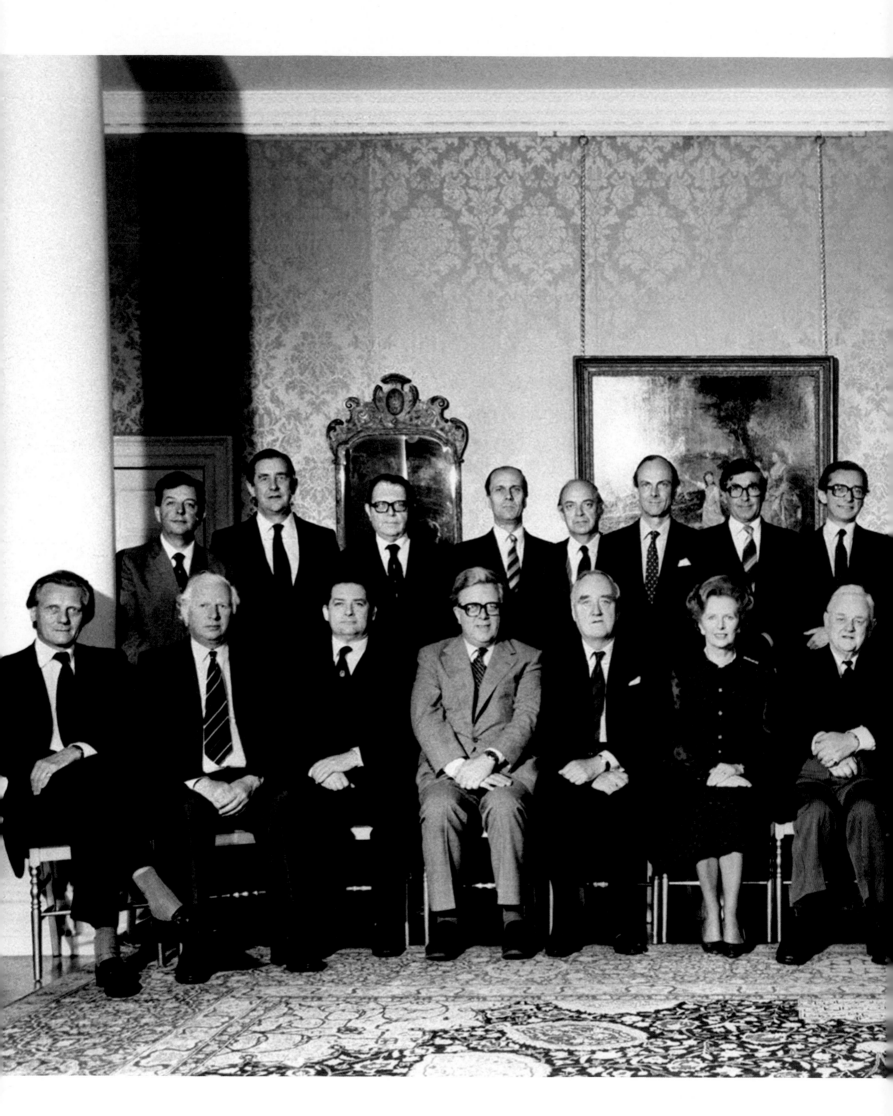

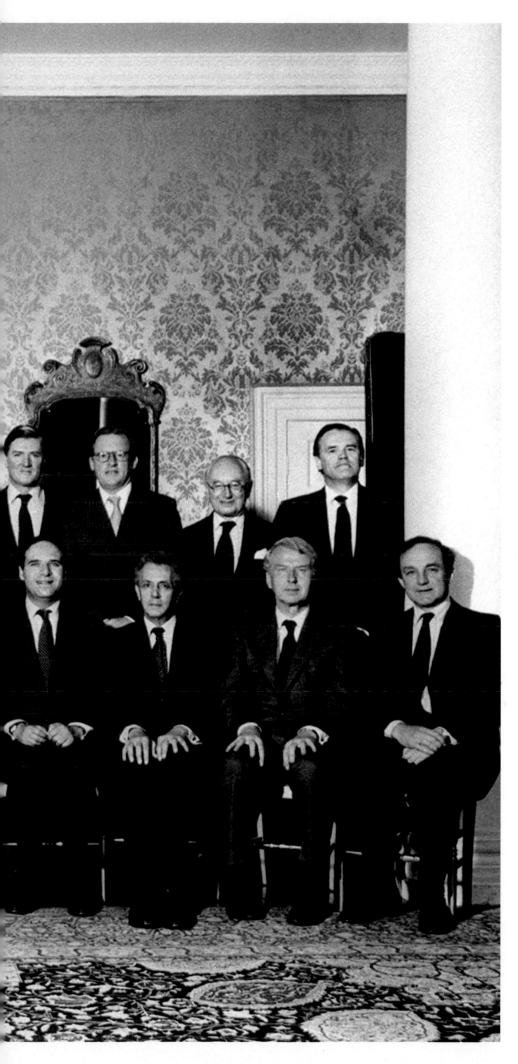

*The new Cabinet. Standing from left,
Chief Whip, John Wakeham; Agriculture
Minister, Michael Jopling; Chancellor of
the Duchy of Lancaster, Lord Cockfield;
Employment Secretary, Norman Tebbit;
Lord Privy Seal, John Biffen; Welsh
Secretary, Nicholas Edwards; Environment
Secretary, Patrick Jenkin; Social Services
Secretary, Norman Fowler; Trade and
Industry Secretary, Cecil Parkinson;
Transport Secretary, Tom King; Chief
Secretary to the Treasury, Peter Rees;
and Secretary to the Cabinet, Sir Robert
Armstrong. Seated from left, Defence
Secretary, Michael Heseltine; Northern
Ireland Secretary, James Prior; Chancellor
of the Exchequer, Nigel Lawson; Foreign
Secretary, Sir Geoffrey Howe; Lord
President, Viscount Whitelaw; Premier,
Margaret Thatcher; Lord Chancellor, Lord
Hailsham; Home Secretary, Leon Brittan;
Education Secretary, Sir Keith Joseph;
Energy Secretary, Peter Walker; and
Scottish Secretary, George Younger.*

7 July 1983

CHAPTER 6

The
Middle
Years

After the euphoria of victory, it's back to the business of running the country. She waits for the arrival of King Taufa'ahau Tupou IV of Tonga at the Foreign and Commonwealth Office in London.

26 October 1983

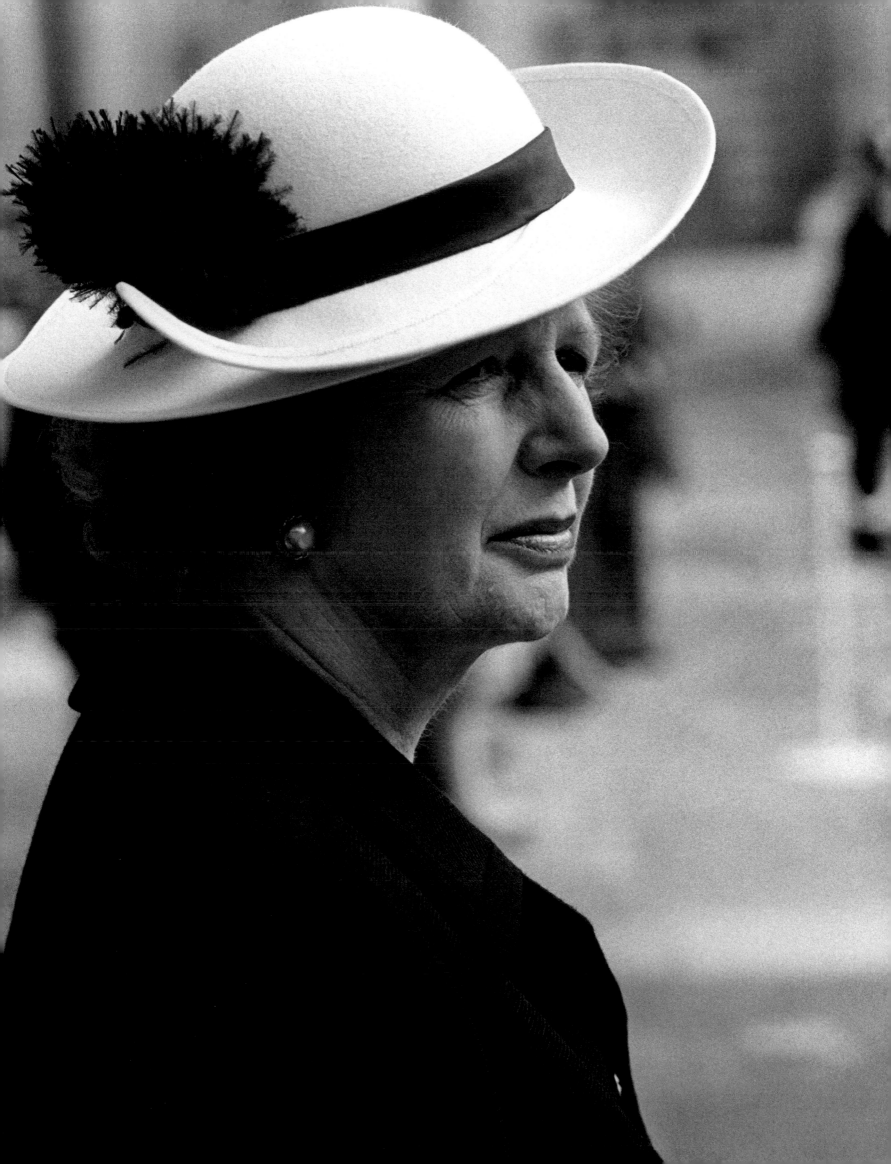

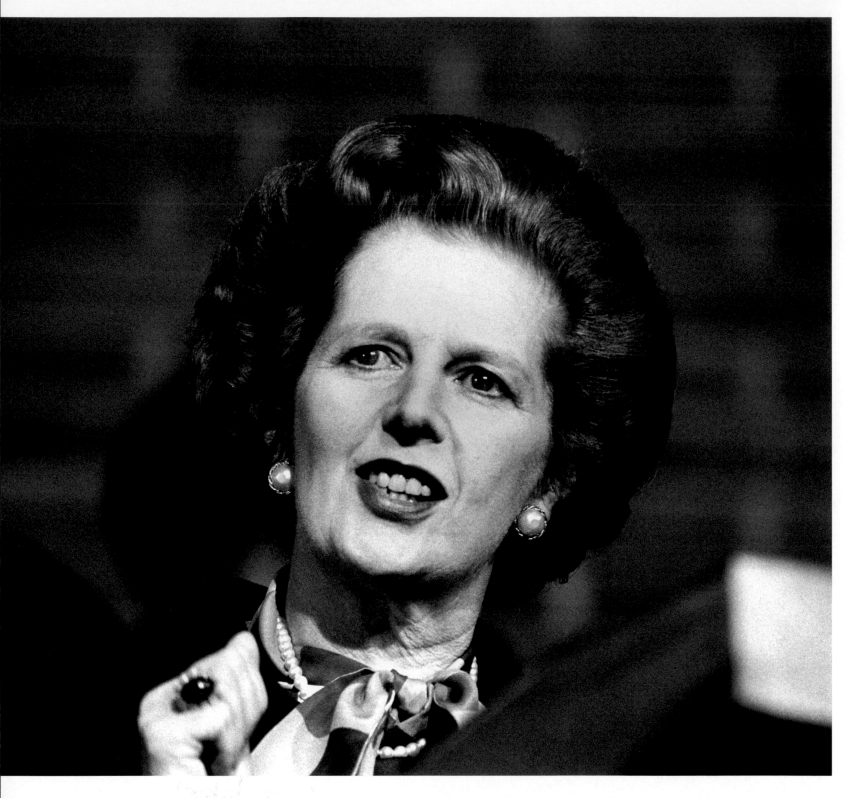

She gives a speech at a Conservative Central Council meeting in London.

6 December 1983

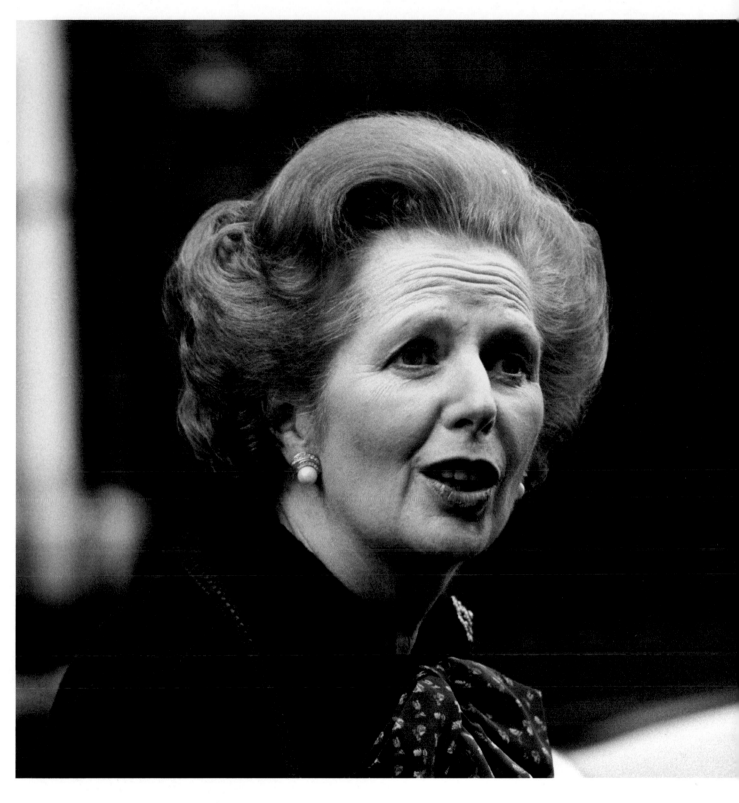

*She leaves London to attend the funeral in Moscow
of the Soviet President Yuri Andropov.*

13 February 1984

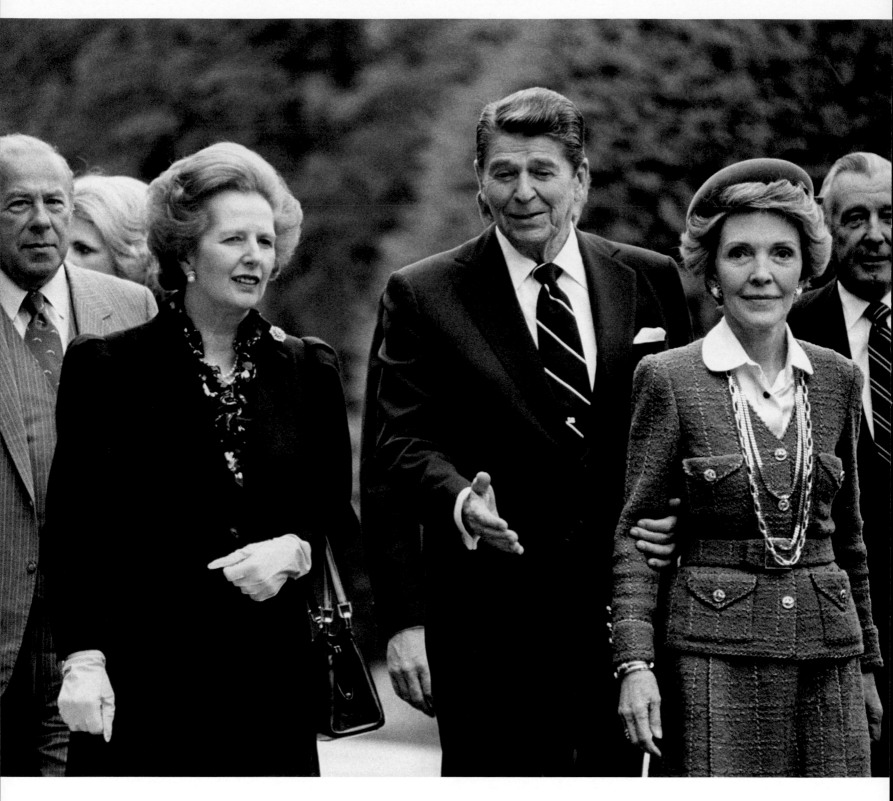

She chats with her long-time friend and ally, US President Ronald Reagan,
and his wife Nancy on their visit to Britain.

4 June 1984

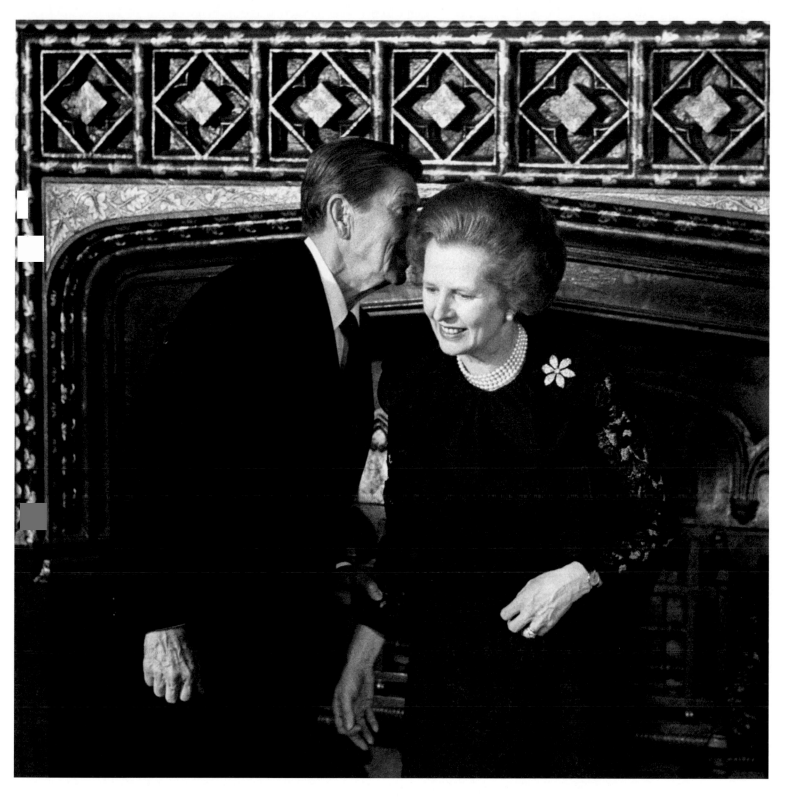

A quiet word in the Prime Minister's ear.

7 June 1984

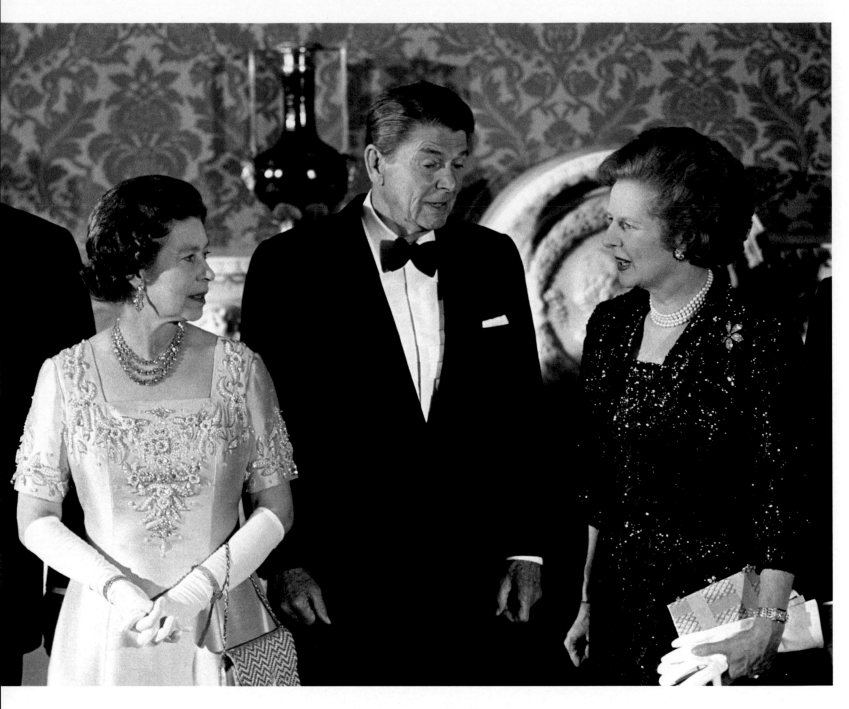

Margaret joins Ronald Reagan and the Queen at a banquet at Buckingham Palace at the end of the London Economic Summit.

9 June 1984

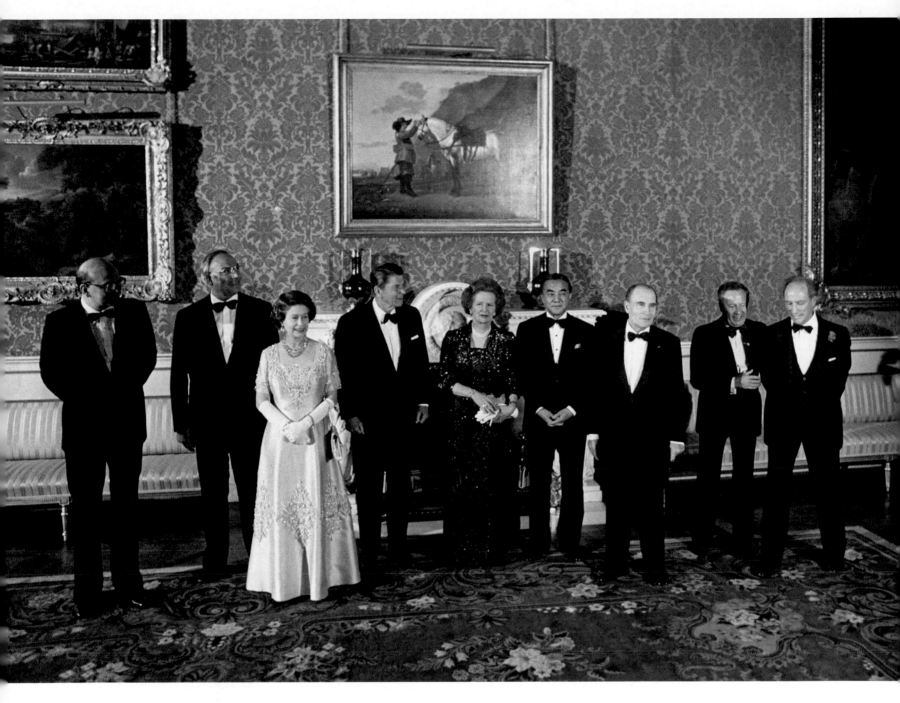

Other guests join the Queen. From left to right: President of the Council of Ministers Bettino Craxi of Italy;
Chancellor Dr. Helmut Kohl of West Germany; the Queen; President Reagan; Margaret Thatcher;
Prime Minister Yasuhiro Nakasone of Japan; President François Mitterrand of France; Gaston Thorn, President
of the Commission of the European Communities; and Prime Minister Pierre Trudeau of Canada.

9 June 1984

She stands beside the second model of herself made for Madame Tussaud's waxworks in London. "It makes me look very nice," she comments. "Better than the last one."

8 August 1984

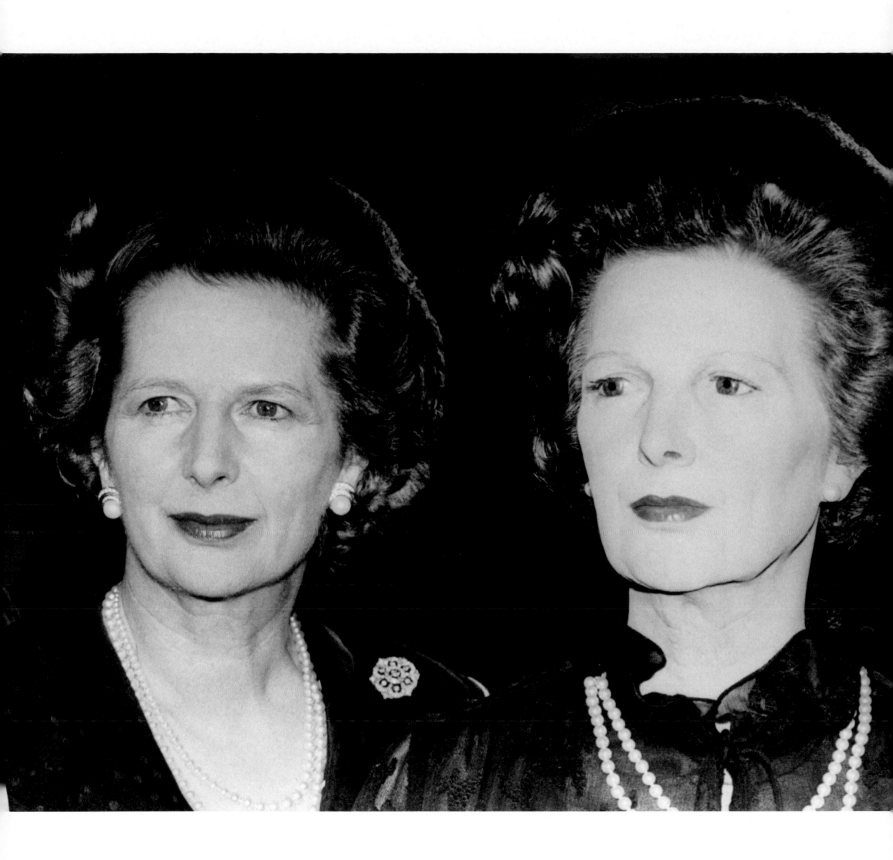

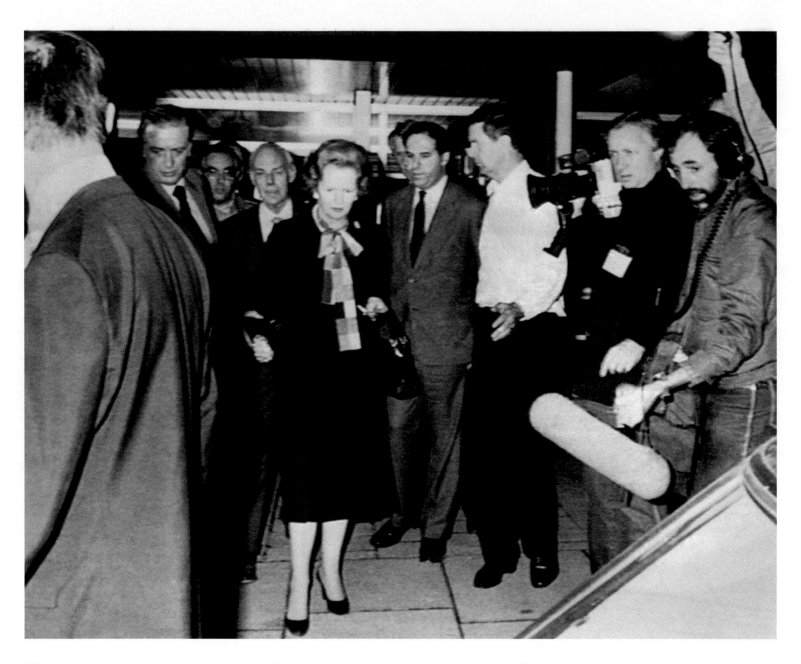

The Prime Minister and her husband leave the Grand Hotel in Brighton, where they were staying for the Tory Party Conference, after a bomb blast ripped through the building. They are unhurt, but five people died in the attack. Norman Tebbit was among the many injured, and his wife Margaret was left paralysed. The IRA claimed responsibility for the attack.

12 October 1984

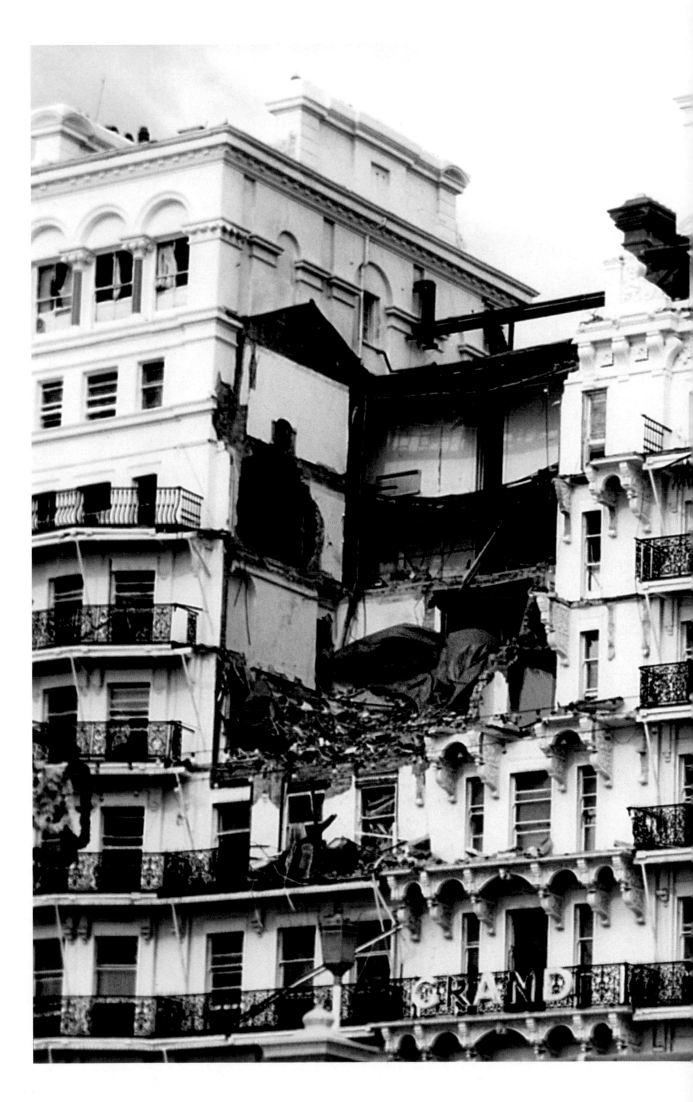

The severely damaged hotel.

12 October 1984

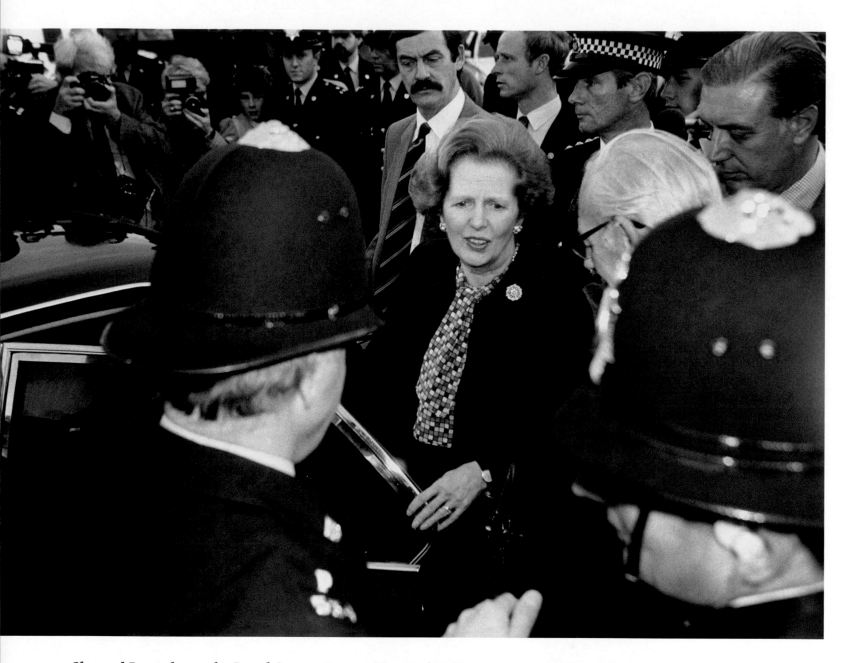

She and Denis leave the Royal Sussex County Hospital in Brighton after visiting the injured. She insists that the conference open on time the next day, in defiance of the bombers.

12 October 1984

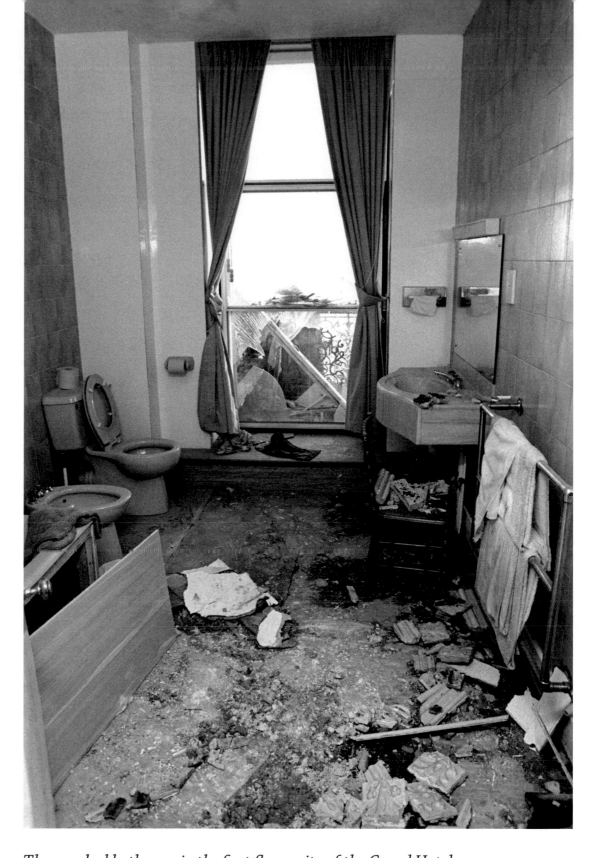

The wrecked bathroom in the first floor suite of the Grand Hotel occupied by the Prime Minister before the bomb went off.

14 October 1984

The Prime Minister talks to journalists of her overwhelming relief at the news that the miners' strike had finally ended after a year of action. Miners' leader Arthur Scargill made the announcement that the campaign against job losses was to continue but the miners would return to work. The final vote by the National Union of Mineworkers' national executive was very close – 98 to 91. The Conservative government went on to close all but 15 of the country's pits, with the rest being either sold or privatised in 1994.

3 March 1985

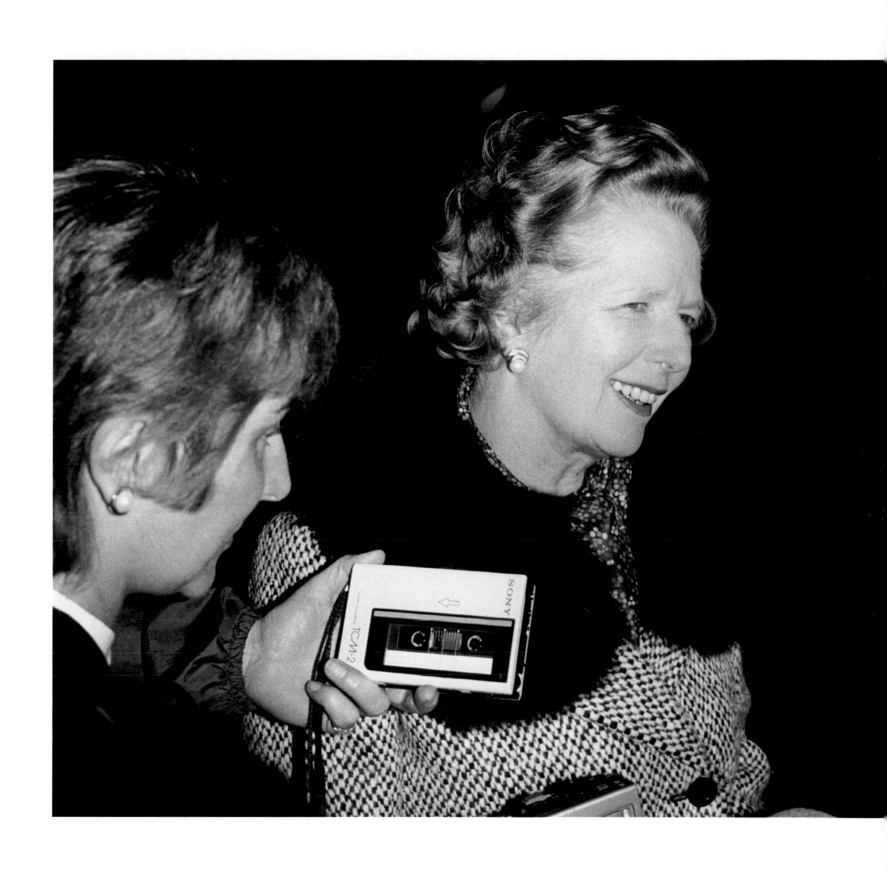

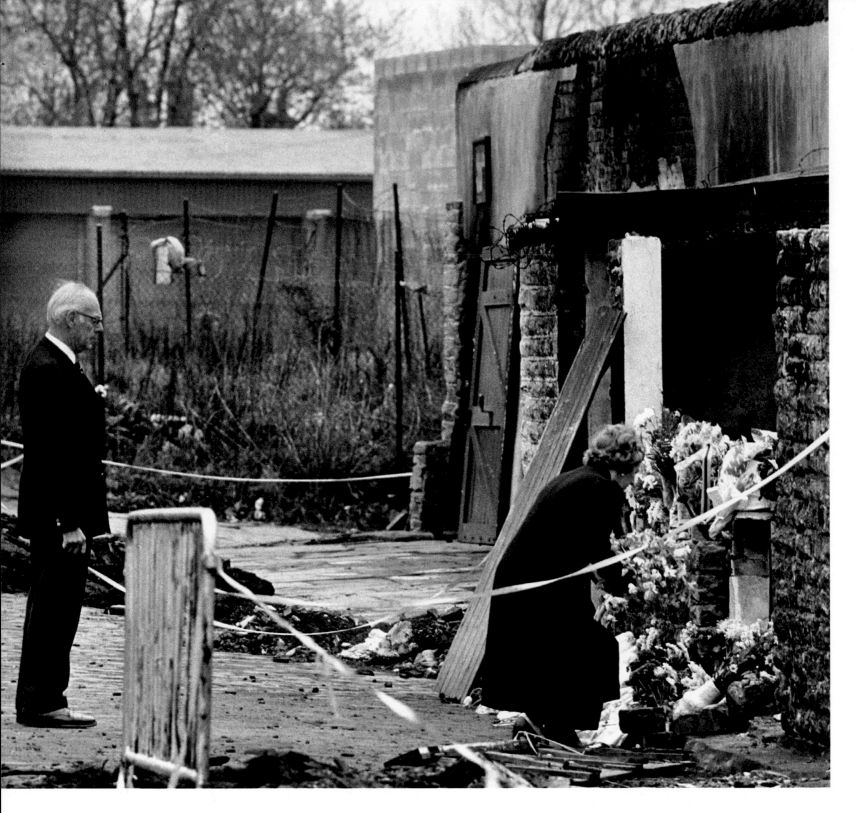

Watched by Denis, she lays a wreath at the Bradford
City football ground where over 50 fans died
when fire broke out in the stadium on 11 May.

19 May 1985

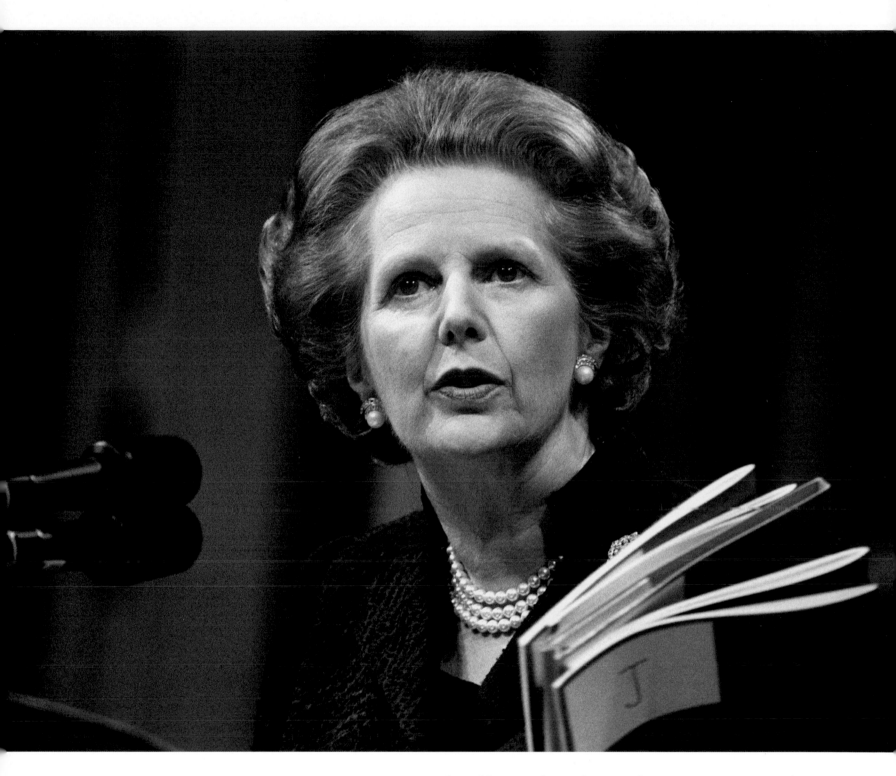

*She addresses the 55th Annual Conservative Women's
Conference at the Barbican Centre in London, where
her keynote speech is on inflation.*

22 May 1985

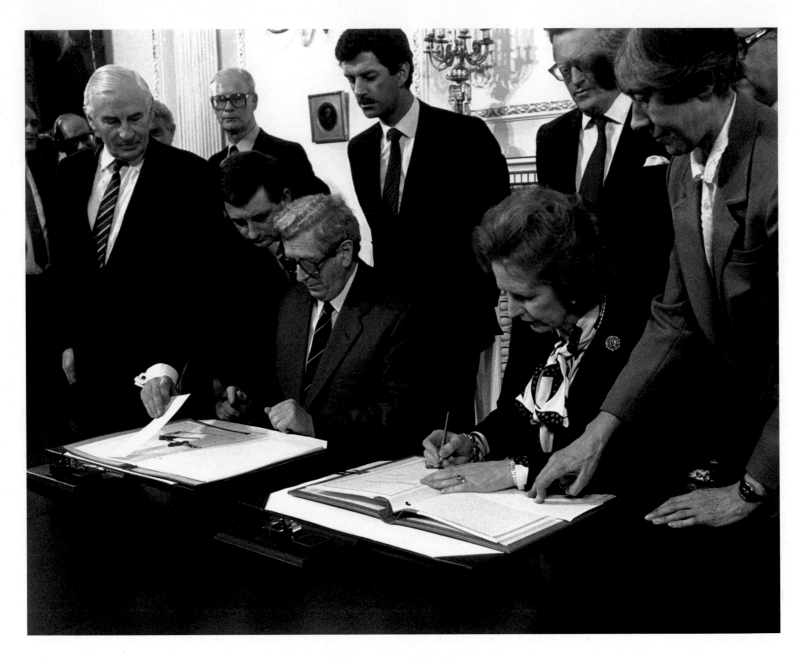

The Prime Minister and Irish Premier,
Garrett FitzGerald, at the Anglo-Irish
Ulster Agreement signing ceremony
held at Hillsborough Castle in Belfast.

15 November 1985

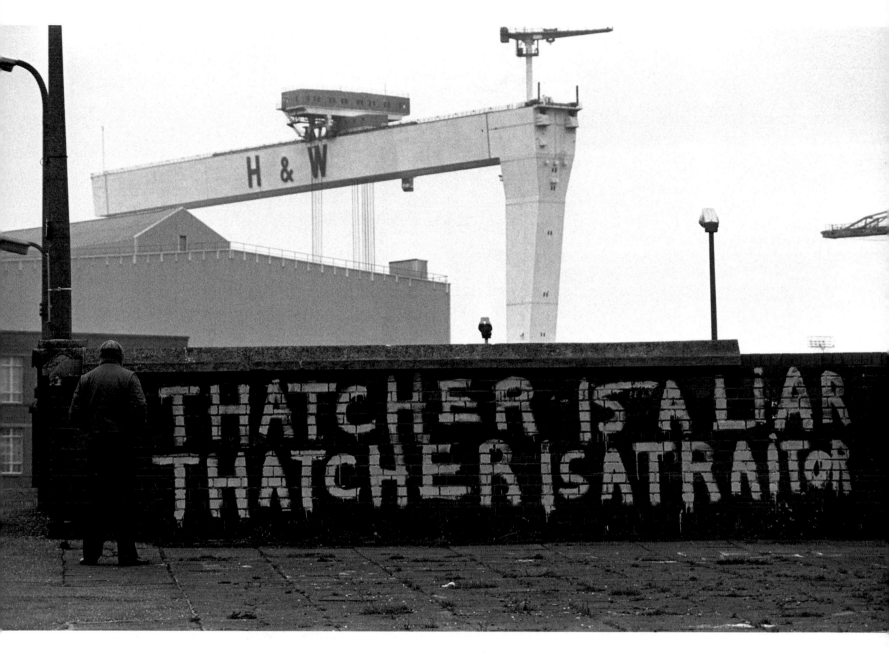

Anti-Thatcher graffiti left by Protestant protestors, near to the Harland and Wolff shipyard in Belfast, following the signing of the agreement.

18 November 1985

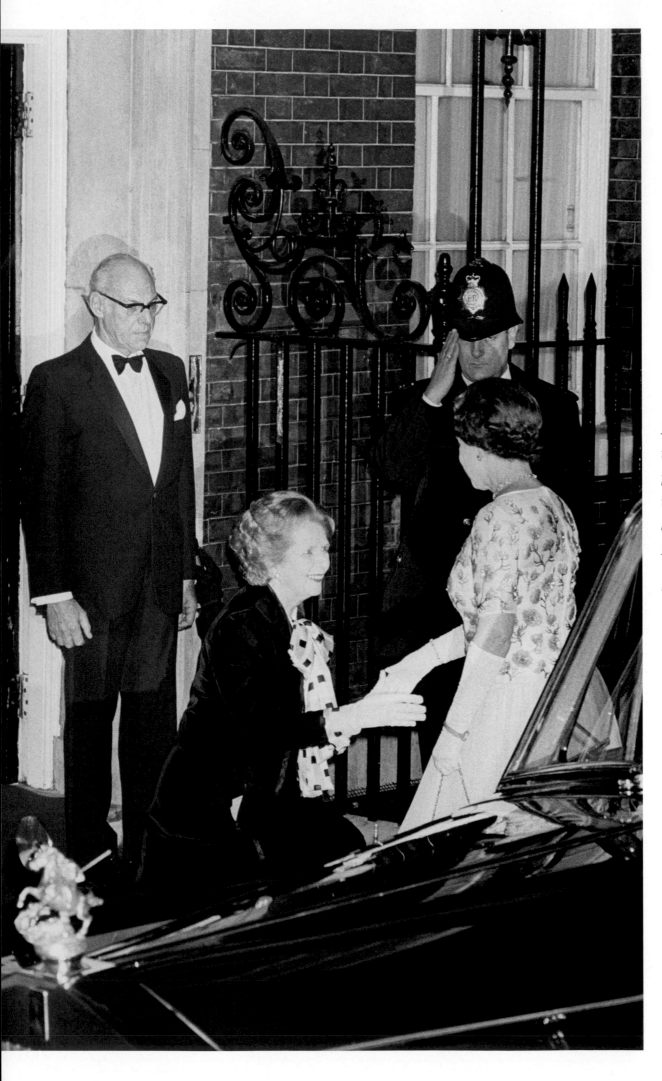

Margaret curtseys to the Queen as she arrives for dinner at No 10 to celebrate the 250th anniversary of the Prime Minister's office.

4 December 1985

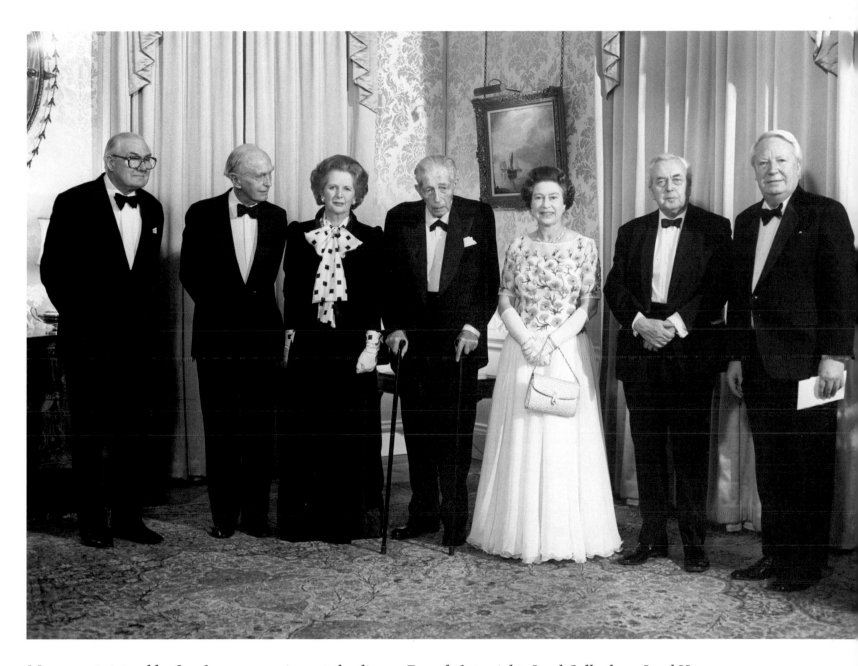

Margaret is joined by five former premiers at the dinner. From left to right: Lord Callaghan, Lord Home, Margaret Thatcher, Lord Stockton (Harold MacMillan), the Queen, Lord Wilson and Edward Heath.

4 December 1985

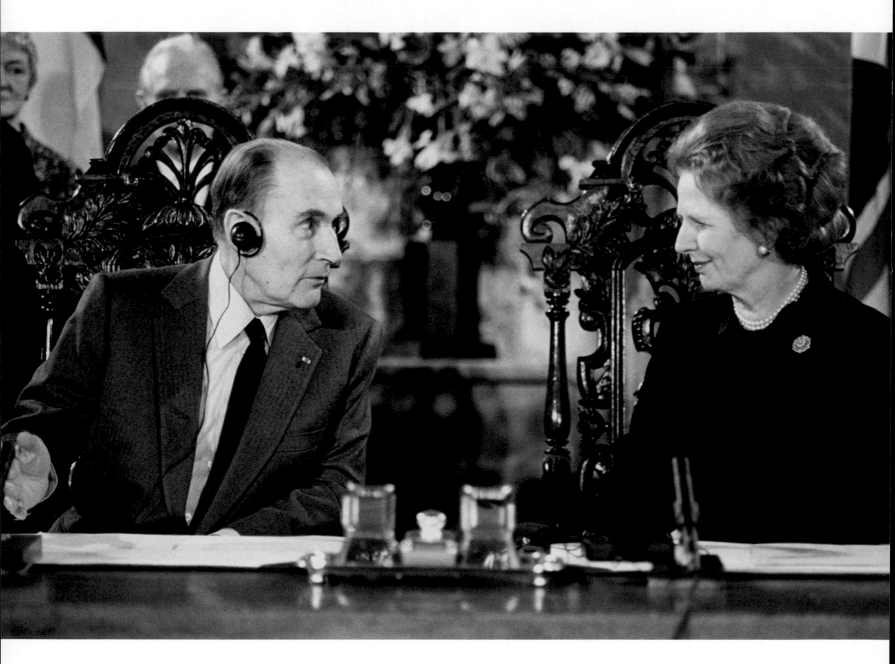

*French President François Mitterrand meets with the Prime Minister
at the Chapter House in Canterbury Cathedral to confirm plans
to build a Channel Tunnel. The Channel Fixed Link Treaty was signed
by the Foreign Secretaries.*

12 February 1986

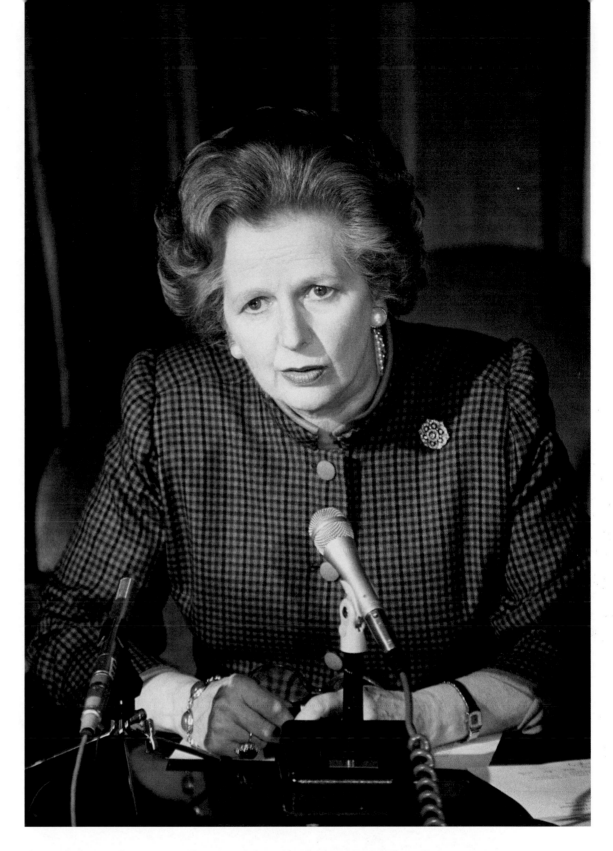

At a press conference at Downing Street, she expresses her distress over the Zeebrugge ferry disaster of the previous day. One hundred and ninety people died when the Herald of Free Enterprise, a roll-on roll-off car ferry, capsized off Zeebrugge in Belgium.

7 March 1987

CHAPTER 7

A Third
Term

The Prime Minister outside Downing Street as she begins her third successive term in office following a Conservative victory in the general election. She is the first Prime Minister since the 2nd Earl of Liverpool, in the early nineteenth century, to lead a party to three successive elections. This record was subsequently equalled by Tony Blair.

12 June 1987

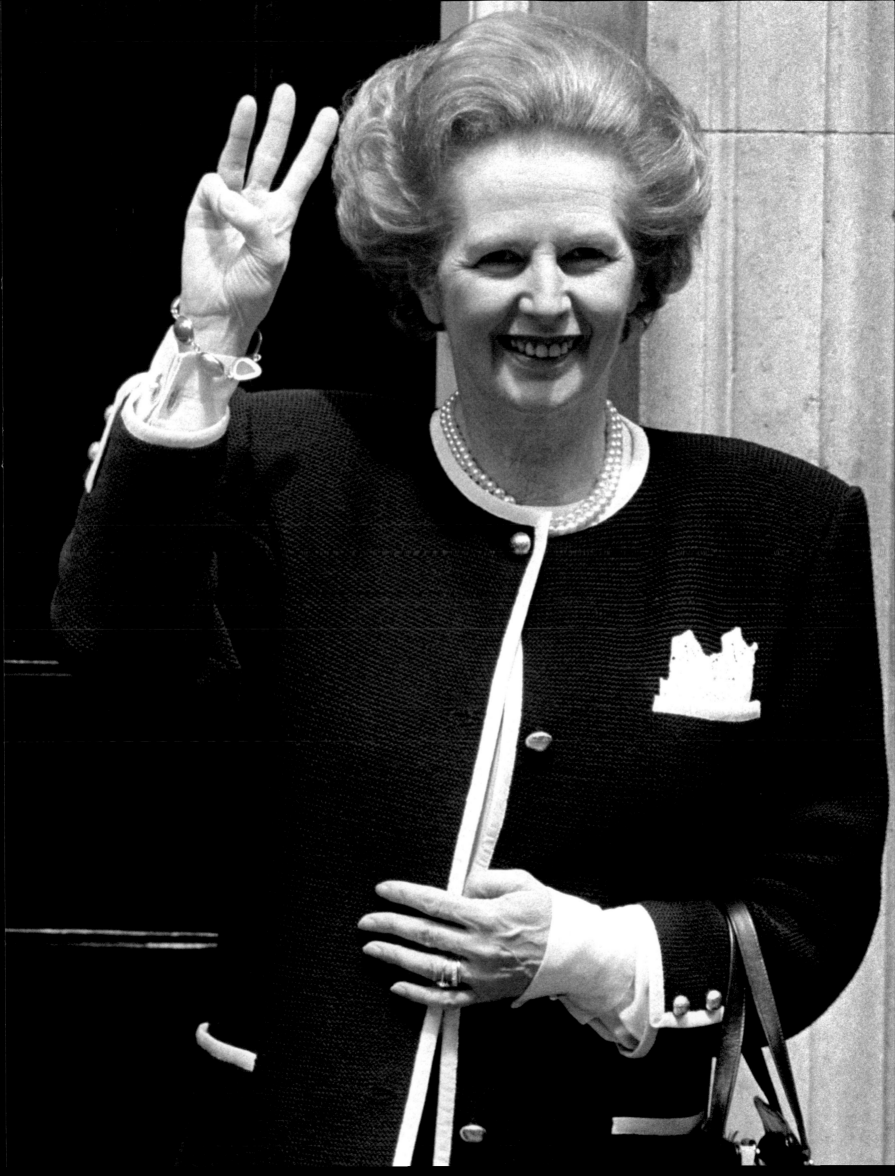

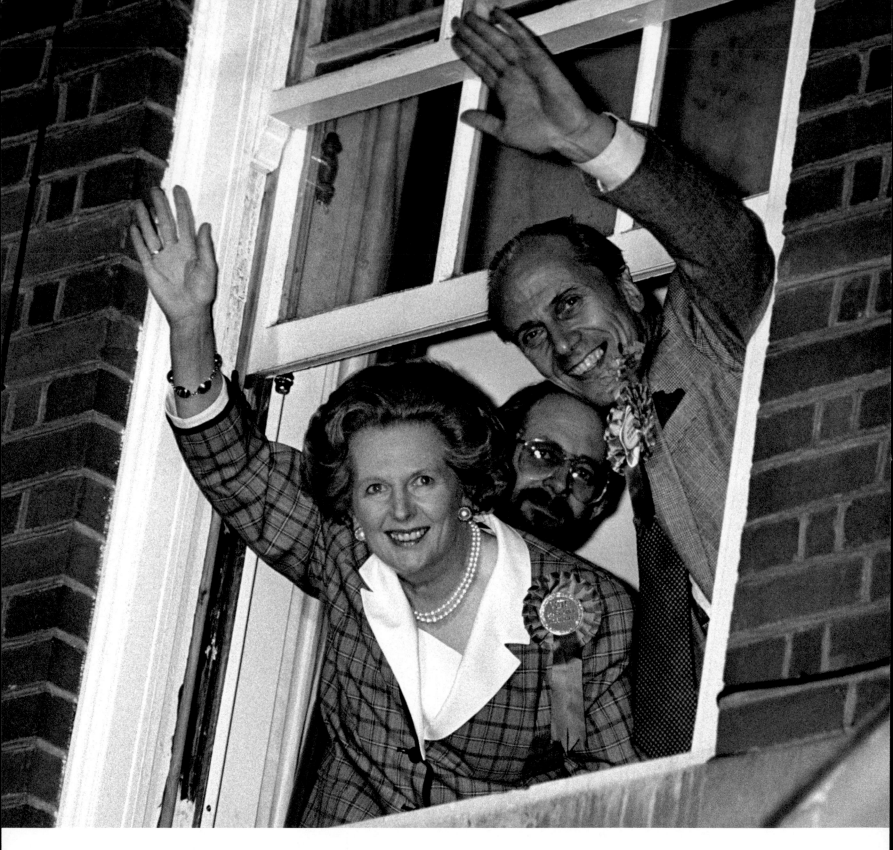

*Margaret Thatcher and Party Chairman Norman Tebbit
wave to the crowd from the Conservative Central Office
in Smith Square, celebrating their victory.*

16 June 1987

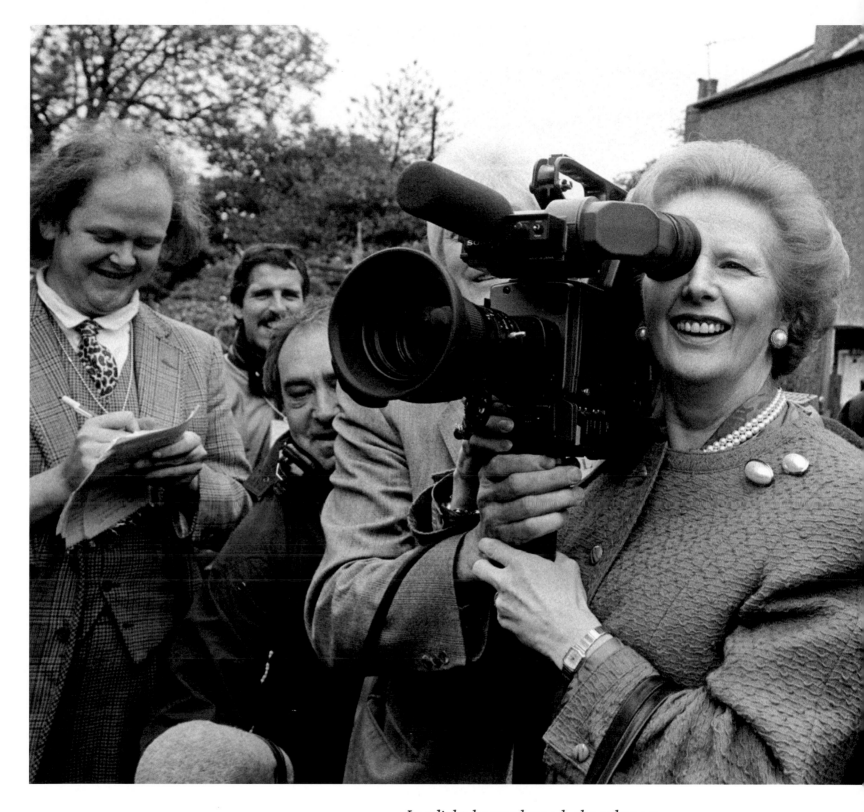

In a light-hearted mood, she takes up position behind the lens, while on a visit to her Finchley constituency.

11 September 1987

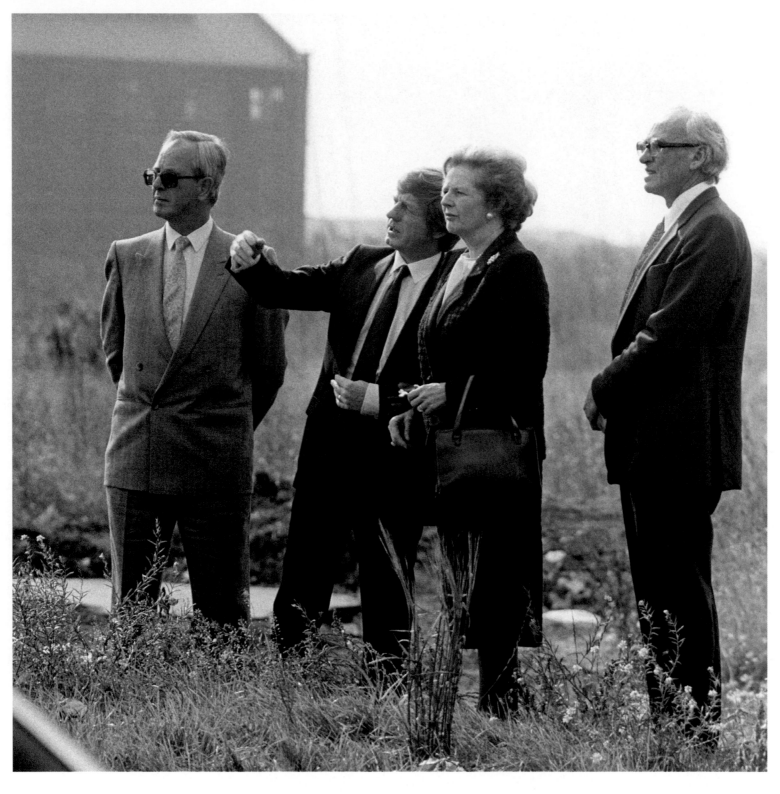

The Prime Minister discusses plans to transform a derelict site on the banks of the River Tees into a housing development, during a visit to Teeside in the North East. She was later to return to the site in 1997 with the then Prime Minister, John Major, to see the completed work.

16 September 1987

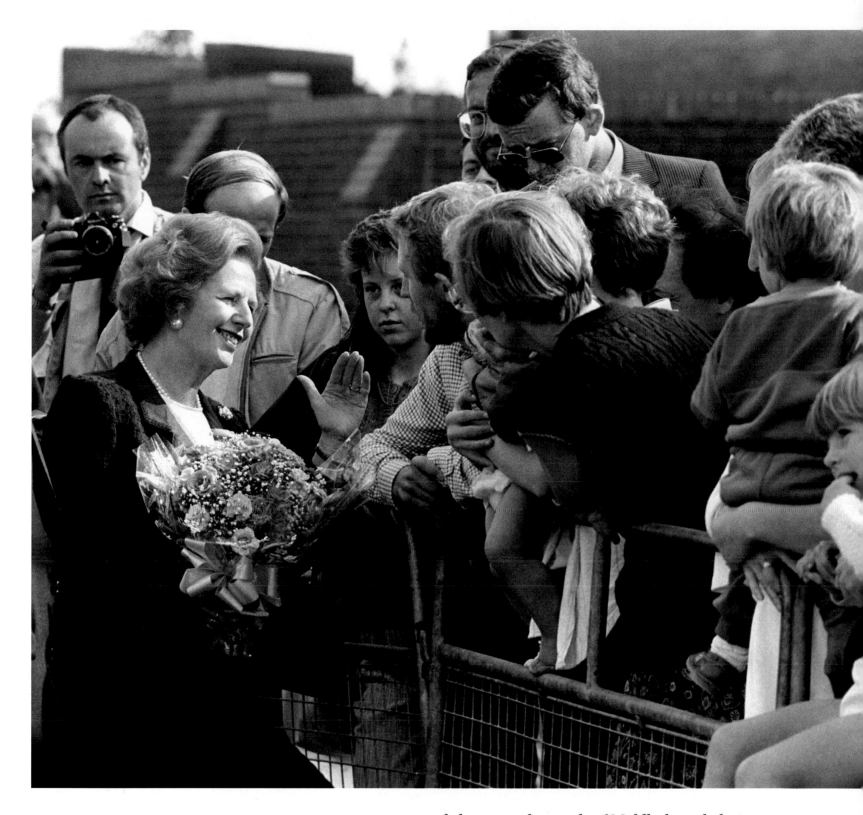

*...and she meets the people of Middlesbrough during a
tour of Britain's industrial black spots in the North East.*

16 September 1987

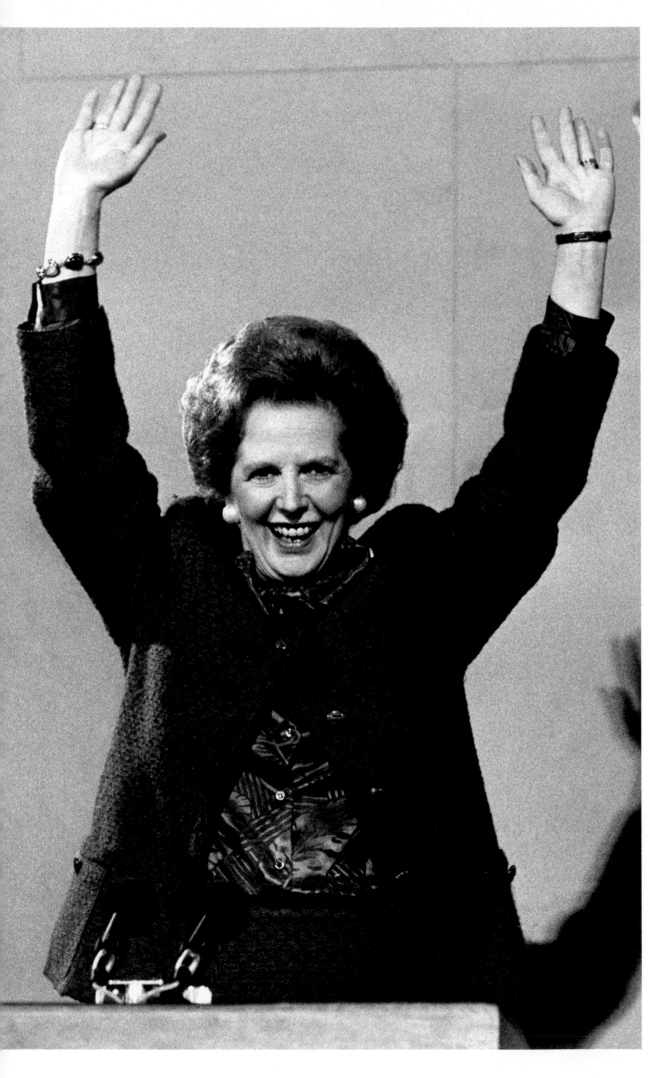

*Margaret acknowledges
an 11-minute standing
ovation after her
closing speech at the
Conservative Party
Conference in Blackpool.*

9 October 1987

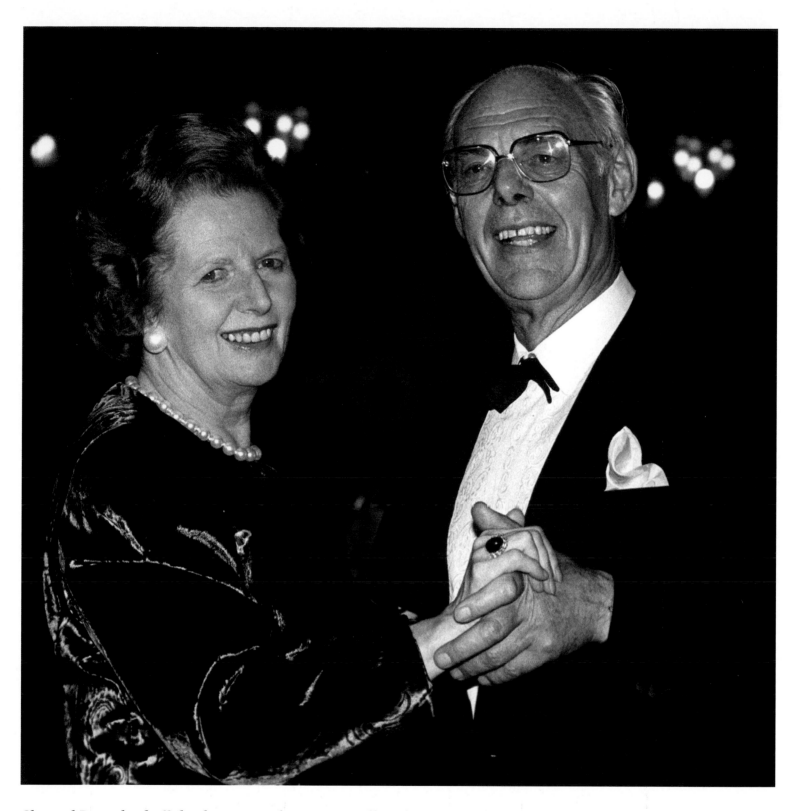

She and Denis lead off the dancing in the Victory Ball at the Empress Hall in Blackpool.

9 October 1987

Margaret and Denis outside No 10 on the day she becomes the longest-serving Prime Minister in the twentieth century. She has been in power for eight years and 244 days, overtaking the record set by Asquith, the Liberal Prime Minister, who served from 1908 to 1916.

3 January 1988

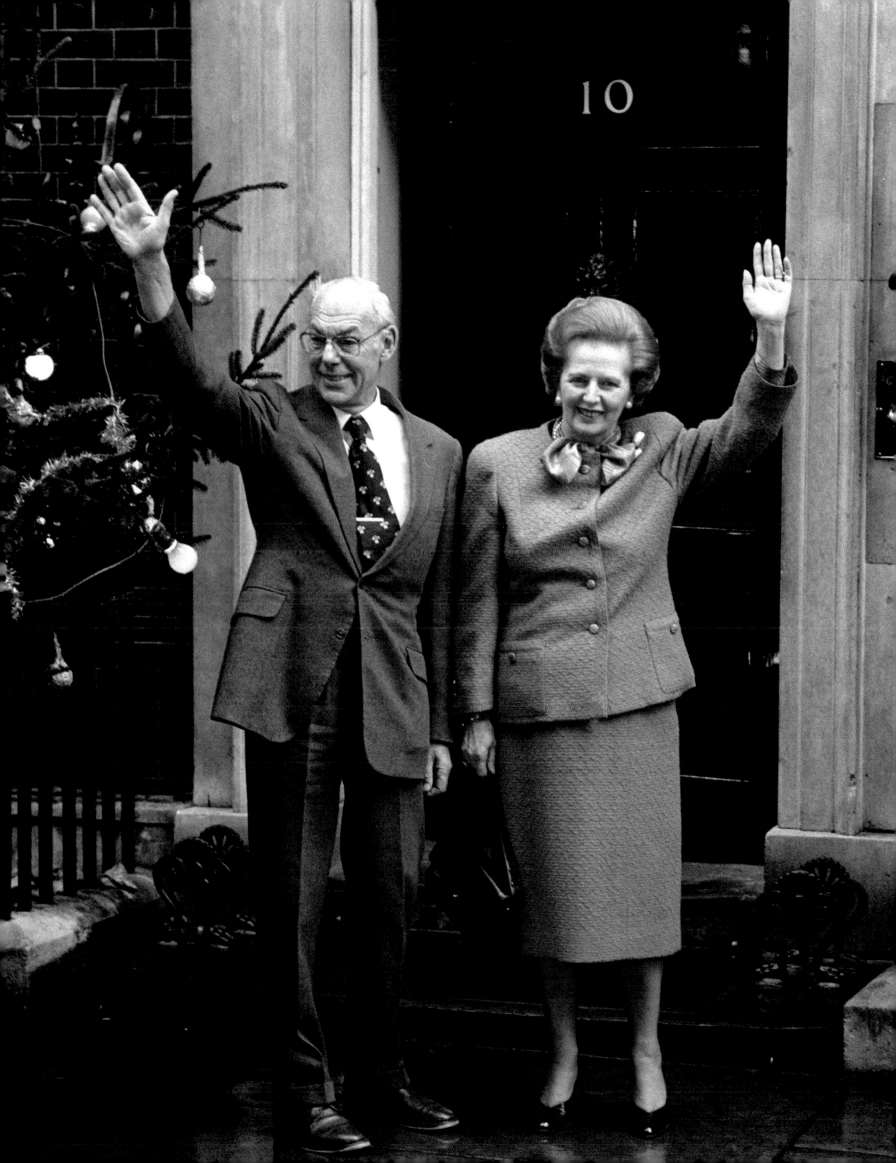

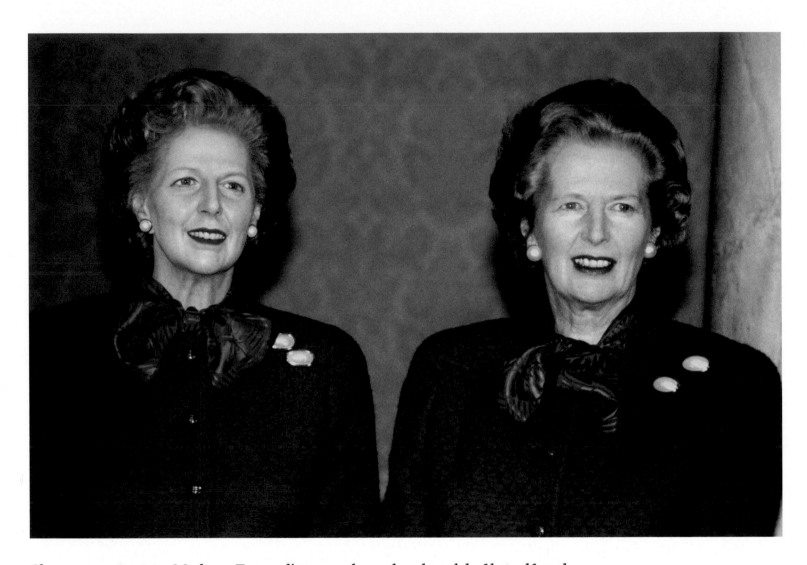

She once again visits Madame Tussaud's to see the updated model of herself at the museum.

16 February 1988

Margaret with Trade and Industry Minister, Kenneth Clarke, wearing protective hygienic clothing as they tour the Campbell's food factory in Salford.

26 February 1988

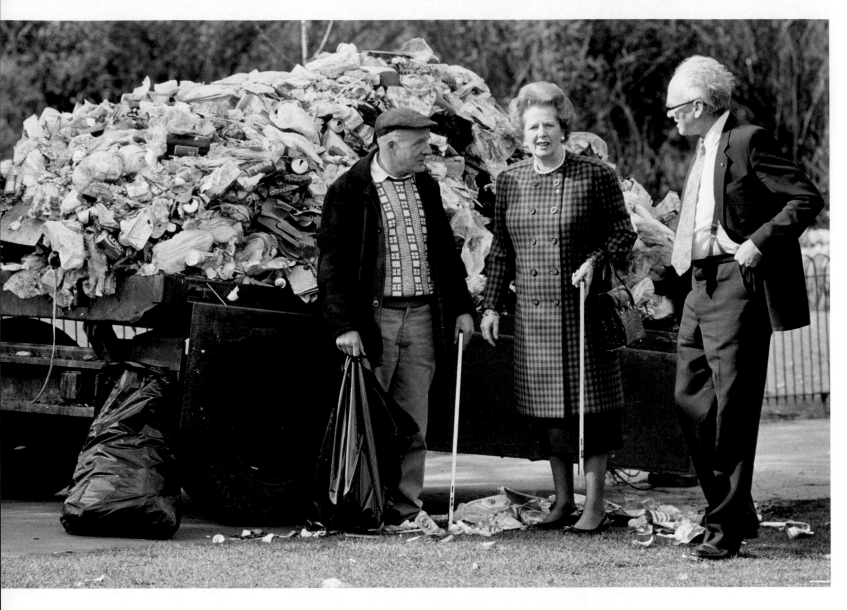

She joins Environment Secretary Nicholas Ridley and gardener Daniel Kelly in front of a pile of rubbish in St James's Park in London at the launch of a new government backed anti-litter campaign, to be run by the Tidy Britain Group.

22 March 1988

FACING PAGE: On a visit from Calcutta, Mother Teresa meets the Prime Minister at No 10, where she has asked for help in setting up a hostel for London's homeless.

13 April 1988

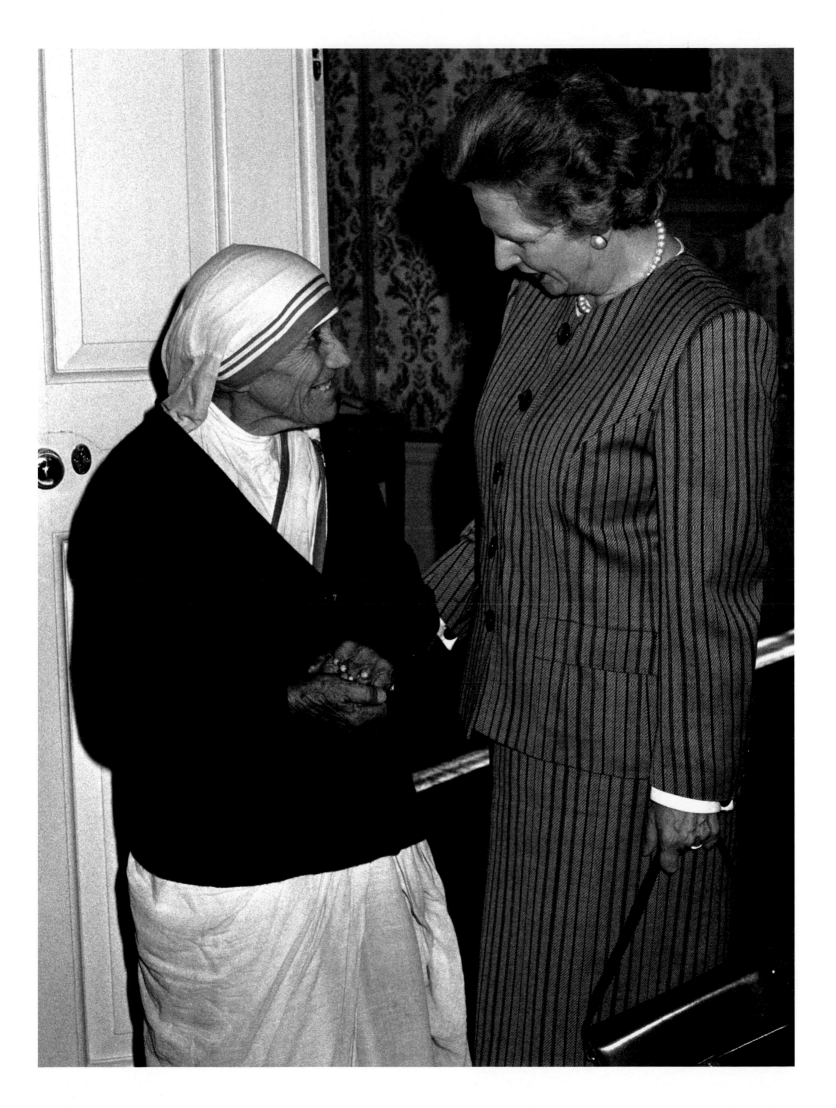

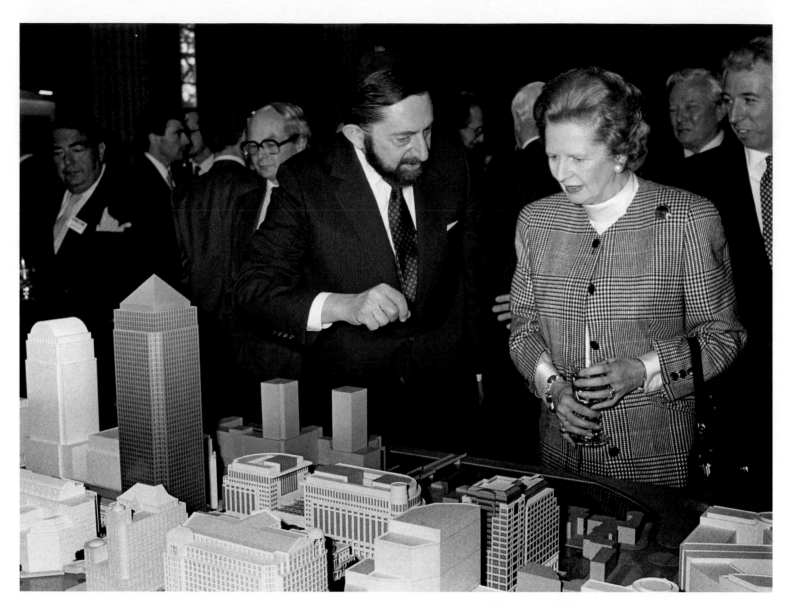

Margaret is shown the model of a proposed development at Canary Wharf, a 71-acre site in London's Docklands, by Paul Reichmann, head of the Wharf's developers, Olympia & York, after the launch of construction at the site.

11 May 1988

FACING PAGE: *She stands in the shell of London's old Battersea Power Station, when she renamed the site The Battersea. At that time there were plans to convert it into a leisure complex which were never carried out, but today there are new plans underway that would make it the most sustainable development ever undertaken in Europe.*

8 June 1988

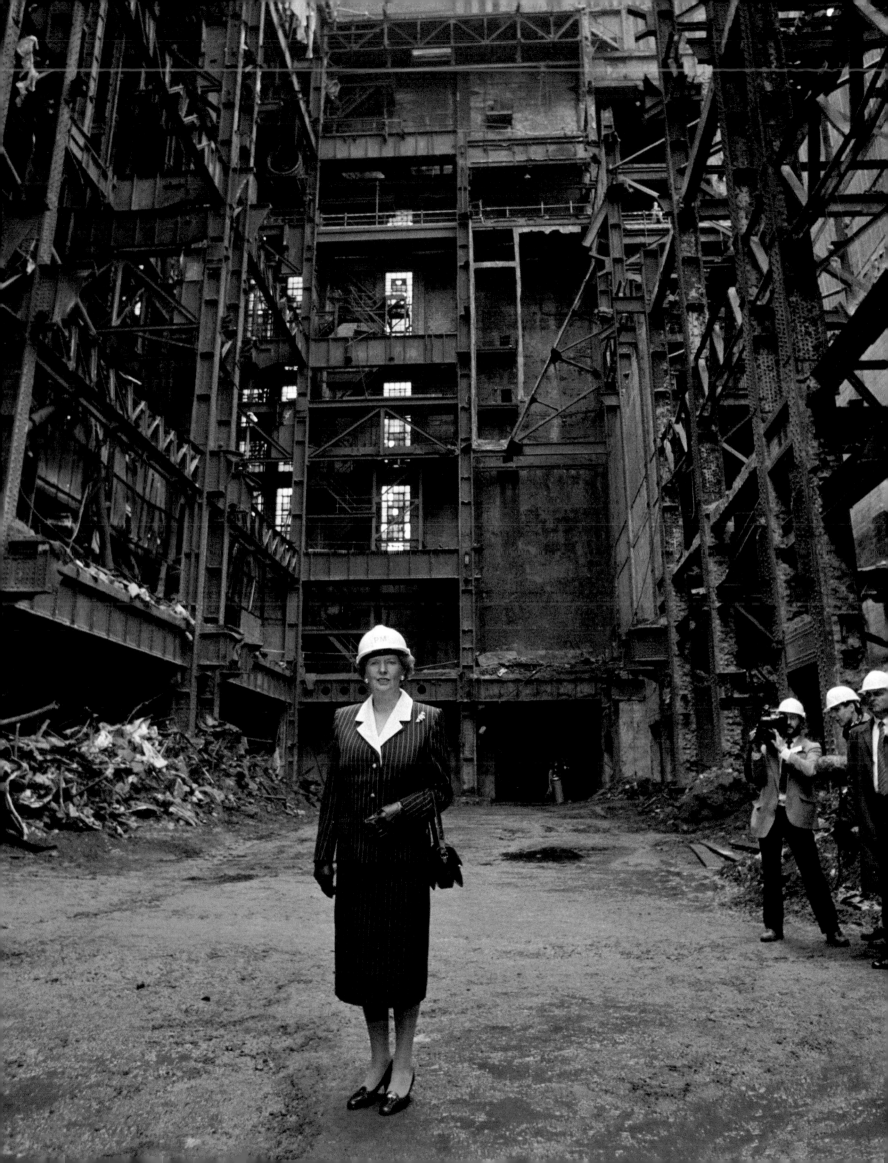

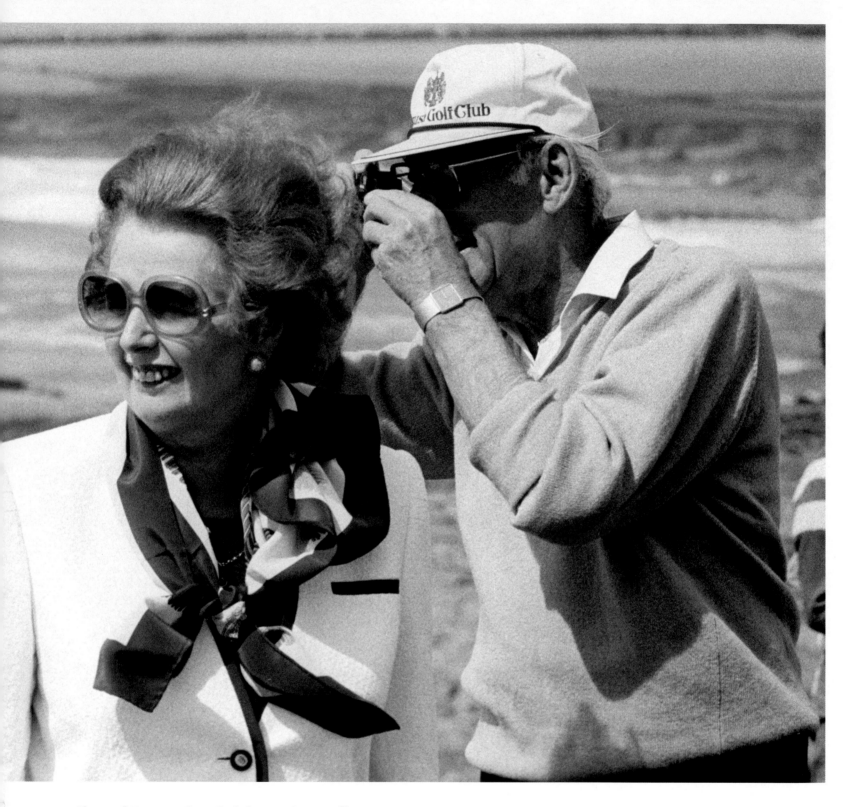

She and Denis take a holiday in Cornwall.

12 August 1988

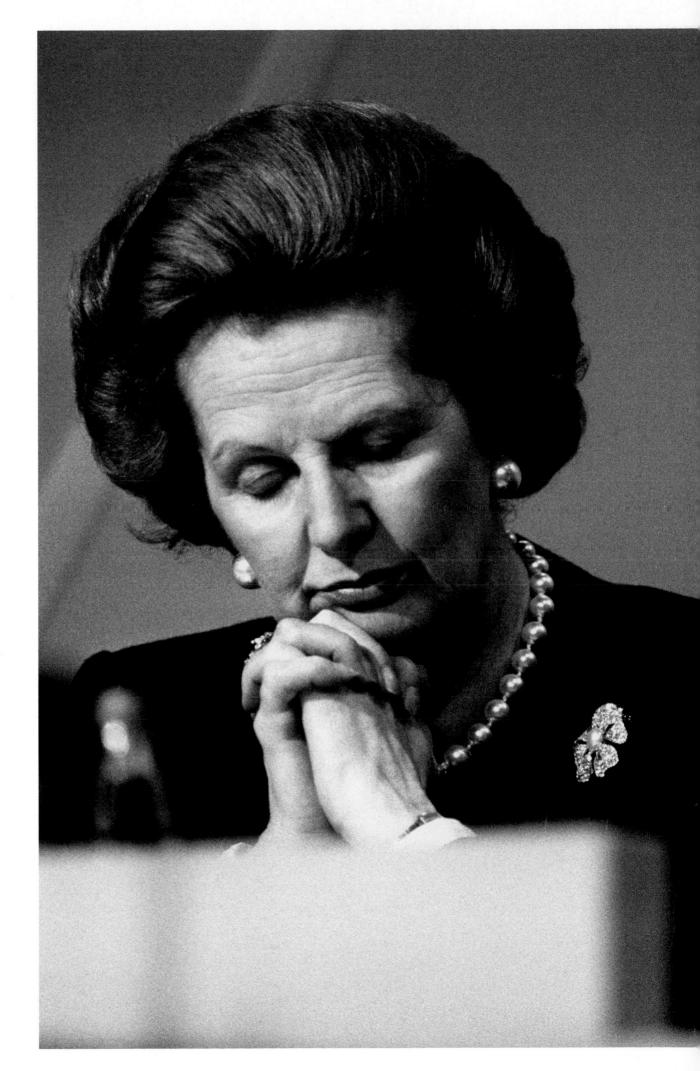

*Tired or just
thoughtful?
Margaret listens
with closed eyes
at the Conservative
Party Conference
in Brighton.*

12 October 1988

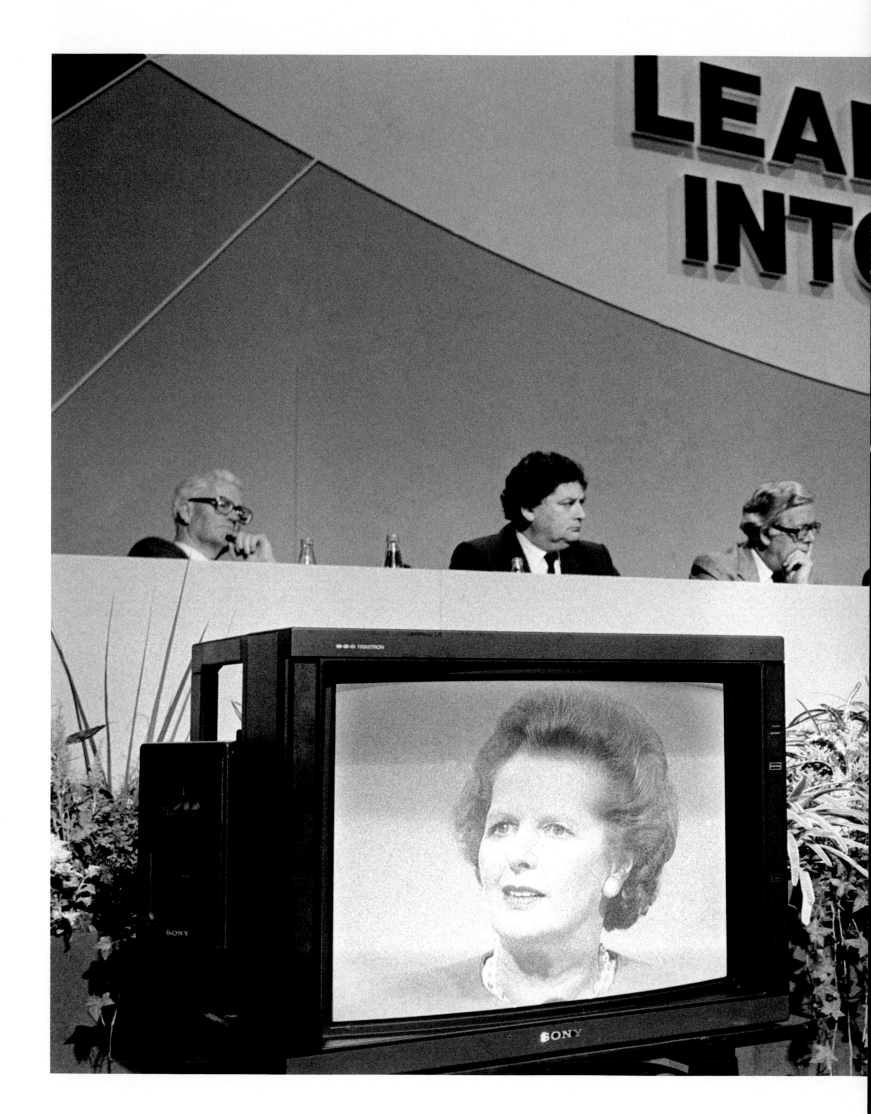

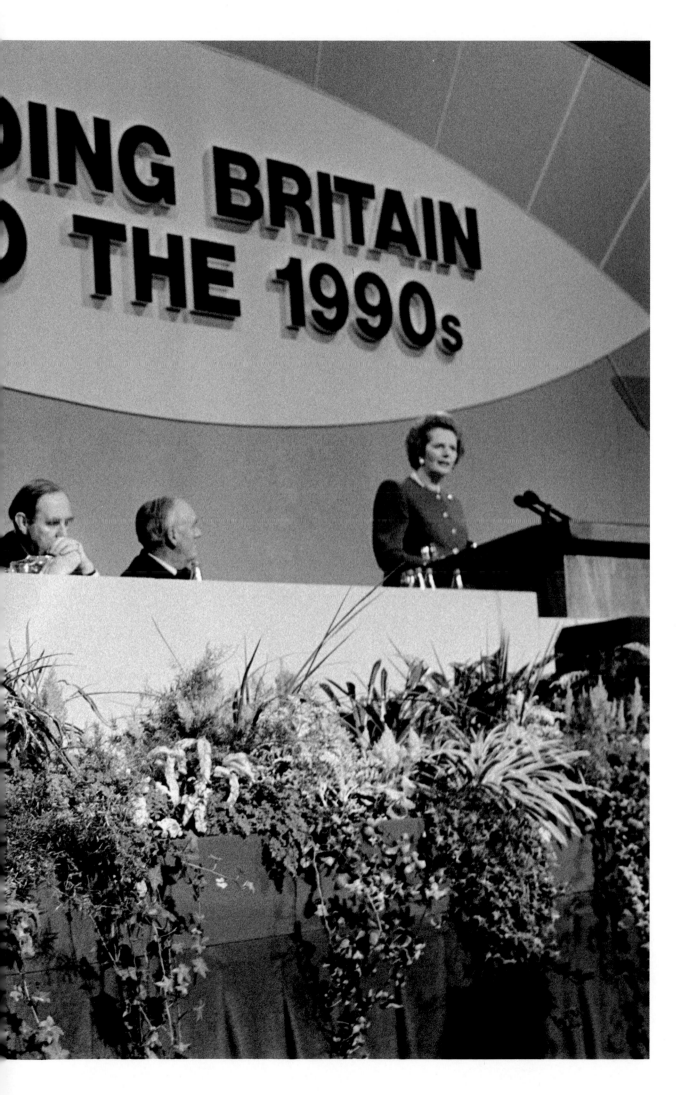

The Prime Minister's closing speech is projected onto a TV monitor at the conference. It is to be just over two years before her days in power come to an end.

14 October 1988

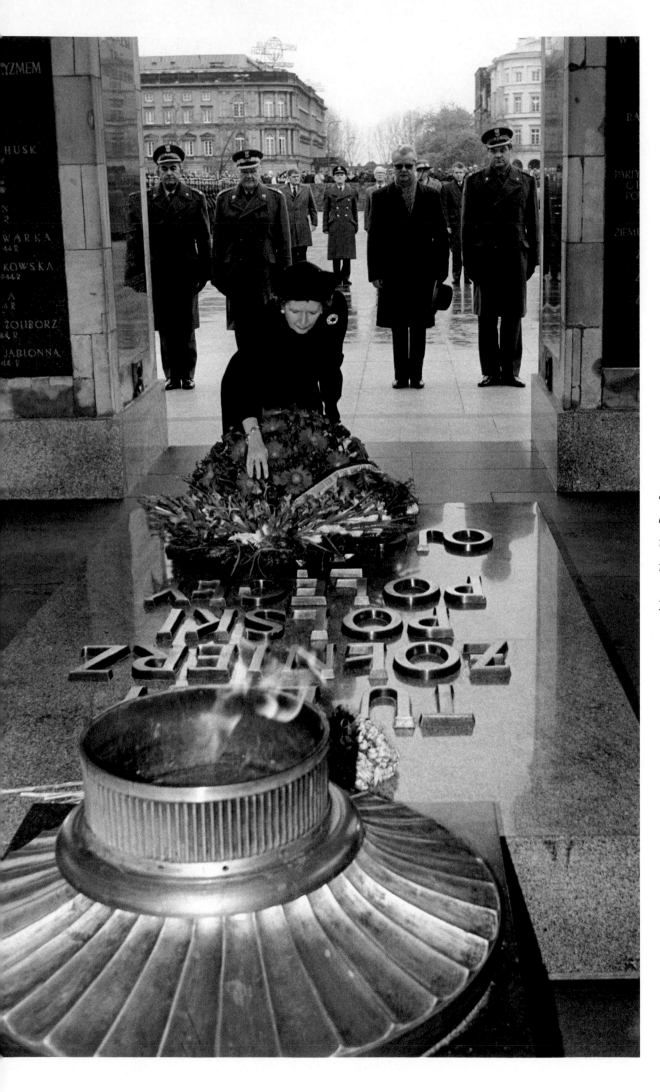

*She lays a wreath
at the tomb of
the Unknown Soldier
in Warsaw, Poland.*

3 November 1988

Speaking at the Lord Mayor's banquet in London's Guildhall, she makes a surprise announcement that Soviet leader Mikhail Gorbachev and his wife Raisa are to visit Britain. East-West relations had eased since Gorbachev's election in 1985.

14 November 1988

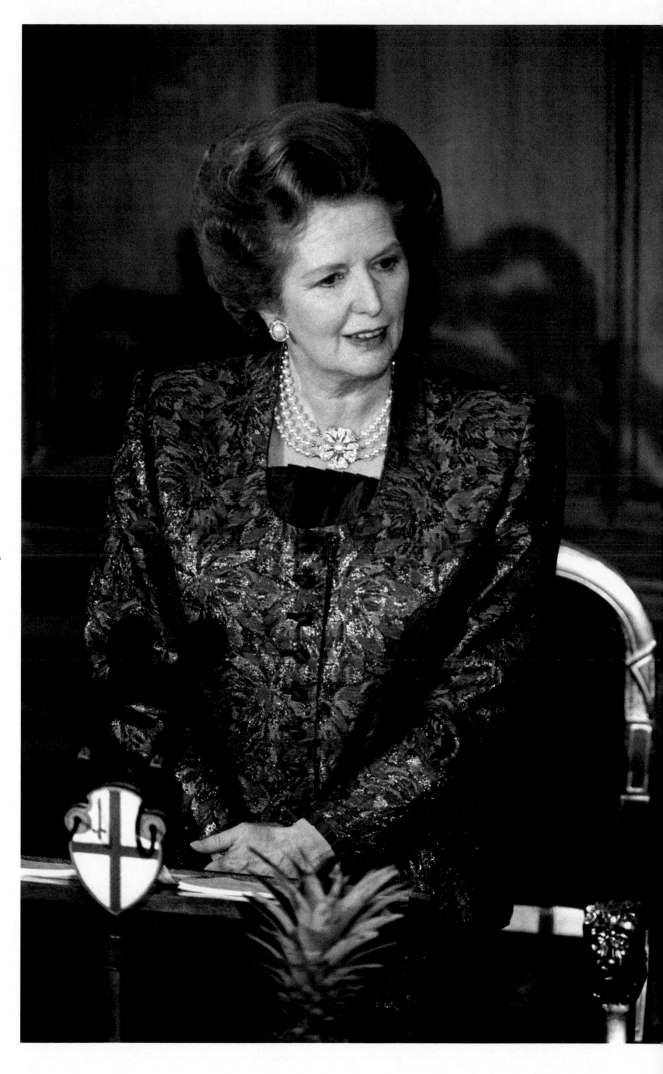

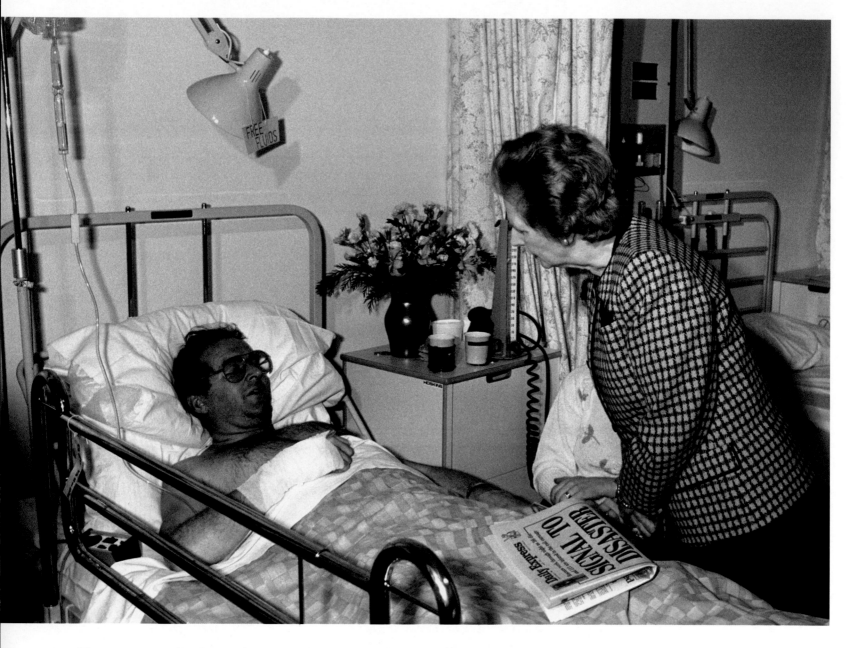

She visits Eric Dadson who is recovering in St George's Hospital in Tooting
after surviving a triple train crash near Clapham Junction, which left 36 dead.

13 December 1988

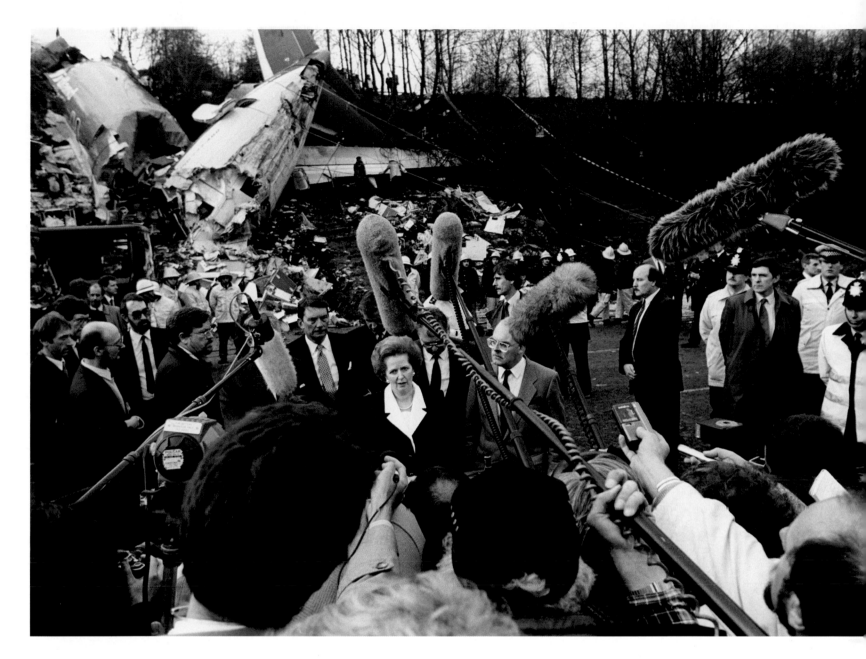

*She talks to the assembled press following the Kegworth air disaster of the previous day,
in which a British Midland plane crashed into the embankment of the MI motorway near Kegworth
in Leicestershire, killing 47 passengers.*

9 January 1989

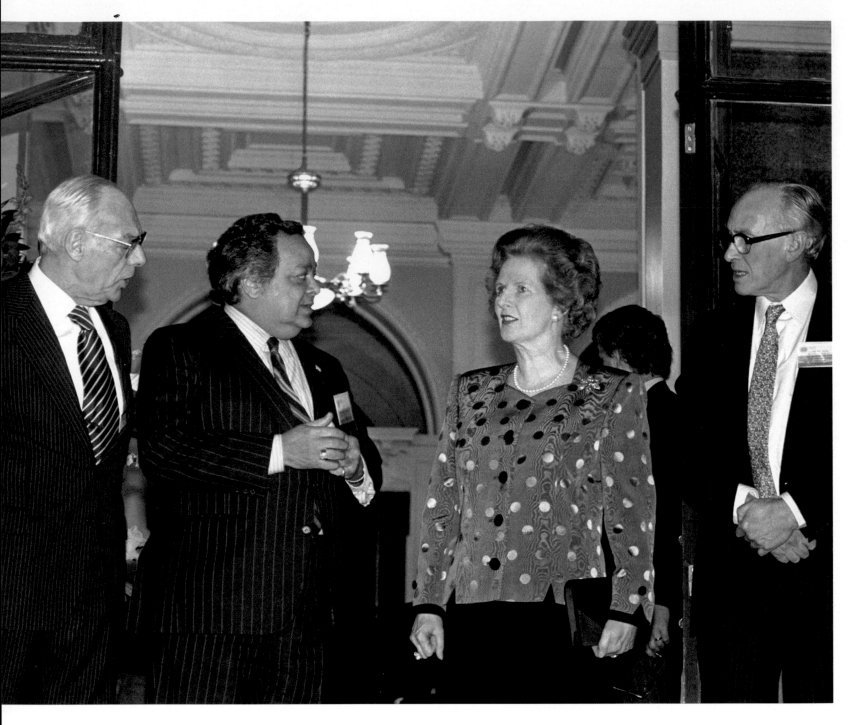

The Prime Minister is joined by (from left) her husband, Commonwealth Secretary General Shridath Ramphal, and Environment Secretary Nicholas Ridley at a Saving the Ozone Layer conference in London.

5 March 1989

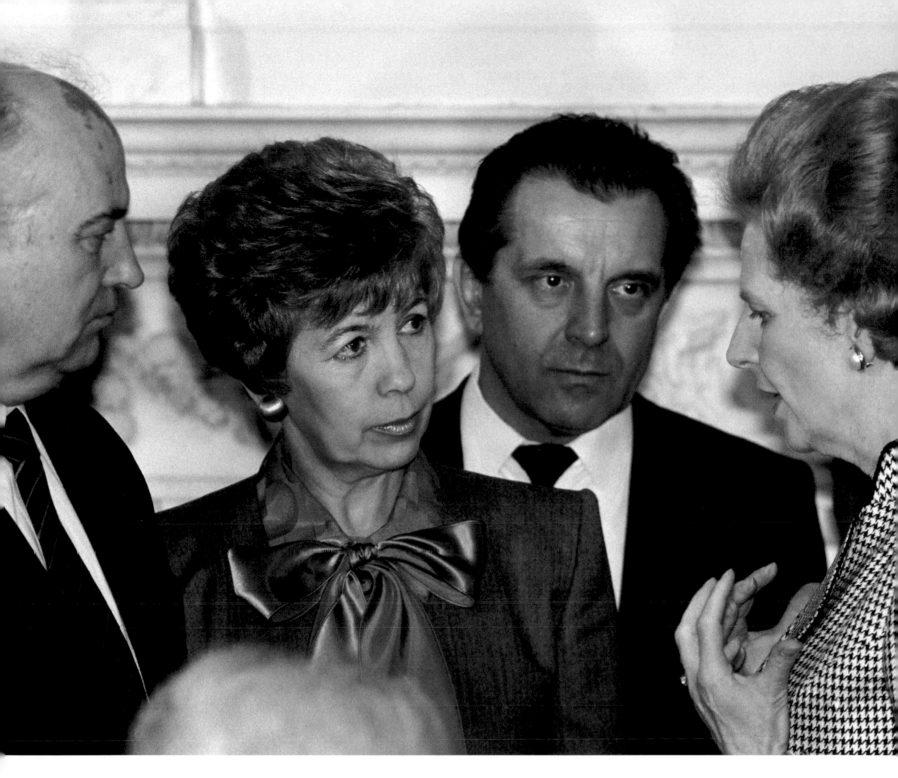

She chats to Soviet leader Mikhail Gorbachev (left) and his wife Raisa at No 10, during their visit to Britain.

6 April 1989

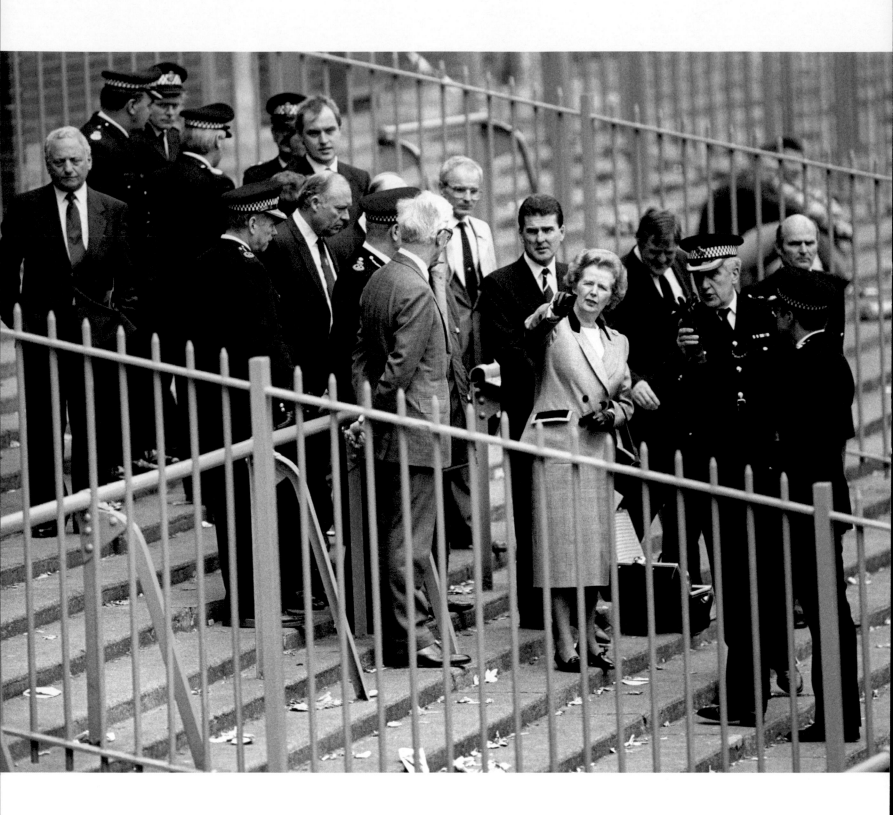

*The Prime Minister visits the Hillsborough Football Ground
on the day after 96 Liverpool fans were crushed to death during
an FA Cup semi-final between Liverpool and Nottingham Forest.*

16 April 1989

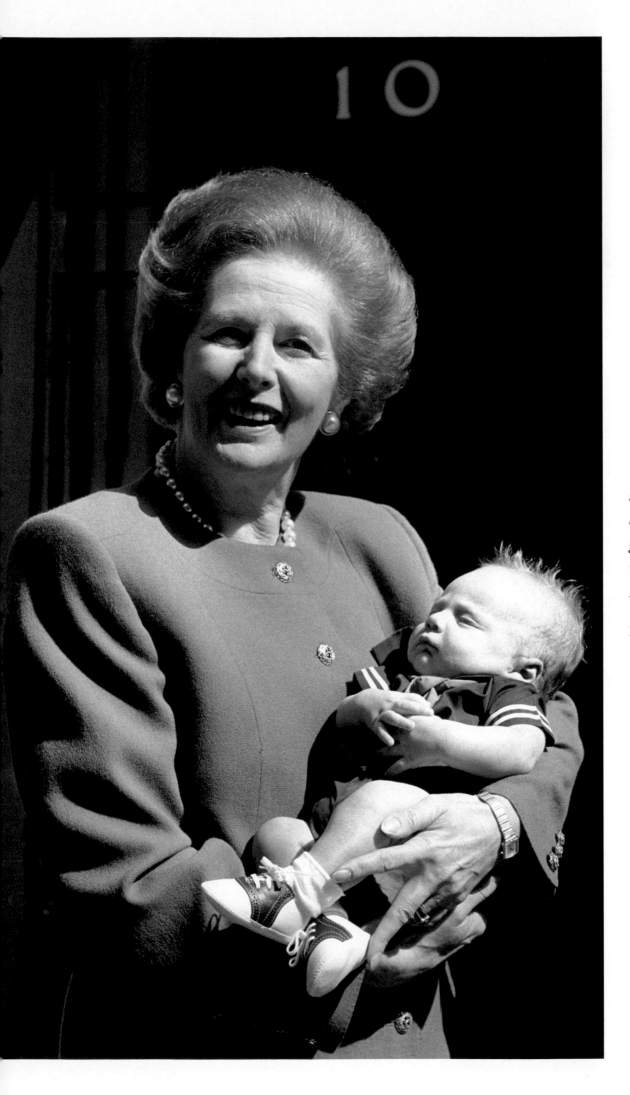

"We are a grandmother,"
she famously announced
at the birth of her first
grandchild, Michael, here
two months old, seen outside
No 10 with his grandmother.

3 March 1989

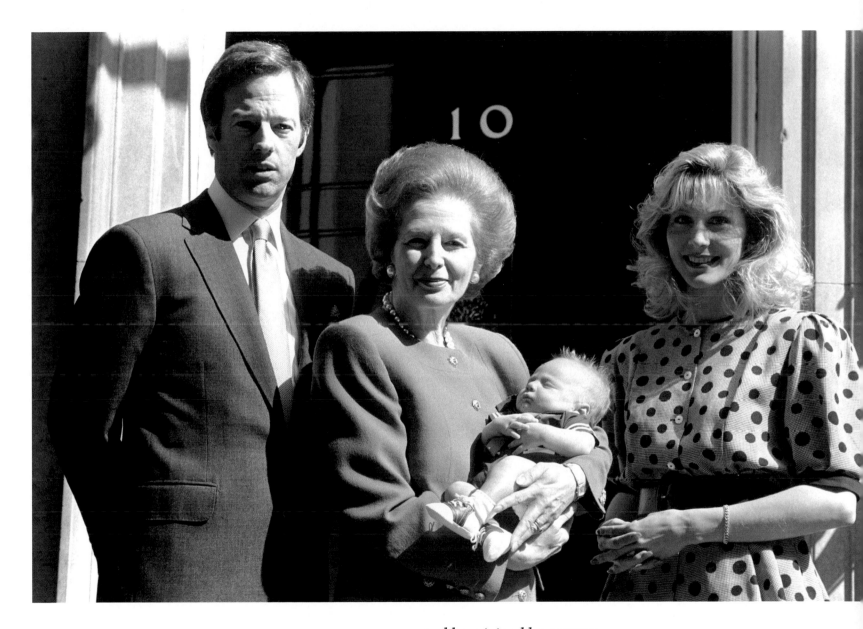

...and here joined by parents
Mark Thatcher and his wife Diane.

3 March 1989

Margaret and Denis on the doorstep of No 10 Downing Street,
10 years after they moved in, following the 1979 general election.

4 May 1989

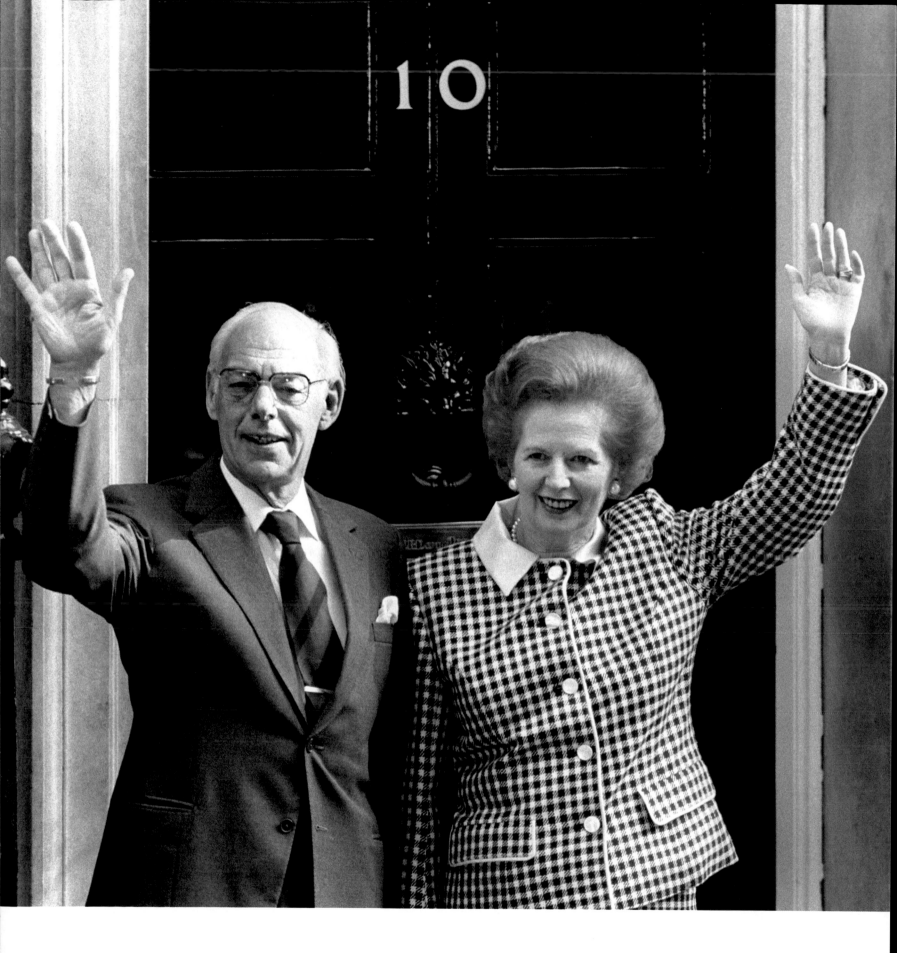

*The Prime Minister fields questions
with Foreign Secretary, Geoffrey Howe,
at a press conference in London to launch
the Conservative European Election manifesto.*

22 May 1989

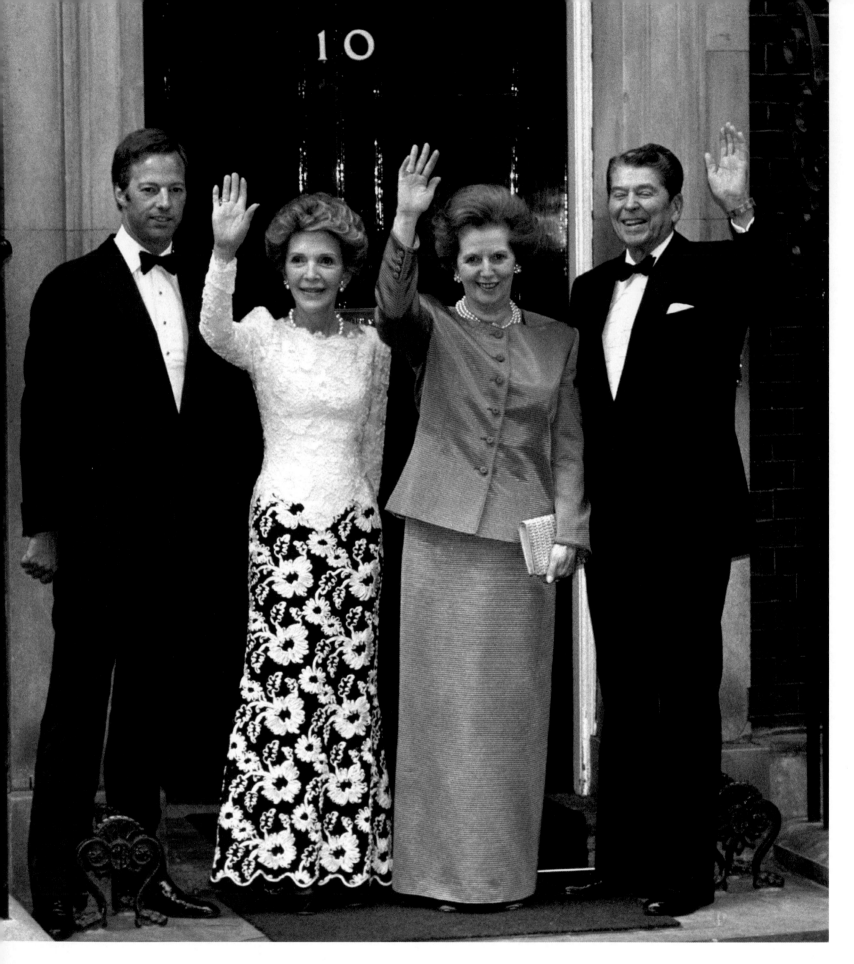

Mark Thatcher joins his mother and former
US President Ronald Reagan and his wife Nancy
on the steps of No 10.

13 June 1989

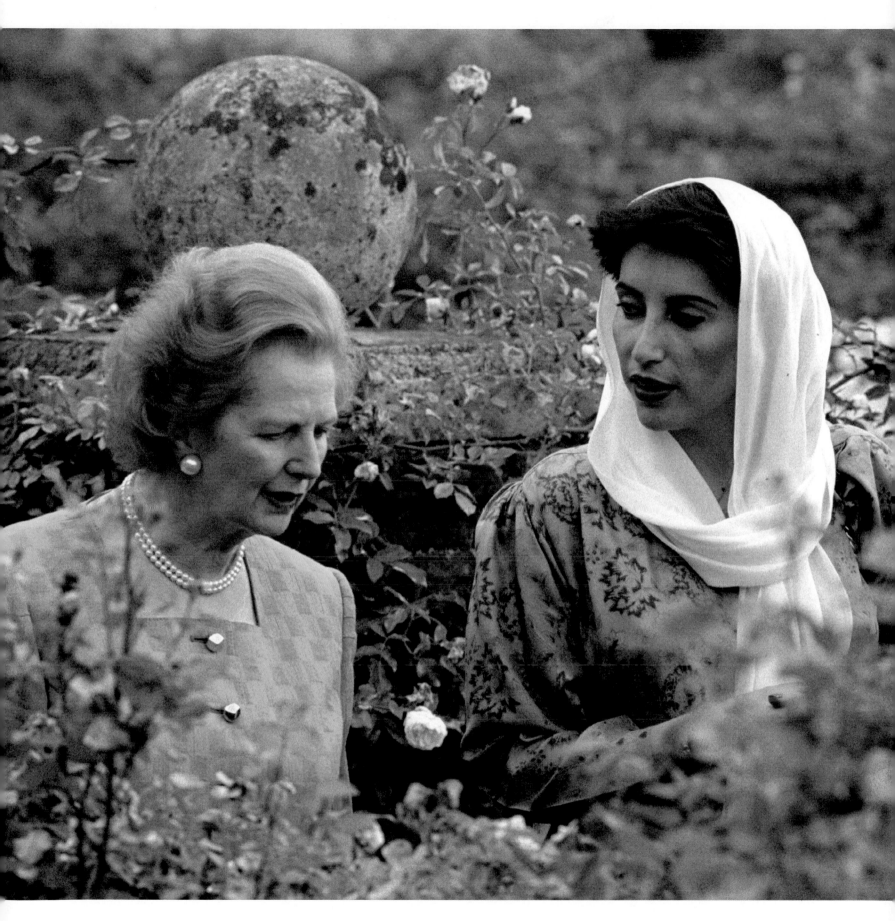

Benazir Bhutto and Margaret Thatcher in the rose garden at Chequers during a visit by the Pakistani Prime Minister to Britain. Benazir Bhutto was to be assassinated on 27 December 2007, two weeks before the Pakistani general election in which she was a leading opposition candidate.

8 July 1989

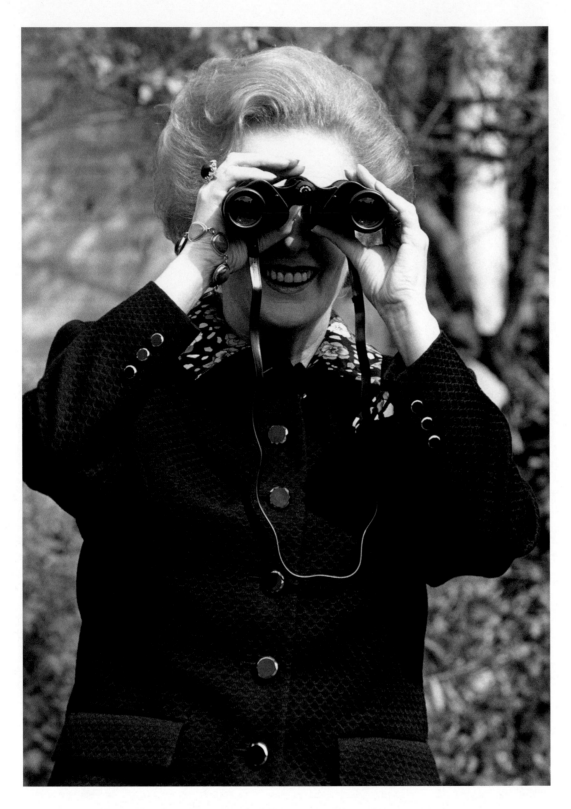

Margaret trains her binoculars on the camera during a visit to the Royal Society for the Protection of Birds' headquarters in Sandy in Bedfordshire.

31 August 1989

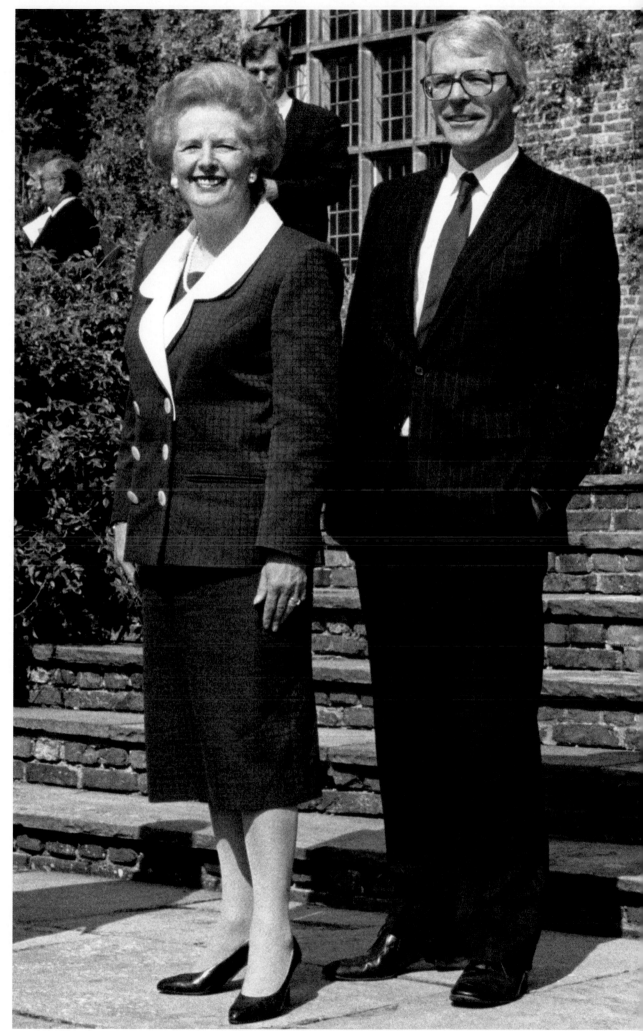

Looking happy and relaxed together, the Prime Minister and Foreign Secretary John Major attend Anglo-French annual talks at Chequers. But it is not to be long before John Major makes his take-over bid for the premiership.

1 September 1989

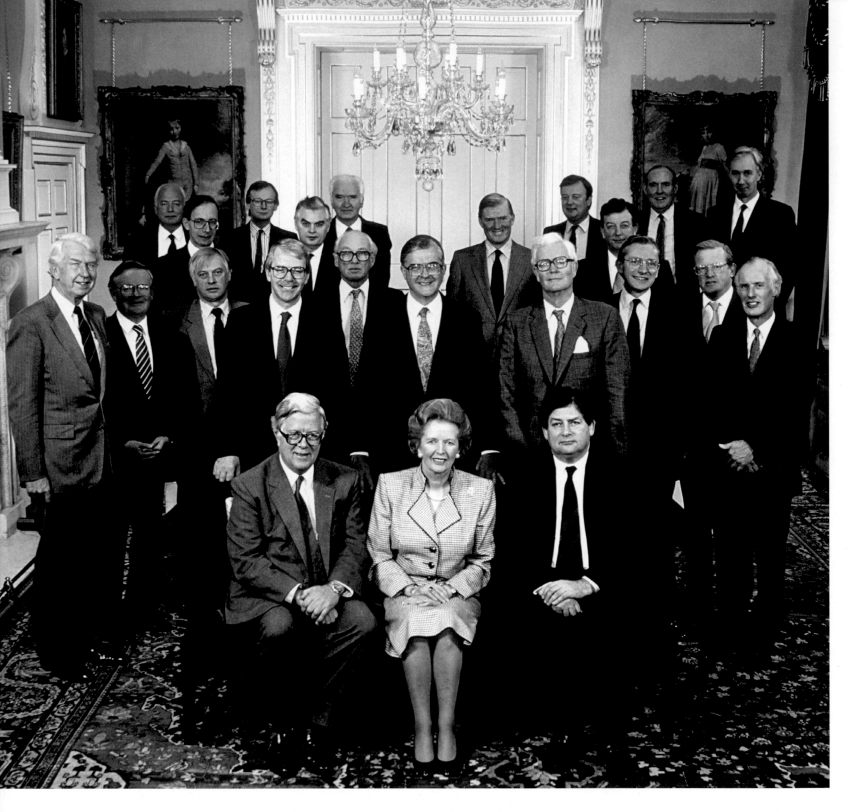

The Prime Minister with her Cabinet at No 10. From left to right seated; Sir Geoffrey Howe, Margaret Thatcher, Nigel Lawson; middle row: Peter Walker, John MacGregor, Chris Patten, John Major, Nicholas Ridley, Kenneth Baker, Douglas Hurd, Norman Fowler, Tom King, Anthony Newton; back row: David Waddington, Malcolm Rifkind, John Gummer, Norman Lamont, Lord Macay of Clashfern, Cecil Parkinson, Kenneth Clarke, John Wakeham, Peter Brooke, Lord Belstead.

13 October 1989

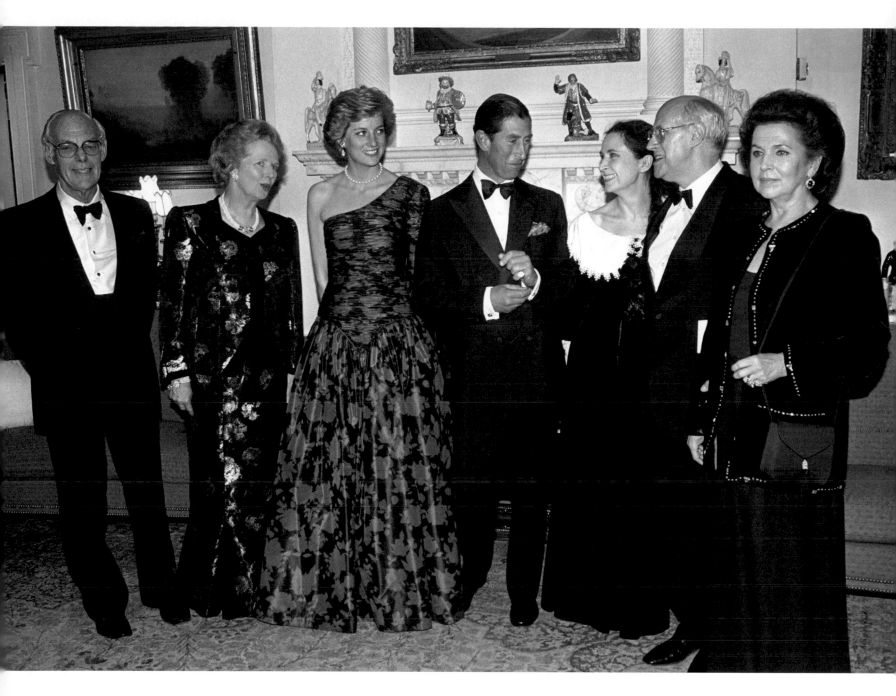

The Prince and Princess of Wales (centre) at No 10 with the Prime Minister, her husband and Russian cellist Mstislav Rostropovitch (second from right), his wife Galina Vishnevskaya (right) and their daughter Elena.

20 November 1989

Students at Warwick University greet the Prime Minister on her arrival to open a multi-million pound advanced technology centre. The students are protesting against the government's proposed loans scheme for students to supplement grants.

8 January 1990

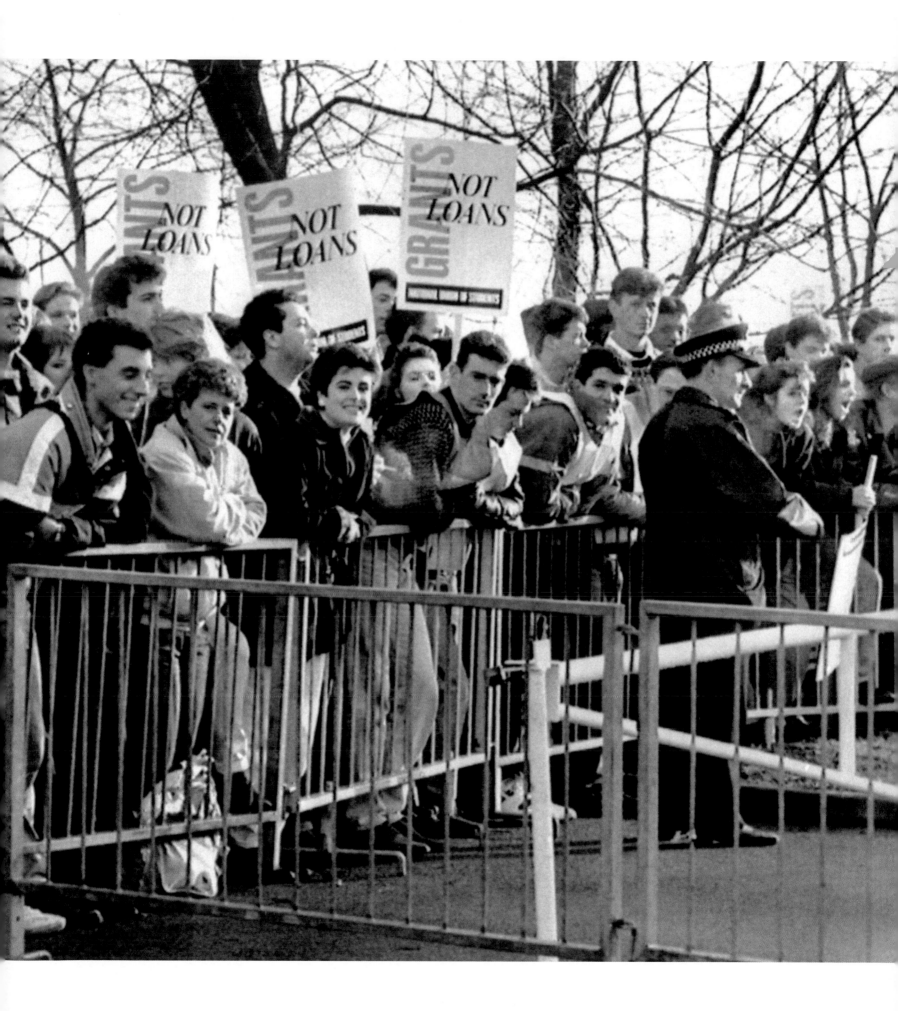

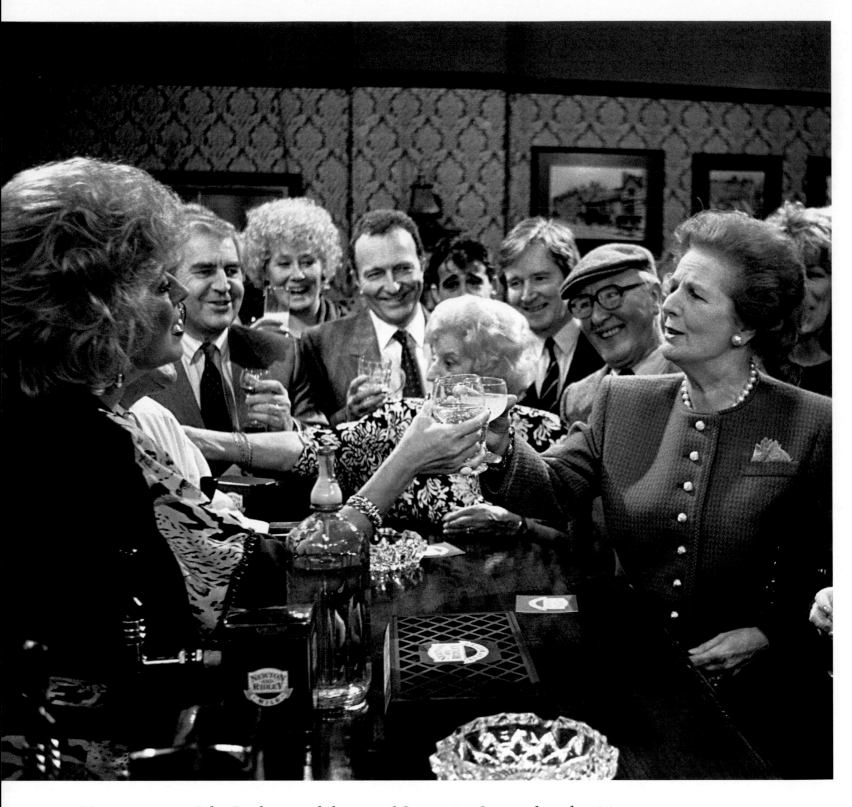

Margaret toasts Julie Goodyear and the cast of Coronation Street when she visits the Rovers Return on the set at Granada Television Studios in Manchester.

26 January 1990

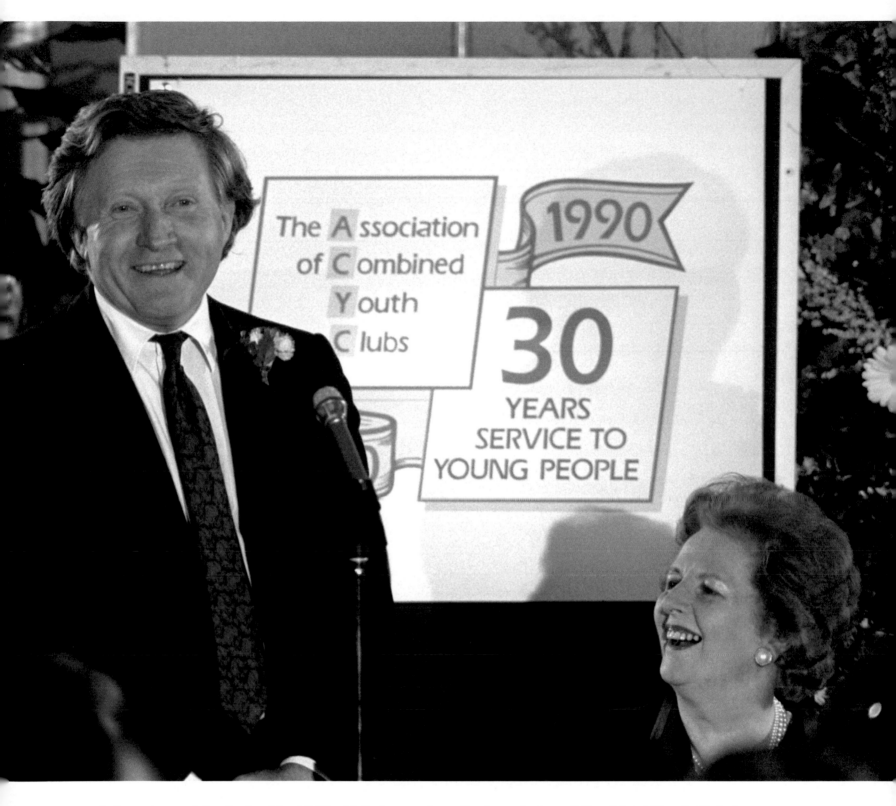

...and she enjoys a joke during David Dimbleby's speech at the Association of Combined Youth Clubs'
30th anniversary lunch in London.

21 March 1990

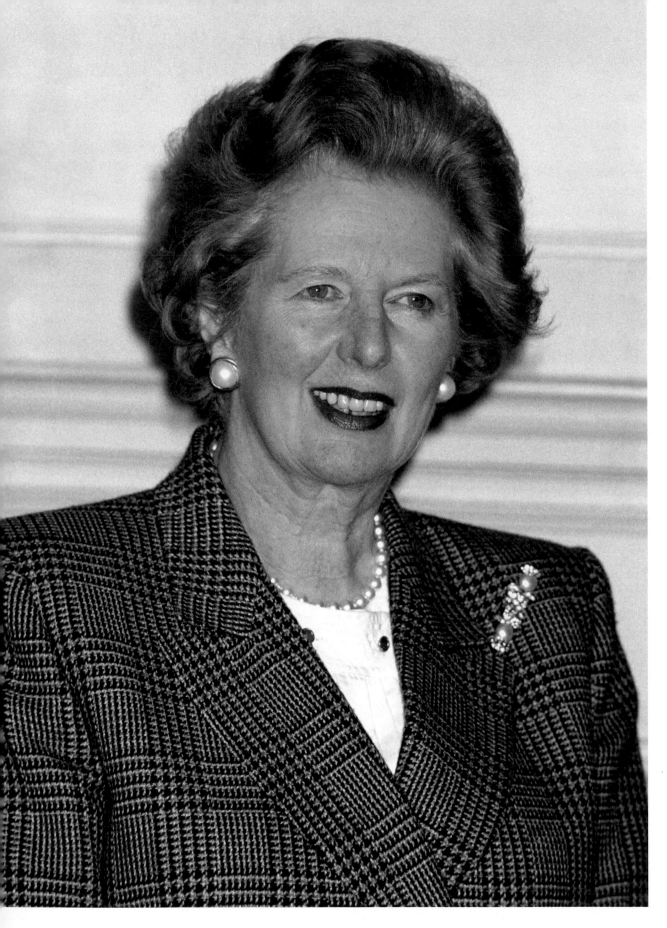

The Prime Minister puts on a brave face after the Tory defeat in the Mid-Staffordshire by-election. Controversial policies, including the Poll Tax, and her opposition to closer integration with Europe, are creating splits within the Conservative Party.

23 March 1990

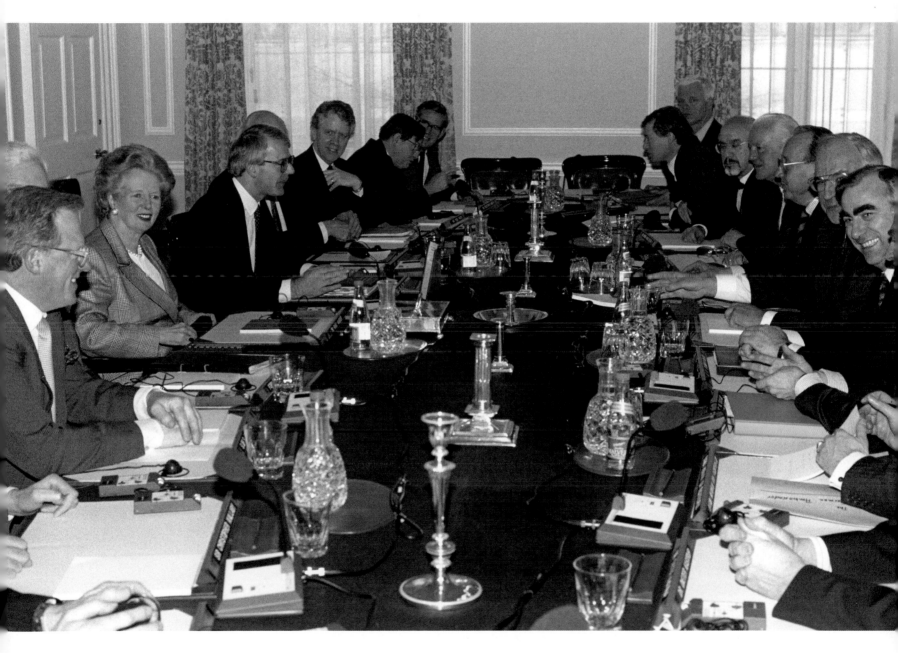

With John Major by her side, the Prime Minister is joined
by West German leader Helmut Kohl at a Cabinet meeting.

30 March 1990

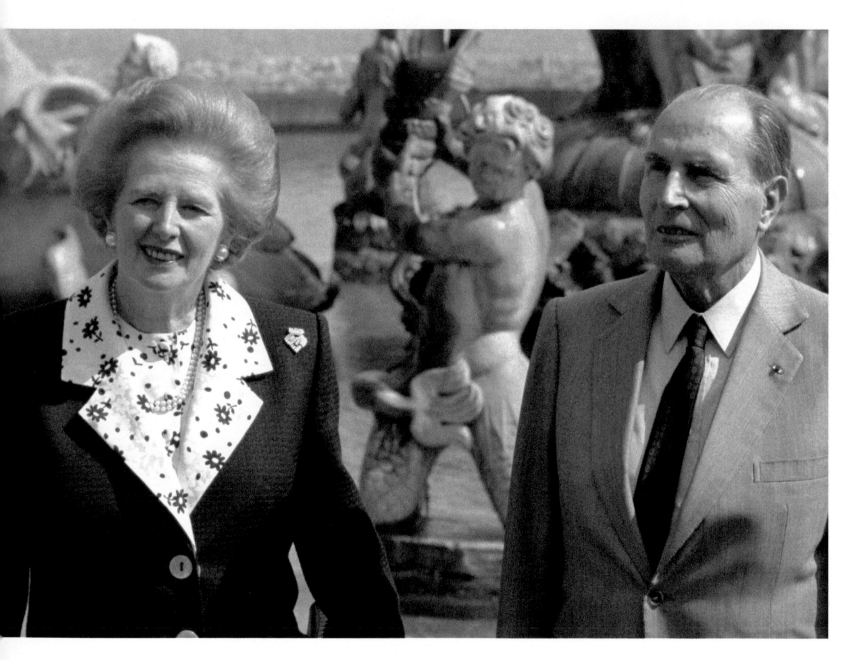

*Margaret with French President François Mitterrand during
a summit meeting at Waddesdon Manor in Buckinghamshire.*

4 May 1990

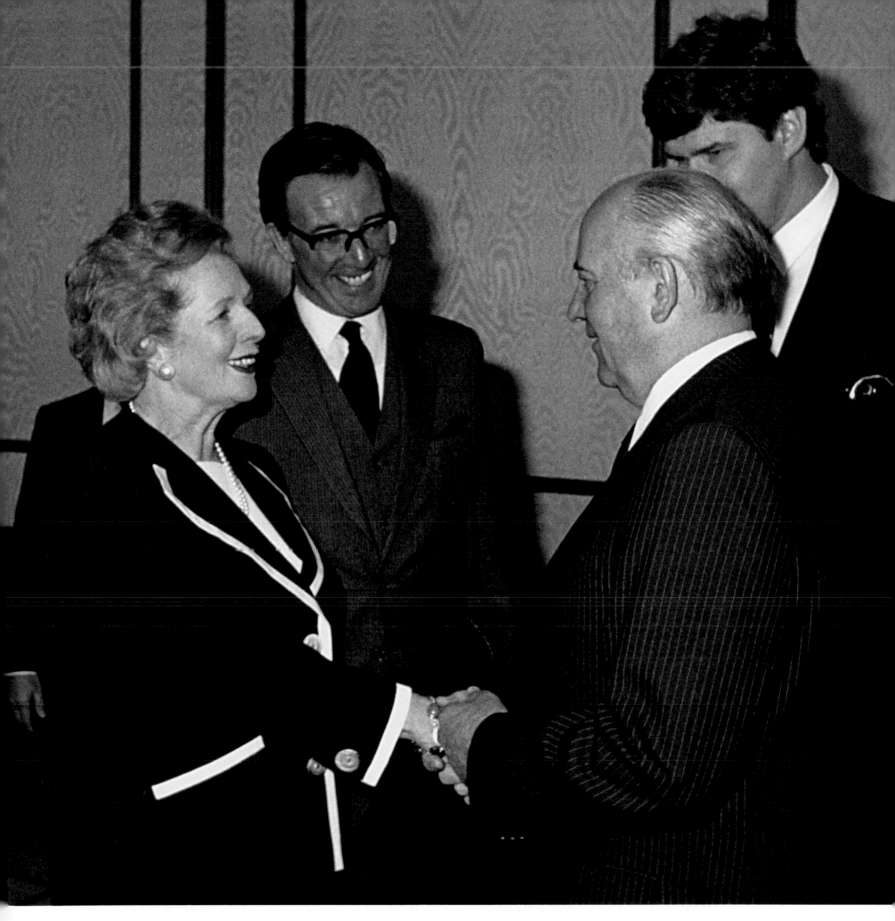

*She meets Soviet President Mikhail Gorbachev at
the Kremlin Palace in Moscow on a four-day visit to the USSR.*

8 June 1990

The Prime Minister at
the end of the Conservative
Party Conference with Dame
Margaret Fry, Chairman
of the Conference, and
the Cabinet. In less than
two months her long reign
will be over.

12 October 1990

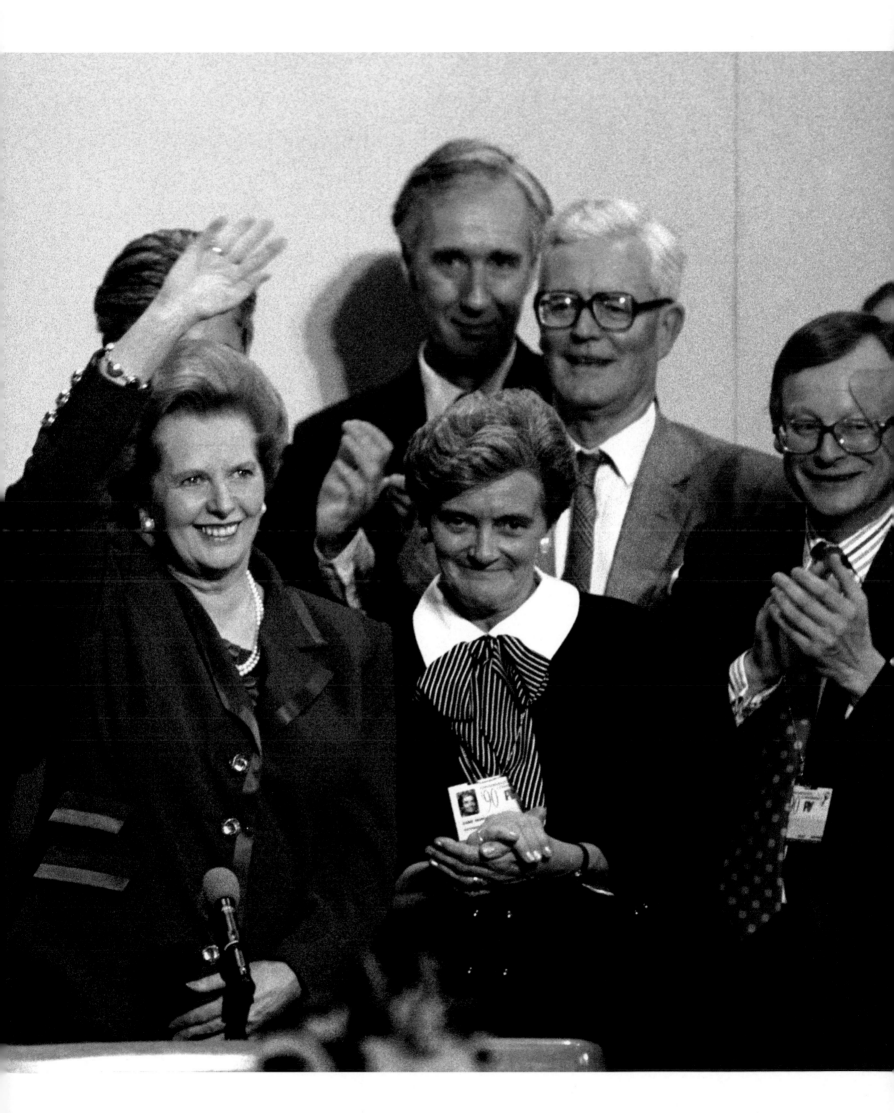

The fight is on. John Major – now Chancellor of the Exchequer, following the resignation of Nigel Lawson – makes his statement on Britain's entry into the European Exchange Rate Mechanism (ERM), in the House of Commons, as the Prime Minister looks on. There are distinct signs of unrest, and talk that she no longer controls her Cabinet, which is to be reinforced by the resignation of Geoffrey Howe on 1 November.

15 October 1990

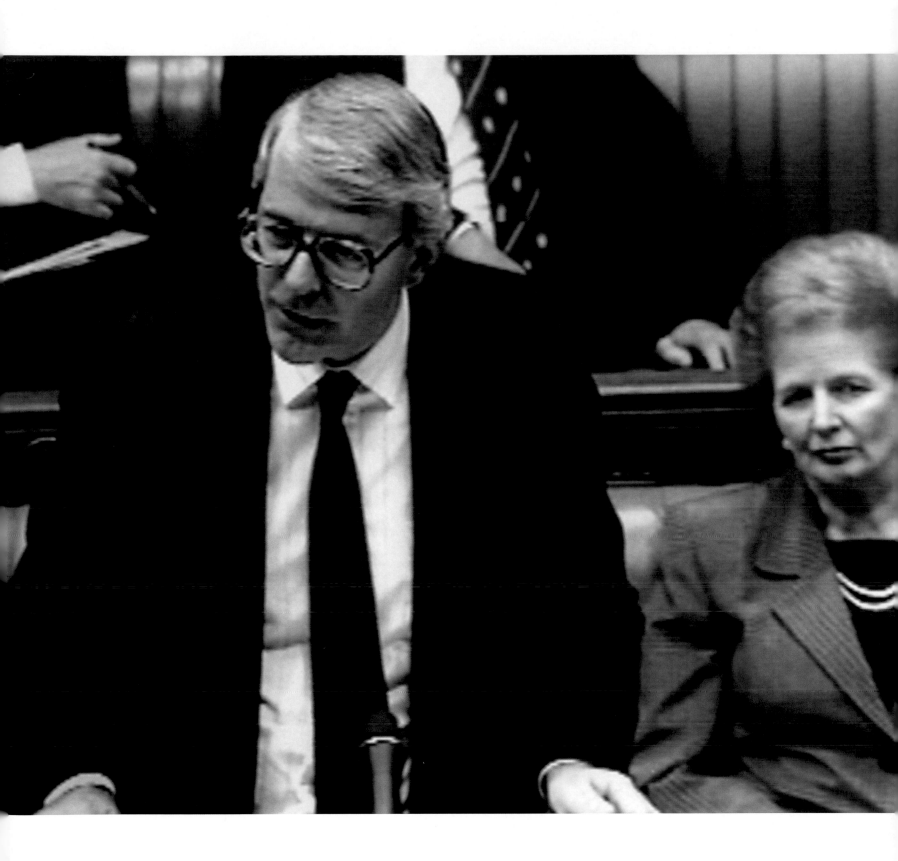

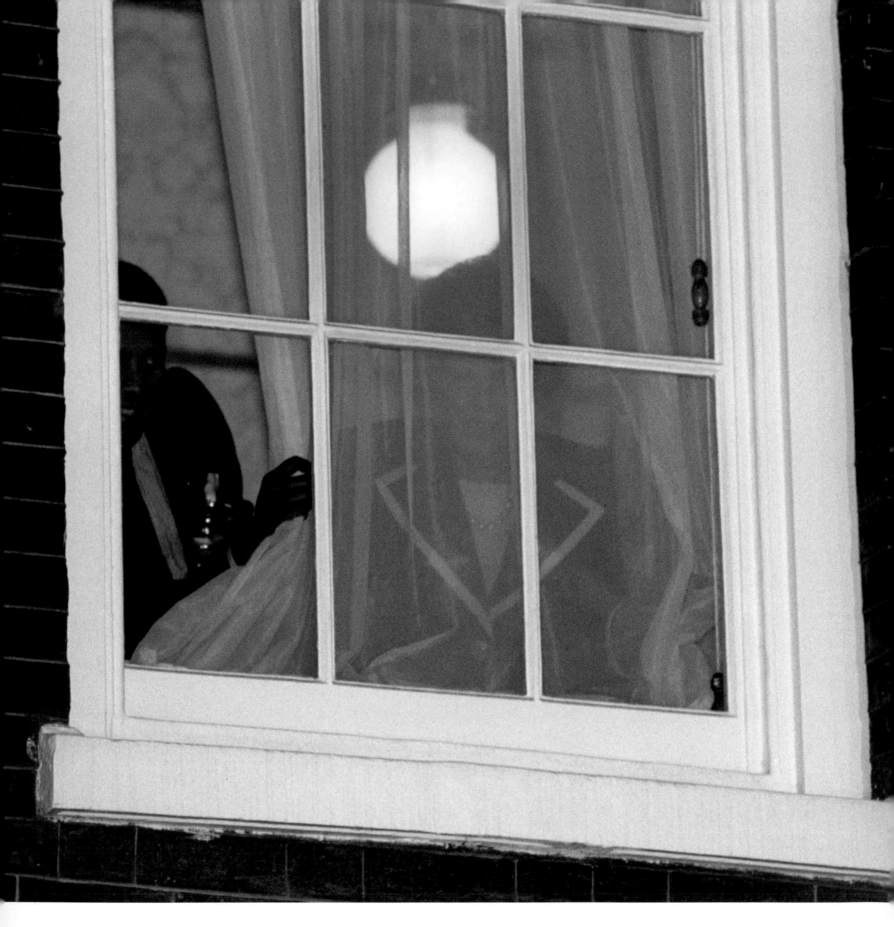

Margaret watches from a top floor window in Downing Street, after hearing the news of John Major's success in the Tory leadership election ballot.

27 November 1990

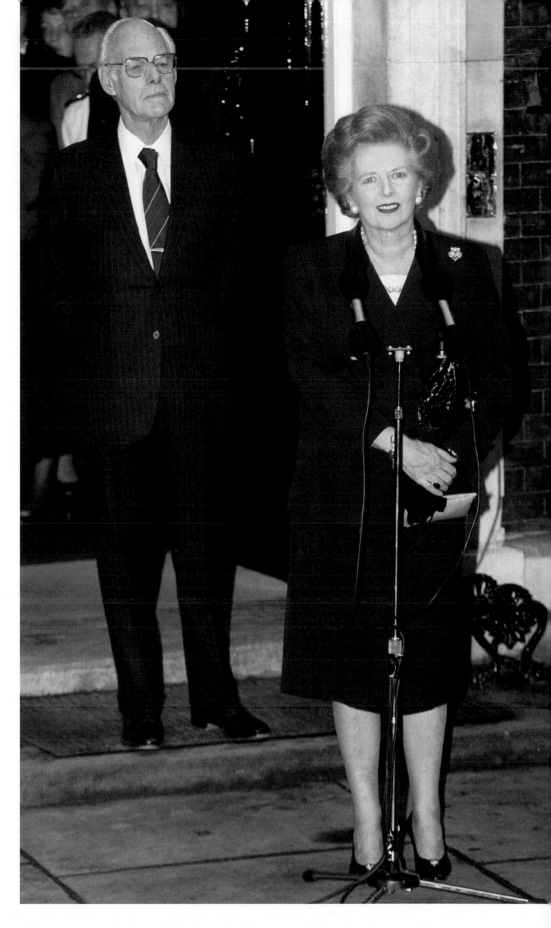

It's over. Accompanied by Denis, Margaret Thatcher leaves No 10 for the last time, before driving to Buckingham Palace to offer her resignation to the Queen.

28 November 1990

After

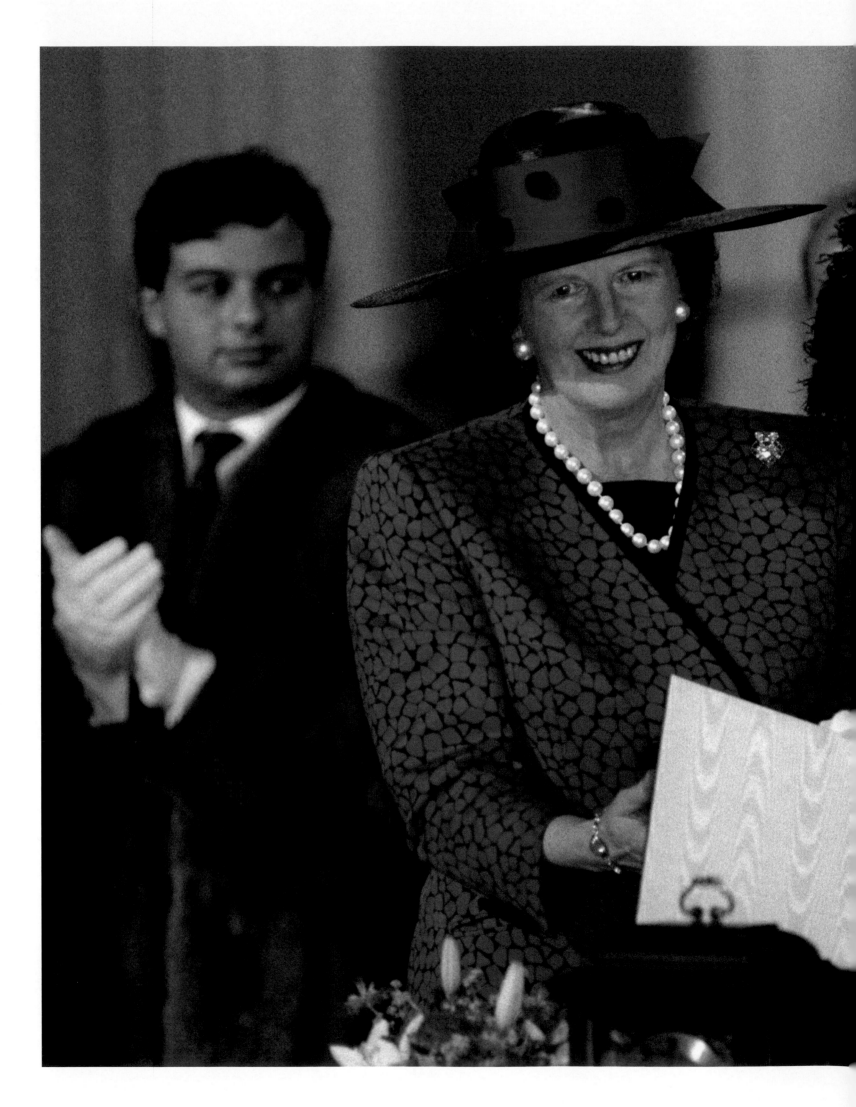

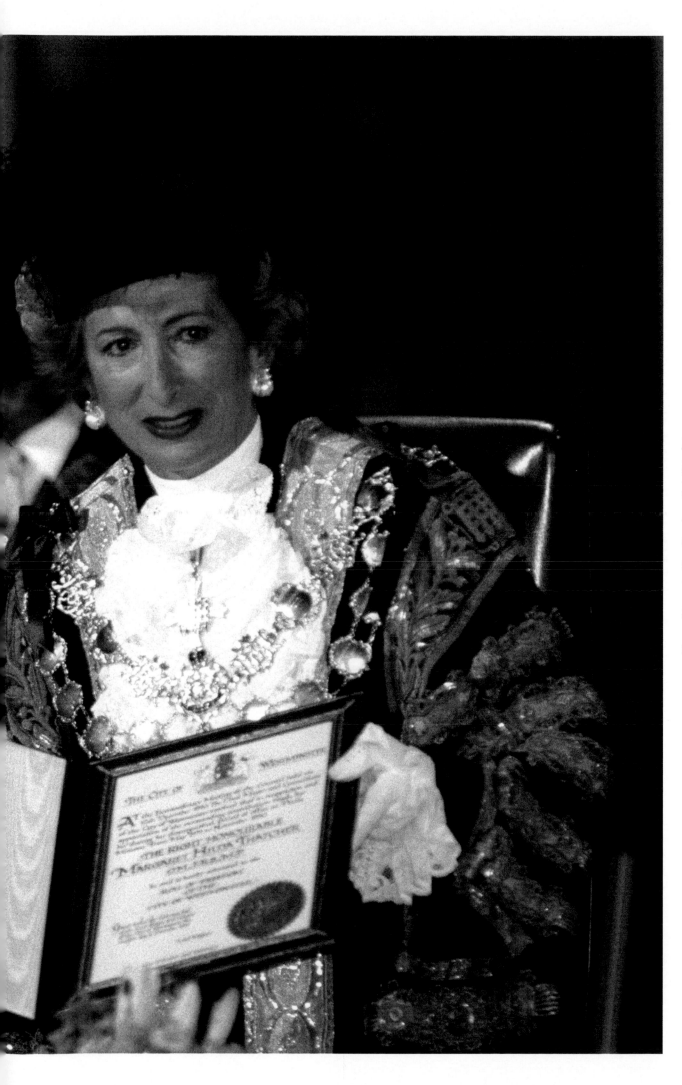

Margaret receives her conferment of the Honorary Freedom of the City of Westminster from the Lord Mayor of Westminster, Lady Shirley Porter.

26 June 1991

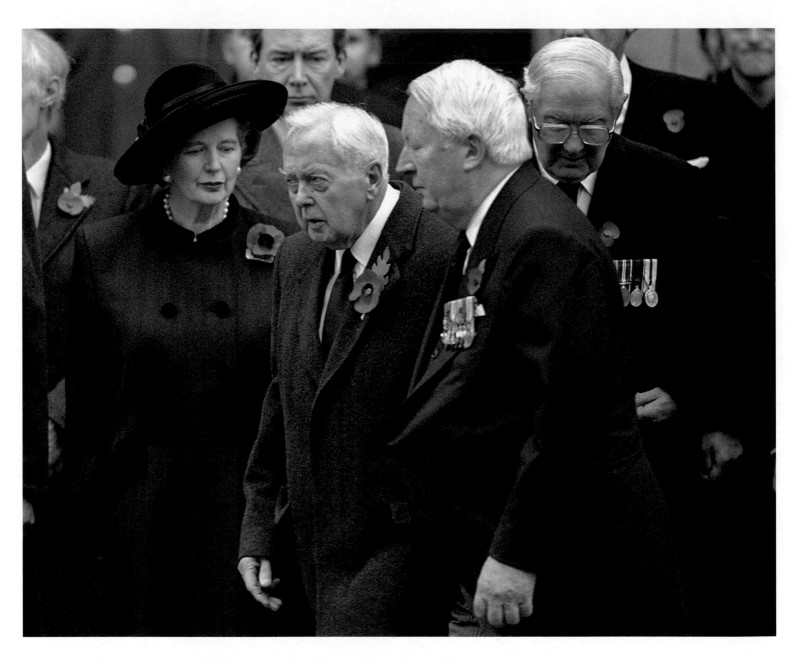

A line-up of former Prime Ministers at the Cenotaph on Remembrance Day.
From left, Margaret Thatcher, Lord Wilson, Edward Heath and Lord Callaghan.

10 November 1991

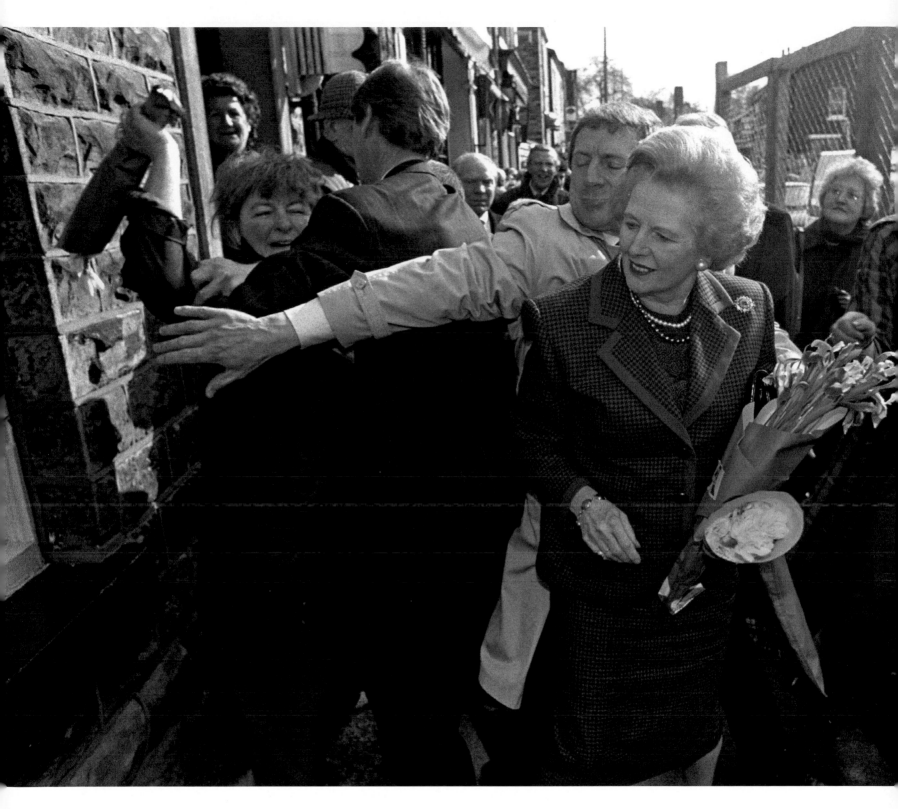

Feelings still run high, even though Margaret is no longer in power. Here an unknown woman attempts to attack her during a walkabout in Marple Bridge in Stockport. The weapon wielded is, however, a bunch of flowers.

23 March 1992

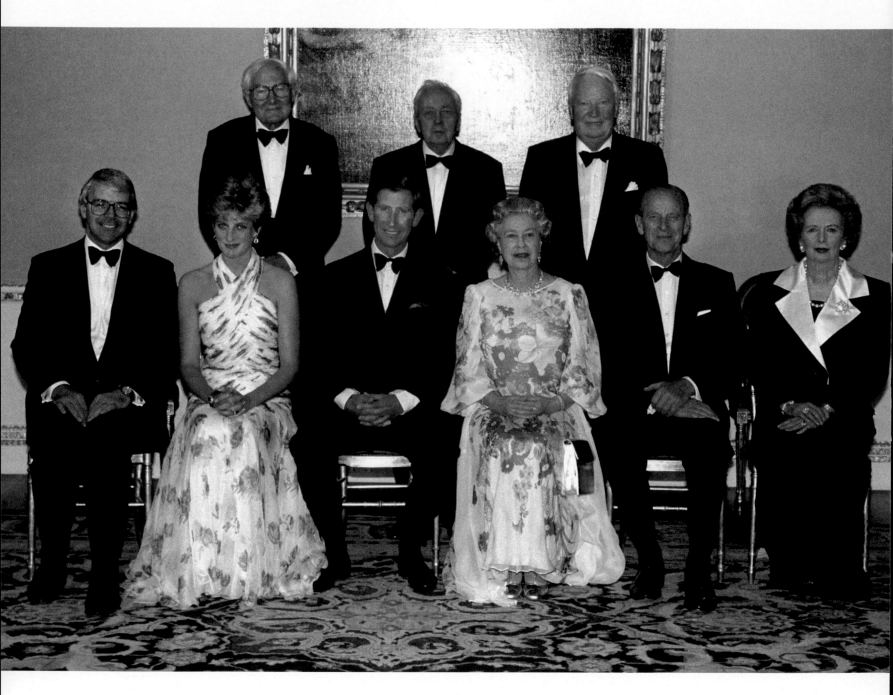

A dinner given at Spencer House in London by former Prime Ministers for the Queen and the Duke of Edinburgh. From left to right, back row, Lord Callaghan, Lord Wilson and Sir Edward Heath; left to right, front row, John Major, the Princess of Wales, the Prince of Wales, the Queen, the Duke of Edinburgh and Margaret, now Baroness Thatcher.

27 July 1992

FACING PAGE: *Just before her 70th birthday, she launches her book* Margaret Thatcher: The Downing Street Years *at Harrods in Knightsbridge.*

8 October 1993

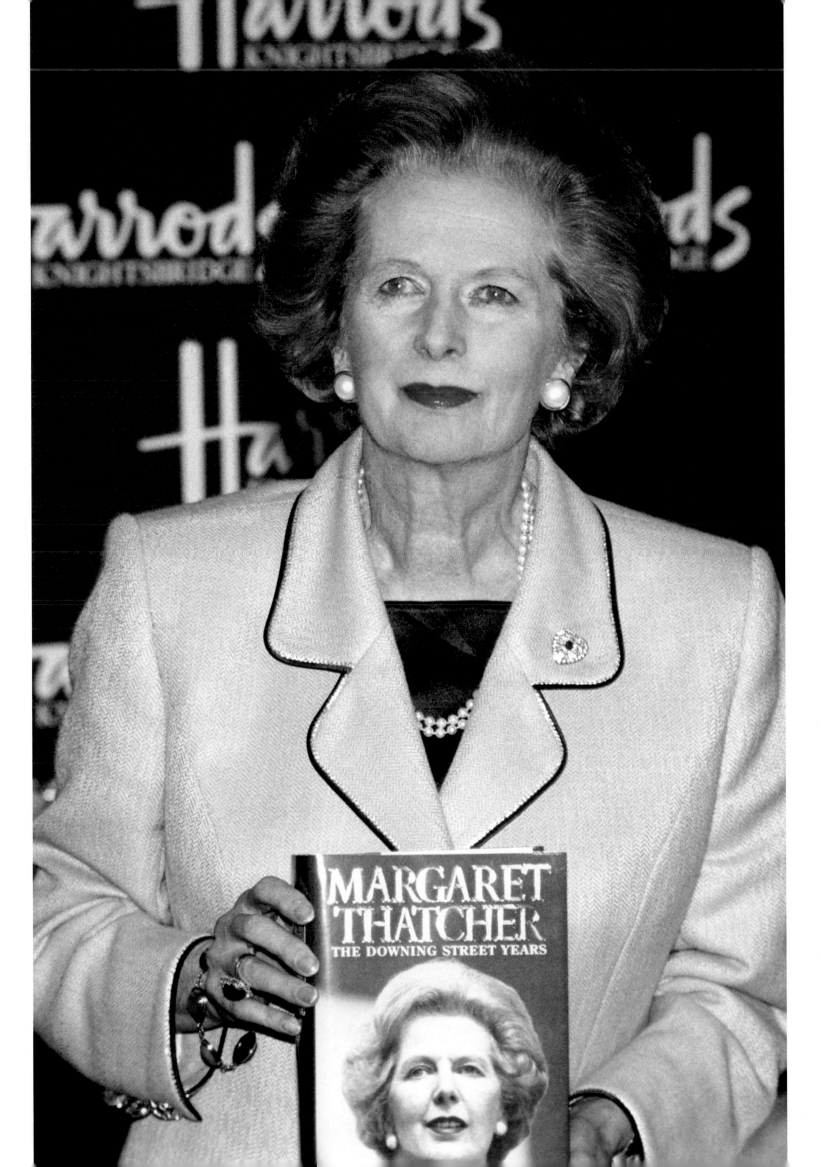

Dressed in her robes, Margaret is seated in the House of Lords during the State Opening of Parliament.

18 November 1993

...and at the official opening of Waterloo International Station in London, the terminus of Eurostar international until 2007 when it was transferred to St Pancras. Margaret was instrumental in the early negotiations for the Channel Tunnel.

6 May 1994

She and Denis attend a Remembrance Day parade held by Jewish ex-servicemen and women at the Cenotaph in London.

20 November 1994

Margaret and Denis leave St George's Chapel at Windsor Castle after she has been installed as a Knight of the Garter in a service attended by the Queen and other members of the Royal Family. Membership in the order is limited to the sovereign, the Prince of Wales and no more than 24 members, or Companions, as they are known.

19 May 1995

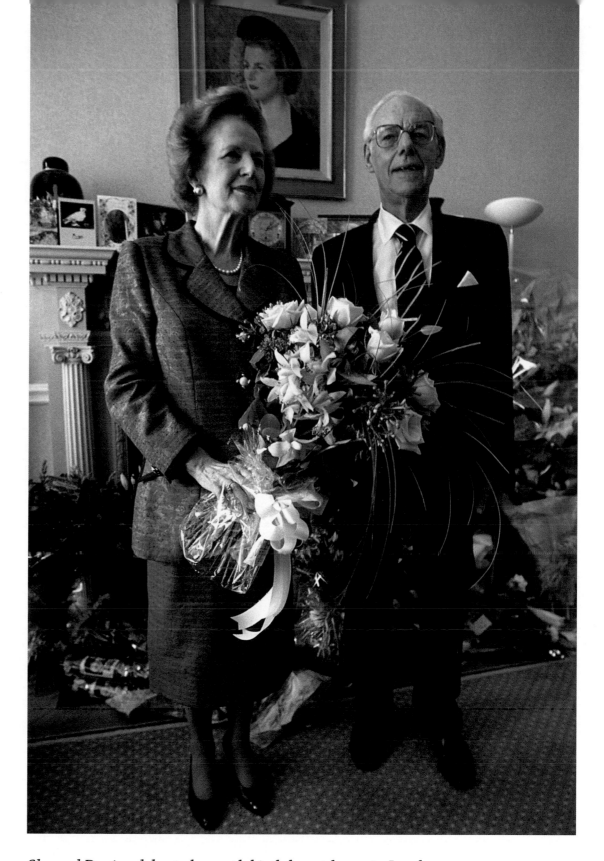

She and Denis celebrate her 70th birthday at home in London.

13 October 1995

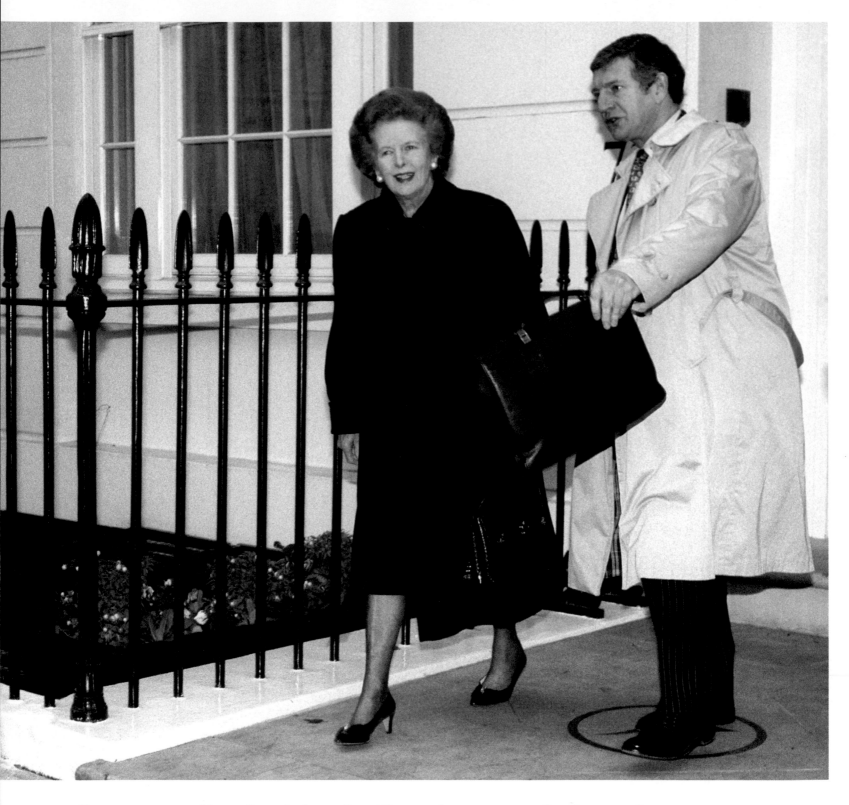

*She is accompanied by a plain-clothes police officer, on her way to give her first speech
on domestic politics since she was ousted from office more than five years ago.*

11 January 1996

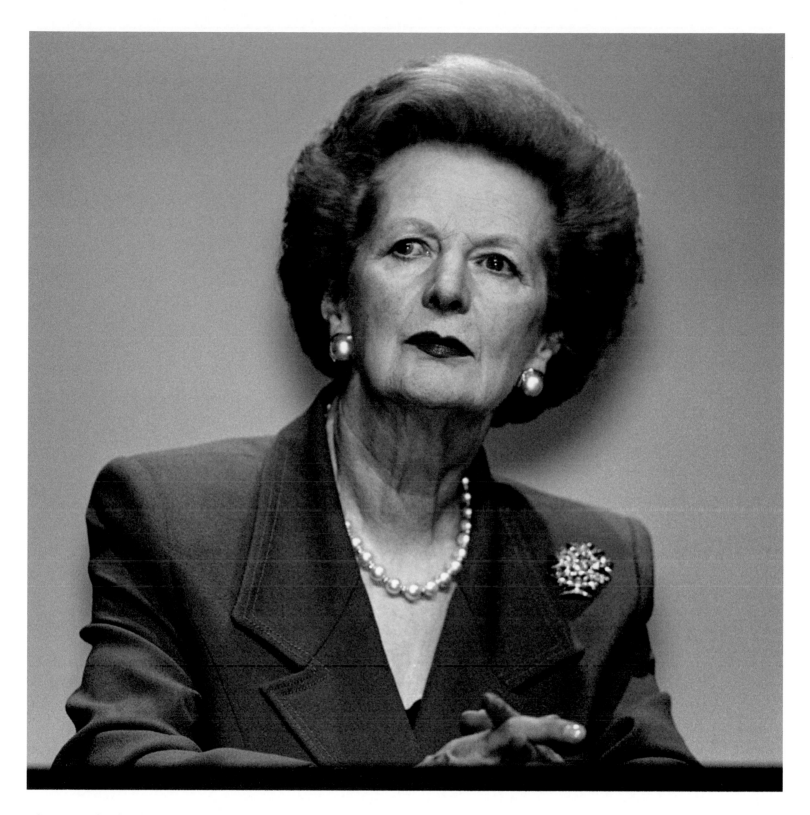

She attends the first day of the Tory Party Conference in Bournemouth.
The Conservatives, under John Major, are to have only one more year in power.

8 October 1996

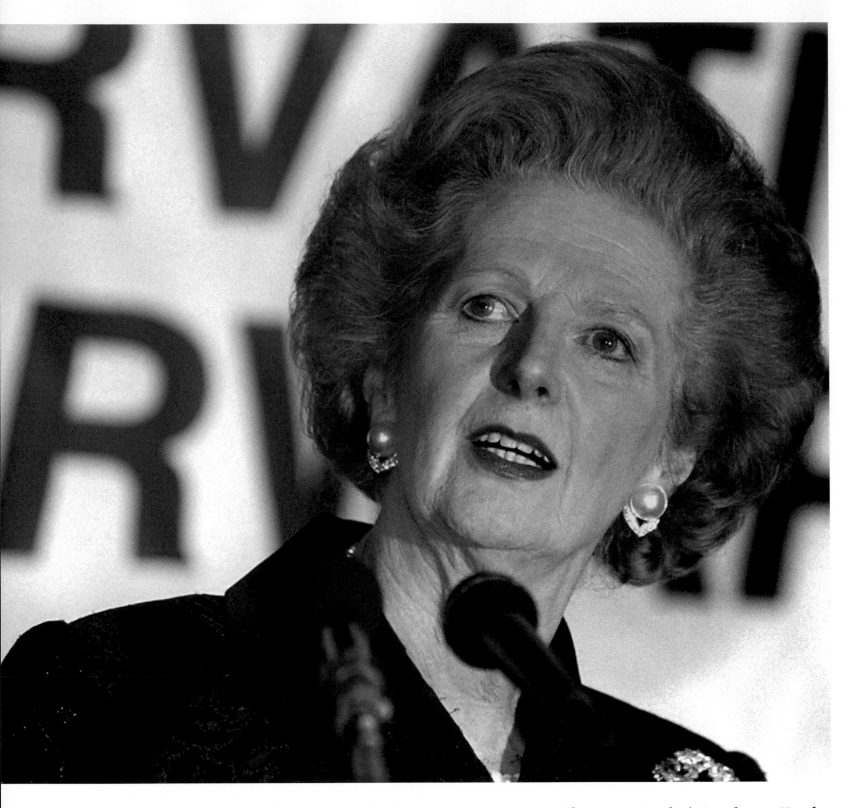

At the Nicholas Ridley memorial lecture to the Conservative Way Forward group at London's Dorchester Hotel,
she warns Tory supporters that socialism is not dead and the threat of New Labour must be tackled
if Tony Blair's party is not to "ruin the economy".

22 November 1996

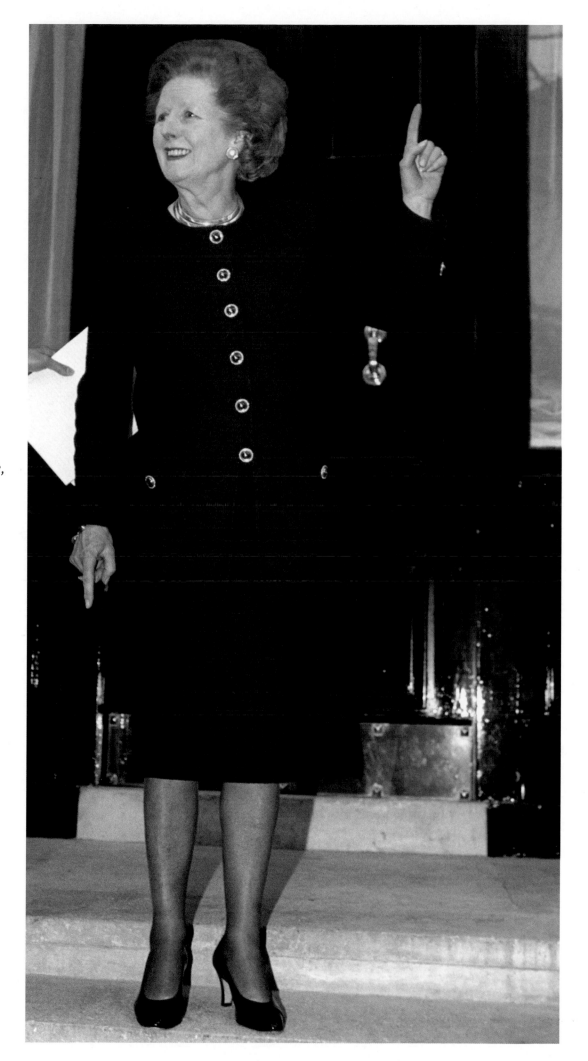

During a press conference on the steps of her London office, she urges voters to: "Stay with us until we cross the finishing line," after Prime Minister John Major set the election day for May 1.

17 March 1997

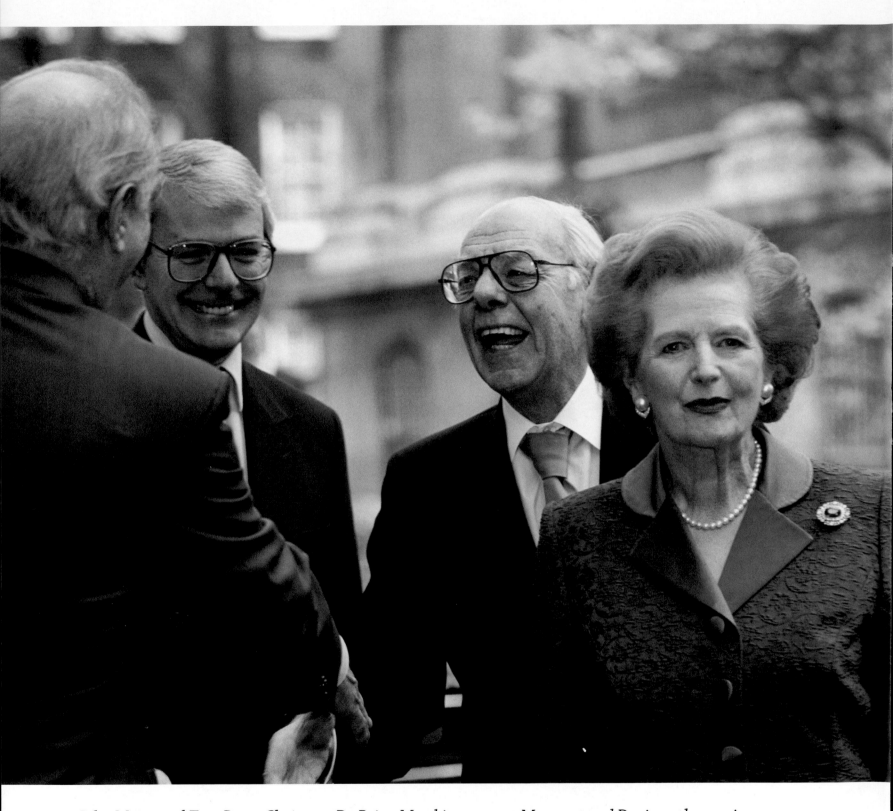

John Major and Tory Party Chairman Dr Brian Mawhinney greet Margaret and Denis as they arrive at Conservative Central Office in London where she has stepped into the election ring to give her support.

6 April 1997

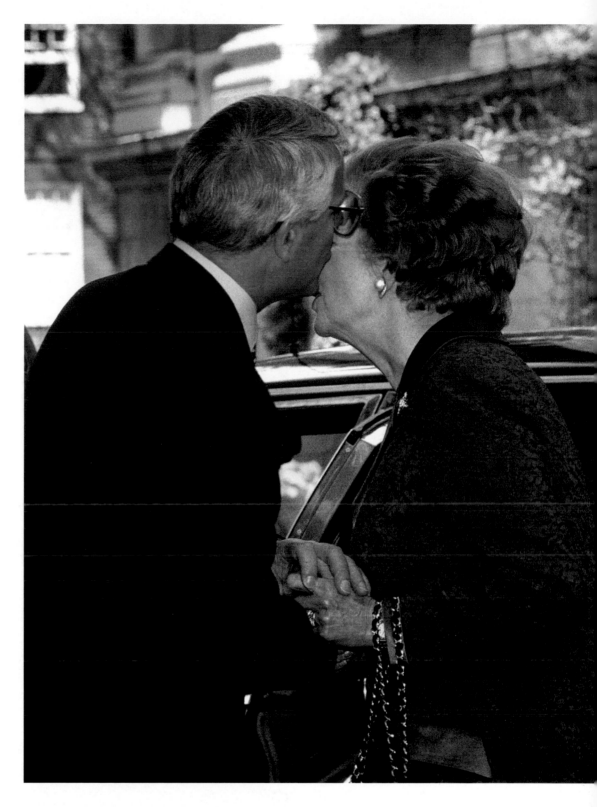

John Major gives her a kiss as she leaves. He is to later reveal
in a series of interviews for the BBC in 1999 that the alliance was
not an easy one, and there were times when he felt antipathy towards
the former Prime Minister. He paints a picture of her shadow falling
over his leadership as she intrigued behind the scenes, adding evidence
to the rumours of a rift between the two leaders.

6 April 1997

Some of the twentieth century's most distinguished performers, scientists, artists and politicians are invited by the Queen to Windsor Castle for an Order of Merit lunch. Back row: Sir John Gielgud, Lord Jenkins, Sir Michael Atiyah, Dr Max Perutz, Lord Menuhin, Dame Joan Sutherland, Lord Porter, Sir Aaron Klug, Sir Edward Ford. Front row: Frederick Sanger, Baroness Thatcher, Professor Owen Chadwick, Sir George Edwards, Prince Philip, the Queen, Sir Isaiah Berlin, Sir Andrew Huxley, Dame Cicely Saunders, Sir Ernst Gombrich.

8 April 1997

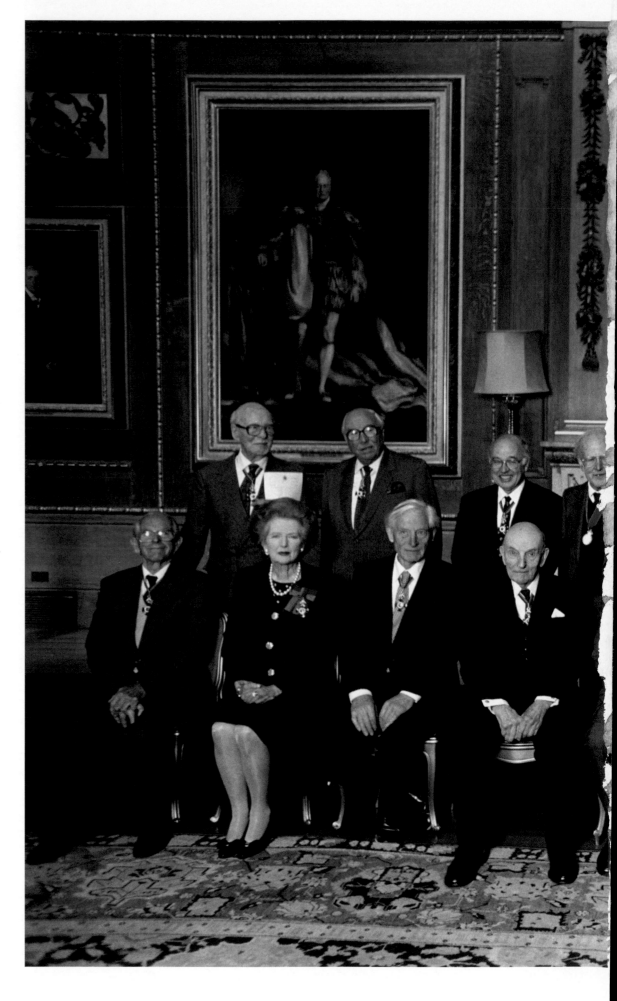

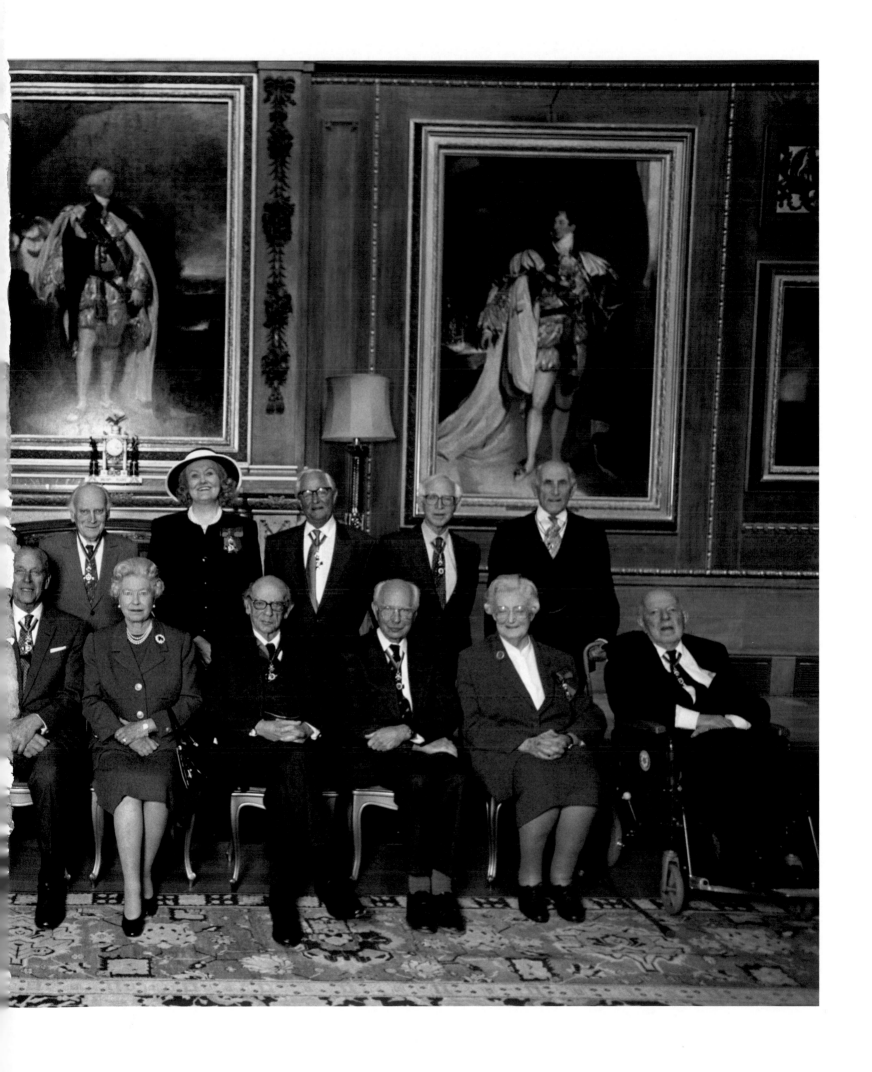

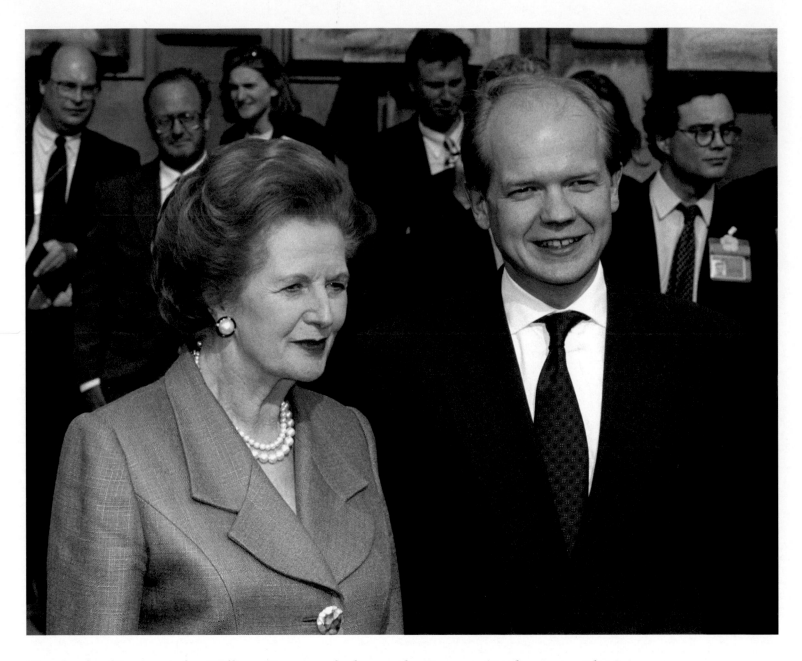

Tory leadership contender, William Hague, as he leaves the Houses of Parliament with Margaret.
It is the third and final ballot in the bid to find John Major's successor, after he dramatically resigned
as party leader on 5 October, having lost the general election in May.

18 June 1997

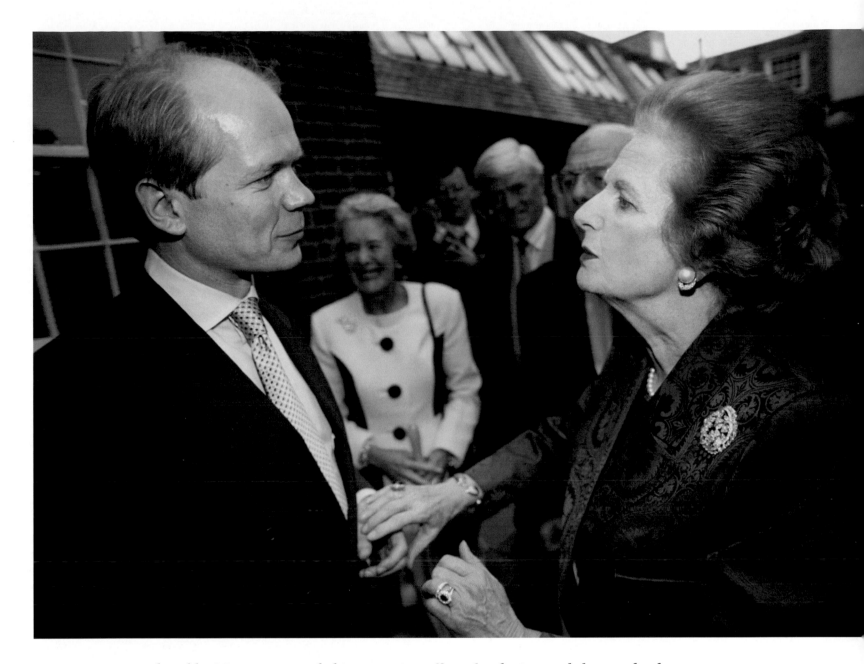

*Hague is congratulated by Margaret outside his campaign office after he is voted the new leader
of the Conservative Party. The 36-year-old defeated the former chancellor Kenneth Clarke by 22 votes
to take over the reins of opposition from John Major.*

19 June 1997

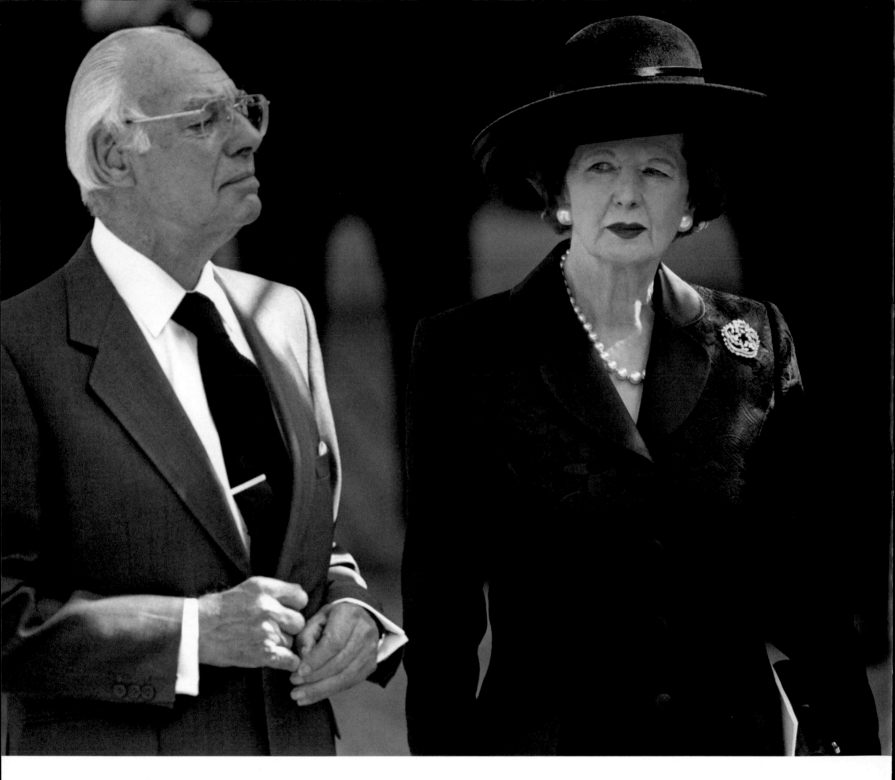

At Westminster Abbey after the funeral of the Princess of Wales.

6 September 1997

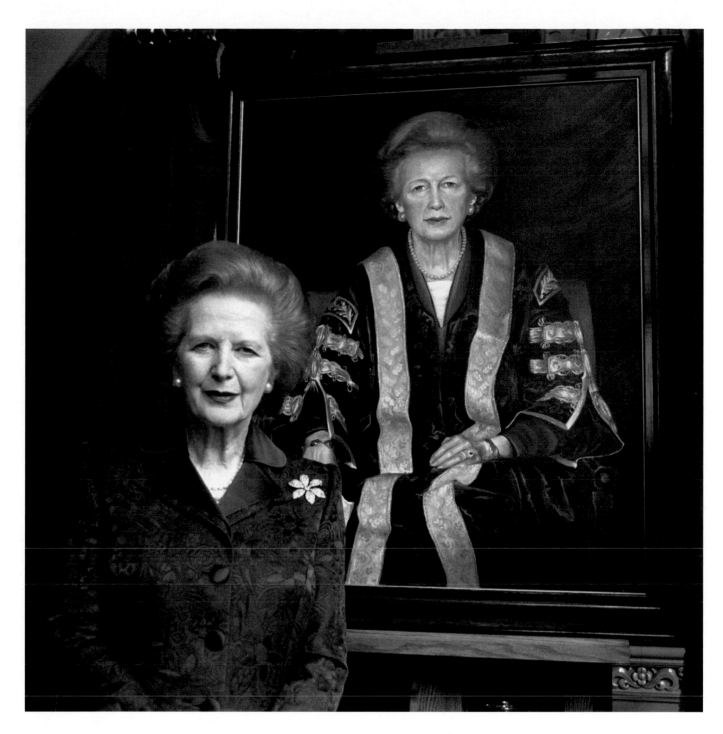

Margaret poses in front of a new portrait commissioned by the University of Buckingham,
painted by James Gillick, the 26-year-old son of morality issues commentator Victoria Gillick.
The only private university in the UK, it was opened by Margaret in February 1976 with 65 students.

3 September 1998

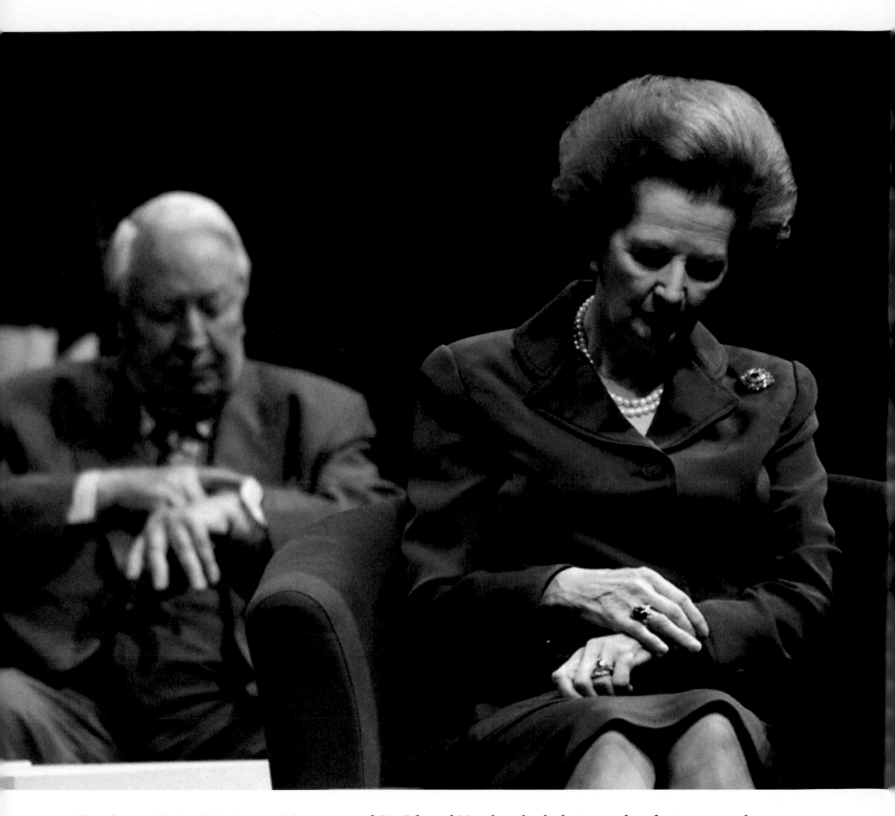

Two former Prime Ministers – Margaret and Sir Edward Heath – check their watches during a speech at the Conservative Party annual conference in Bournemouth.

7 October 1998

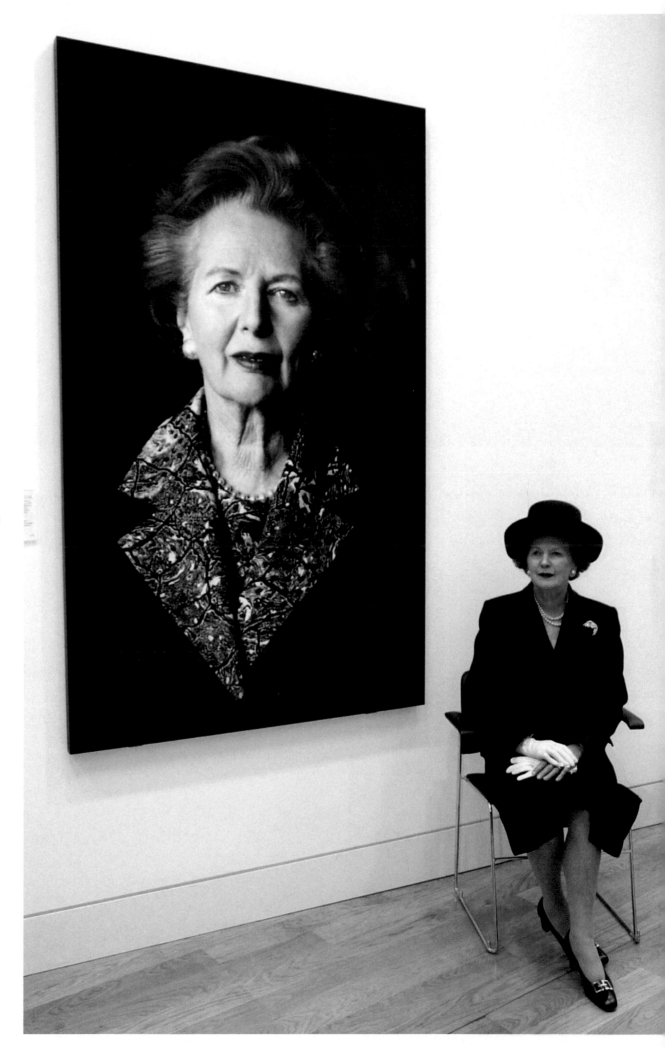

She sits beside her portrait at the National Portrait Gallery in London where the Queen has opened the new wing.

4 May 2000

Her 75th birthday.

13 October 2000

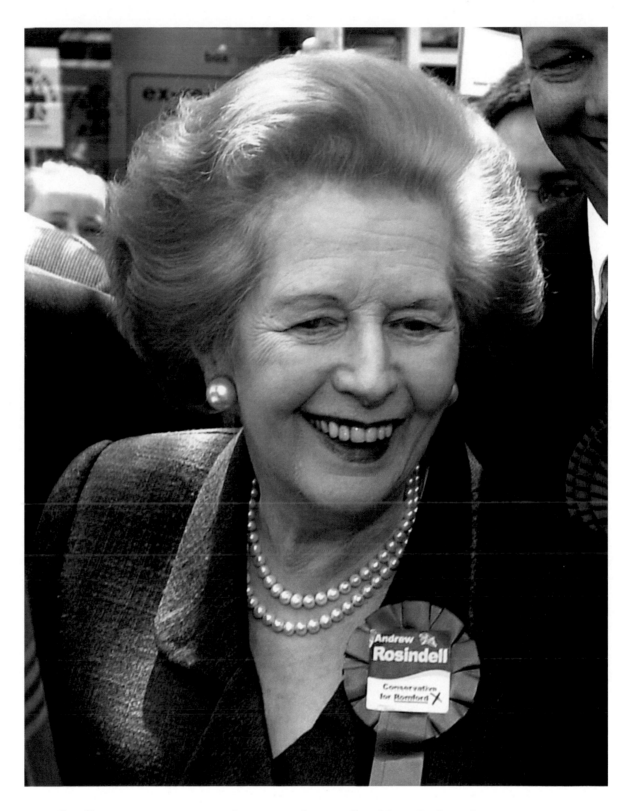

...and still campaigning. Here she meets the people of Romford as she tours the shopping centre with Tory candidate Andrew Rosindell.

5 June 2001

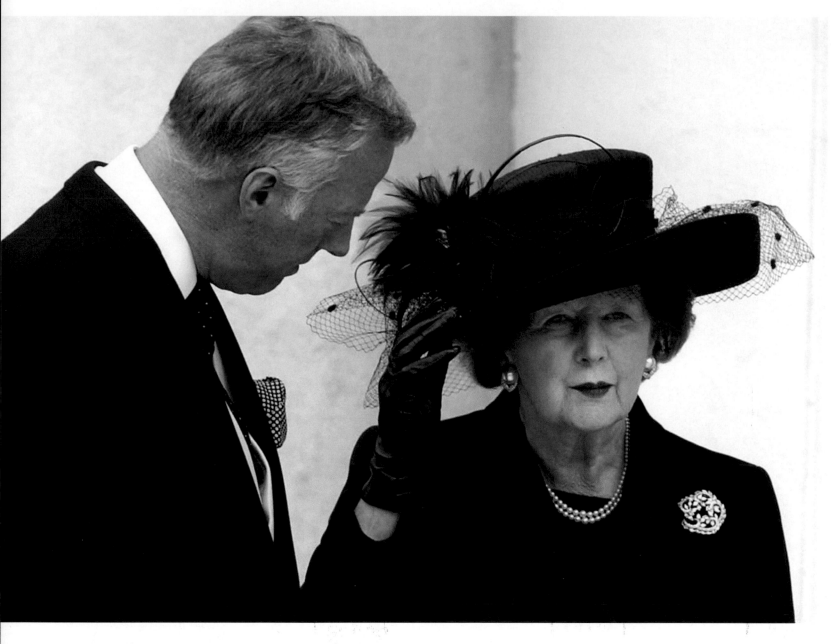

Margaret with her son Mark at the funeral of her husband Denis who died, aged 88,
on 26 June after having undergone a heart by-pass operation earlier in the year.

3 July 2003

FACING PAGE: *An unguarded moment of grief after a memorial service*
for Denis in the Guards Chapel in Birdcage Walk.

30 October 2003

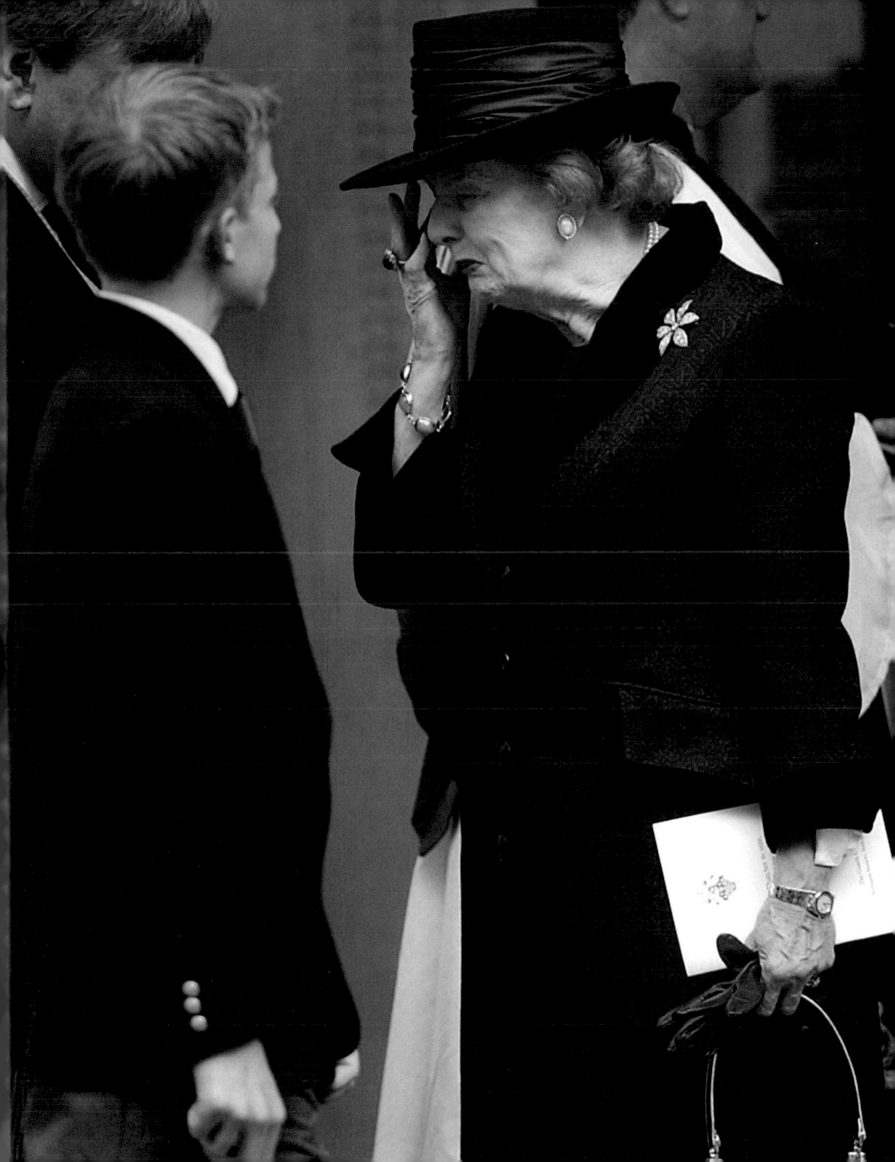

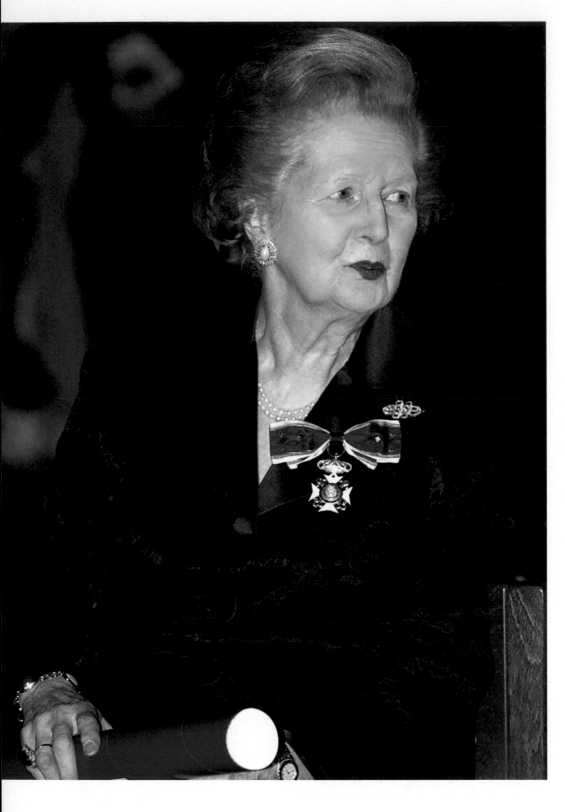

Margaret at an investiture ceremony at Westminster Cathedral where she is made Dame Grand Cross, the highest honour of the Royal Order of Francis for a lifetime's work towards inter-faith dialogue.

14 November 2003

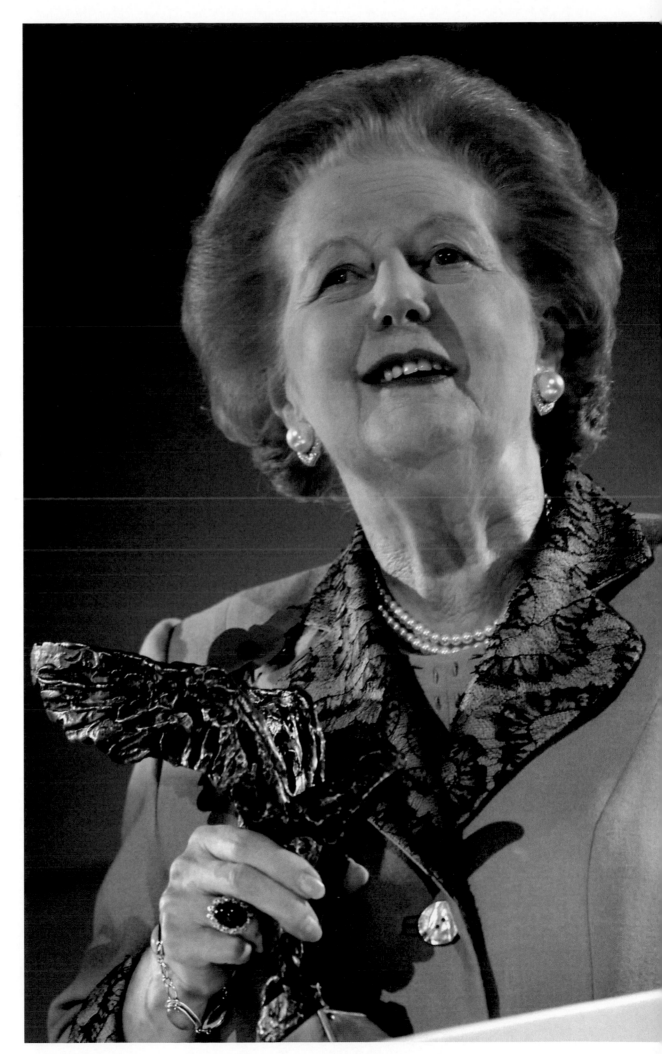

She receives the Lifetime Achievement award at the 50th anniversary lunch for the Women of the Year Awards at the the Guildhall, London.

3 November 2005

She joins Chelsea Pensioners during a visit to the Royal Hospital Chelsea.
The Pensioners are, from left: John Walker, John Ley, David Poultney and Charles McLaughlin.

14 February 2008

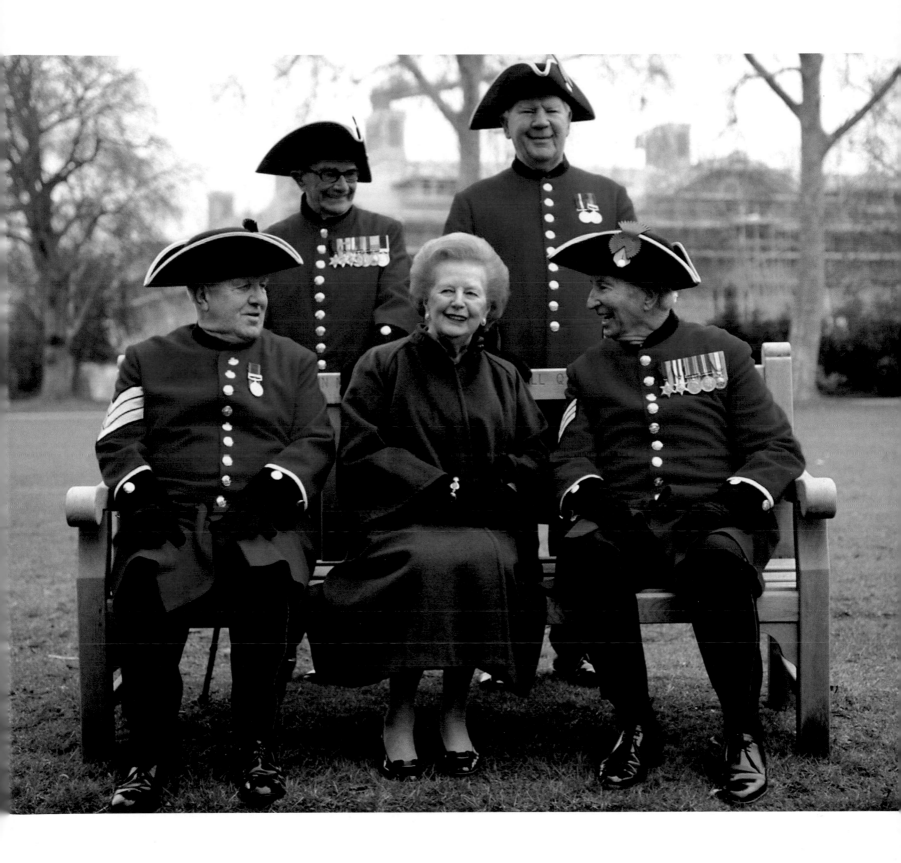

 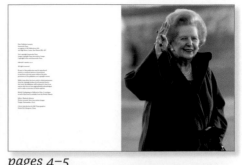

page 1 *pages 2–3* *pages 4–5* *pages 6–7*

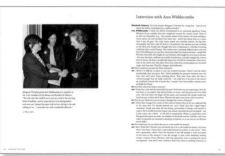 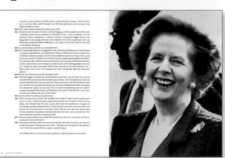

pages 14–15 *pages 16–17* *pages 18–19* *pages 20–21*

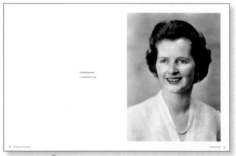 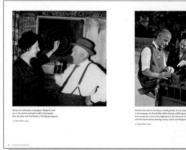 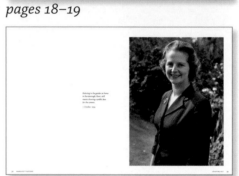

pages 28–29 *pages 30–31* *pages 32–33* *pages 34–35*

 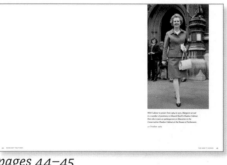 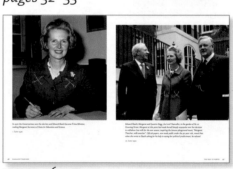 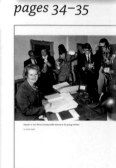

pages 42–43 *pages 44–45* *pages 46–47* *pages 48–49*

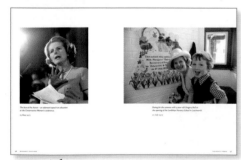 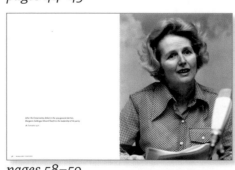 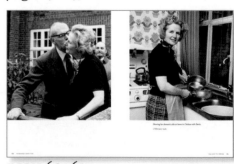 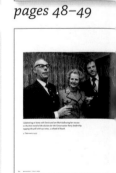

pages 56–57 *pages 58–59* *pages 60–61* *pages 62–63*

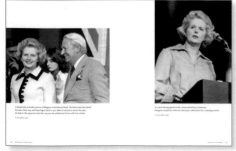 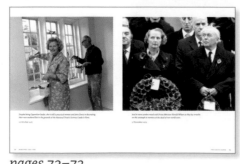 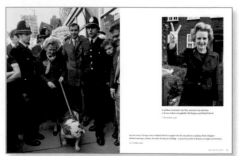

pages 70–71 *pages 72–73* *pages 74–75* *pages 76–77*

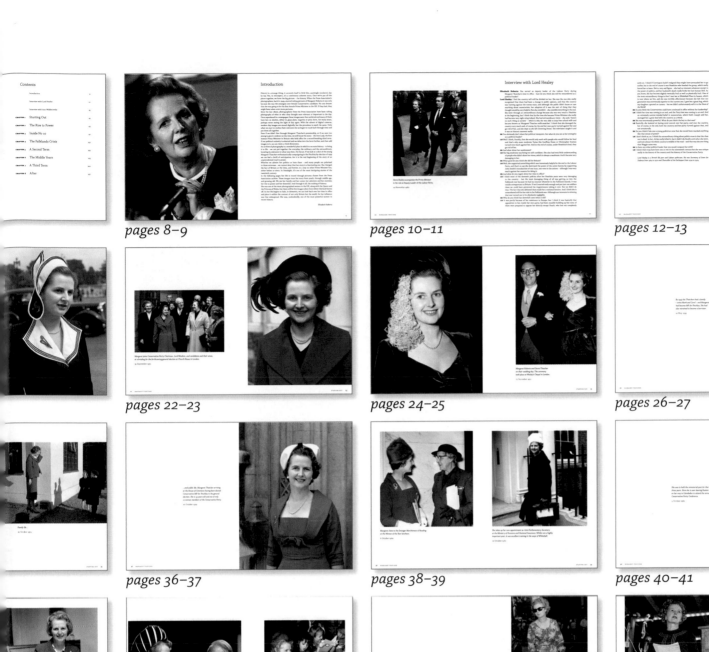

pages 8–9

pages 10–11

pages 12–13

pages 22–23

pages 24–25

pages 26–27

pages 36–37

pages 38–39

pages 40–41

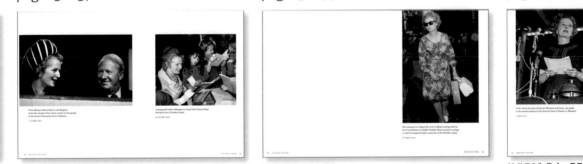

pages 50–51

pages 52–53

pages 54–55

pages 64–65

pages 66–67

pages 68–69

pages 78–79

pages 80–81

pages 82–83

pages 84–85

pages 86–87

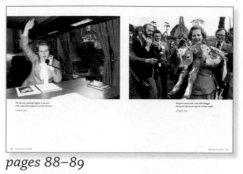

pages 88–89

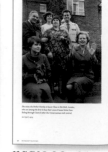

pages 90–91

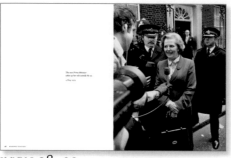

pages 98–99

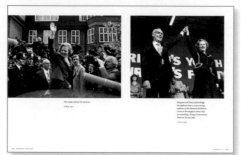

pages 100–101

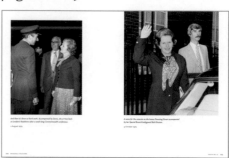

pages 102–103

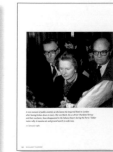

pages 104–105

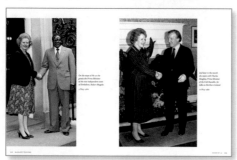

pages 112–113

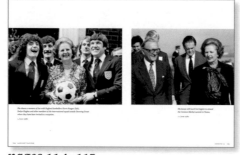

pages 114–115

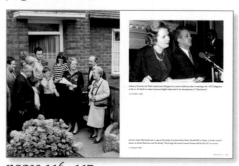

pages 116–117

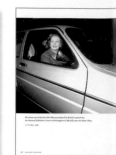

pages 118–119

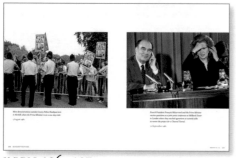

pages 126–127

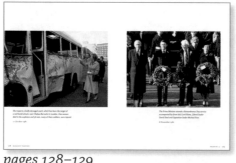

pages 128–129

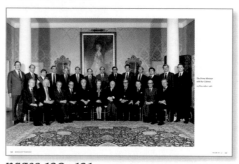

pages 130–131

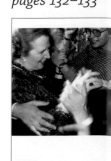

pages 132–133

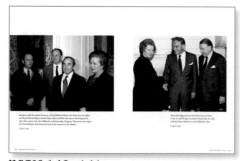

pages 140–141

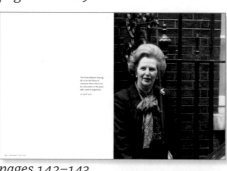

pages 142–143

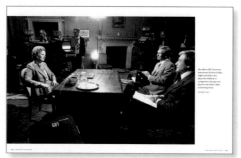

pages 144–145

pages 146–147

pages 154–155

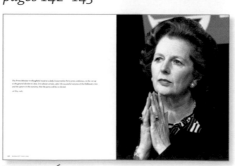

pages 156–157

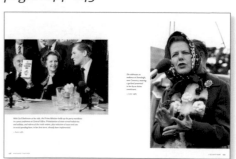

pages 158–159

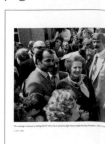

pages 160–161

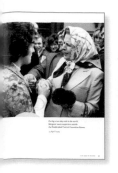

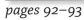

pages 92–93

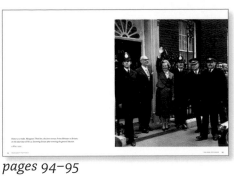

pages 94–95

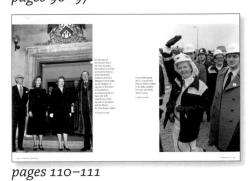

pages 96–97

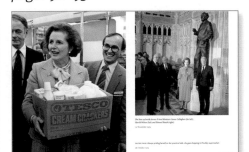

pages 106–107

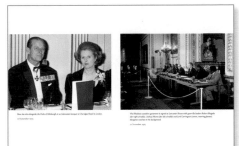

pages 108–109

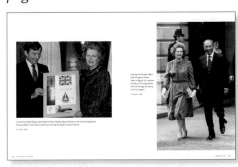

pages 110–111

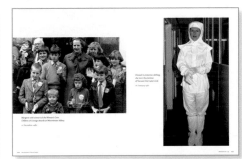

pages 120–121

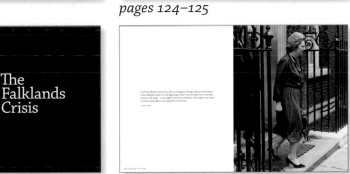

pages 122–123

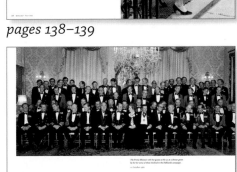

pages 124–125

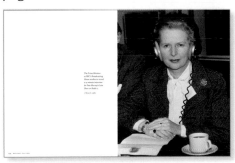

pages 134–135

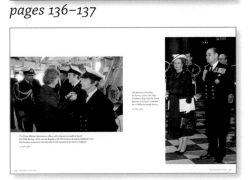

pages 136–137

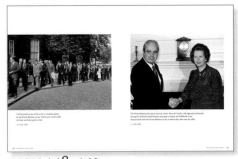

pages 138–139

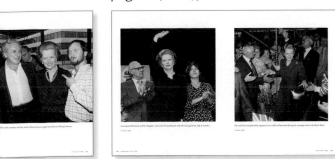

pages 148–149

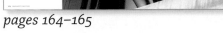

pages 150–151

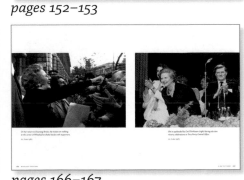

pages 152–153

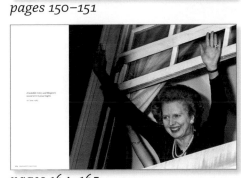

pages 162–163

pages 164–165

pages 166–167

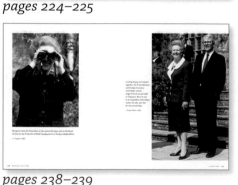

pages 168–169

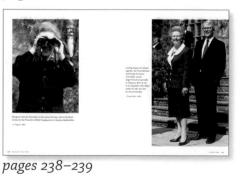

pages 170–171

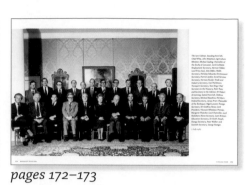

pages 172–173

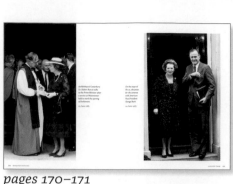

pages 174–175

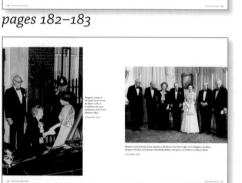

pages 182–183

pages 184–185

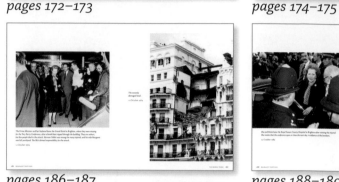

pages 186–187

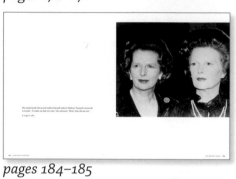

pages 188–189

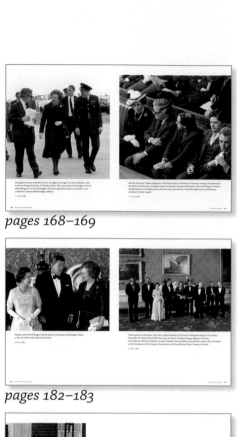

pages 196–197

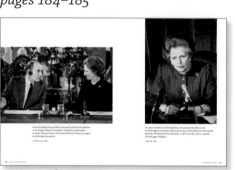

pages 198–199

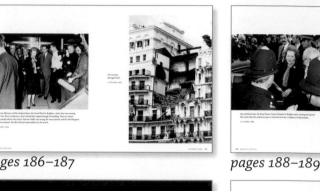

pages 200–201

pages 202–203

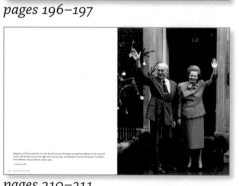

pages 210–211

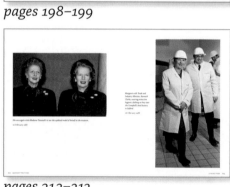

pages 212–213

pages 214–215

pages 216–217

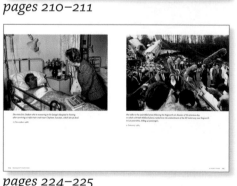

pages 224–225

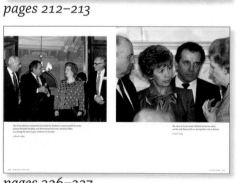

pages 226–227

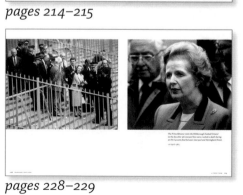

pages 228–229

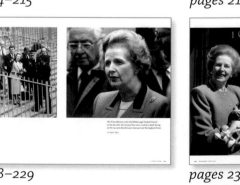

pages 230–231

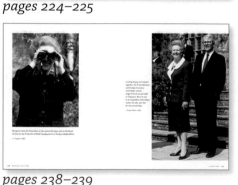

pages 238–239

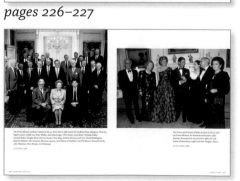

pages 240–241

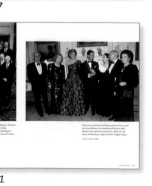

pages 242–243

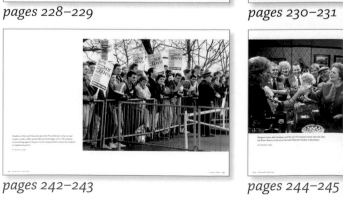

pages 244–245

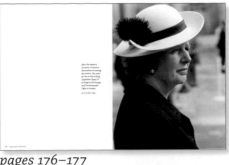

The
Middle
Years

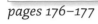

pages 176–177

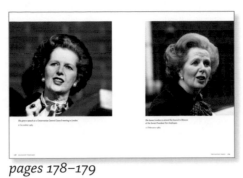

pages 178–179

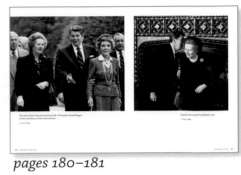

pages 180–181

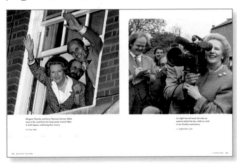

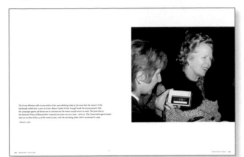

pages 190–191

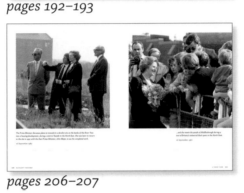

pages 192–193

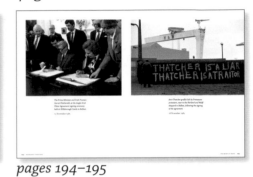

pages 194–195

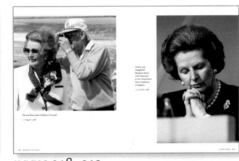

pages 204–205

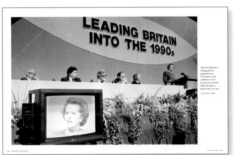

pages 206–207

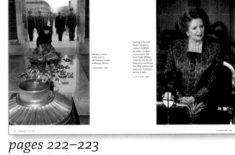

pages 208–209

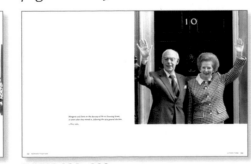

pages 218–219

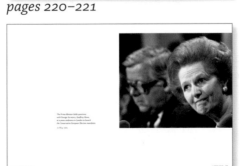

pages 220–221

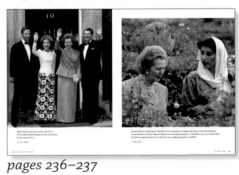

pages 222–223

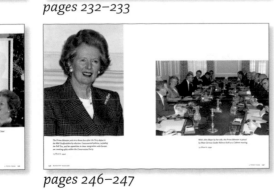

pages 232–233

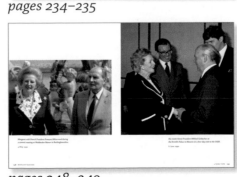

pages 234–235

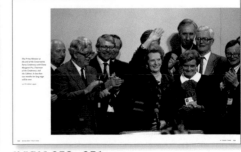

pages 236–237

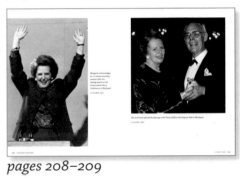

pages 246–247

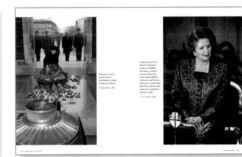

pages 248–249

pages 250–251

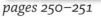

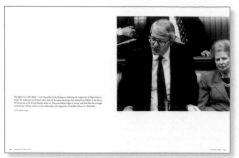

pages 252–253

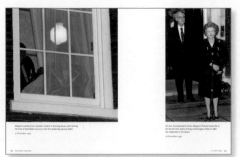

pages 254–255

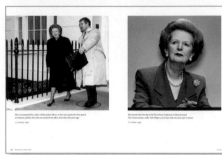

pages 256–257

pages 258–259

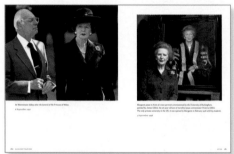

pages 266–267

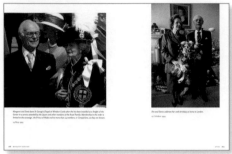

pages 268–269

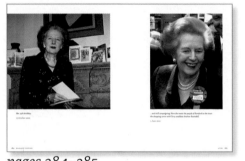

pages 270–271

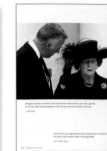

pages 272–273

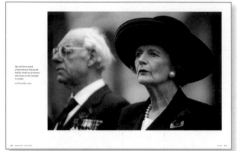

pages 280–281

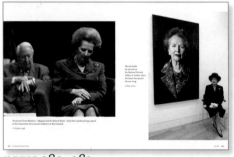

pages 282–283

pages 284–285

pages 286–287

pages 294–295

pages 296–297

pages 298–299

page 300

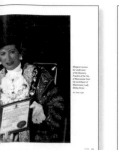
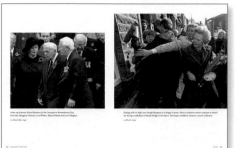
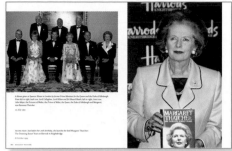
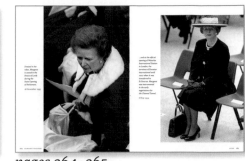

pages 260–261

pages 262–263

pages 264–265

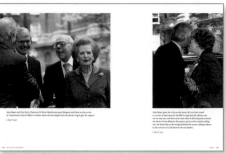
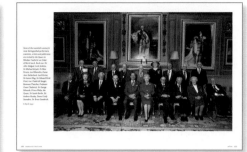
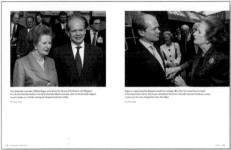

pages 274–275

pages 276–277

pages 278–279

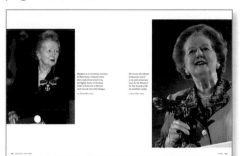
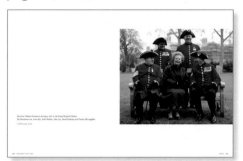

pages 288–289

pages 290–291

pages 292–293

The Publishers gratefully acknowledge Press Association Images, from whose extensive archive
the photographs in this book have been selected. Personal copies of the photographs in this book,
and many others, may be ordered online at www.prints.paphotos.com

For more information, please contact:
Ammonite Press
AE Publications Ltd. 166 High Street, Lewes, East Sussex, BN7 1XU, United Kingdom
Tel: 01273 488005 Fax: 01273 402866
www.ammonitepress.com